		8.	* *		
•					
			- A		
h					

•		

NORMAN ROCKWELL ILLUSTRATOR

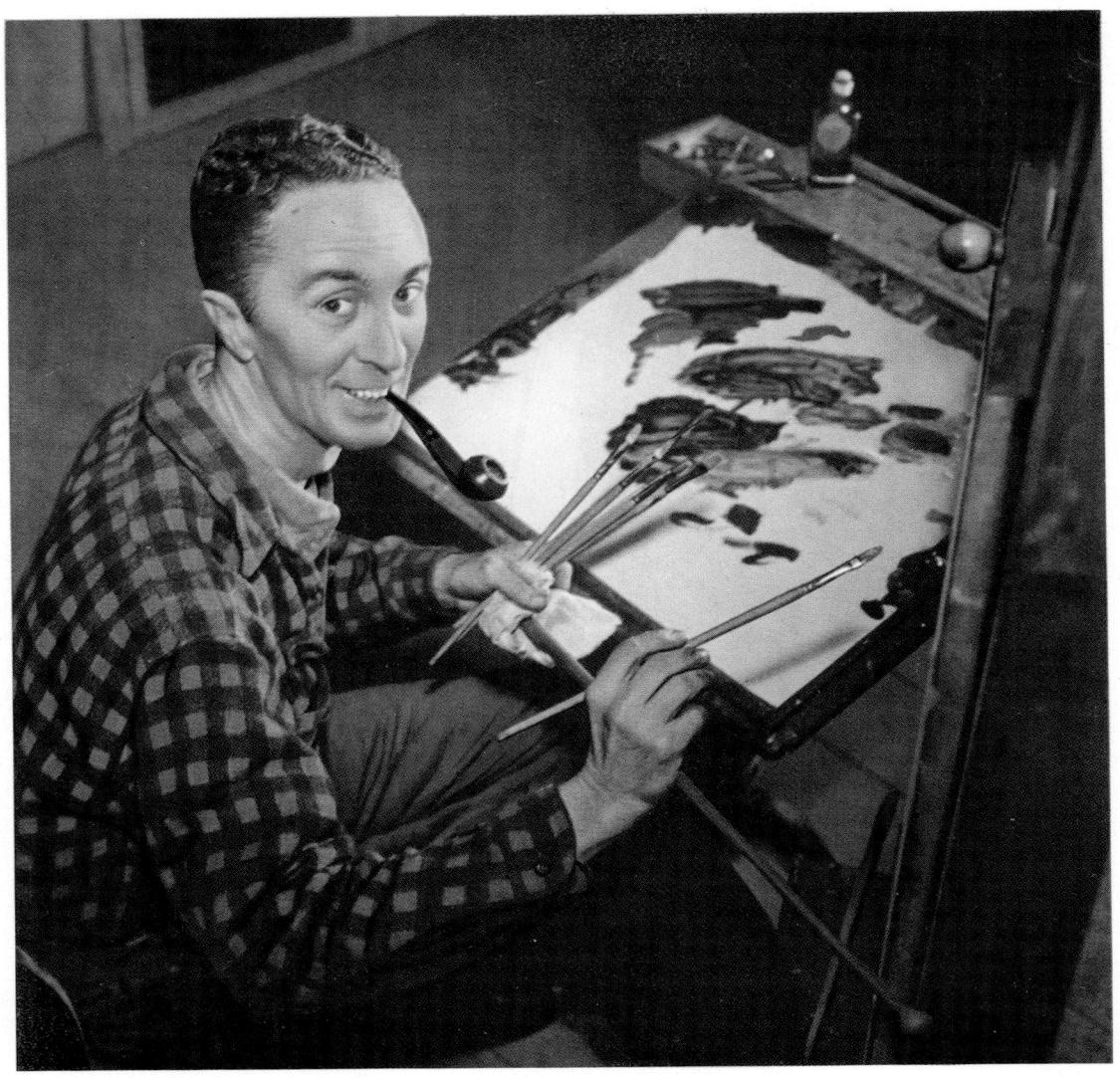

COURTESY THE SATURDAY EVENING POST

COLOR PHOTO R. F. GARLAND

NORMAN ROCKWELL ILLUSTRATOR

By ARTHUR L. GUPTILL

Preface by

DOROTHY CANFIELD FISHER

Biographical Introduction by JACK ALEXANDER

WATSON-GUPTILL PUBLICATIONS

NEW YORK

Publisher's Note

This book was first published in 1946, when Norman Rockwell was at the height of his fame as America's most popular illustrator. In the years that followed, the artist's achievement has not only endured, but the art world has witnessed a deepening appreciation of Rockwell's unique place in the history of American painting. Now, on the twenty-fifth anniversary of its publication, we are proud to reissue a book which is, in its way, an American classic: Norman Rockwell, Illustrator.

First published 1946 in New York by Watson-Guptill Publications. All rights reserved. No part of the contents of this book may be reproduced or used in any form or by any means without the written permission of the publishers. Watson-Guptill Publications, a division of Billboard Publications, Inc.

Manufactured in Japan
Library of Congress Catalog Card Number: 75-125848
FIRST EDITION, 1946
SECOND EDITION, 1947
THIRD EDITION, 1970
SECOND PRINTING, 1970
THIRD PRINTING, 1971
FOURTH PRINTING, 1971
FIFTH PRINTING, 1971
SIXTH PRINTING, 1972
SEVENTH PRINTING, 1972

Preface: Dorothy Canfield Fisher

MAY I SUGGEST a perspective for looking at this book, for seeing its significance, and the reason for publishing it. Suppose that in some uncatalogued pile of 17th century archives, a manuscript should be discovered doing for—well, let us say for Ter Borch, or Jan Steen, or Peter de Hooch, what is here done for a man who portrays the everyday life of everyday people in his time as they did in theirs. Would you fall eagerly upon such a record of the development of one of the Dutch genre painters? You know you would. And you would be richly rewarded if the artist had, as Rockwell does in this volume, lent himself with honesty and a disarming lack of complacency to a report on his training in youth and his work up to his middle period.

There are so many little—and vital—things which nobody ever tells us about the artists of the past. Take the brothers LeNain, who alone among the French artists of their period, painted the plain farm men and women and the artisans of the 17th century. How much it would mean to us if we could learn how they set their palettes, how they prepared their canvases, how they learned draughtsmanship, what they did to earn their livings in their apprentice period, what the effect upon them was of the understanding (in their case, probably, the misunderstanding, underestimating and neglect) of their work by their contemporaries.

Suppose that such a book were about Jan Steen, and that from it we had learned that he had, in his youth, painted (an amusing idea) some pious altar-pieces, with portraits on each side of the rich donor and his

wife stiffly dressed up in their brocaded Sunday best. Such painting for pay was in those days, we may assume, the equivalent of advertisements for the modern artist. The comparison of such early work with Jan Steen's later competent painting of noisy tavern scenes would probably be as striking as, in this book, the comparison between the youthful Norman P. Rockwell's advertisements and covers, with such a canvas as his fine, imaginative, harmonious portrait of Ichabod Crane, with its touch of just-right grotesqueness.

For a young person a chance to study the beginnings of a mature character is priceless. But he does not get many such opportunities. Most people have a strong Minerva-springing-full-grown-from-the-head-of-Jove complex. They cover up with nervous care evidences of the fact that they too were once young and fumbling their way uncertainly towards maturity. Very few have the quiet lack of personal vanity of the subject of this book; a quality truly surprising (human nature being what it is) in a man so widely loved and admired as he.

All in all, I feel that if you want to understand this report about a contemporary, you will do well to consider it such a record as the hypothetical ones I have imagined, not only of the development of an illustrator and painter, but of an interpreter of his nation's life.

I have recently written a defense of those serious and sincere modern authors who attempt to understand and portray what they see in American life, even if their report is shocking to those who have never come in contact with filth and moral degradation. My argument is that if, in American life, such sordidness and misery are often found, nothing is gained by pretending in books that things in our country are different from what they are.

Having gone on record publicly with this claim of the right of an honest portrayer of human life to give us his report, even if it sickens us, I think I have the right to make the same claim for another honest portrayer of human life even if his report cheers and comforts us.

Just at present the one is up on the see-saw of aesthetic fashion and the other is down. This is, I think, an especial reason for calling the attention of Americans to the story of Norman Rockwell's work (up to his PREFACE

middle period). If he had painted in the mid-Victorian period of hush-hush about the ugly and ignoble aspects of human life, a comment on what he gives us should, perhaps, have contained a reminder that—the traditional European reproach to Emerson—he does not look at death, failure, defeat. But we have in these last decades supped deep of portrayals of frustration and defeat. Such portrayals give but one aspect of real life. Another aspect has the right to our recognition. It is true that, in our country, minorities suffer from savagely unjust discriminations, that there are shocking inequalities of opportunity which cause widespread human misery. But in our America there are also—so familiar that a portrayal of them gives to millions the pleasure of recognition—uncountable homes, warm with love and trust, and with thankfulness for the shelter, in the very midst of the typhoon of human struggle, which such homes give to those who live in them.

No one can deny that in many tenement houses the poor are ground down by poverty, disease or racial injustice into the dreadfulness of wishing, being hurt themselves, to hurt others weaker than they. Our hearts have been frozen by many a powerful book-presentation of this literal but partial truth. Norman Rockwell reminds us (we must not forget that he is as accurately true to the literal fact, and as partial), that in those same tenement houses are also many homes in which the safe return of a soldier son—insignificant droplet in the military ocean—sets off an explosion of a joy magnificent in its power and purity.

We have always imagined the smart British officers, and the well-trained, well-equipped British professional soldier, sneering coldly at our Yankee Doodle bumpkin. Norman Rockwell shows them laughing in easy, golden good nature at the hobbledehoy. Undoubtedly some of them did so. That is as likely, granted British character, as the other. (In passing don't fail to examine with attention the admirable draughtsmanship in the page of preliminary drawings of the old British grenadier.) In a period when wormwood and vinegar are the fashionable flavorings, it is genuine originality for Rockwell to dip his brush into the honey-pot of lovableness and zest in living.

His originality (it must take some courage, too) in thus painting an

aspect of the truth which he chooses to paint, is shown again by his swimming against the current of fashion—in ignoring what is known as "natural" beauty. Just as he does not portray misery and malicious wrong-doing (although the extreme sensitiveness of his face in the photograph standing before his easel, page xxxii, gives evidence that he cannot but be aware of it) so he resolutely does not paint landscapes. In a period so given over to the Romantic School preoccupation with "nature effects" that the general public almost considers red barns and covered bridges and mirror reflections in water, or at least vegetables and fruit, as the only subjects for "real pictures," here is a painter who ignores the non-human scene.

He has some to-be-respected forerunners in this. The great Londoner Dr. Johnson had no use for the globe save as background for human life; Daumier the mighty, hardly ever shows anything on his canvases but men and women and children. Hogarth found humanity enough. One might be permitted to cite here, because it is undoubtedly an expression of what many people feel, the remark of that city-loving Cabot who said to a friend about to spend a day in the country, "Just kick a tree for me, will you?"

Before the nineteenth century most people took this indifference to or dislike of the country for granted. But the modern Nature cult has been so permeating that in our times that section of humanity which is bored by trees and rivers and barns, and interested only in other human beings, scarcely realizes it. And if they were consciously aware that this is their real feeling, few of them would dare to raise their voices against that most unquestioned of all dictatorships, a prevailing aesthetic fashion.

In the case of a man so transparently sincere, so honestly earnest as Norman Rockwell, does it take "courage" to go against a fashionable aesthetic convention? Probably not. Probably he has no time to think whether he is going against what the knowing ones of his period accept. It is obvious from the story of his life and work that he is single-heartedly focused on what makes up the life of any kind of creative personality, the long, desperate struggle with his own limitations. But if we are to understand him, we will do well to remember that it does not make sense

хi

to think that his elimination of tragedy and cruelty can be laid to a wish to please the people who look at his work, because he leaves out, firmly and consistently, something else that would please them, something which moderns love to look at—the beauty of Nature.

In both instances it is plain that he purposefully makes his own choice from an inner necessity. Every artist learns early, or he is no artist, that he must drink out of his own cup, must cultivate his own half-acre, because he never can have any other.

ACKNOWLEDGMENT

To Norman and Mary Rockwell, to whom the author and publishers of this book are deeply indebted for their constant help in a hundred ways. . . . To Dorothy Canfield Fisher, for her significant preface concerning her Arlington neighbor and friend. . . . To The Saturday Evening Post—especially Kenneth Stuart—without whose wholehearted cooperation a comprehensive volume on Rockwell would have been impossible; to Jack Alexander of the Post, author of our revealing biographical introduction. . . To numerous others who have unhesitatingly lent us original paintings or granted us reproduction rights, including The American Magazine, Boy Scouts of America, Brown & Bigelow, Coronet, Crowell-Collier Publishing Company, Fisk Tires, Funk & Wagnalls Company, Interwoven Stocking Company, Ladies' Home Journal, Nassau Tavern, New Rochelle Public Library, Parents' Magazine, Popular Science Monthly, Society of Illustrators, 20th Century-Fox Film Corporation, the United States Army, Woman's Home Companion; Steve Early, J. Waring Rockwell, Ben Harris, Mead Schaeffer, Harold N. Hill, H. M. Haiston and Col. Henry Fairfax Ayers. . . To a host of individuals—photographers, engravers, paper merchants, printers, binders and their assistants—who have made an extraordinary effort to produce a volume worthy of its distinguished subject, and to meet an exacting publishing schedule.

Table of Contents

PREFACI	E: DOROTHY CANFIELD FISHER	vii
	BIOGRAPHICAL INTRODUCTION: JACK ALEXANDER	xix
	LIST OF ILLUSTRATIONS	xv
	BY WAY OF PROLOGUE	31
I: ,	A VISIT TO ROCKWELL'S STUDIO	33
II:	HOW ROCKWELL PAINTS A POST COVER	45
III:	SOME COME EASY: SOME COME HARD	53
IV:	MAGAZINE ILLUSTRATION	7 1
V:	ILLUSTRATING THE BOOK	101
VI:	MURALS, PORTRAITS AND SUCH	III
VII:	ADVERTISING ART	129
VIII:	NOW IT'S CALENDAR TIME	135
	THE FOUR FREEDOMS	141
	THIRTY YEARS OF ROCKWELL POST COVERS	151
IX:	ROCKWELL'S CREATIVE AND TECHNICAL PROCEDURE	193

List of Illustrations

* Stars Represent Reproductions in Color (Chapter Headings and Decorations by Rockwell not listed)

*NORMAN ROCKWELL—PHOTOGRAPH IN COLOR	iv
NORMAN AND HIS BROTHER JARVIS—PHOTOGRAPH	xxii
A LEAD PENCIL DRAWING BY ROCKWELL'S FATHER	xxiii
PAGES FROM A ROCKWELL ART SCHOOL SKETCHBOOK	xxiv
THE ROCKWELL HOUSE, ARLINGTON—PHOTOGRAPHS	XXX
TYPICAL ROCKWELL POSE—PHOTOGRAPH	32
ROCKWELL FAMILY—SKETCH	36
MARY ROCKWELL IN HER STUDY—PHOTOGRAPH	38
MY STUDIO BURNS—DRAWINGS	39
ROCKWELL'S NEW STUDIO—PHOTOGRAPHS	40-200
ROCKWELL'S STUDIO—PLAN	41
ROCKWELL AT WORK (1925)—PHOTOGRAPHS	44
FLAT TIRE, SATURDAY EVENING POST COVER, AUGUST 3, 1946:	
IDEA SKETCH—PENCIL	45
TWO PRELIMINARY STUDIES—CHARCOAL	46
PHOTOGRAPHIC DATA	47
FURTHER STUDIES—CRAYON	48-49
*COLOR STUDIES—OIL	50
*FINISHED PAINTING—OIL	51
FINAL COVER	191
CHARWOMEN, SATURDAY EVENING POST COVER, APRIL 6, 1946	; :
*COLOR STUDY—OIL	52
ORIGINAL SKETCH—PENCIL	54
FINAL COVER	54
	0.1

LAYOUT—CHARCOAL *FINISHED PAINTING—OIL	56 57
THANKSGIVING, POST COVER, NOVEMBER 24, 1945:	07
PENNELL HOUSE, BRUNSWICK, MAINE—PHOTOGRAPHS	62
PHOTOGRAPHIC DATA	66
DETAILED DRAWING ON CANVAS—CHARCOAL	67
FINISHED PAINTING—OIL	69
FINAL COVER	189
FOUR REPRESENTATIVE MAGAZINE ILLUSTRATIONS—OIL	70
ROCKWELL'S FIRST PUBLISHED ILLUSTRATION (1911)	73
ANOTHER EARLY ILLUSTRATION (1912)	73
EIGHT MAGAZINE COVERS (1916-1921)	74-75
LOUISA MAY ALCOTT SERIES:	
THREE MAGAZINE ILLUSTRATIONS—WOLFF CRAYON	76-77
ILLUSTRATION—OIL *ILLUSTRATION—OIL	79 81
	-
DANIEL WEBSTER AND THE IDES OF MARCH—OIL	78
TYPICAL MAGAZINE ILLUSTRATION—OIL	79 82-83
CIRCUS SCENE—OIL *HOSPITAL RECEPTION ROOM—OIL	02-03 84
*FULL-SIZE DETAIL OF ILLUSTRATION—OIL	85
*PRIZE FIGHT—OIL	86-87
*RATION BOARD—OIL	88-89
*BLACKSMITH SHOP—OIL	90-91
EXTERIOR VIEW—WOLFF CRAYON	96
COUNTRY EDITOR SUBJECT: *PRELIMINARY COLOR STUDY—OIL	92
MARGINAL SKETCH—WOLFF CRAYON	92
*SECTION OF FINAL PAINTING—OIL	93
ENTIRE PAINTING—MINIATURE	93
WHITE HOUSE SUBJECT:	
FOUR PAGES OF DRAWINGS—CRAYON AND WATERCOLOR.	94
FULL-SIZE DETAIL—CRAYON	95
A NIGHT ON A TROOP TRAIN—PENCIL SKETCHES	97
THE COMMON COLD—PEN-AND-INK SKETCHES	
TOM SAWYER AND HUCKLEBERRY FINN SERIES:	
*FULL-SIZE STUDY OF TOM—OIL	100
TWO TYPICAL TOM SAWYER ILLUSTRATIONS—OIL	102

	xvii	
	104	
	105	
4	107	
	108	
	110	
	III	
	112	
	113	
т	14-115	

LIST OF ILLUSTRATIONS	AVII
PRELIMINARY STUDY FOR TOM SAWYER—OIL* *ILLUSTRATION FROM TOM SAWYER—OIL TWO TYPICAL HUCKLEBERRY FINN ILLUSTRATIONS—OIL *ILLUSTRATION FROM HUCKLEBERRY FINN—OIL	104 105 107 108
PORTRAITS OF ROCKWELL CHILDREN—RED CRAYON JERRY ROCKWELL—WOLFF CRAYON	111
DOVER COACH; OVER-BAR PAINTING: *OIL PAINTING AND SETTING—PHOTOGRAPH IN COLOR PAINTING ONLY—OIL	112
*YANKEE DOODLE; MURAL PAINTING—OIL	14-115 115 116
*TAVERN SIGN PAINTER—OIL *LAND OF ENCHANTMENT—OIL	
ICHABOD CRANE—OIL* *ICHABOD CRANE—(ANOTHER TREATMENT)—OIL	122
*PORTRAIT; COLONEL HENRY FAIRFAX AYERS—OIL	124 126 127
*ADVERTISEMENT; INTERWOVEN SOCKS—OIL PORTION OF SIMILAR ADVERTISEMENT—OIL	128 129
*ADVERTISEMENT; FISK TIRES—OIL	131 132
*WAR POSTER; LET'S GIVE HIM ENOUGH AND ON TIME—OIL *CALENDAR; BOY SCOUT (1946)—OIL	133 134 136
CALENDAR; MRS. O'LEARY'S COW—OIL CALENDAR; FOUR SEASONS—WOLFF CRAYON	136 139
THE FOUR FREEDOMS	
THE FOUR FREEDOMS	
*FREEDOM OF SPEECH—OIL	143
*FREEDOM OF WORSHIP—OIL	145
FREEDOM FROM WANT—OIL *FREEDOM FROM FEAR—OIL	147
	10

THIRTY YEARS OF ROCKWELL POST COVERS

A Section Containing Miniatures of Every Rockwell Saturday Evening Post Cover

Rockwell Satu	O	Evening Pos	,		
1916-1917	154			169	
1917-1918-1919	155			170	
1919-1920	156	00 00	1933	171	
1920	157	1933-1934		172	
1921-1922	158	1934-1935		173	
1922-1923	159			174	
1923-1924	160	1937-1938		175	
1924	162	1938-1939		176	
1924-1925	163	1939-1940		179	
1925-1926	165	1941-1942		180	
1926-1927	166	1942-1943		184	
1927-1928	167	1943-1944		185	
1928-1929	168	1944-1945		189	
1945-1946			191		
PAGE-SIZE POS	T C	OVER	PAINTINGS		
*ROCKWELL'S FIRST COVER,	MAY	20 1016		150	
				152 161	
*CHRISTMAS COVER, DECEMBER 8, 1923 *COLONIAL SIGN PAINTER, FEBRUARY 6, 1926					
*ROCKWELL SELF-PORTRAIT,				164	
*THE SHERIFF, NOVEMBER 4,				177	
*APRIL FOOL COVED APRIL 2	1939.			178	
*APRIL FOOL COVER, APRIL 3	, 1943	CC CEDER	KDDD C	181	
*WILLIE GILLIS FAMILY PORT				183 187	
*CHICAGO RAILWAY STATION INTERIOR, DECEMBER 23, 1944 *HOME-COMING SOLDIER, MAY 26, 1945					
*THE SWIMMER AUGUST	AY 26,	1945		188	
*THE SWIMMER, AUGUST 11,	1945 .			190	
*HOME-COMING MARINE, OC	LOBE	CR 13, 1945	j	192	
CREATIVE AND T	ECF	INICAI	L PROCEDURE		
POST COVER, MARCH 2, 1946,	AND	THREE S'	TUDIES FOR SAME	196	
TICKET AGENT COVER, APRIL 24, 1937—CHARCOAL STUDY					
	POST COVER, DECEMBER 28, 1945, AND STUDY FOR SAME				
	1045			201	
HOME-COMING SOLDIER CO		AND STUI	DY FOR SAME	203	

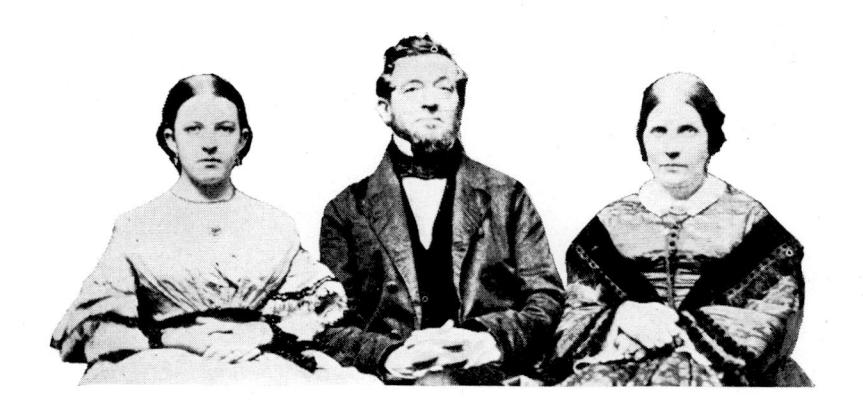

Biographical Introduction: Jack Alexander

NORMAN ROCKWELL discovered the Century of the Common Man a generation before the statesmen did. This was appropriate enough, for great painters—and great novelists, poets and essayists—have always jumped the gun on history while the political leaders were squatting back on their haunches awaiting an audible signal or a significantly planted boot. Intuition is a wonderful thing.

Rockwell's Century of the Common Man began in the early spring of 1916 when he was a skinny, twenty-one-year-old artist dabbling around a studio in New Rochelle, New York. He was worrying along blithely on fifty dollars a month which a boys' magazine was paying him for drawing the cover of each issue, illustrating two stories and performing the duties of art editor.

It was a thankless grind, and his studio mate, a cartoonist named Clyde Forsythe, kept telling him that he ought to be aiming, instead, at the cover of America's dominant magazine, *The Saturday Evening Post*.

"Gosh, the *Post*," was all young Rockwell said at first. But the idea stuck in his mind like a bur-and he soon began experimenting with sketches. They were pictures of unreal, glorified girls dawdling around with collar-ad men. The *Post*, Forsythe advised him paternally, didn't use that kind of cover; it wanted scenes showing real people in simple, everyday story situations. Forsythe was pretty well established as a newspaper artist and knew the ropes. Under the pseudonym of Vic, he was drawing a popular sports-page comic strip based upon the adventures

xix

Photo at top: Rockwell's paternal grandparents

of a ham prize fighter named Axel and his manager, Flooey. Rockwell bowed to superior knowledge, and did two paintings on the subject he knew best—boys. He added a rough sketch of a third.

Although scared at his own brashness, young Rockwell prepared cannily for his call in Philadelphia. He was, and still is, the impulsive type of person who gets his fingers tangled in the string while untying a package. To avoid such a fiasco and also to impress the art editor, he had a harness maker build a big wooden case for his paintings. Except for the fact that it was covered with black oilcloth, the case might easily have been mistaken for a child's casket. But it opened and shut easily.

The then art editor, Walter H. Dower, received the paintings and the rough sketch with a look of mild amazement at Rockwell's carrying case, and took them into his private office. Rockwell, with his case across his knees, sat nervously and waited for the verdict, looking like one of his subsequent cover subjects. He glanced at the walls of the anteroom and saw hanging there originals by well-known *Post* artists. That gave him a sinking feeling.

Two men, who, he later learned, were Irvin S. Cobb and Samuel G. Blythe, sauntered through the room and stopped. Rockwell stared at them, and they stared at the black case on his lap. With exaggerated frowns, they walked around and around it. Just then Dower came out of his office and said he was buying both the paintings and wanted Rockwell to go ahead with the sketch idea. Further, he said, he had consulted George Horace Lorimer, the editor, and they had decided that they ought to have three more covers from the new artist. Dazed, Rockwell accepted a check Dower proffered and got up to leave.

Cobb stopped him. "Young man," he said, pointing to the box, "is that a coffin?"

Rockwell mumbled that it wasn't.

"That's good," said Cobb. "We were afraid you had a body in it."

Cobb and Blythe laughed, and Dower laughed, and, the strain having been broken, Rockwell laughed too. When he got outside, he sent a dutiful telegram to Forsythe and went to Atlantic City and celebrated. The happy outcome of Rockwell's self-introduction to the *Post* resulted

in the promulgation of an office rule assuring the personal attention of the art editor, or his assistant, to any artist bringing his wares to the editorial offices.

It was love at first sight between Rockwell and the *Post*, and today the affair is going as strongly as ever. The first Rockwell cover appeared on the *Post* of May 20, 1916, and more than 200 have appeared since then. Editors and associate editors have come and gone in that time, and the present ones are as enthusiastic over Rockwell as their predecessors. Rockwell, for his part, has never wavered in his attachment to the *Post* and its traditions.

He has retained his pristine awe for it as an American institution and his wonderment over the fact that a kid artist could walk unheralded into its offices and have his talent immediately recognized.

Year after year, he has gone on portraying the Common Man on this magazine's jacket—and the Common Man's wife, his children, his pastor, his doctor, his garage mechanic, his druggist, his grocer, his barber, his flivver, his dog and his neighbors. Rockwell's Common Man was earthily American. He raised no clenched fist and carried no banner demanding anything, and he didn't incite anyone to riot. It is doubtful if the artist would have recognized the term "social significance" if someone had bellowed it at him from a platform. But social significance his covers had, because his characters wore the natural dignity of the ordinary man who prefers to carry his own weight, if given the chance.

Rockwell liked his characters and he painted them with sympathy and a decent humor, never with the stark distortion of his more arty contemporaries. "I guess I am a storyteller," he says now, in discussing his work, "and although this may not be the highest form of art it is what I love to do." Because Rockwell breathed affection into his paintings, they aroused affection in the heart of the beholder, and one was dull indeed who did not comprehend that the Common Man was a quite uncommon fellow. The political implications of the Rockwell covers were obvious enough. Through the masterly indirection of the artist, the Common Man asked only his rights as an American and silently pledged his faith in the promise of his country and in the system under which he

lived and raised his family.

Rockwell's men are not Hollywood heroes, his girls are not Powers models and his boys are not flaxen-haired angels. They are real people, marked by the attritional processes of life, and they are faithfully rendered to the last wrinkle, callus, crow's-foot, shoulder stoop and irregular nose line. They are people who have been thwarted and have had their small triumphs; who have hungered and have sometimes feasted; who have spoken their minds in meeting and have prayed, in the confidence that their words were as important as those of a president or king; who have kept alive in their hearts the hope of a constantly improving world. They are the masses. Some other professed spokesmen for them have used the cynical paintbrush or the strident larynx.

Rockwell, with the sure perception of the great artist, has made their dreams sing by helping to make America conscious of its quiet strength. *Post* readers, writing in, often say, "He understands us," and no interpreter could win higher praise. So true is the Rockwell portrayal that mention of his models is sometimes used in lieu of words themselves. During the war, a New York Times war correspondent described a fellow passenger in an Army plane thus, "A small private sitting behind me, who might have posed for one of Norman Rockwell's *Saturday Evening Post* covers, tapped my shoulder." Willie Gillis, come true.

Once a year or so, Rockwell leaves his home in Arlington, Vermont, and lectures at the Society of Illustrators in New York City, where he always talks to a packed gathering. As an artist unaffected by any current fad, and intent only on straight portrayal of American life, he is something of a curiosity, but students sit at his feet solely to learn something about his remarkable technique.

These visits are homecomings for Rockwell. He was born and spent his childhood on Manhattan's Upper West Side, where he was a choir boy at the Cathedral of St. John the Divine. He inherited artistic talent from his father, a cotton-goods merchant who was an amateur sketcher, and from his maternal grandfather, Thomas Hill, an English artist who emigrated to this country. Hill, who was fairly well known, specialized in portrayals of his clients' favorite dogs or roosters, hair by hair and

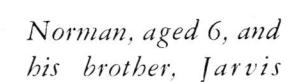

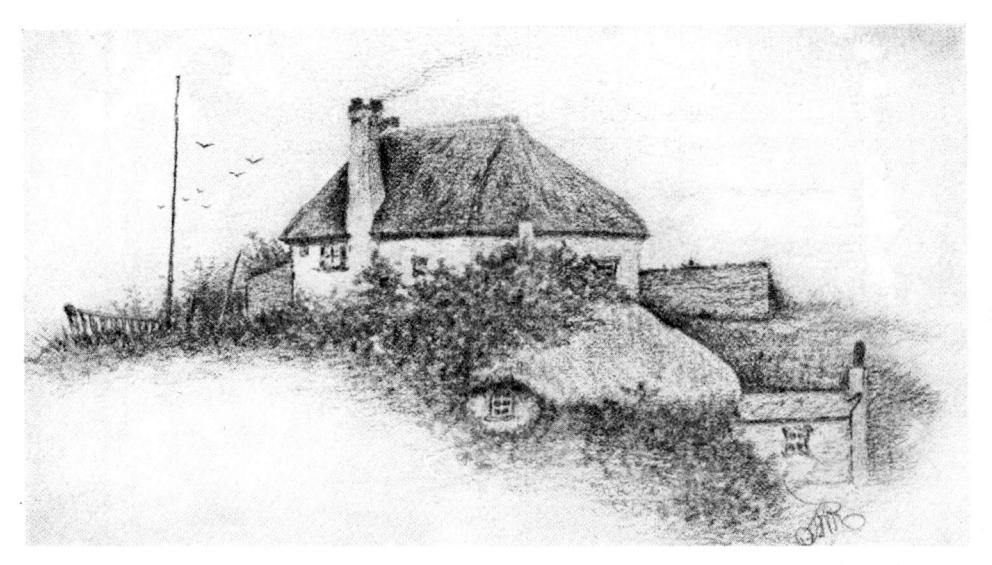

A LEAD PENCIL DRAWING BY ROCKWELL'S FATHER

feather by feather, and Rockwell thinks that his own passion for detail may trace back to his grandfather. In his paintings, Rockwell never fakes a detail. If a setting calls for a Colonial bedstead or footstool, he haunts auctions or antique shops until he gets what he wants. He gets his dog models from the nearest dog pound because, he says, the inmates have taken a beating from life and have character. He paints from live human models wearing clothing taken from a wardrobe of 200-odd costumes he keeps on hand. When traveling, he constantly adds to the wardrobe. In the collection is a battered hat he bought for two dollars from a guide who was taking him through Death Valley. It has appeared in four *Post* covers, to date.

Rockwell says that a hat cannot be aged artificially; it needs plenty of sweat and sunlight. A few years ago, while in the vicinity of Hannibal, Missouri, preparing to illustrate special editions of *Tom Sawyer* and *Huckleberry Finn*, he hailed a farmer who was plowing a field and offered to trade trousers with him and throw in four dollars to boot. Eager to make money the easy way, but suspicious that he was dealing with a genial maniac, the farmer insisted on getting the four dollars in advance.

Rockwell got out of his car and handed it over, and under a tree they silently detrousered themselves and made the exchange. Rockwell drove away well satisfied; he had added a superbly weather-beaten pair of pants to his collection.

As a boy, Rockwell was always sketching, and when he was in his second year of high school he quit and entered the National Academy of Design. After a morning at the Academy, he would spend the afternoon at the Art Students League, where he came under the tutelage of an eminent teacher, George Bridgman. At seventeen, he was illustrating children's books for a New York publishing firm and at eighteen he worked into the boys'-magazine job he was holding down when he made his *Post* debut, in 1916.

A year after his first *Post* cover had appeared, the United States declared war on Germany, and Rockwell, outwardly an almost giddy lad, but deadly serious inwardly, laid aside his brushes and tried to enlist in the Navy. The recruiting office turned him down because he was eight pounds underweight. Overnight, the candidate gorged himself on an appalling diet of bananas, warm water and doughnuts, and applied again in the morning. He was accepted this time and shipped off to the navy yard at Charleston, South Carolina.

Like most boys his age, Rockwell was anxious for action, but after he had made a casual drawing of a chief petty officer, his identity as a *Post* contributor was discovered. The commandant sent to New York for his brushes and materials, and installed Rockwell in the officers' quarters. Rated a third-class varnisher and painter, Rockwell, against his will, became the commandant's pet. When British or French admirals were visiting, Rockwell was summoned to the official dinner to sketch the visitors, and his work delighted everyone. In between drawing naval officers, he was permitted to paint *Post* covers, and during his stay at Charleston his income was greater than an admiral's. Rockwell, his *Post* covers and his impromptu drawings were the pride of the base.

After a year of this sybaritic existence, Rockwell wangled an assignment to Queenstown, Ireland, where he was to paint insignia on American naval planes based there. The transport on which he was a pas-

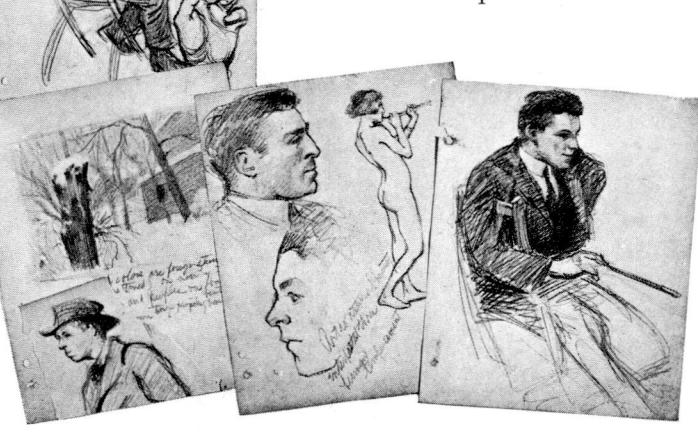

Typical pages from a Rockwell art school sketchbook of 1912

senger was stopped in mid-Atlantic by an American submarine, whose skipper, yelling from the conning tower, ordered the vessel to turn about and return to port. Rockwell never did learn the reason for this, but for a time suspected that the Charleston commandant had something to do with it. When news of the armistice arrived, Rockwell applied for his discharge and was told he would have to wait.

"Unless," his patron added, "you commit some crime and get a dishonorable discharge. Or you might get an inadaptability discharge, which would mean that you were too stupid to perform your duties. Of course, you wouldn't want that." The officer was surprised when the young man who was on his way to fame as an artist accepted an inadaptability discharge as a third-class varnisher and painter. He was mustered out on November fourteenth, one of the first members of the armed services to get out of uniform. "I was painting a cruiser captain at the time," he says now, reminiscently.

Rockwell's *Post* covers up to this time had been mostly of boys. After the war, he painted old men for a time and gradually worked people of all ages into his paintings. He became so popular that the *Post's* editors almost had to place an armed guard around him to fend off other patrons. Rockwell had the easygoing, carefree nature which is endemic among artists, and found it difficult to say no to anyone who sought his services. A result was that his *Post* cover schedule was irregular at times. Another difficulty was a yearning Rockwell had for turning out a magnum opus, a painting that would mark him for the ages. It is a dream that all artists have to face at some time in their lives. Professional friends, dabbling in modernism, told him he ought to learn something about dynamic symmetry, and their arguments worried him. "If you don't get on the modernist band wagon, you're licked," they kept saying.

Stewing and fretting, Rockwell packed up and went to Paris to seek refreshment of style at the feet of the moderns. He attended lectures and bought Picassos to hang in his studio for inspiration. On his return he set about applying what he had learned to *Post* covers. The dynamically symmetric results were nightmares. When Editor Lorimer examined the first new-Rockwell offerings he laid them aside and gave

Discharged:
A wartime sketch (1918)
for "Afloat and Ashore."

the artist a paternal lecture on the value of being one's self, pointing out in passing that it was conceivably better to have one's work displayed on the *Post's* covers than to have it embalmed in art museums. Chastened, Rockwell agreed, and went back to being himself. He now refers to his temporary aberration as "my James Joyce-Gertrude Stein period."

What did most to get Rockwell back on the beam and keep him there was a vacation trip he made in 1930. While visiting his old friend Clyde Forsythe in California, he met a Stanford girl named Mary Barstow. Three weeks later they were married. That was the fastest important job Rockwell ever completed. In his *Post* art work he hesitates to trust his own judgment, or anyone else's, and a person who didn't understand the perfectionist instinct of the good artist would think he was shilly-shallying. Periodically he comes down to Philadelphia to submit seven or eight rough pencil drawings of cover ideas, and bubbles with enthusiasm as he discusses them. If, say, four are approved for completion, he may discover, on the ride back to Vermont, that two are imperfectly conceived and telephone from Arlington for permission to change them. Or he may decide to abandon one or both of them.

The calm that Mary Rockwell has brought into his home life doesn't touch the nerve-racking routine of seeing a painting through to completion, except during the actual brushwork itself. When Rockwell is before his easel, she reads novels or biographies aloud to him, and this seems to aid him in concentrating. But somewhere along the route, Rockwell usually pulls up short with a terrible feeling that something is wrong with the picture. If Mrs. Rockwell can't supply the answer, a call is put in for Mead Schaeffer or John Atherton, two other Post cover artists who also live in Arlington and operate, with Rockwell, a Mutual-Admiration, Hand-Holding and Aid Society. When any member gets into a jam over procedure, he calls in one of the others, or both of them, for consultation and comfort. If Schaeffer happens to be the troubleshooter, his wife, Elizabeth, comes along, too, and the quartet solemnly pick the painting to pieces. If the problem survives this attack, anyone who happens to be near by is summoned—the men planting apple trees in the yard, the grocery boy, the carpenter at work on a shed or any

other Arlington friend, from the station-master to the general-store proprietor, who can spare half an hour.

While the lay experts are wagging their heads and venturing opinions, Rockwell keeps up a low, miserable chant consisting mostly of "Oh, gosh, oh, gosh, what a palooka I turned out to be!" His state of indecision sometimes persists for days. Meanwhile, he sleeps badly, tries out new approaches to his idea and restlessly hikes through the near-by Green Mountains, his reedy, 135-pound frame bent over like that of a mongoose flushing a cobra. Ultimately, the agony comes to an end with the dawning of a gentle inner light, and Rockwell has what he describes as "something I can sincerely paint." He paints it and bundles the canvas off for Philadelphia. "Then," he says, "I sit back and pray."

There is a saying in Arlington that posing for Rockwell, Schaeffer and Atherton is one of the town's more important industries. It is rarely necessary for the artists to look beyond the town's boundaries for the right types. The reason rural Vermonters make such good models, Rockwell thinks, is that they are a proud breed who would die before trying to be like anyone else, and hence have an individuality unmarred by attempts at imitation. City people, on the other hand, are ridden by all sorts of strange inhibitions about appearance and tend thereby to lose their distinctiveness, he says.

The Rockwells go to the village square dances and at one of them Rockwell spotted a youngster named Bob Buck. Buck straightway became the model for a Willie Gillis cover which was so popular that Rockwell made it into a series. Justice of the Peace Nip Noyes is a heavy-set man, whom he uses for doctors, judges and stout gentlemen of good digestion. Harvey McKee, another justice of the peace, and his wife, Jennie, have appeared on covers in innumerable roles, as has Walter C. Squiers, a building contractor. Dan Walsh, who drives the mail truck, does doctors and brokers for Rockwell, and occasionally poses as a Santa Claus. And so on and on, with most of the town participating. Sometimes, too, Rockwell, Schaeffer and Atherton pose for one another or borrow one another's children as models. For instance, on the flat tire cover showing two girls, both girls were modeled by Schaeffer's daughters.

The Four Freedoms series turned out to be one of the hardest jobs Rockwell ever tackled and he lost ten pounds working on the idea. The idea came to him at three o'clock one morning, when he awoke suddenly, gripped by a fear that people were saying, "Oh, yeah, the Four Freedoms," without actually understanding their implications. He tried to get back to sleep, but without success, and at five he dressed and went to the studio, where he sketched trial approaches to the concepts. Later, still in a state of inner excitement, he telephoned Mead Schaeffer and got him excited too. The upshot of their discussion was a trip to Washington, where Rockwell tried like a demon to give his idea to the Government, and Schaeffer faithfully seconded him. For two days they were shunted from bureau to bureau and didn't succeed in raising the blood pressure of a single bureaucrat. After a couple of days of this, they decided their expedition was a flop and headed sadly for home. As the train neared Philadelphia, Rockwell's face lighted up. "The Post, of course," he said. "Why didn't I think of it before?"

It was the only time in Rockwell's career that he didn't think of the Post first. If the Post's rival had been another jade of a magazine, the editors would have been sore, but they didn't mind being second choice to a Government at work on a war. Since the war came to an end Rockwell has been busy on *Post* covers, and in between these assignments he has been recording in paint and charcoal high spots in the lives of the Common (i.e., the Ordinary) Man, which the *Post* publishes as art spreads. Some of these, such as the one on a Ration Board's activities, were completed before the end of the war. Others, including the widelyacclaimed spread on a day in the life of a country editor, are products of the post-war Rockwell. A note common to almost all of Rockwell's spreads is that they deal with life in the middle areas of the United States, a region in which he feels as much at home as he does in his adopted state of Vermont. An exception is a spread he did on the waiting room of a maternity hospital in which the sorrows of expectant fathers were graphically portrayed. That waiting room could exist in New York City or Seattle as well as in the corn belt, and it doubtless does.

NORMAN ROCKWELL ILLUSTRATOR

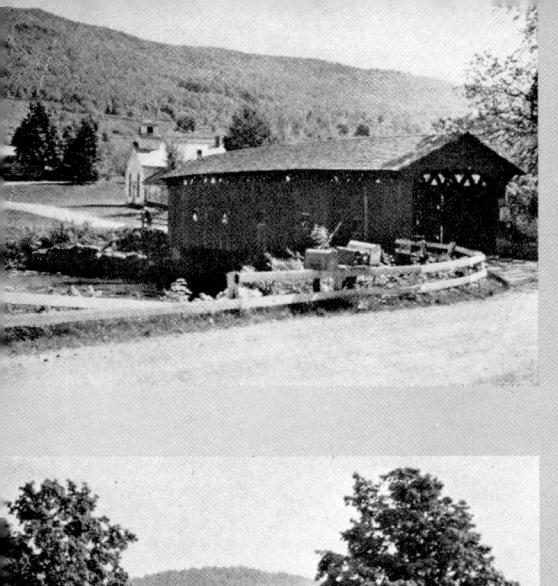

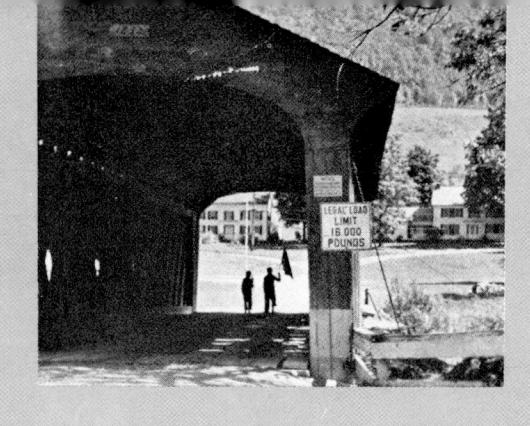

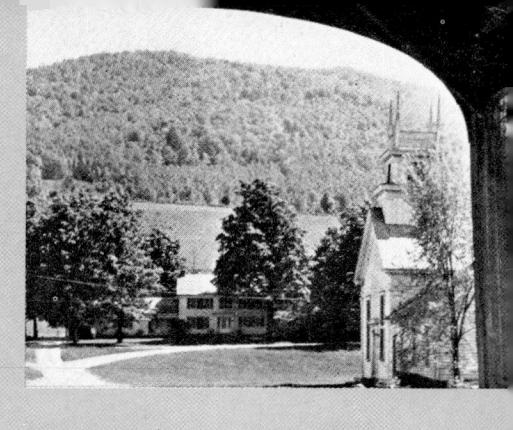

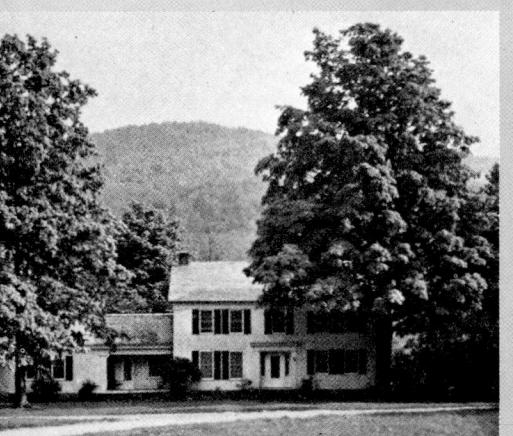

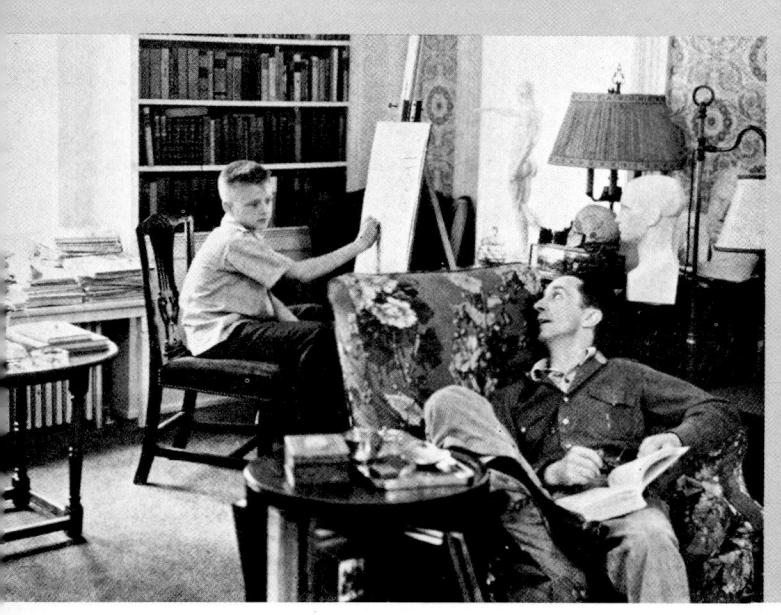

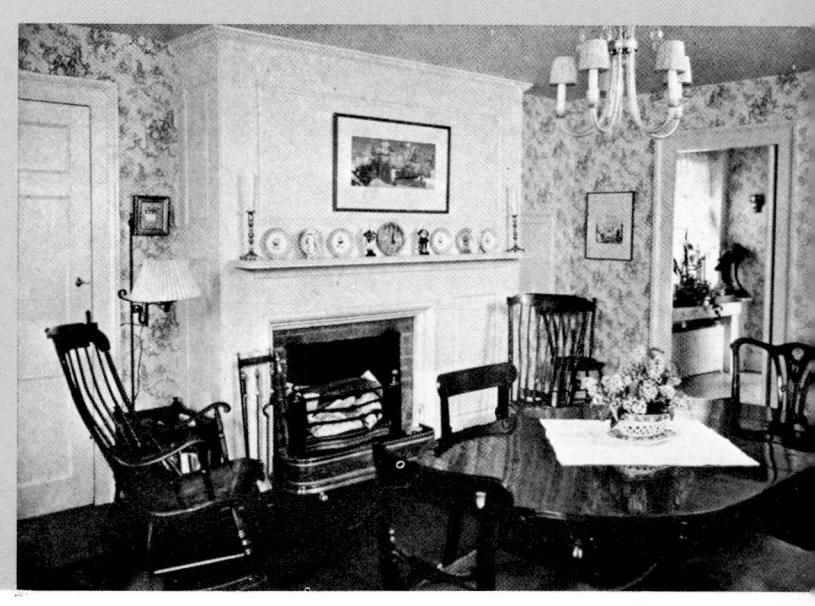

PHOTOS ROBERT MCAFEE

THE ROCKWELL HOUSE AT ARLINGTON, VERMONT, IS APPROACHED BY WAY OF A QUAINT AND WEATHERED COVERED BRIDGE, DATED $_{1852}$

Top Row: The bridge over the Batten Kill, the church, and Rockwell's residence. Middle Row: Close-up of house; Norman and Tommy at lunch; rear view of house with Elizabeth and Albert La Bombard, the household staff. Bottom Row: Tommy calls on dad for help; a corner in the dining room.

By Way of Prologue

We are going on a personal visit to Norman Rockwell. Through the pages of this book we'll meet the noted artist face to face; we'll say hello to his wife and family—take a quick glance at his house and its surroundings. We'll walk into his studio and stay as long as we like, poking around at leisure, examining every nook and cranny. We'll see some of his recent drawings and paintings and thumb through many examples of his previous work, including every Saturday Evening Post cover which he has painted in thirty years of prolific production.

Best of all, we'll look over his shoulder as he paints a magazine cover, watching him hour after hour, asking questions, listening to his comments, learning precisely how he accomplishes every step from the conception of the original idea until the final painting is ready for delivery. Rockwell will even tell us what brushes, canvases, paints, mediums and varnishes he prefers and exactly how he employs them. We will also discover how he does other types of work—book and magazine illustrations, advertising art, murals and portraits.

At times we'll accompany him as he wanders here and there rounding up his models and accumulating props. And on these trips, as well as in the studio, we'll hear from his own lips not only some of his amusing and illuminating experiences but why he paints as he does, divining the thinking behind his doing.

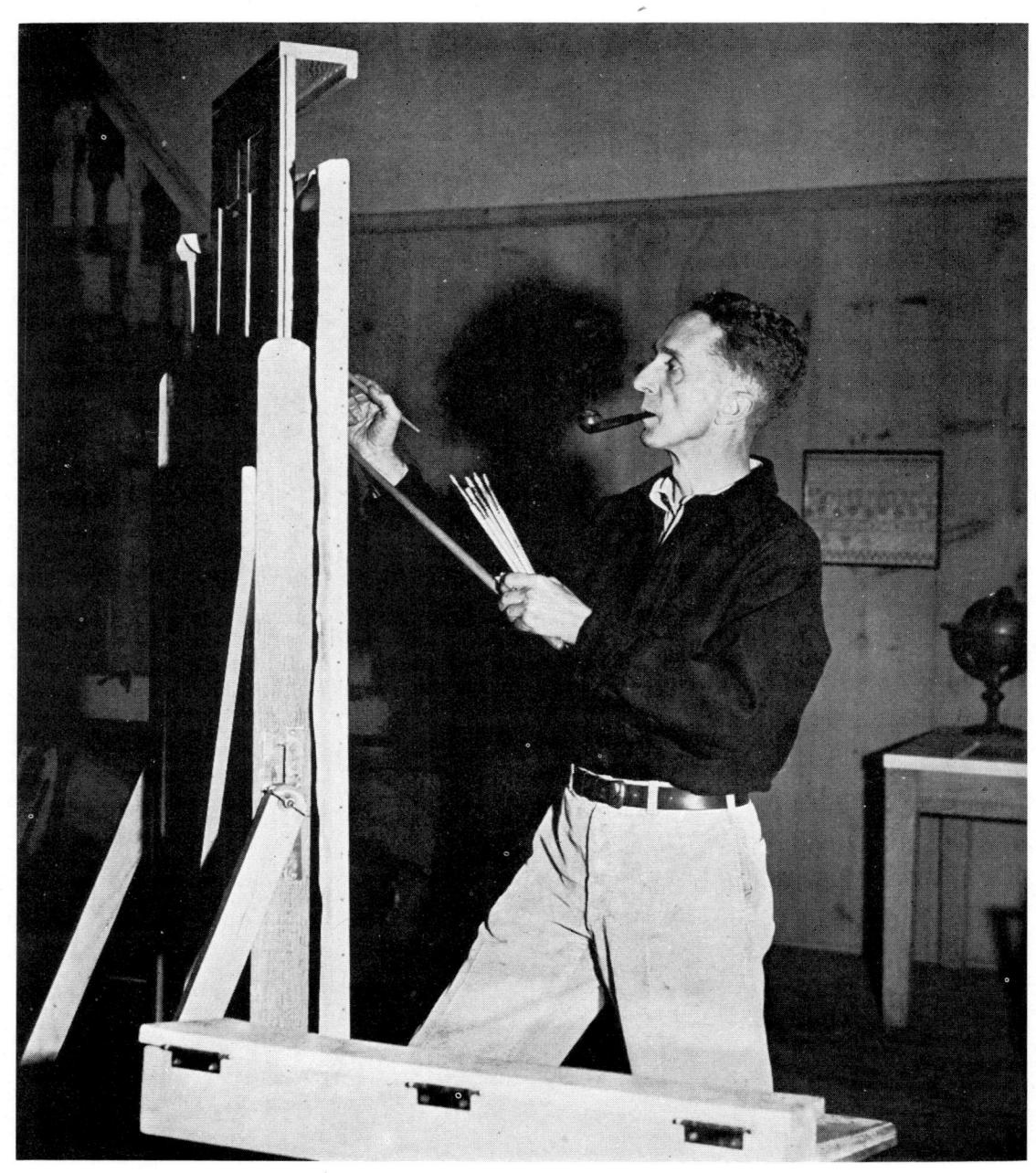

PHOTO METROPOLITAN PHOTO SERVICE

A TYPICAL ROCKWELL POSE—HE SITS HALF OF THE TIME

The artist is tall, wiry and energetic—boyish for his years. An indefatigable worker, he has produced during three decades an amazing number of pictures.

I: A Visit to Rockwell's Studio

THOUGH CITY BORN and bred, Norman Rockwell has for some years chosen to live and work just outside the Green Mountain village of Arlington, Vermont. It's hard to say which is the more fortunate, Arlington or Rockwell. It is certainly a compliment to the little village and to the State of Vermont that this much-travelled artist, familiar with all America and possessing the freedom to live anywhere, has selected this peaceful spot in a perfect corner of one of America's most beautiful states.

"As long as my fundamental purpose is to interpret the typical American," says Rockwell, "Arlington affords the ideal residence. From this calm vantage point, far from the cities with their crowds and clamor, I can view things with detachment and serenity; also, I can go about my task with a minimum of interruption and with the knowledge that right here are exactly the models needed for my purpose—the sincere, honest, homespun types that I love to paint."

In point of time, Rockwell is by no means far removed from New York and Philadelphia, to which in the course of his business he must frequently go. By rail, or on any of several excellent highways, he can reach either within a day. A particularly lovely drive from New York City to Arlington is via Route 7. If we take this road north—we pick it up by cutting across into Connecticut or Massachusetts—we will pass successively through such delightful Berkshire communities as Great Barrington, Stockbridge and Pittsfield. By the time the concrete snakes

33

My studio has been likened to a factory; my product has been described as "corn"! N.R.

itself through Williamstown and across the Massachusetts-Vermont border, we will have feasted upon some of the loveliest of New England's rugged landscape.

Still driving north through historic Bennington—an attractive Vermont city with its college and superbly located battle monument—it is but a matter of minutes before Arlington comes into view. Gradually the farm-checkered valleys have narrowed as the surrounding hills have grown in number and stature, shouldering higher and higher against the sky.

Arlington village, with its broad and shady streets, its substantial, well-kept houses, its stately old inn and its notable church with an ancient burying ground, has for years been the residence of many distinguished artists and authors. Today there is little in this quiet spot to remind us that it was the stamping ground of boisterous, courageous Ethan Allen and his hell-raising, ready-for-a-scrap Green Mountain Boys of Ticonderoga fame. Yet in this very place, nearly two centuries ago, Ethan's lustily shouted battle cry was often heard, a monstrous bellow from mighty lungs that brought his clan a-running, whether the enemy consisted of the British or the equally detested "Yorkers" to the west.

But enough for Arlington proper, for we are impatient to meet Rock-well, who lives at West Arlington a few miles away. So just north of the churchyard we turn left from Arlington's main street onto Route 313. Almost at once the village dwindles and the drive becomes more intimate, the road skirting the Batten Kill, a winding stream which busily works its way toward the Hudson some thirty miles distant, well over the New York State line.

And so on we roll past a scattering of houses, past the West Arlington store (the storekeeper standing in the doorway looks familiar—he must be one of Rockwell's models), past the Sandgate road (on which lives Rockwell's artist friend, Mead Schaeffer), until at length, having followed the murmuring stream for some minutes, we find ourselves with almost startling suddenness before a landmark which gives access to Rockwell's domain—a weather-beaten covered bridge exhibiting the

date 1852. This bridge bears sharply away from the river road to span the Kill. We brake for the sudden turn and dive into the dark tunnel; it's good to hear the planks rattle as we dash through.

Before us the road now intersects a green. At our immediate right stands an old church, still in use; attached to it is the Grange hall. At our left is the more modern, but appropriately modest, schoolhouse. Straight ahead we note a pair of stately Colonial farmhouses almost identical in design. That at the right is Rockwell's. Our journey is over.

As we approach the house we discover Peter Rockwell—the youngest son, aged ten—playing on the lawn, marvelously accourted with Wild

West weapons. He clanks away to announce our arrival and, by the time we reach the porch, Mrs. Rockwell is there to welcome us. In the midst of our greetings the artist himself appears, summoned from his studio behind the house. Accompanying him are Tom and Jerry, his other sons, thirteen and fifteen respectively, and a couple of dogs from the Edgertons' next door—there is always at least one dog about the place. Introductions follow and we pass on into the house.

When you meet Rockwell for the first time several things are quite likely to impress you: First, he's just an everyday sort of fellow. It wouldn't be surprising to discover that Norman's head had been somewhat turned by all the adulation that his pre-eminent position has brought him over the years. But no. He is extremely modest. He is also sincere; there's no sham or pretense about him. And he's as friendly as he is sincere; the moment you meet him his warm handclasp and ready smile, plus the merry twinkle in his eye, win you completely. Soon you feel that you have known him for years.

As to physical characteristics, there is little we need add to what our photographs reveal. Rockwell misses being a six footer by only half an inch. He is lean and wiry, quick as to movement, and, when painting, wears blue jeans and a flannel shirt, the everyday work clothes common to his neighborhood.

One thing that strikes you immediately is Norman's boyishness, his exuberant attitude toward life. Though past the half-century mark in years, in a certain admirable sense he has never quite grown up. Possessing not only physical vitality but a whiplash mind, he exhibits enthusiasm for everything he does. In his conversation he reveals his youthful point of view: his observations are both keen and stimulating, and they are delivered with an effervescence that is all too rare in people of any age. Even in weighty discussions his conversation is full of wit and anecdote. He likes the dry and homely idiom of the Vermont countryside and employs it tellingly.

Rockwell loves fun. Although an extremely serious fellow at his easel—he has an amazing capacity for sustained effort—he extracts an unusual amount of joy from life. In moments of relaxation he fairly bubbles over with good spirits and, even as he paints, he is ready for a laugh at any comical situation which may arise. All of this is reflected in his pictures, and accounts for much of their appeal.

The Rockwell family life quite naturally revolves around Norman and his work. During rush periods, especially as he approaches his important delivery deadlines, he is kept as free as possible from needless interruptions. Now and then he finds a moment to play ball with the boys or to pit his skill with a .22 calibre rifle against theirs, but that's about all. The boys are well able to look after themselves, however, for with games and sports, including fishing in the Kill, they lead the normal lives of country boys everywhere. They are learning that life is earnest as well as fun; Jerry has a job as porter at the local inn during

Norman, Mary, Jerry, Tommy, Peter, Raleigh

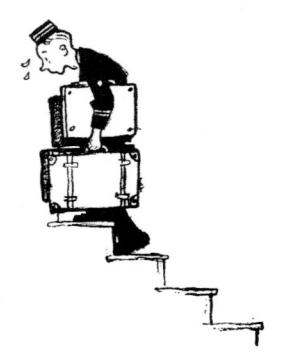

the summer and Tommy earns his spending money by mowing neighbors' lawns.

The Rockwells really *belong* to Arlington; they greatly enjoy taking an active part in its affairs. One evening while I was visiting them, Norman collected tickets at the village square dance; he is on the dance committee. Meanwhile his wife, Mary, helped with the refreshments. This is typical of their cooperative interest in all such things.

Now for a quick look at Rockwell's house; then we'll go on to the studio. The house, dating from 1792, is exactly what you would expect, knowing its occupants and its Vermont heritage—an ample wooden farmhouse, painted white, of that chaste, impeccable design and sturdy construction that our New England forefathers mysteriously managed to achieve. Before the Rockwells occupied the place in 1943, soon after fire had destroyed the studio at their former Arlington residence a few miles to the east, the house was thoroughly and sympathetically remodelled. The interior walls are covered with reproductions of ancient wallpapers, an ideal background for the furniture which is Early American blended with a few pieces of Victorian. Some of these pieces have a familiar air; they have served as models in Rockwell paintings.

The pictures on the walls are notable, being originals by such artists as Arthur Rackham, Howard Pyle, Hugh Thomson, C. E. Brock, A. B. Frost, Edmund Dulac, Walter Addison and Thomas Fogarty.

Conspicuous as one enters the living room from the hall are a large south window facing the studio and, on the west wall opposite the entrance, a generous fireplace which in that country is essential to comfort even in summertime. Like the rest of the house, this room has a pleasant, lived-in appearance with its abundance of books and magazines and comfortable places to sit and read. Just now, one end has taken on a studio look, for Tommy is showing an interest in drawing; his father has set up an easel and is coaching him in the rudiments. At this end of the room, too, has been placed an old-fashioned parlor pump-organ which Peter recently won on a ten-cent chance at a local raffle. So there, side by side, the boys are going in for the fine arts.

Across the hall lies the dining room, and back of this is Mary Rock-well's study. This is an important room, for here she keeps the family accounts and helps her artist-husband in a hundred and one other ways. It is here that Rockwell's fan mail is sorted and read. Rockwell, either directly or through *The Saturday Evening Post*, receives an astonishing amount of such mail. His April Fool cover of April 3, 1943 brought thousands of letters, a number exceeded only by the avalanche which followed the publication of the "Four Freedoms" paintings.

Norman greatly enjoys this fan mail. The arrival of the rural delivery man often finds him at the house for a brief respite, a "coke" and a look through his letters. "When you plug away pretty much by yourself as I do," he says, "you don't know what your public's reaction to a new job may be until your fan mail starts to arrive. I look forward to it eagerly; if I don't get any for four or five days I really feel hurt. After all, any artist works for public acknowledgment and appreciation—at least I do. I love it and fairly lap it up."

But now to Rockwell's studio, the workshop in which he creates his paintings. We can stroll out via the flagstone walk which winds its way past the smokehouse, garage, and a corncrib, now converted into a shed for storing garden utensils and the family bicycles. The studio is a somewhat barn-like structure, red with white trim. It looks so seasoned—so much in harmony with the other buildings near by—that it is hard to realize that it is relatively new.

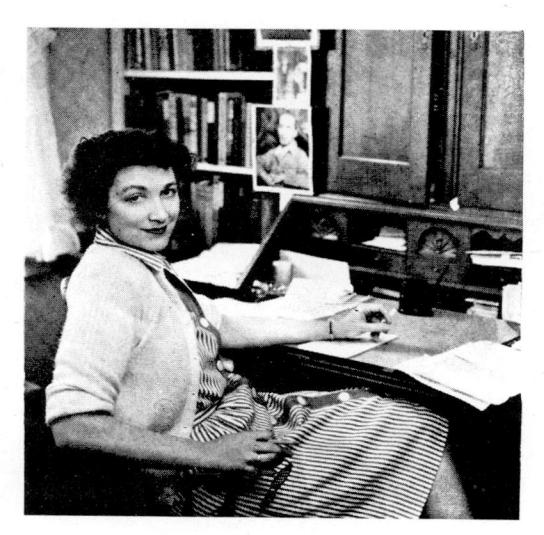

MARY ROCKWELL IN HER STUDY

IN 1943, ROCKWELL'S STUDIO BURNED

Though Norman made light of his fire (forgive pun) by immediately doing these sketches for the Post, it was actually a severe blow—it destroyed his studio and barn. Both were filled with original paintings, drawings and notes; also a superb collection of irreplaceable antiques, costumes, books, prints and clippings. Friends sent him many items to help make up the loss. From the Society of Illustrators came a complete set of reproductions of his own work— a much appreciated gift.

OPPOSITE: DRAWINGS FOR THE SATURDAY EVENING POST, JULY 17, 1943 ORIGINAL 17" X 22"

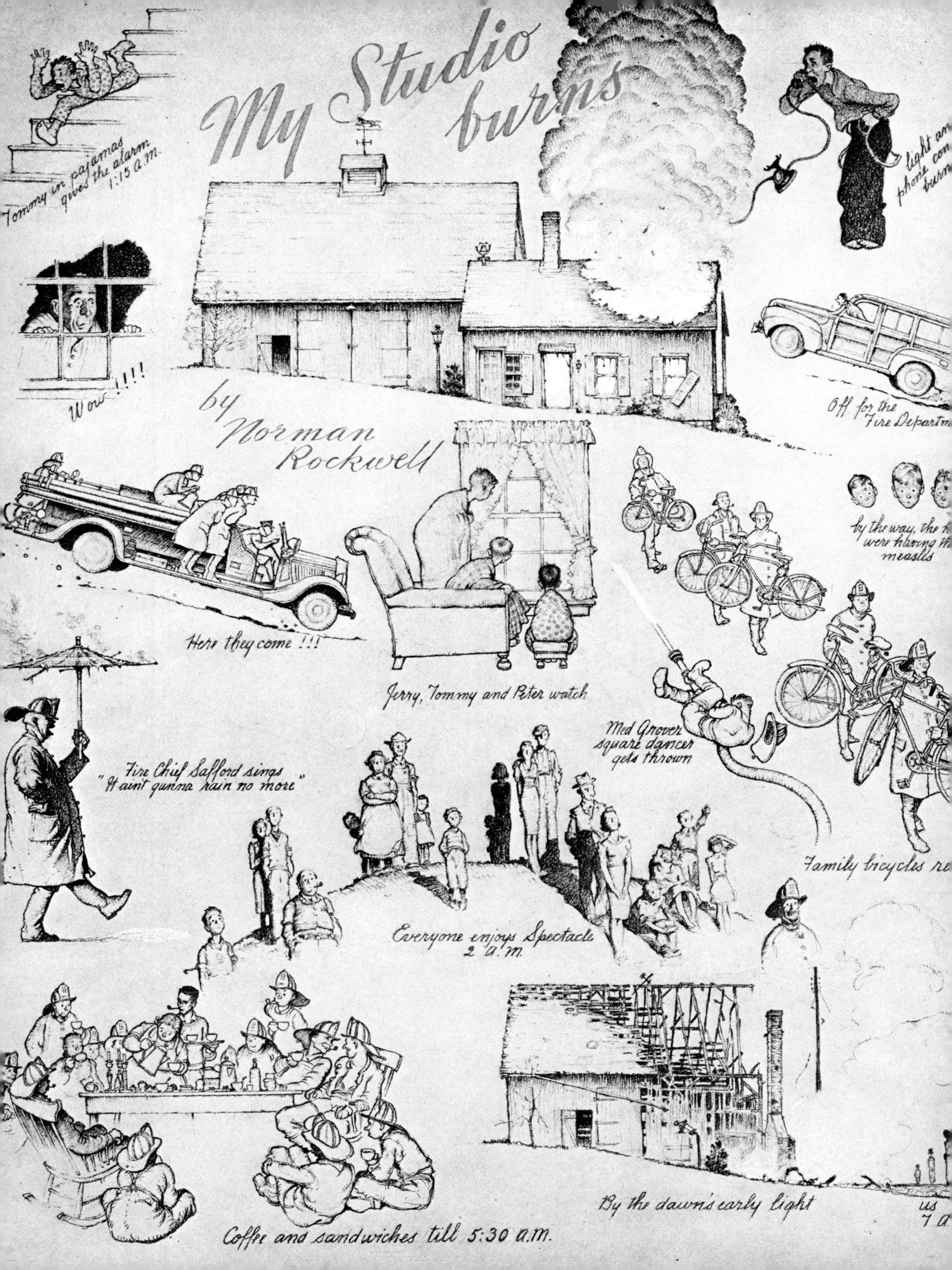

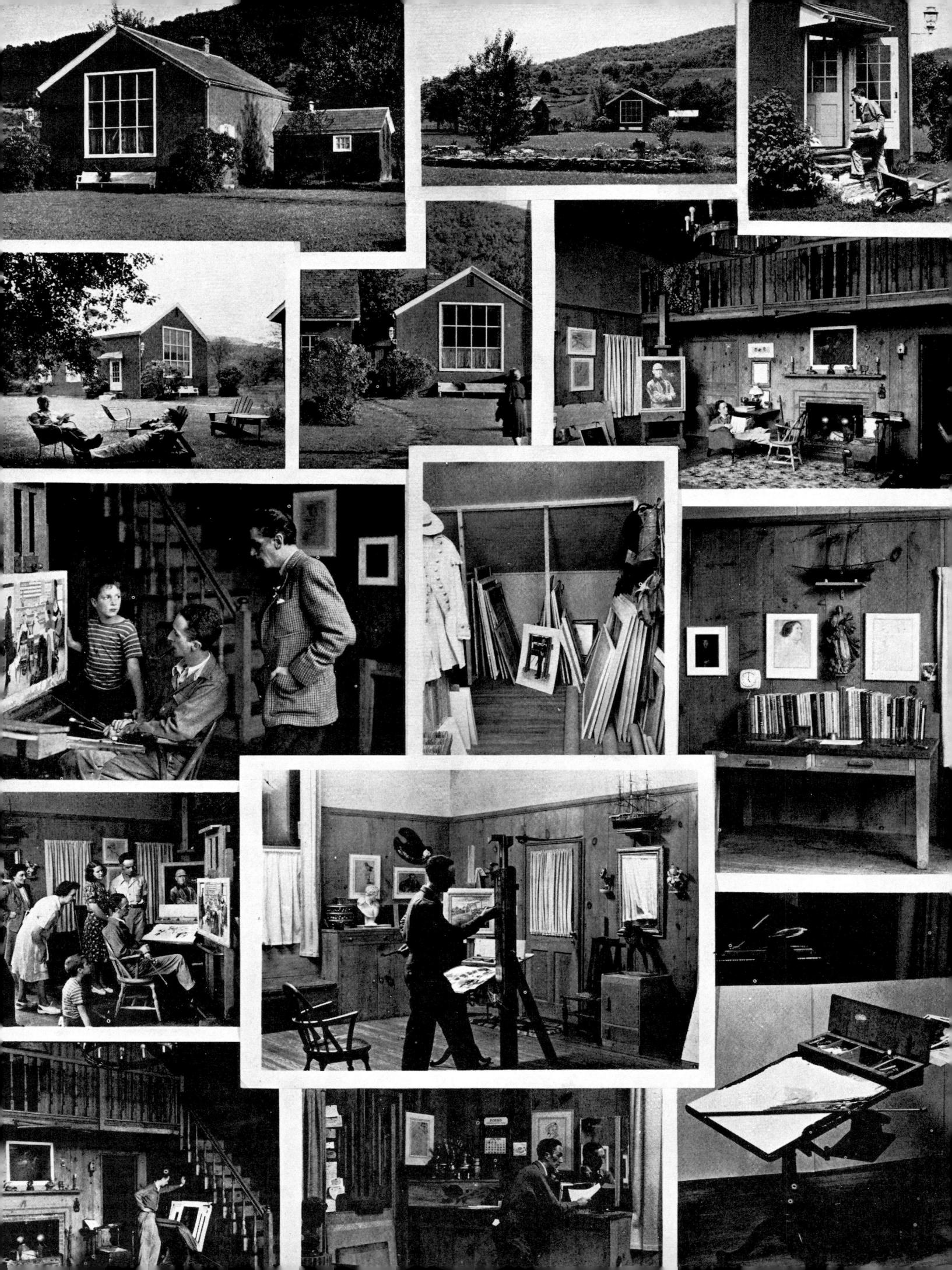

ROCKWELL'S NEW STUDIO

Top Row: Left and Center—General views of studio. The red and white structure forms an effective picture against the green Vermont hills. Right—Rockwell replenishes his wood supply. This is the door the horse went through; see account of the "Battle of the Bulge."

Second Row: Left—Artist Rockwell and Author Guptill relax as they plan their trip to Maine. Center—The flagstone walk to the studio. Right—The studio interior, with Norman reading a copy of the magazine "American Artist." On the easel is an unfinished portrait of Colonel Fairfax Ayers.

Center Row: Left—A professional criticism. Neighbor Mead Schaeffer (another Post cover artist) has been called in for an opinion. Peter Rockwell looks on. Center—Frames, paintings, materials and costumes are neatly stored on the balcony. Note the rolls of canvas. Right—The studio contains numerous useful and decorative articles.

Fourth Row: Left—Family and friends are often asked to pass judgment on the artist's work. Note Mary Rockwell under the ship model; the Edgertons from next door are at Norman's left; Peter sits on the floor. Albert stands back as his wife, Elizabeth, leans forward for a better look. Center—Rockwell in his customary working stance. Beyond him at the right is the entrance door; at the extreme left the huge north window.

Bottom Row: Left—Norman studies some old master prints as inspiration for his next painting. Center—A phone call to Philadelphia; to reach central, Rockwell turns the crank concealed within the circular opening at lower right. Behind him is his radio, and on the wall a group of squares, rulers and straightedges. Right—His palette stand with its white glass top and its box to accommodate tubes of color. A flat shelf behind (hidden) holds brushes and the like; on the adjustable bracket arm in front are vessels for turpentine and mixing medium.

The new studio was designed by Architect Payson Rex Webber, following the lines of the one which burned. The plan at the right shows the general layout. Note the workbench conveniently located in the room behind the fireplace.

4 I

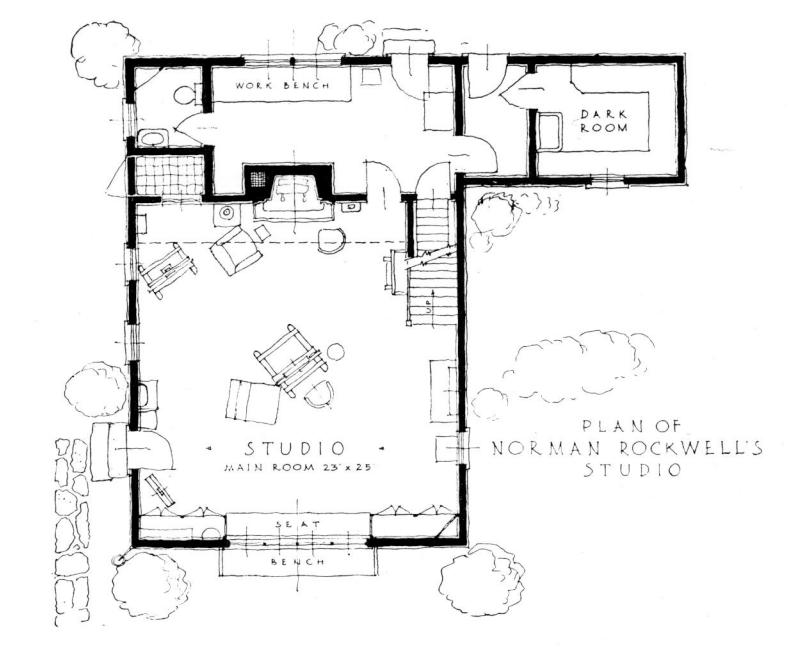

PHOTOS ROBERT MCAFEE

The entrance door is on the east side toward the front. Rockwell tells of a time when he needed a horse as a model for one of his pictures and was faced with the task of getting him through this door. "I borrowed the horse from a neighbor," he relates, "and then we tried to lead him into the studio. Did you ever attempt to get a horse through a normal-sized door? Well, it's not easy. It took four of us, one at the head to pull, one at the tail to push, and one at each side to compress his belly. It was a sort of battle of the bulge! Finally we got him past the jamb, and he snapped back to natural size again. Once inside, and expanded to his full proportion, he looked simply enormous. You never realize how big a horse is until you see one in the middle of your own room."

The studio window at the north starts some three and a half feet from the floor and is eleven feet high. It is double-glazed to keep out the cold. The lower part is covered with a curtain, creating a semitop light. There are also long opaque shades that pull up to permit further control of the light; the studio can be darkened completely in a moment. At night or on dark days, lighting is provided by a fluorescent fixture which hangs near the window. This contains a dozen long tubes, giving a quality of illumination remarkably like daylight; this fixture may be raised or lowered at will.

On the opposite wall is a fireplace with comfortable chairs before it. Above is a railed balcony reached by a staircase. On this balcony, hidden from the main studio by curtains of monk's cloth, are convenient racks which provide for the storage of finished pictures, frames and new canvases. In the space beneath this balcony, behind the fireplace wall, are additional storerooms, the lavatory, a rear entry, and the door to a recently built darkroom. Previously the darkroom was in the basement, now occupied by heating and air-conditioning units. The

studio walls, to the height of the balcony, are of knotty pine stained a brownish gray, forming a fitting background against which are displayed not only original paintings, drawings and reproductions, but many utilitarian and decorative objects, among them a fine pair of ship models, and several carved figures presented to Norman by his friend, Walt Disney.

In the center of the studio floor is the artist's easel, so turned as to receive the direct north light; beside it is his palette stand and chair. Spare easels accommodate his studies and finished paintings.

For some work, Rockwell builds within this studio meticulously realistic settings to serve as backgrounds for his models—entire room corners, for example, complete down to the last detail of furniture and furnishing. Strange people, strange creatures, strange things have been brought in to meet the artist's ever-changing demands. His tendency today, however, is to seek suitable existing settings outside, no matter how far afield. No simulated setting can prove as convincing.

A striking characteristic of Rockwell's studio is its tidiness. All is slick as a pin. Rockwell confesses to being a bit finicky about the place. He sets it in order and sweeps it himself several times a day, mainly as relaxation from his work. "The older I get, the more I neaten up," he explains, as he leans over to rescue a burnt match from the floor. "The more time I take to neaten up, the less time I have to paint. In my last years I shall probably abandon painting altogether and devote my whole time to neatening up."

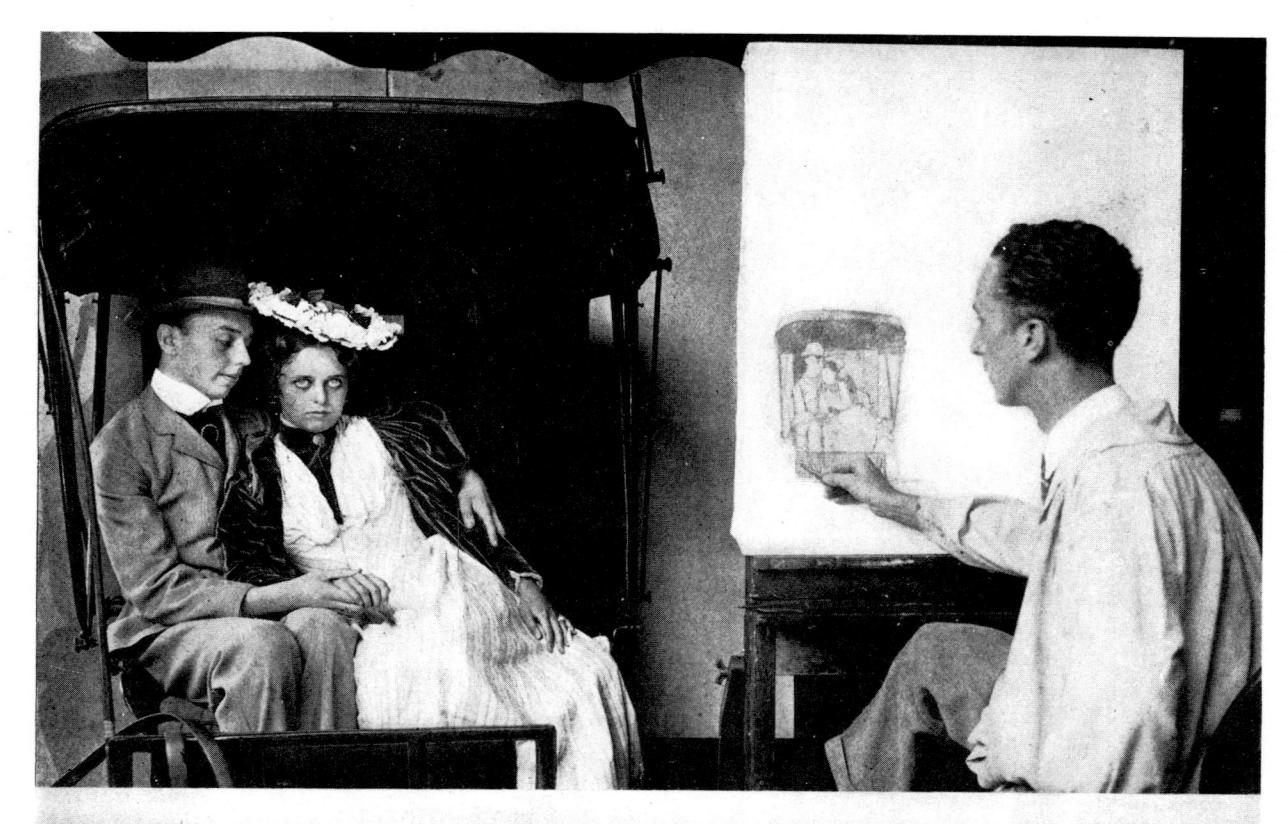

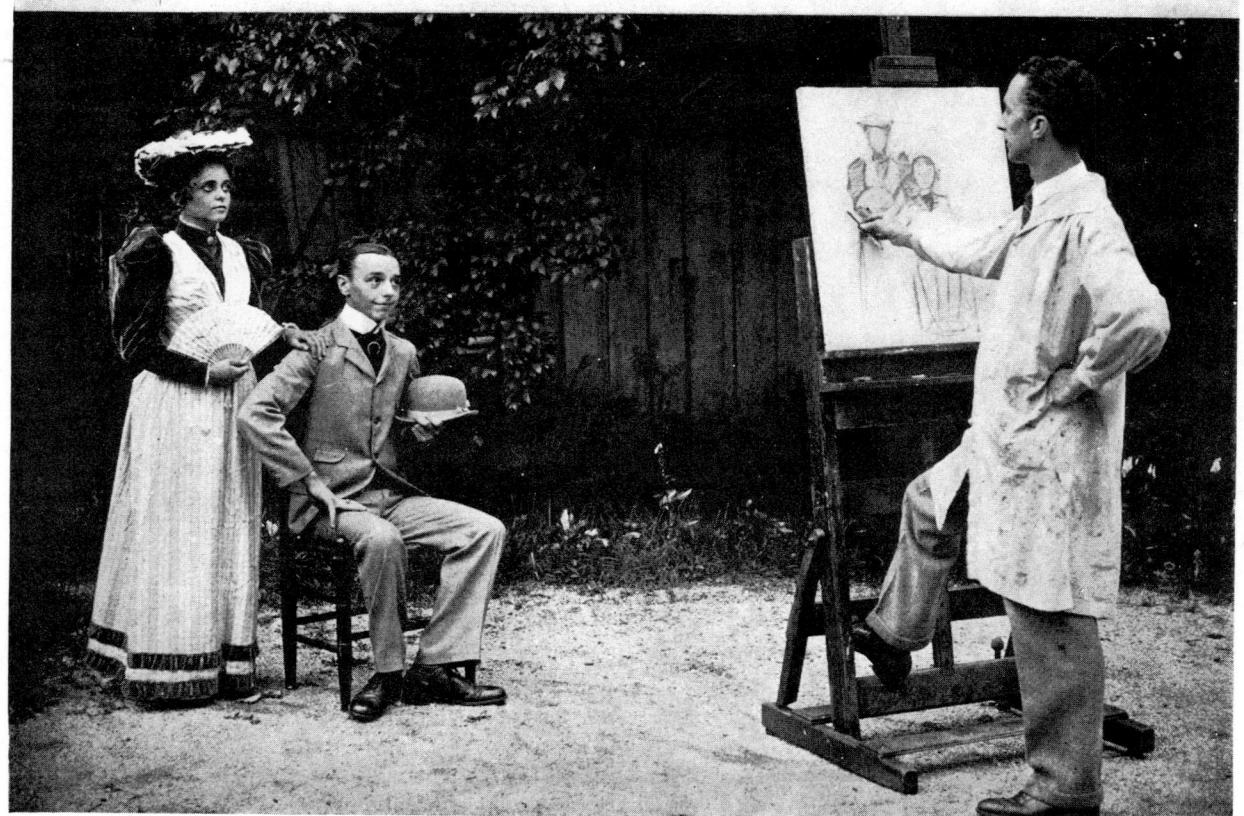

ROCKWELL IN 1925 WAS ALREADY RATED AS A TOP-FLIGHT ARTIST

See page 163 for the Post cover based on this upper photograph.

II: How Rockwell Paints a Post Cover

Wherever Rockwell goes, there is one question which is almost invariably asked by layman and artist alike: "Tell me, Mr. Rockwell, how do you paint a *Post* cover?"

Here is the answer in the form of a complete series of drawings and paintings made by the artist in producing his cover picture for August 3, 1946. These illustrate, step by step, Norman's process from the conception of his idea until the delivery of his painting. In the accompanying captions, the artist describes the procedure in his own words.

Those who desire a more detailed account are referred to Chapter IX, "Rockwell's Creative and Technical Procedure," which deals fully with his materials and painting methods. It also includes a discussion of many of the diverse problems of the cover artist, and ways in which Rockwell solves them.

RIGHT: THE ORIGINAL IDEA SKETCH

The first job is to hit on a good idea. Having found one for this cover, I made the accompanying rough sketch at this exact size. Then I took it to the Post, and Ken Stuart okayed it. Next, I scouted around the countryside seeking the old shacks, goats and other things I needed. As each was found, I sketched it and also had it photographed. I borrowed the station wagon from the Ford agency and posed that. N.R.

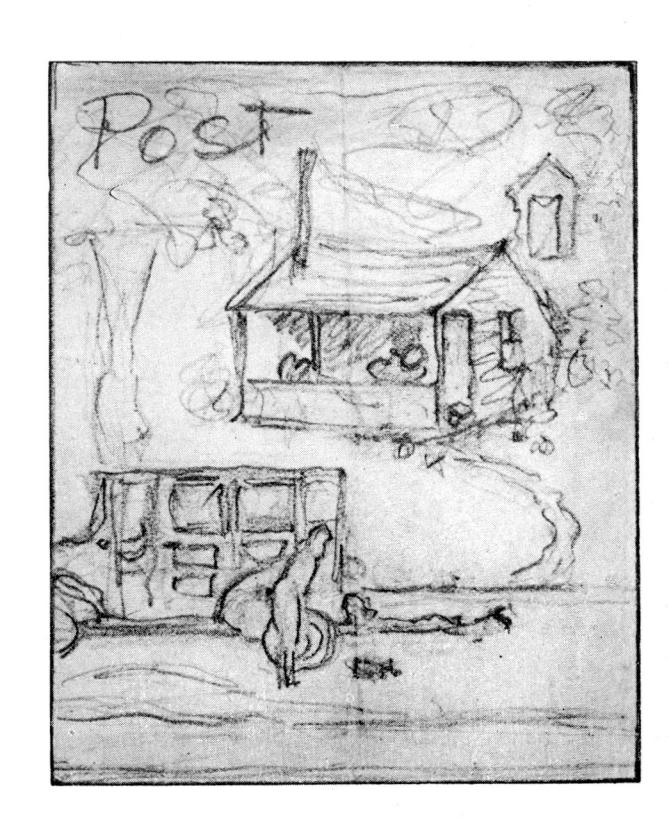

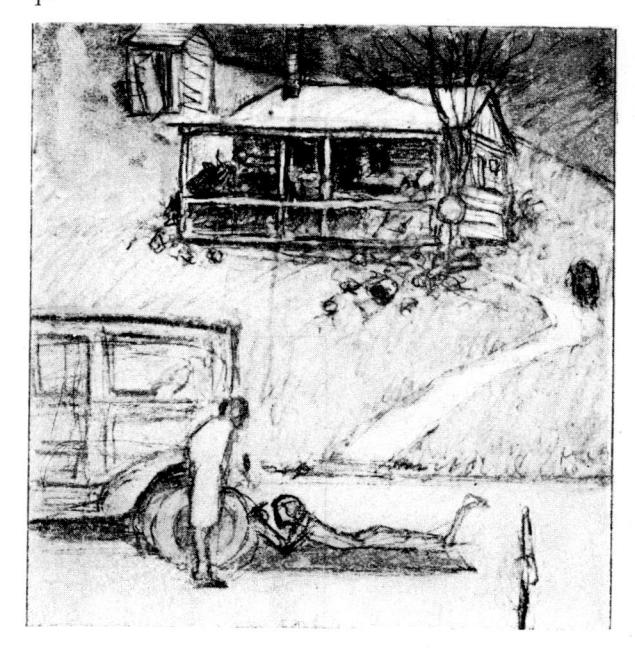

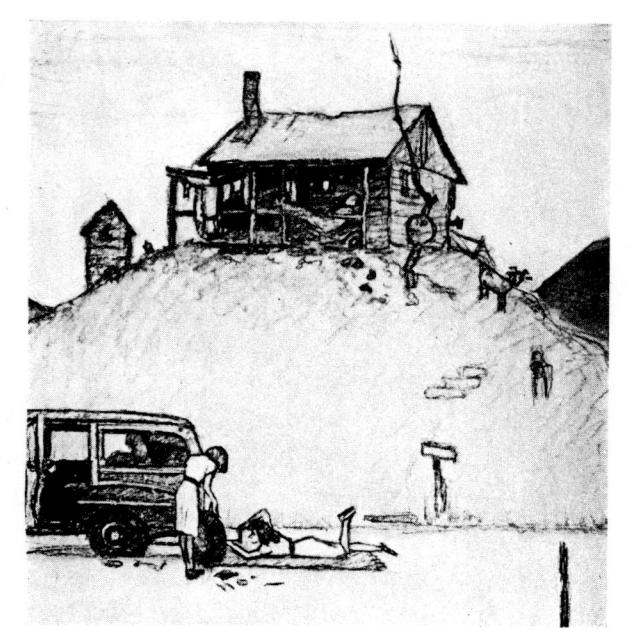

REVISED STUDY IN CHARCOAL

COMPOSITION AGAIN REVISED

After hunting up a suitable model for the rocking chair loafer, I returned to the studio where I posed and sketched him. In the meanwhile my photographer "shot" him from various angles. (Perhaps I should explain that when photos are needed I never take them myself, though I direct them. There are too many other things for me to be doing.) I next repeated the same procedure with Mead Schaeffer's daughters, Lee and Patty, who served as my models for the girls. Even the dog had his day; we recorded him with pencil and camera from almost every angle . . . The layman is usually surprised at the amount of such reference material—sketches, photos and notes—provided by an illustrator before he really gets under way. I often make a couple of dozen preliminary sketches and diagrams and, as to photos, I sometimes have seventy or eighty taken for a single cover. I may actually use only a few of them, but I never can tell in advance . . . In this instance, when I had acquired all the data I could possibly need, I did several little charcoal studies, including the two above, trying to express my cover idea effectively. (Each of these, drawn on tracing paper, was about a foot wide.) The gag in such a cover must be made so evident that even the casual reader won't fail to get it. The picture must compose well, too. In this respect the sketch at the right is much more dramatic than the other. N.R.

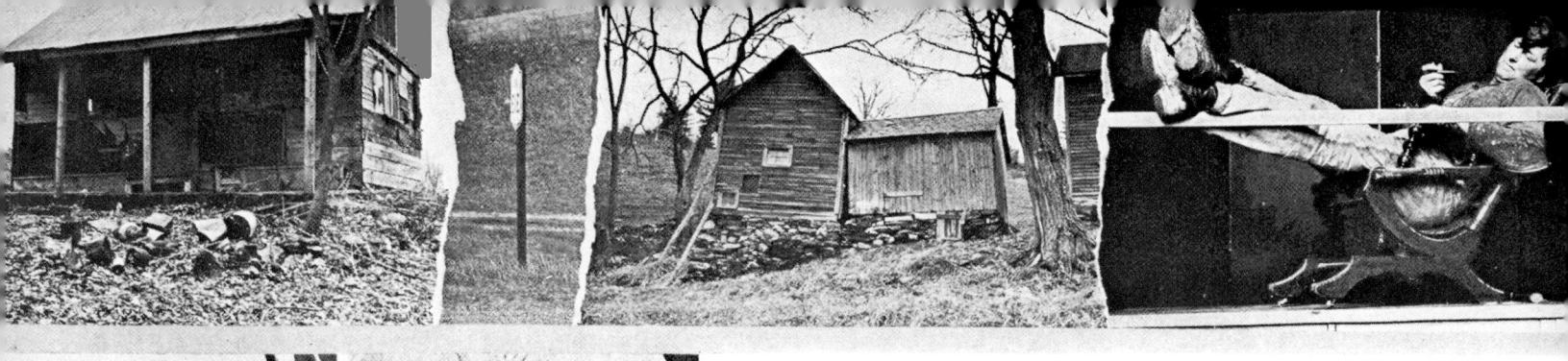

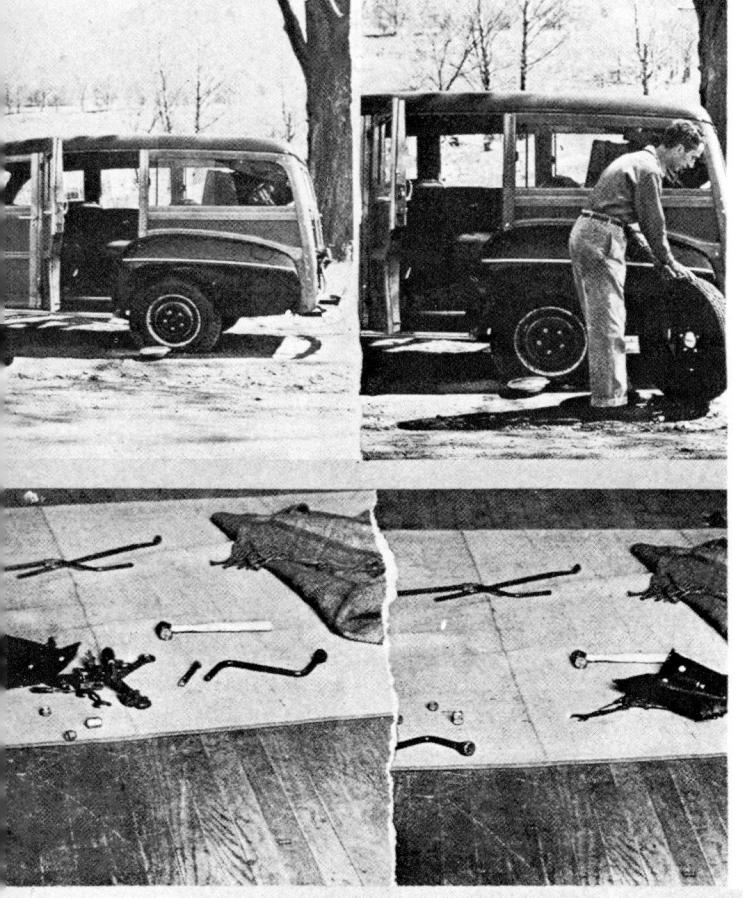

PHOTOGRAPHIC DATA

For twenty-three years I did all of my drawing and painting without any help from the camera. Even to-day I often work without photographs, yet I have found that if they are properly utilized they can sometimes prove an invaluable aid. Practically all illustrators use them to some extent. I feel very strongly, however, that no one should resort to photographs until he has learned to draw and paint extremely well without them. If eventually he turns to the camera as a supplementary tool, he will find it especially helpful in recording transient effects, difficult poses, and subject matter far from the studio. We shall deal with all this as we go along, particularly on pages 198-200, Chapter IX. N.R.

PHOTOS GENE PELHAM

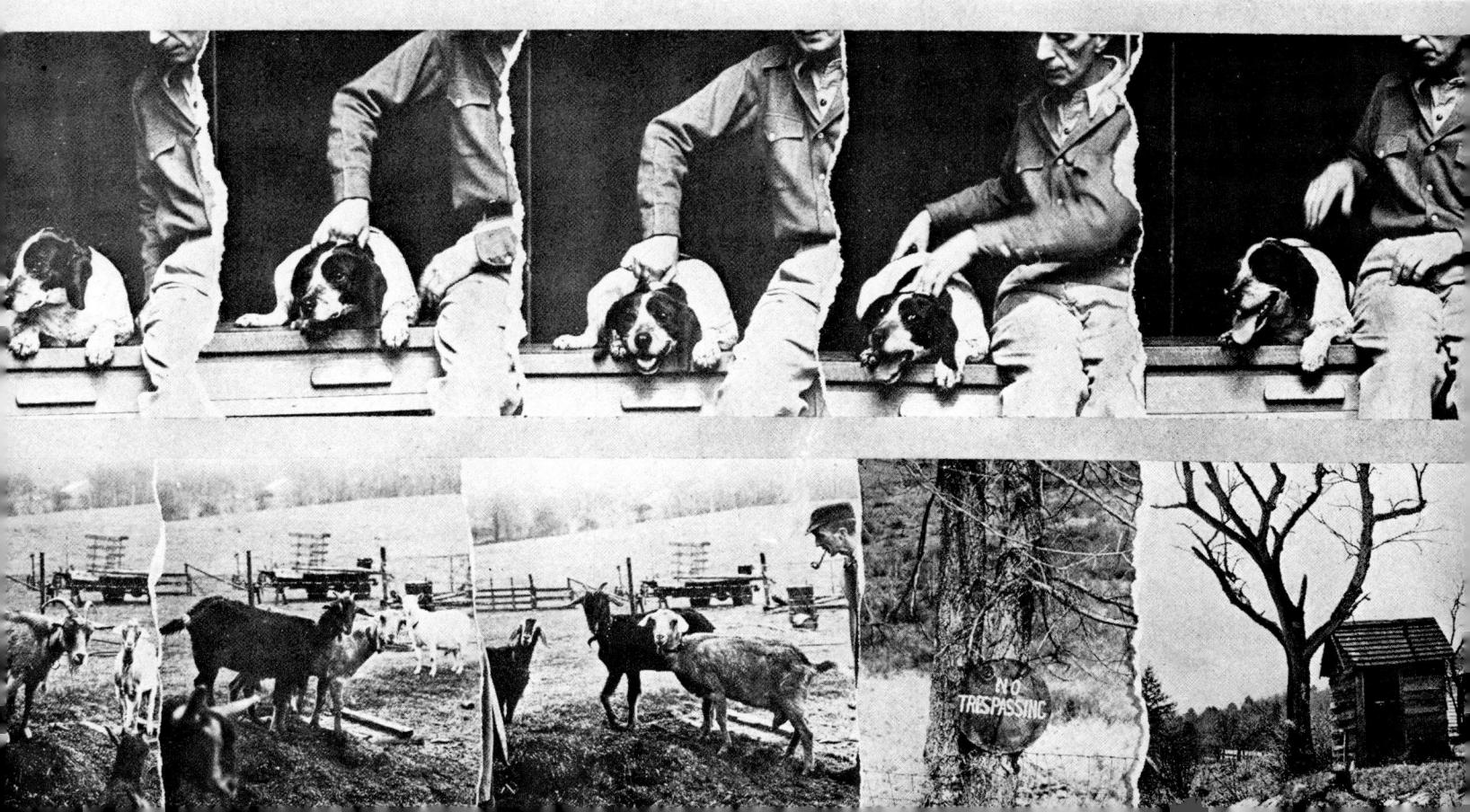

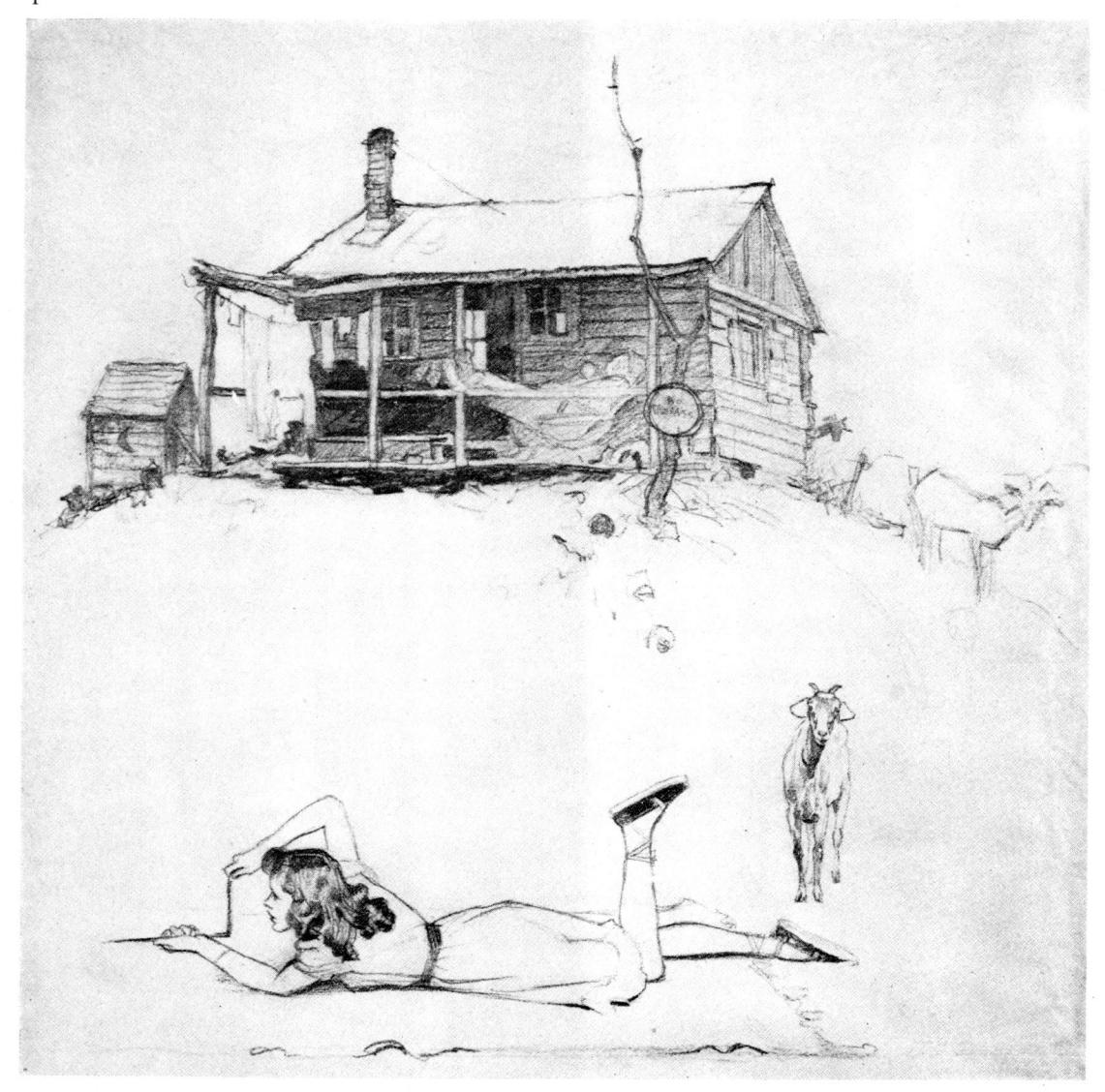

CRAYON STUDIES DRAWN ON LARGE TRACING PAPER SHEETS

With all the preliminary work disposed of, I went at these larger crayon studies, in which I further crystallized my ideas, selecting the best of the reference material and refining and combining it to serve my purpose. This making of studies is a vital part of cover design—in fact the success or failure of a cover may depend largely on the thought and effort which go into it. These were drawn rather large, each about two feet wide. N.R.

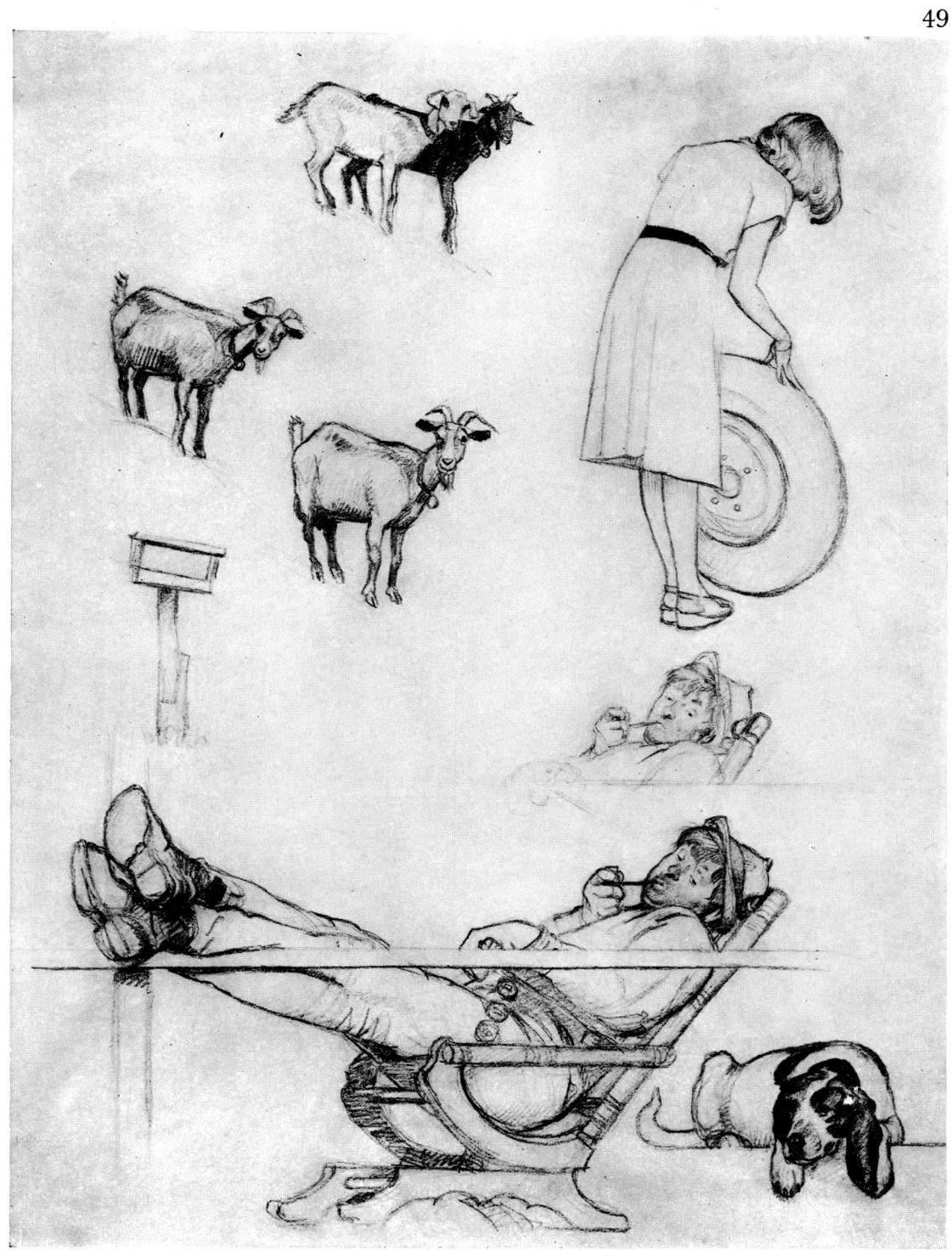

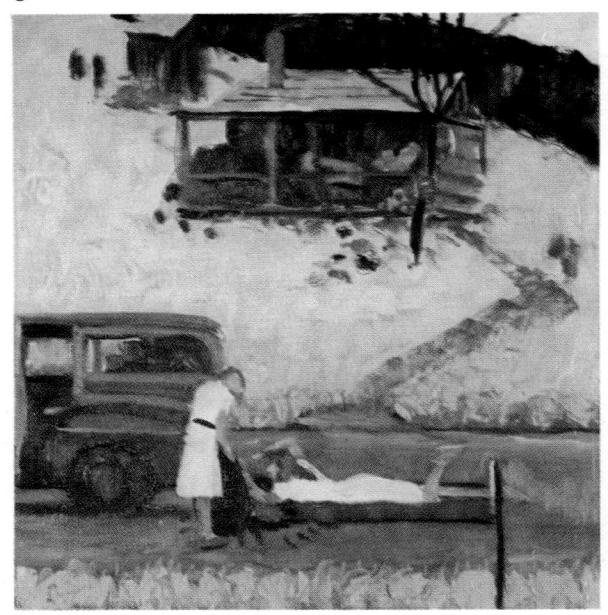

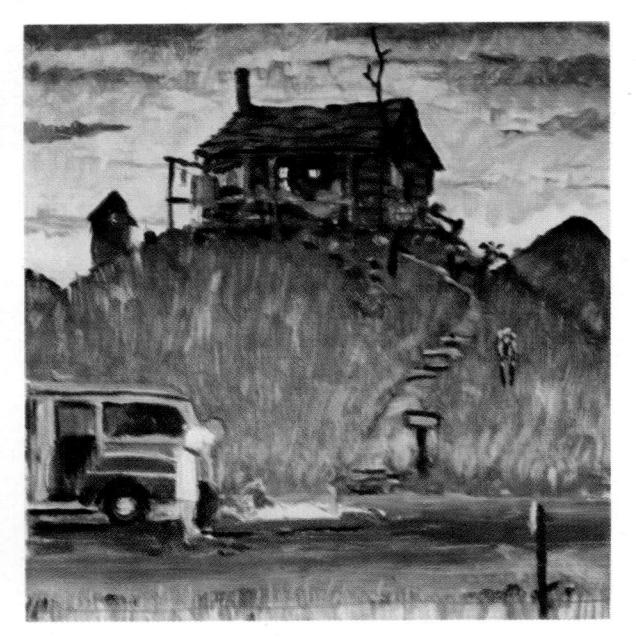

A COLOR STUDY DONE IN OIL

REVISION OF FORM AND COLOR

At this point I normally draw an extremely complete and accurate charcoal "layout," at the exact size at which I intend to make my final painting, working over it until I am reasonably satisfied with every detail. (On page 56 is such a layout.) Then I transfer the proportions to the canvas—using the method presented in Chapter IX-after which I determine upon my color scheme by making a color study or two in oil. Only then do I proceed with the final painting . . . In the present case, I made no such charcoal layout, but after finishing the black and white studies on the preceding page I sketched the entire subject directly upon the canvas, refining it as I did so. Even before this, I painted the two color studies above, each about eighteen inches square. This helped me to determine upon the relative merits of the two schemes shown on page 46. I also painted a third color study, not reproduced, which I liked better than the other two, so it became my guide for the coloring of the painting opposite. The latter was made at smaller size than most of my paintings, though I vary them considerably . . . Unfortunately the degree of reduction necessary in reproducing magazine covers robs them of much of the detail, especially if it is fine. The loafer on the porch, for example, is too small in the final reproduction to permit much facial expression. N. R.

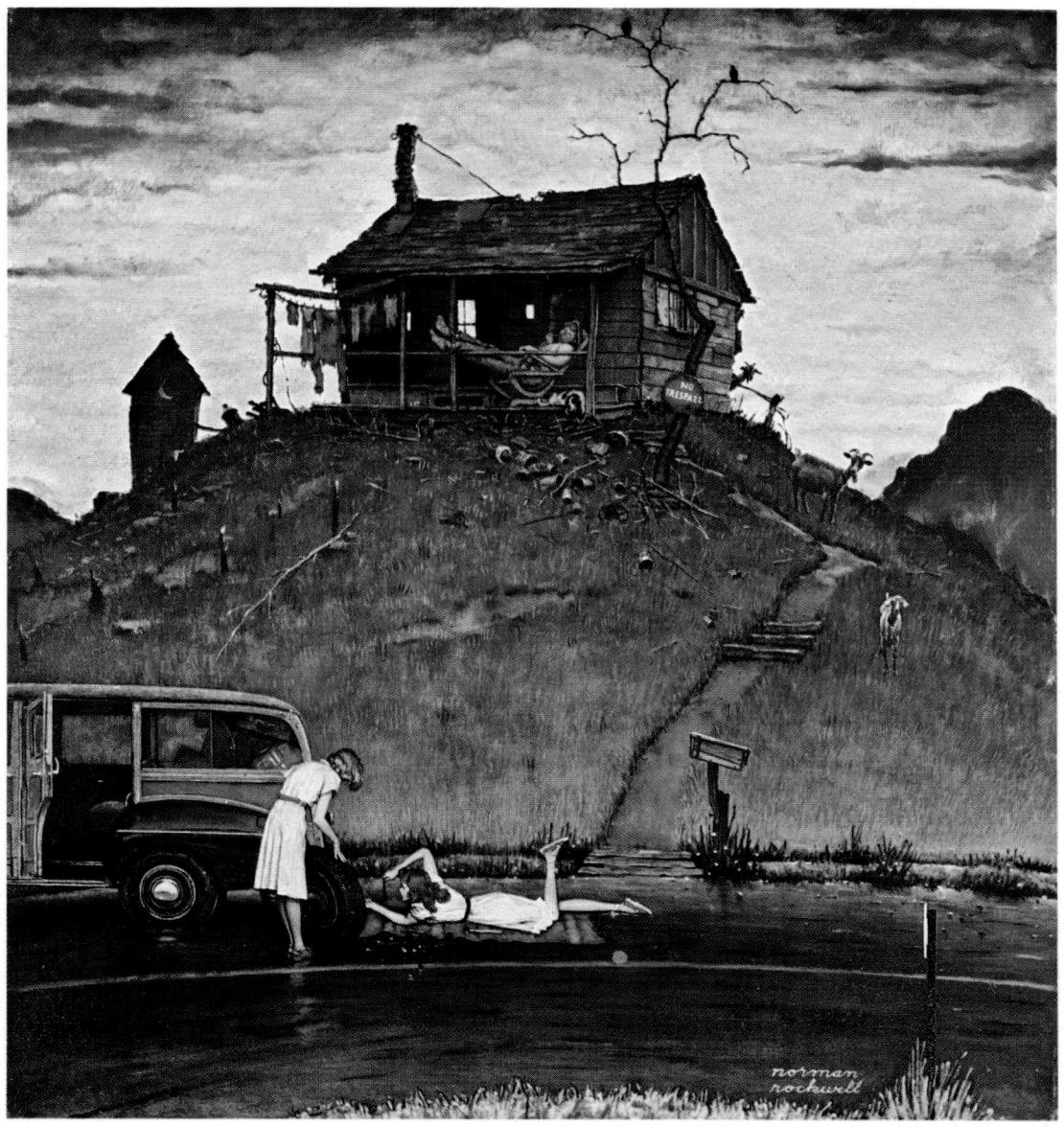

COURTESY THE SATURDAY EVENING POST

HERE IS THE FINISHED PAINTING, READY FOR DELIVERY

With my preliminaries completed for this Post cover of August 3, 1946, I went ahead rapidly with my final painting, keeping in mind the effect I wanted in the cover itself. The miniature reproduction on page 191 demonstrates how the painting and the title "Post" were combined. N.R.

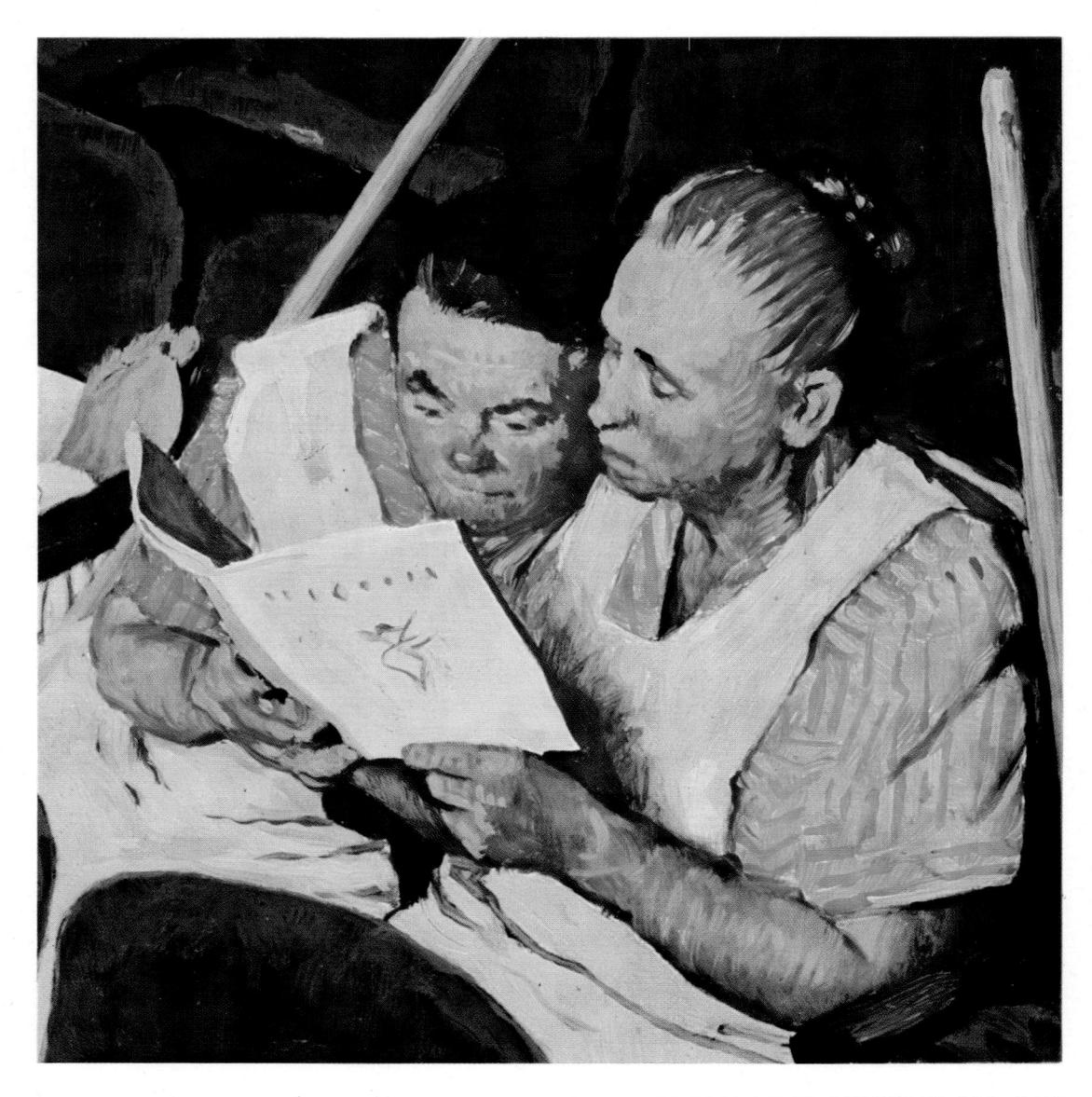

AN EXACT SIZE DETAIL OF A PRELIMINARY STUDY IN OIL

This color study was painted directly upon a photographic print of my charcoal layout on page 56, the print having been purposely made at the actual size of a Post cover. Compare this study with the final painting on page 57 which was based on it. Often I make several of these color studies. Thus, having done my thinking in advance while working at relatively small scale, the actual cover painting can be accomplished very rapidly. N. R.

III: Some Come Easy: Some Come Hard

WE HAVE SEEN in the previous chapter that Rockwell follows a very definite step-by-step procedure in painting his covers. This enables him not only to obtain better results, but to save an immense amount of time and energy.

At best, however, almost any cover requires many more hours than the layman would imagine. Practically never can one be painted in less than a week from the time the idea has been settled upon; sometimes a month or more is needed.

Let's take a look at the history of the painting of two covers, one of which might be called a "quick and easy" cover, as it was carried forward rapidly without a hitch, while the other proved to be a "slow and hard" cover, in that it not only demanded far more time, but even in the end didn't work out as intended.

The first of this pair—it took only a few days to complete it—was the charwomen subject reproduced on page 57: this appeared on the *Post* for April 6, 1946. I asked Norman how he got the idea. "Gee, I don't know," he replied. "It just came to me. I think I have always wanted to paint a charwoman or some similar type of worker—the poor little drudge who has to tidy up after more fortunate people have had a good time. I've been interested in the hotel maid, for instance, who has to lay out her ladyship's gown; in reality the maid may be more of a lady—but let's not get into the social angle.

"Having decided on this charwomen subject and that the theatre

Here, at exact size, is the first rough sketch of my idea. This I did in carbon pencil on a scrap of paper. N.R.

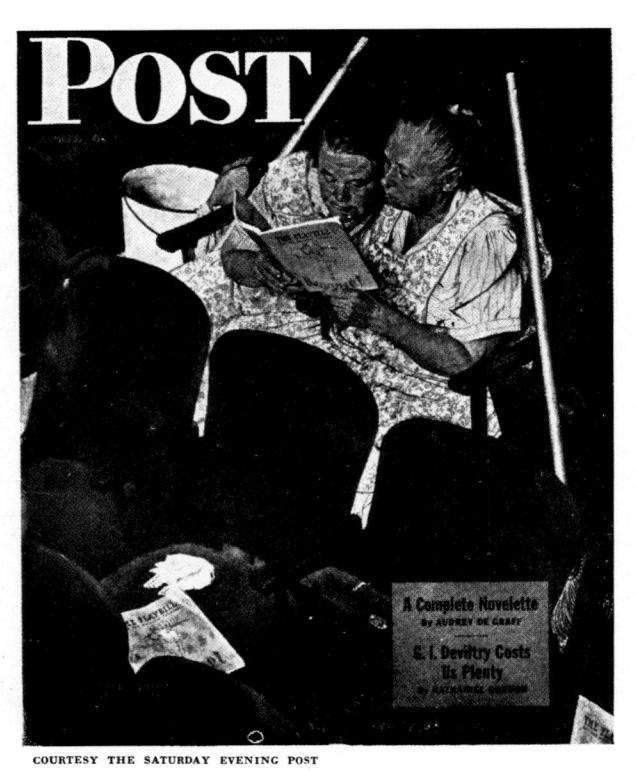

Compare this reproduction of the final cover with the original sketch at the left, and with pages 56 and 57. N.R.

This cover developed naturally from start to finish; there were no difficult problems to delay progress. The final painting is surprisingly like the original idea sketch at the left, above. In some covers, the final painting wanders a long way from the idea sketch, because one improvement after another occurs to me as I work . . . On the whole it is far better to get a really good idea right at the start and stick to it rather closely than to flounder around with a second rate one, hoping that by some good fortune it can be improved. A poor idea at the beginning is almost certain to prove a flop in the end . . . And always the illustrator's work should proceed in accordance with a well-thought-out plan. A haphazard approach is practically certain to result in failure, just as it would in any other line. Yet some young illustrators foolishly start work at once upon their canvas, blindly trusting to some kind providence to guide the arm. The canvas shouldn't be touched until one knows exactly what he wants to put on it—and how. N. R.

was a logical setting, I made my little idea sketch. As soon as Kenneth Stuart, Art Editor of The Saturday Evening Post, had okayed this, I decided to go to an actual theatre to obtain authentic information on such things as seats and aisles. I wanted my data in the form of sketches and photographs which I could use later in my studio as reference material. So I went to the office of the Shubert Theatres in New York. I had supposed that it would be simple to learn just where to go to sketch and photograph the empty seats; it looked like a job which could be completed in an hour or two. Actually it took a lot longer. The physical properties manager felt that the Majestic Theatre, where Carousel was playing, was typical, so we decided on that. A minor hitch came when I learned that just to turn on the lights would cost about forty dollars. (It seems there is a Union requirement that a full force of electricians and their assistants must be paid a day's wages to switch on even one light. After considerable negotiation, a way was found to reduce this force to one electrician and his assistant.)

"With this adjusted, off we went to the Majestic, where I sketched and measured while a photographer took some pictures—one never knows how much information he may need when he gets to work far from his original source. Everybody was very accommodating. Then back I hurried to Arlington where two neighbors, Mrs. Harvey McKee and Mrs. Charles Crofut, posed as the charwomen. I felt hesitant about asking them to represent such humble characters, but they were very good sports about it.

"My task as I went ahead with my studies and final painting was mainly one of orienting the figures to the theatre interior. Every detail must be right; my audience is supercritical. After the painting was published, a reader wrote to ask why I had failed to show chewing gum beneath the seats! It seemed best not to use the playbill bearing the word 'Carousel,' as there was no certainty that the play would still be running when the cover came out, so I tricked up the playbill to represent an imaginary play. That's the whole story."

And that really is the whole story excepting for such technical considerations as we deal with in Chapter IX, page 193.

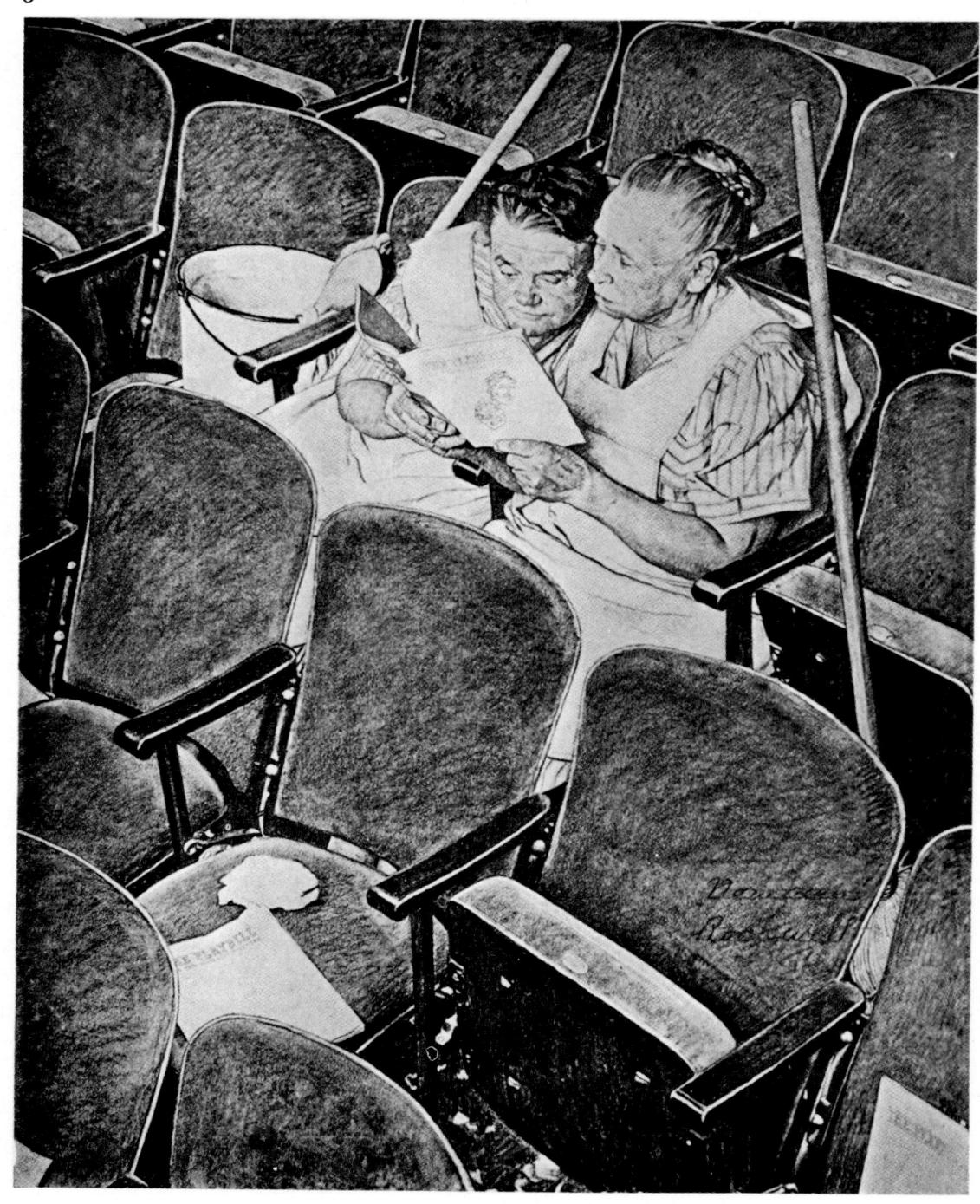

CHARCOAL STUDY OR "LAYOUT" FOR THE PAINTING OPPOSITE

Almost invariably I make one of these extremely exact layouts. N.R.

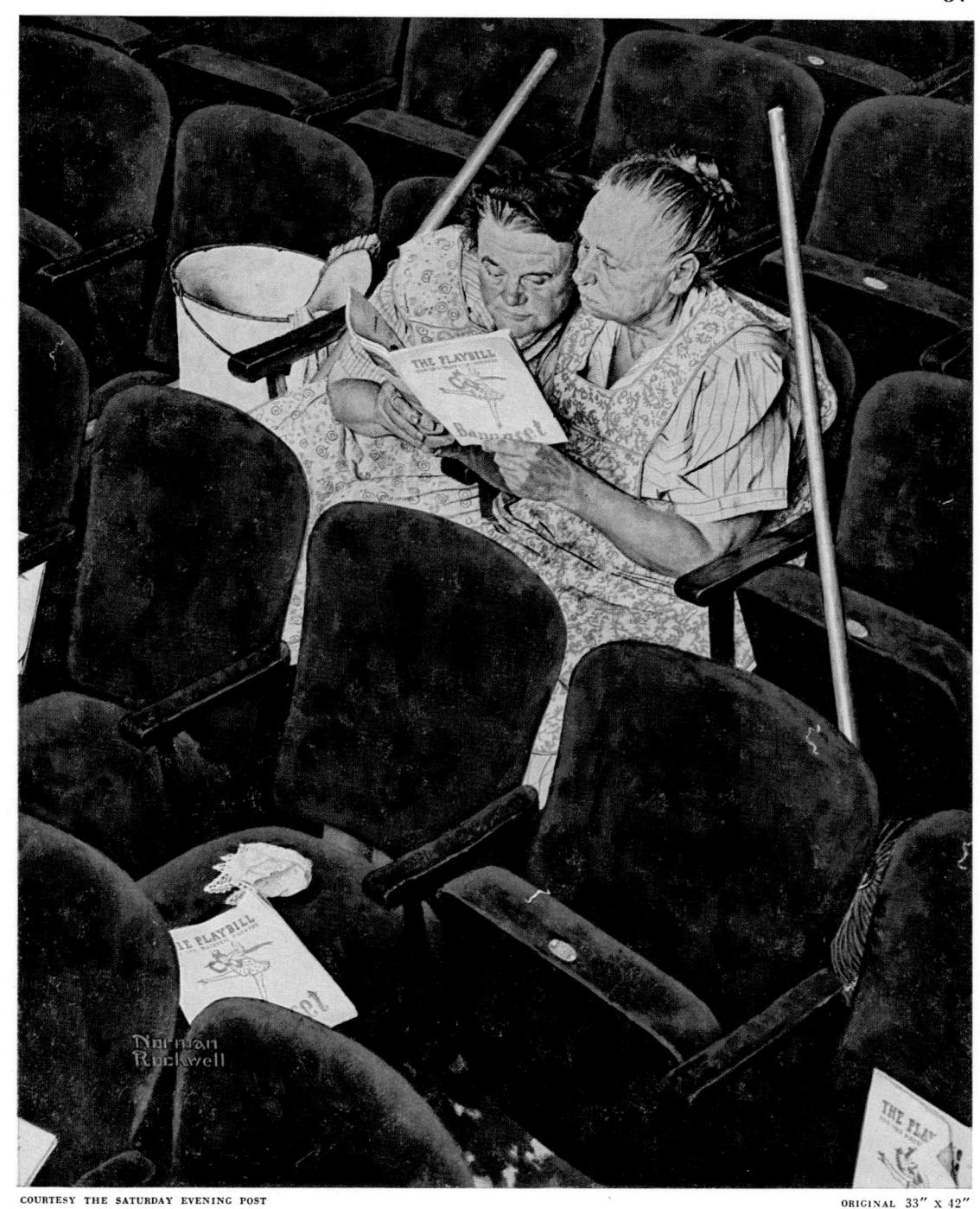

THIS FINAL PAINTING FOLLOWS THE STUDY VERY CLOSELY

This was used on the Post cover for April 6, 1946. See page 54.

Now let us contrast with the above forthright procedure, the round-about ramblings required in producing our "slow and hard" cover—that for Thanksgiving, 1945. I shall describe these ramblings at some length in order to emphasize several pertinent points: that such an artist as Rockwell often finds it advisable to go a long distance from home for his setting and characters; that even the most skillful illustrator frequently has to struggle to obtain a satisfactory result in time to meet his deadline; that the metamorphosis from the initial idea sketch to the final painting is not always as simple and predictable as the casual reader might imagine.

In August, 1945, Rockwell was ready to begin this Thanksgiving cover. By way of a change from his familiar Vermont, he decided to visit Maine for his setting and characters. Knowing that I originally came from Maine and was free at the moment, he invited me to join him.

The week's trip proved more thrilling than either of us had anticipated. First, it was a job to round up enough gas coupons. But finally we had them and on Tuesday, the 14th, we headed for the coast. The beginning of the drive was pleasant but uneventful, though by the time we reached Portsmouth, N. H., the rear of our car was filled with antiques—notably a miniature desk—which Norman had acquired along the way as props for future paintings.

But now the excitement started! We had crossed the bridge into Kittery, Maine, and were headed north somewhere between Ogunquit and Wells when, at seven o'clock, news came of Japan's capitulation. Autos suddenly appeared in amazing numbers, their horns blaring; village church and school bells started clanging; sirens shrilled. Townspeople rushed onto their porches and into the streets, laughing, shouting, waving flags. Hitchhikers sought the larger centers, which were soon filled with celebrating throngs. Kennebunk was bedlam; Biddeford and Saco (pronounced "socko") well-nigh impassable, with mill whistles and fire sirens adding to the unearthly din. It was worth one's life to drive, yet, with horn screaming, we kept on. It was all great fun; a momentous hour. Nevertheless it was with something of relief that we abandoned Route I just beyond Saco for a side road that led

us to the relative quiet of the shore and to our day's destination, the Bay View Lodge.

But it was no time to remain quiet; history was in the making; so half an hour later we were back on the main road, soon to enjoy one of those shore dinners for which The Cascades is famous. With the inner man appeased, Norman, ever interested in the reactions of people (he sees everything as a possible *Post* cover), suggested that we loop through the heart of near-by Old Orchard Beach—Maine's Coney Island. This we did. To our surprise, though night had now fallen all amusement places were closed, the customary strident sounds and garish lights of carnival-land strangely absent. Not that the place was dark and still. Quite the contrary! Sidewalks and streets were packed with boisterous throngs; impromptu parades threaded through the traffic as best they could; sailors and soldiers danced gayly with their sweethearts. Autos worried their way along, dragging tin cans and wash boilers. Trucks came and went, filled to overflowing with singing, shouting merrymakers. But gradually the excitement passed; we returned to the Lodge, took a short walk along the beach, and the first day of our Post cover forage was over.

Never was a morning more nearly perfect than that of Wednesday, August 15th. After our eggs (and, amazingly, bacon!) we drove to Portland in search of a photographer, as Norman would require some photographic data to supplement such notes, sketches and studies as he might make. There, the street sweepers were endeavoring to reduce the piles of paper which marked the celebration of the night before—a good cover idea if it could have been instantaneously utilized. But soon we discovered that Portland, like the rest of America, was on a two day holiday, photographers and all, so our project was of necessity postponed.

Norman had long planned a pilgrimage to Winslow Homer's studio at Prout's Neck, a few miles from Portland, so, to use our time to advantage, out to the Neck we drove, pausing at the one and only store to inquire our way. While I was at the phone, Norman chanced to overhear a customer mention his familiarity with Prout's Neck. "Per-

haps," Normal inquired, "you can direct me to Winslow Homer's studio?"

"I am it!" came the booming but friendly reply.

"You aren't the deceased Homer himself?"

"No, but his nephew Charles Homer. I occupy Uncle Winslow's studio. It's only a step away."

So Norman introduced himself, and me, and soon we were seated in the great master's living room, still maintained much as it had been in his day. There for an hour we were regaled with rare anecdotes of the noted artist—stories extremely well told by our most genial host. Many of these have never been published; and, alas, some cannot be, though we were told that several will appear in a forthcoming volume on Homer by Professor Beam of Bowdoin College. We hope so. For these incidents tend to correct the long-established but apparently erroneous notion that Homer—at any rate in his later life—was chronically irascible. Instead he enjoyed a good joke; he loved a good time. With a touch of whimsy he once painted with his own brush a sign which his nephew showed us, to be set up on occasion beside the path leading to his sketching grounds. It reads, "Snakes! Snakes! Mice!"

I was particularly glad to discover this side of Homer's character, for once as a boy I tried to watch him at his easel along these very shores, only to be driven away by vehemently shouted imprecations. From his snake sign and his shouts at me, it seems apparent that neither females nor youngsters were wanted on sketching days, yet Charles Homer's stories are evidence that his Uncle Winslow could, when it suited, be a delightful fellow indeed.

When at last we left Prout's Neck it was to enjoy, as we drove west across the Scarboro marshes, a fiery sunset, magnified by myriad reflections in each bend of the little meandering tide streams.

But such pleasures of the traveller are almost certain to be tempered occasionally by trouble or inconvenience. Scarcely had the sunset faded when we were confronted with an unexpected eating problem. Driving merrily back to The Cascades, our mouths watering for another shore dinner, we were refused admittance though it was still well before closing hour. The demands of the unexpected holiday had exhausted the food supply—far from surprising, for we soon discovered that many other restaurants had been forced to close.

I might almost say that "all" restaurants were closed, for now started a two hour search for something to eat. Finally, at the entrance to one well-known place the hostess locked the door as we approached. In desperation, I decided to resort to strategy. Not knowing the hostess from Eve, I nevertheless hurried around to the side porch, where I accosted a chair-tilting old gentleman who seemed to belong to the place.

"Is Suzie in? The hostess?" I asked. "I'm Guppy from out to Gorham." (I was raised in Gorham, not many miles away.)

"She's not Suzie. She's Abbie. Abbie Smith. I'll see if I can get her," and pulling himself from his chair with evident reluctance he ambled away.

And soon Abbie appeared, obviously tired. "Abbie," I lied, standing in the shadow to hide my face, and giving her no chance to say a word, "You remember me. I'm Guppy from out to Gorham. You can't guess who's with me in the car? Norman Rockwell! The artist who does all the Saturday Evening Post covers—the Four Freedoms posters. You know—famous! I got him to Maine to do a Post cover showing Maine hospitality. And we just can't find any Maine hospitality. He's hungry. I'm hungry. Every place is closed. Abbie, he's all for going back to Portsmouth to eat. That would mean a New Hampshire Post cover. Abbie, you've just got to feed him for the sake of dear old Maine!"

I delivered all this at top speed. At the end she sighed, "Well, I

Guppy of Gorham

suppose you'll have to bring him in; come around this back way. I shouldn't do it. You may have to wait."

And wait we did, but not for long. And what a feast! Then Norman autographed paper napkins for Abbie and the girls, and soon we were back at the Lodge.

By now we had learned with pleasure that the command, "Fill her up!" had again come into use and that coupons, precious yesterday, today no longer counted; so Thursday found us with a tank full of gas, rolling on to Brunswick where we hoped to gain some valuable assistance from Robert P. Tristram Coffin—Maine's noted poet, author and artist—in discovering a suitable setting for that Thanksgiving *Post* cover based on a Maine kitchen.

While Rockwell and I felt certain that a man who had written books of recipes on Maine cooking could direct us to the ideal spot, we were scarcely prepared for the unusually interesting house to which he conducted us at Pennellville, on the Harpswell road, a few miles south of Brunswick.

This house was erected by the Pennells—a ship-building family noted for designing and constructing some of the most famous of

PHOTOS JOHN SHELLEY

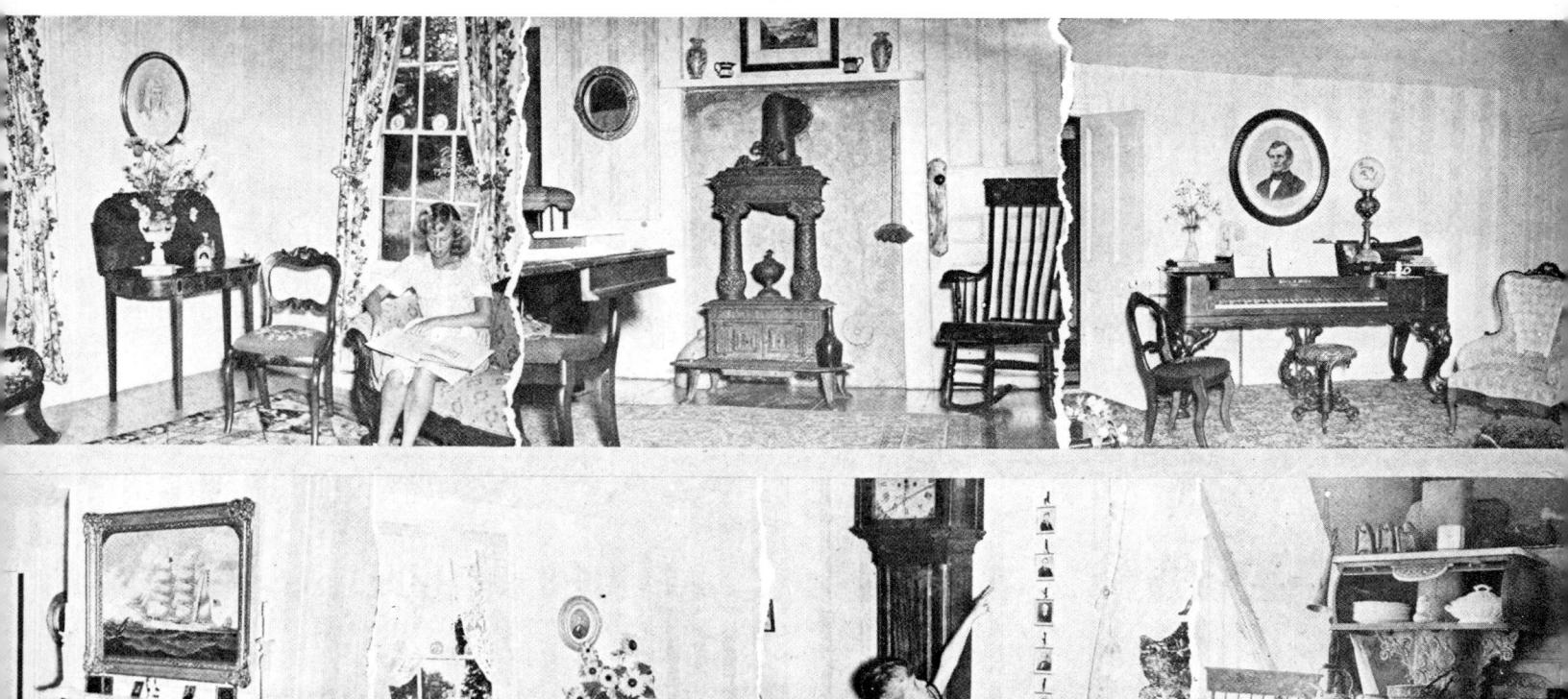

Maine's sailing ships of the period 1780-1875. These were built in sight of the house, several of them right beside it, with the lines attached to trees which still stand. The house, dating from 1837, has been occupied by five successive generations of Pennells. At present it is the summer home of Andrew Pennell, a Bath banker, and his wife Alice, who is Dr. Coffin's sister. (It is their daughter Arline and their son Carroll who appear in our photographs, the latter pointing to his fifth generation picture.)

Every room of this sturdy old house, with its fine period furnishings and decoration, would delight the heart of the antiquarian. But Norman was impatient to be shown into the kitchen. What a gem it proved to be, with its elaborately ornamented kitchen range set before a brick oven of still earlier date—the latter flanked by a built-in caldron. Almost every detail was fascinating—the brass fog horn on the wall (still used to call the family to dinner), the decoy ducks, old flatirons, kerosene lamp and candles.

But since the late afternoon light was ill-suited to sketching and photography, and as Rockwell had not as yet chosen people to pose for him, back we hurried to Brunswick, the immediate aim being to round up the right type of soldier to pose for the ex-serviceman. First came a visit to the USO, where the hostess, Miss Bangs, was most cooperative, repeatedly telephoning for us and serving as our guide as we rushed hither and yon around town comparing one prospect with another. Still later, Norman and I stood on street corners seeking our prey; we hung around the Moulton Union at Bowdoin while dozens of service men had their evening meal; we drove slowly along the streets, scanning faces. At length Norman concluded that Richard Coffin, the author's son, while too young to have been in service—he

This old house, opposite, is located near Brunswick, Maine. It was built by the Pennells, a shipbuilding family, and has been occupied by them for five generations—see young Carroll Pennell pointing to his portrait. Robert Tristram Coffin led us to the place, and I chose the kitchen (right) as the setting for my Thanksgiving cover, 1945. But read what happened! N.R.

was sixteen—would do. So again we drove to the Coffins'. Richard consented, and now the problem was to find a uniform to fit him. After an hour or more we discovered and borrowed one from a veteran recently back from overseas.

The rest proved easy. Mrs. Pennell consented to pose as the boy's mother and Mr. Coffin agreed to act in any desired capacity if called upon; so with the hour set for a morning rendezvous, we drove to the Eagle Hotel for a belated dinner.

The next morning—Friday—we shopped for vegetables needed in the picture and, picking up Shelley, our photographer, were soon off for the Pennell home. There we found that Mrs. Pennell, throwing herself wholeheartedly into the thing, had baked a pie and some pans of raised biscuits. She even had steam up in the kettle! All we lacked was a turkey!

Norman now sprang into action—he was all over the place. There was hardly time for him to make his customary sketches and studies he must strive for an adequate photographic record. First he worked with Shelley, to determine the camera's position. Next Richard was posed this way and that, amidst a bombardment of good-natured commands: "Toe in! No! Try your feet on the chair rung. Good! Now raise your elbow. Relax! Lean forward! Look lovingly at that imaginary turkey; that's right, keep your eye on the little birdie! Lean forward still more! Get your knife on that potato! Relax! Stick out your chin! That's right! Hold it there! Hold it!" And back and forth Norman darted between camera and model, sometimes taking Richard's place in the chair in order to demonstrate the desired attitude. Shelley had plenty to do, too. Before each exposure he tested with his light meter; his job was far from easy, as he was working from too close a position and with natural light-Norman wanted no flash bulbs to create artificial effects.

In the meantime, the rest of us perched around, enjoying ourselves and tossing far-from-helpful comments to and fro, until at last poor Richard, somewhat the worse for wear, was released. Now, much the same performance was repeated with Alice Pennell, while the spectators held reflectors to aid in the control of the light. Finally came shots of Dr. Coffin, and others of the background alone.

The reader might wonder at the need for such careful photography, since the illustrator customarily takes many liberties with his subject matter when he starts to paint. Yet the reason is obvious if it is remembered that in this case the actual cover was to be executed hundreds of miles from the scene, making it necessary to record everything which could conceivably be needed. Then, too, Rockwell usually paints with almost photographic realism, so no matter how many changes in form and tone he may ultimately make from his photographs, they must nevertheless be very true as to detail if they are to be of much help.

It was about noon when, the photography finished, we offered the Pennells and Coffins our thanks and our adieus. It would be a full day before Shelley could develop his film and deliver the prints. The war was over, gas available, the weather perfect, so why not take to the broad highway once more? Therefore we sought Route I again, and rolled "down east" to Cherryfield, not far from the Canadian border. Here we spent the night with my uncle, Frank Stewart, and his family.

The next afternoon—following a morning's visit to thousands of acres of blueberry "barrens" near Cherryfield, and a tour through one of the Stewart canning factories—we returned to Brunswick to pick up the photographs seen in this chapter, and many more. The purpose of our trip accomplished, we now headed for Arlington via the White Mountains of New Hampshire. On Sunday, after a pleasant jaunt through the mountains, we reached the valley of the Connecticut River down which we drove to Brattleboro. Our 1300 mile circuit completed, another hour saw us over the Molly Stark Trail to Bennington; from there we drove to Arlington in ample time for Norman to obtain a good night's rest before starting his cover on Monday morning.

Alas, the trials of the cover artist! In the days immediately following, Norman labored assiduously to convert all this Maine material into an acceptable *Post* cover. Study after study was made, but nothing

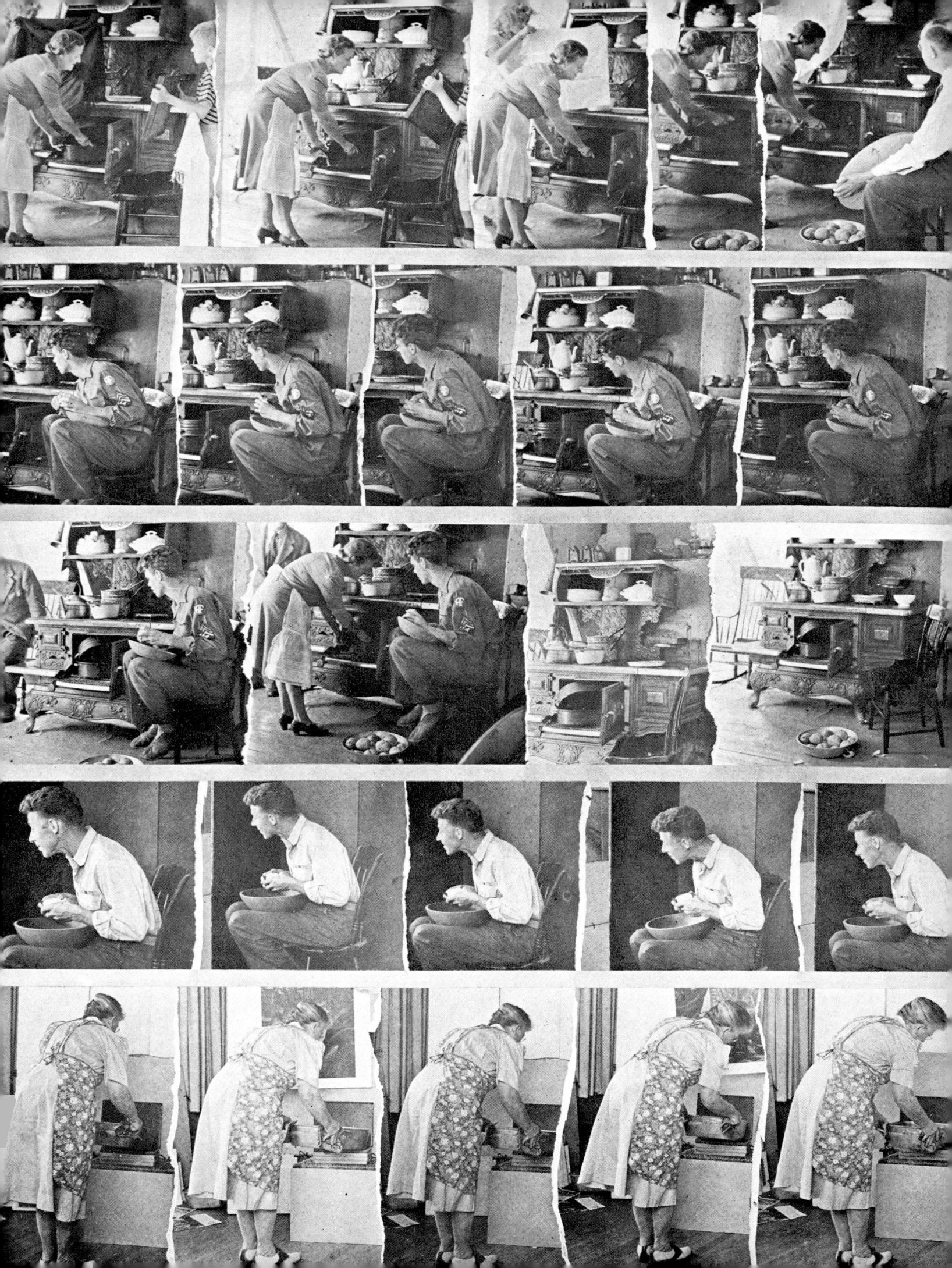

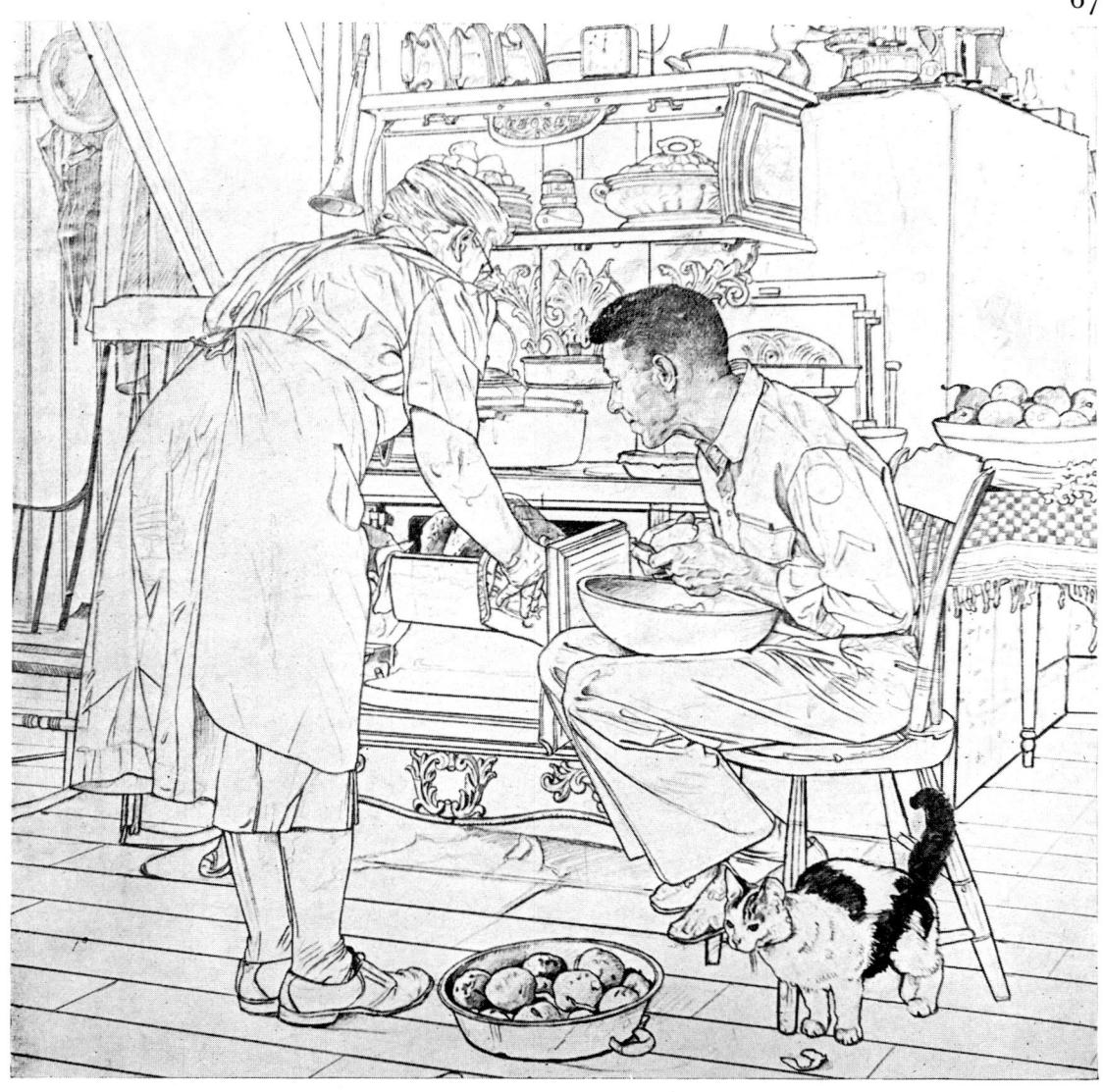

A DETAILED DRAWING ON CANVAS, ALL READY FOR PAINTING

Who would think that an artist would go as far with a picture as I did with the one above, only to abandon it and make a fresh start? But that's what happened! Perhaps that study would have resulted in a good cover—who knows?—but I gradually lost all interest in it, just couldn't go on. I couldn't seem to loosen up—to get away from my photographic references. I wasn't satisfied with the substitution, either, but deadlines are deadlines. N. R.

PHOTOS JOHN SHELLEY

went right. First, the perspective angle proved disappointingly sharp—the camera had, as we have seen, been very close. Then it was decided that Richard Coffin showed too few signs of strain for a returned veteran. A young man better suited to the cast was rounded up at Arlington; new photographs were made, and new studies. Still the thing was all wrong. Perhaps Mrs. Pennell wasn't quite the old-fashioned type one would expect to find in such a kitchen? Another substitute model was chosen, posed, and photographed. More studies were undertaken, along with a full-size charcoal layout. A final drawing was now done on canvas.

But the longer Rockwell worked the more discouraged he became. The figures faced the wrong way like actors turning from their audience; there were too many opposing lines, too many confusing elements of detail. The whole thing appeared staged and photographic; Norman couldn't break away sufficiently from his reference material. Time was running short; nerves were frayed.

So in desperation, with only a few days to his deadline, the artist started afresh. He threw overboard all that had resulted from that week's hunting in Maine; nothing was left but his basic idea. A new setting was arranged in his studio. New models—local people—were posed; new sketches and studies were hurried through. At last the subject was on the canvas; the work was pushed forward at full speed; the final stroke was completed only in time to rush the cover to the *Post*.

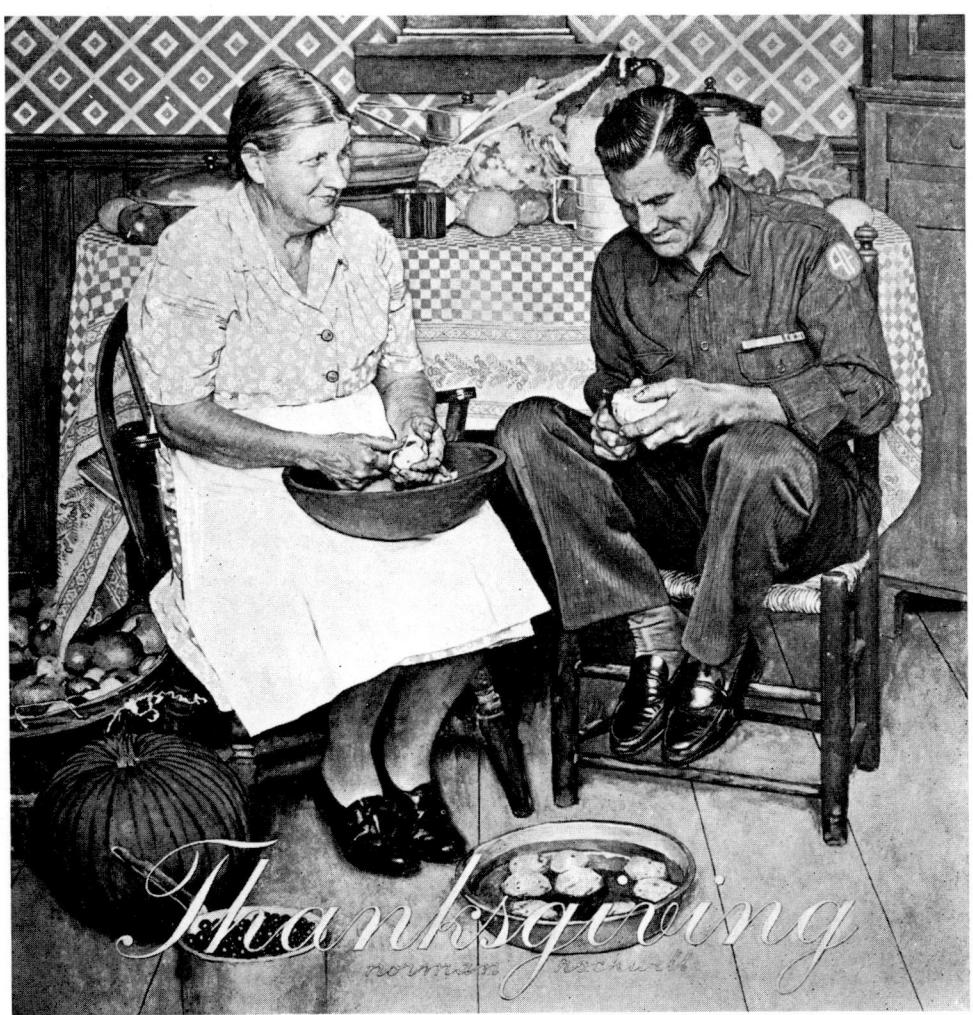

OIL PAINTING FOR POST COVER OF NOVEMBER 24, 1945

COURTESY THE SATURDAY EVENING POST

AT THE VERY LAST MINUTE, THIS WAS SUBSTITUTED

The would-be cover artist, when planning to submit ideas to such a publication as the Post, would do well to forget for the time being such special covers as those for Thanksgiving, Christmas, and the Fourth of July. For these are assigned well ahead of time to established artists. This leaves plenty of in-between issues, however. It should be remembered, though, that magazine covers are done from four to six months ahead of publication; therefore one shouldn't approach an art editor at the last minute with any expectation of selling him an idea for some early issue. N. R.

2

A REPRESENTATIVE GROUP OF ROCKWELL MAGAZINE ILLUSTRATIONS

1. FROM THE SATURDAY EVENING POST, MARCH 19, 1938; 2. FROM LADIES' HOME JOURNAL, FEBRUARY 1939; 3. FROM LADIES' HOME JOURNAL, MAY 1927;
4. FROM THE SATURDAY EVENING POST, MARCH 27, 1939 PUBLISHED BY PERMISSION

IV: Magazine Illustration

WHILE ROCKWELL is best known for his *Post* covers, these have by no means been his only work, for over the years he has executed an astonishing number of other commissions in a wide variety of fields. There have been covers for other magazines, for instance, and almost endless "undercover" illustrations, not only in the *Post*, but in *The Country Gentleman*, *Ladies' Home Journal*, *Woman's Home Companion*, *Mc-Call's*, *American Magazine*, and the old *Life* and *Judge*.

Yet young Rockwell really got his start by illustrating books. In 1911, through the noted illustrator, Thomas Fogarty (one of his teachers at the Art Students League), the seventeen-year-old artist met Condé Nast, who gave him his first professional break by commissioning him to illustrate a volume called *Tell Me Why Stories*. Also, at about that time he did an illustration for the American Book Company for a volume on Samuel de Champlain. We reproduce this illustration

It is more difficult to make an illustration than to paint a cover, as you must customarily interpret the author's text. Yet some of my illustration is the best work that I have done. In covers, the detail essential to storytelling may hurt, rather than help, the esthetic qualities; in illustration, one strives more for atmosphere, and can approach the esthetic standards of the fine artist . . . The piano illustration, opposite, was posed in a piano warehouse in New York; the subject above it, portraying Martha Washington, was painted in Washington's Valley Forge headquarters. N. R.

on page 73 as an early—perhaps his very first—published drawing. "I had a terrible time with this," he recalls. "I didn't know enough about perspective to show the river lower than the parapet on which Champlain stands."

His next job was to illustrate a book on camping, hunting and fishing. Edward Cave, Editor of *Boy's Life*—the official organ of the Boy Scouts of America—was the author. Norman wasn't much of an outdoor man so the subject was new to him, yet he produced authoritative pen drawings demonstrating such skills of outdoor life as packing a burro and carrying a canoe.

His success with this led him to the magazine field and his first salaried position, Art Editor of Boy's Life. Here he spent one day every week accepting or rejecting submitted illustrations (including his own). He also did the covers and illustrated two stories for each issue. To supplement his meager income from this, he produced covers and illustrations for other boys' and children's magazines—St. Nicholas, American Boy, Youth's Companion and Everyland. He likewise illustrated some books by Ralph Henry Barbour, including Four Afloat, Onward and Forward and The Crimson Sweater.

This, then, was his start. Scarcely had he come of age when, in 1916, he landed on the *Post*, thus completing what he calls "my journey from pillow to *Post*." By this time he was also working regularly for other front-line publications, doing both covers and illustrations. Advertising demanded more and more of his effort, too. At an age when most young men are leaving college, Norman already ranked as one of America's leading illustrators.

It would be pointless to recount his whole career from that day to this, for his published work itself affords an adequate record. Enough to say that each passing year found him more sure of himself, and more firmly entrenched as a top-flight man. For a long period there was scarcely a leading publication that didn't carry its quota of Rockwell illustrations in charcoal, crayon, pen-and-ink, wash, or color.

Norman enjoys recalling an early experience when he got himself into a tough corner trying to make a favorable impression upon Will

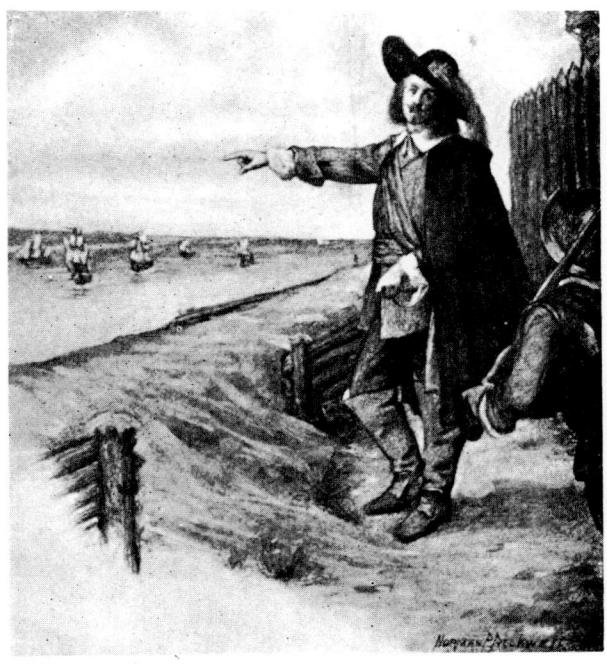

COURTESY AMERICAN BOOK COMPANY

Above: My first published illustration, done in 1911 when I was seventeen. Right: One from 1912. The "P" in my signature stands for Percy; do you wonder I dropped it? N. R.

Bradley, then Art Editor of Collier's. He had been told that Bradley, a Californian, would receive with particular affection any artist who hailed from his native state. So when Norman presented his portfolio of samples he managed to make known the fact (or rather the lie) of his California origin. "Well, well," genially exclaimed Bradley, "I'm a Californian myself! San Francisco, eh? Lots of nice people out there. Live right in the city? What street?" Poor Norman was stumped; he didn't know the name of a single street in his "native" city. But he had heard of a Sunset Magazine so, grinning as he thought one Californian should grin at another, he replied, "Sunset Avenue." Bradley grinned back politely but appeared nonplused. "Hmm," he

Text continued on page 78

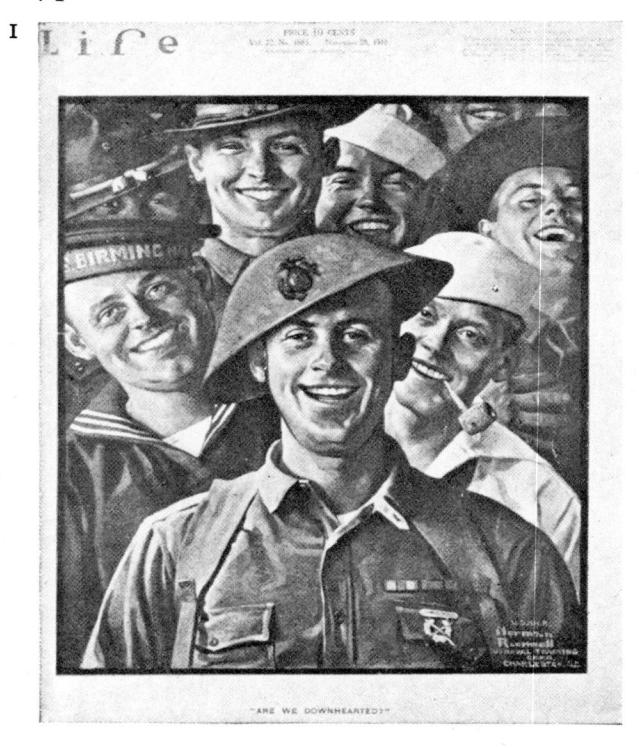

Are You Well Bred?
22 Tests — By Dr. Frank Crane

1. LIFE, NOVEMBER 28, 1918; 2. JUDGE, MAY 25, 1918; 3. THE AMERICAN MAGAZINE, OCTOBER 1921; 4. THE LITERARY DIGEST, JANUARY 17, 1920; 5. LESLIE'S, OCTOBER 8, 1916; 6. POPULAR SCIENCE MONTHLY, OCTOBER 1920; 7. COLLIER'S, MARCH 29, 1919; 8. FARM AND FIRESIDE, MAY 1919. REPRODUCED BY PERMISSION

MISCELLANEOUS MAGAZINE COVERS FROM ROCKWELL'S EARLY WORK

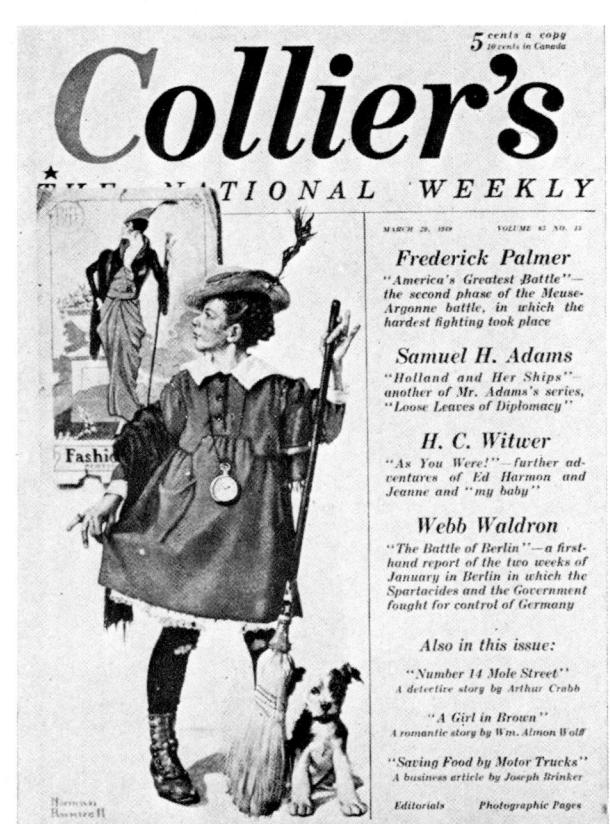

Than a Million a Week

7

More

DURING A LONG PERIOD, MANY MAGAZINES USED ROCKWELL COVERS

This authentic scene from the Alcott living room shows Louisa being educated by her father.

Louisa's father, Bronson Alcott, is quite perturbed to learn that Louisa was not born a boy.

As preparation for these Louisa May Alcott illustrations, which I was commissioned to do for the Woman's Home Companion, I went to the Alcott home at Concord, Massachusetts, accompanied by Henry Quinan, then art director of that publication. (Incidentally, Quinan is one of the great art directors of all time, as well as very much of a gentleman.) We spent several days at Concord, making sketches and absorbing the atmosphere of the house—the whole house is as it was—even the attic, which still remains just as Louisa May Alcott left it. A few days spent on the spot like that is worth hundreds of photographs, because you get the real feel of the thing. We saw Louisa's old swing, her lamp. We knew how she went out of her room-how she went around the place . . . I had to read "Little Women" in order to illustrate it, so, as I was going on a hunting trip, I took it with me. Every evening I would sit reading "Little Women" while my three companions—great husky, broadshouldered guys-were talking about killing moose. They must have wondered what was wrong with me. Then I came home and got busy with my pictures for "Little Women." N. R.

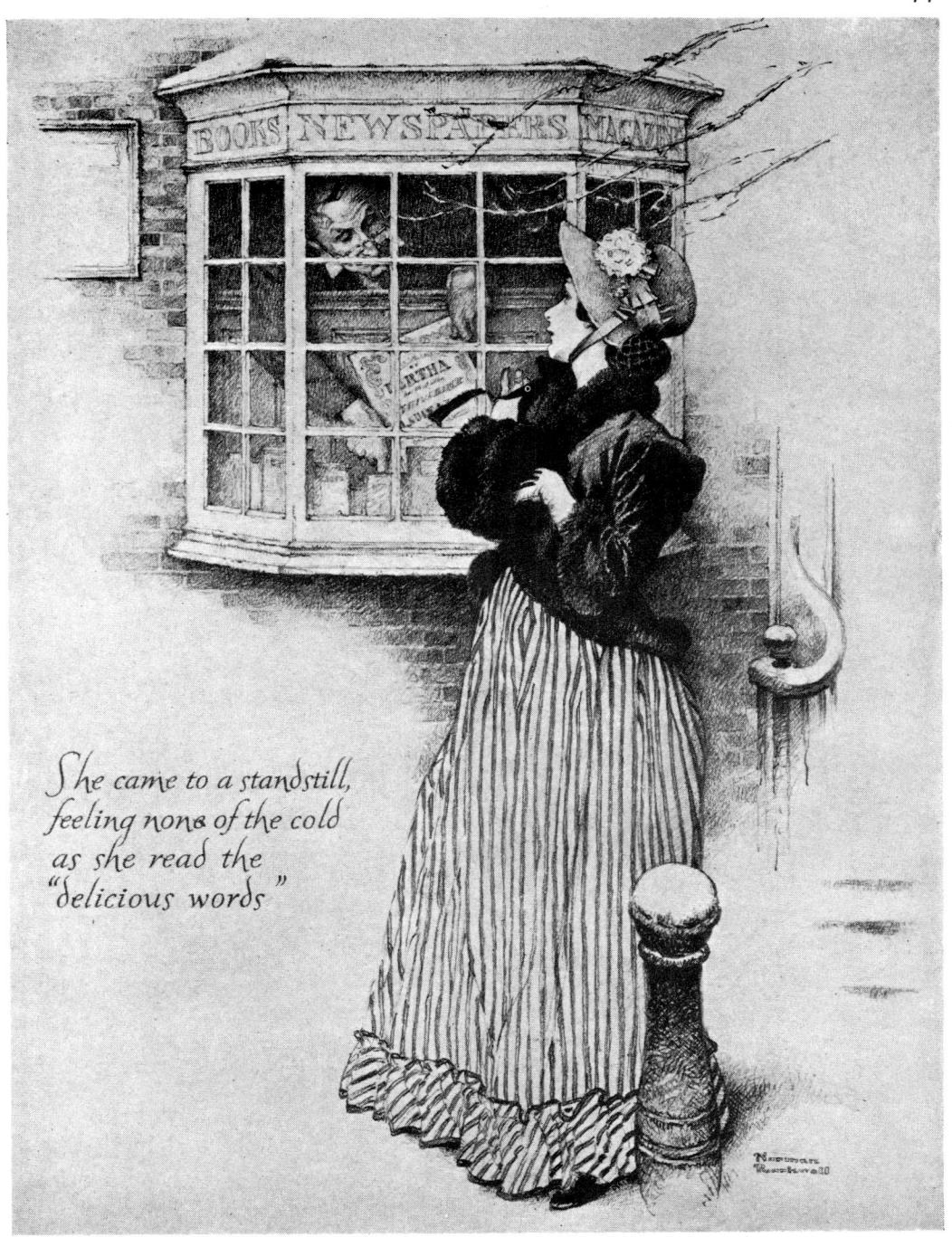

ABOVE AND OPPOSITE: ILLUSTRATIONS FOR "MOST BELOVED AMERICAN WRITER," BY KATHARINE ANTHONY, WOMAN'S HOME COMPANION, DECEMBER 1937 THROUGH MARCH 1938.

BEAUTIFULLY TREATED IS THIS LOUISA ALCOTT SERIES

pondered, "Sunset Avenue: I don't seem to . . . in just what section of the city is that?" Things were getting pretty hot for Norman; sweat moistened his brow. But he wasn't licked yet! "Why, out in the Sunset section," he extemporized. "Sunset section?" mused Bradley. He wheeled around in his chair and stood up. "Just a minute," he said. "Let me go inside and get my map!" That was too much for Norman. When the door closed behind Bradley, the young fibber grabbed up his pictures and fled to the elevator. Safe in the lobby he discovered he had left his hat—with the label of a New York store!

And so young Rockwell went the rounds, trying out his schemes for selling, learning the tricks of the trade. Gradually he disposed of more and more work, and bit by bit his already substantial reputation grew. After his first covers appeared on the Post, he was in frequent communication with its editors, often by phone. He was sharing a New Rochelle studio with his friend, Clyde Forsythe. "I was really aweinspired over the Post business," he says, "terribly impressed and absolutely afraid of the editors. They would call me from Philadelphia by long distance, and it always made me so excited I could scarcely hear or speak. Clyde, or 'Vic,' as he was called, was a very good mimic and an inveterate joker. He knew this weakness of mine and would call me up from outside the studio and say, 'This is Walter H. Dower of The Saturday Evening Post speaking.' Immediately, I would get all jittery, scared half to death, and stutter, 'Y-Y-Yes, Mr. Dower,' and then Vic would come back with some remark that can't be quoted. One day when Vic was out, the telephone rang and a voice said, 'This is Walter H. Dower speaking,' 'Oh, is it?' I shouted. 'Well, you old sonof-a-gun, you can go straight to hell!' The voice on the other end of

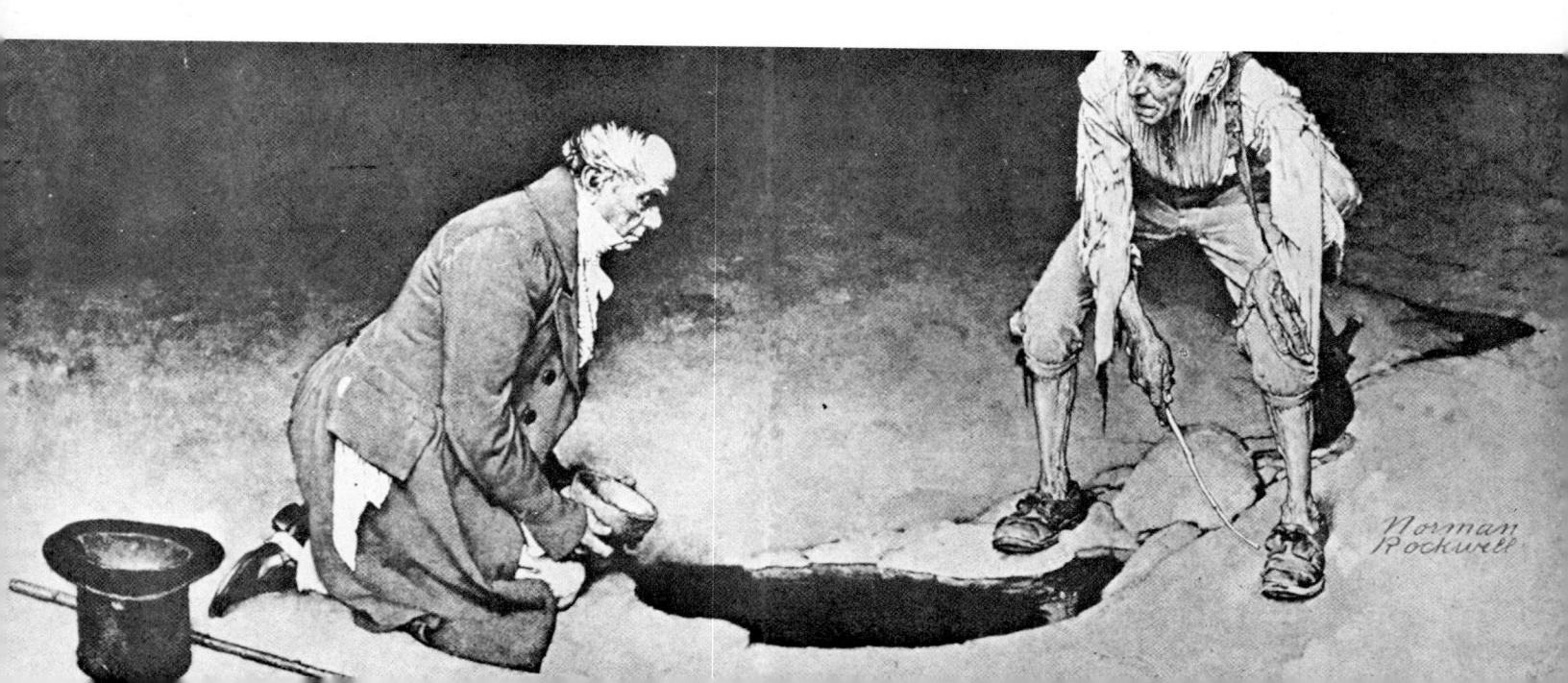

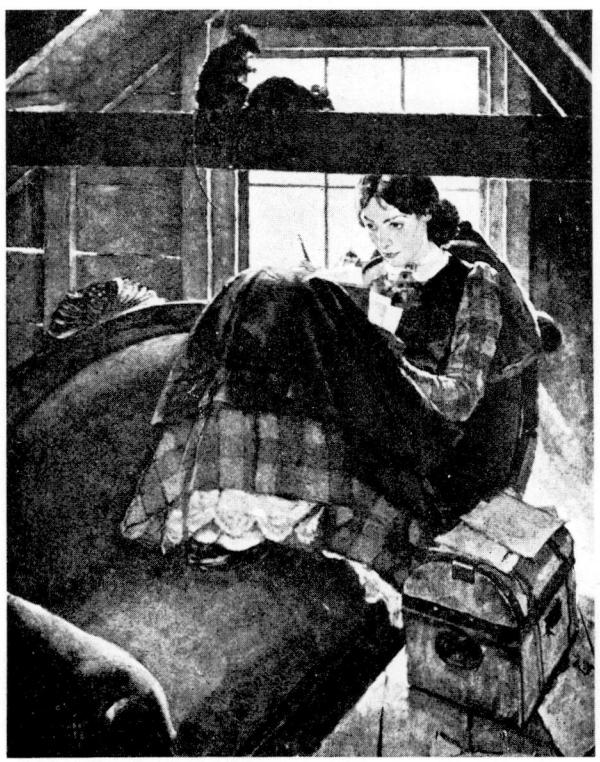

COURTESY WOMAN'S HOME COMPANION

Louisa May Alcott in her attic at Concord, where she did her first writing.

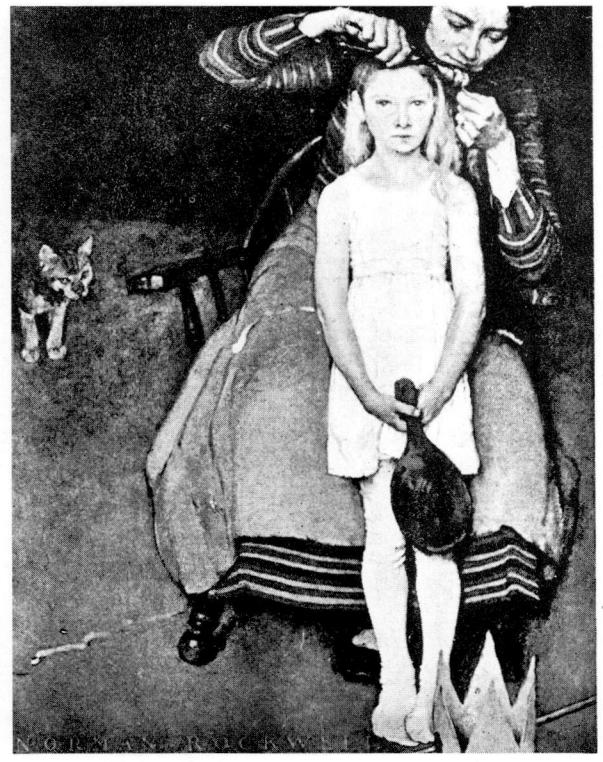

COURTESY SATURDAY EVENING POST

This composition, with the figures at one side, is unusual but effective.

the wire came back in a tone of mild surprise, 'What did you say?' It was really Dower!

"Another disconcerting habit Forsythe had: he would wait until I was on the phone with Dower or some other client. Suddenly, in the raucous voice of our iceman he would bellow, 'Hey, there, hey! Any ice today?"

Rockwell was not cut out to be an illustrator of the popular boy and girl type of periodical literature. He had no interest in painting pretty faces, and he admits that no matter how seductive he might try to picture women—and he did try—they always turned out to look more like a fellow's mother or sister. But the Louisa May Alcott serial that ran in the *Woman's Home Companion* several years ago brought out

Opposite: Illustration for "Daniel Webster and the Ides of March," by Stephen Vincent Benét.

the best that was in him. This, unlike frothy light romance, was solid; it gave him something to put his teeth into.

His handling of the hospital waiting room subject (page 84) which ran in the *Post* reflects his whole attitude toward illustration; it points up his insistence upon making his own commentary on life rather than merely picturing incidents lifted from an author's manuscript. That story was about two boys on a bicycle trip. There was bare mention of the fact that one of them, a year before, had anxiously sat in a hospital waiting room. The tense atmosphere of that situation and the reaction of three people to it represented something so significant in human behavior that Rockwell, always the philosopher, could not pass it up. Such independence, however, drives authors crazy; they are more interested in the illustrator's skill with a brush than in his philosophy!

We have just called Rockwell philosopher; perhaps "historian" would be more accurate, although his canvases that depict the current scene go far beyond graphic reports of its customs and manners. They derive their incentive from the artist's emotional kinship with the people he portrays—his response to the spirit with which they meet life's manifold problems. If they attract us at first by their picturesqueness, they

Text continued on page 96

One of the real handicaps to American illustration is the fact that every girl, in every illustration in every magazine, must be made beautiful—no matter what the story. Most magazine editors seem to believe, and perhaps rightly, that the American women readers will just not stand for anything but glamorous females . . . In the illustration opposite, which depicts Louisa May Alcott as a young woman interviewing her first publisher (supposedly a racy, rather vulgar type of person), I at first tried to paint her as she appeared in her own photographs. Though she had character, they showed her as anything but beautiful. But the editor made me "pretty her up" a lot; I felt that this weakened the picture . . . The model for the man was Fred Hildebrandt, a swell fellow and a great fisherman. He was a friend of all of us artists in New Rochelle, where this was painted. He posed for us, criticized our work, and helped us a great deal . . . The costumes were made for me in Concord. N. R.

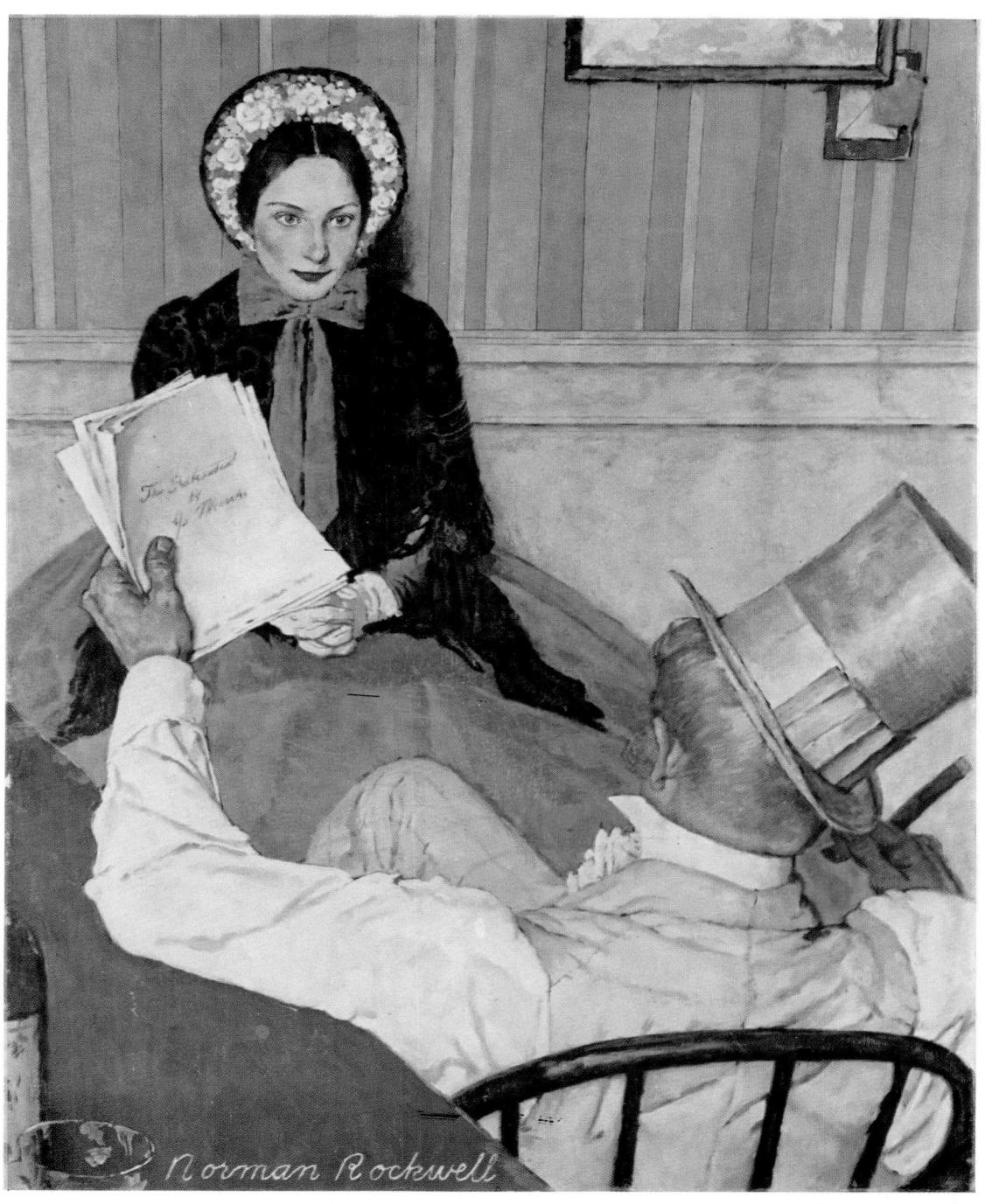

ILLUSTRATION FOR "MOST BELOVED AMERICAN WRITER," BY KATHARINE ANIHONY, WOMAN'S HOME COMPANION, DECEMBER 1937 THROUGH MARCH 1938.

COURTESY WOMAN'S HOME COMPANION

ILLUSTRATION IN OIL FOR LOUISA MAY ALCOTT SERIES

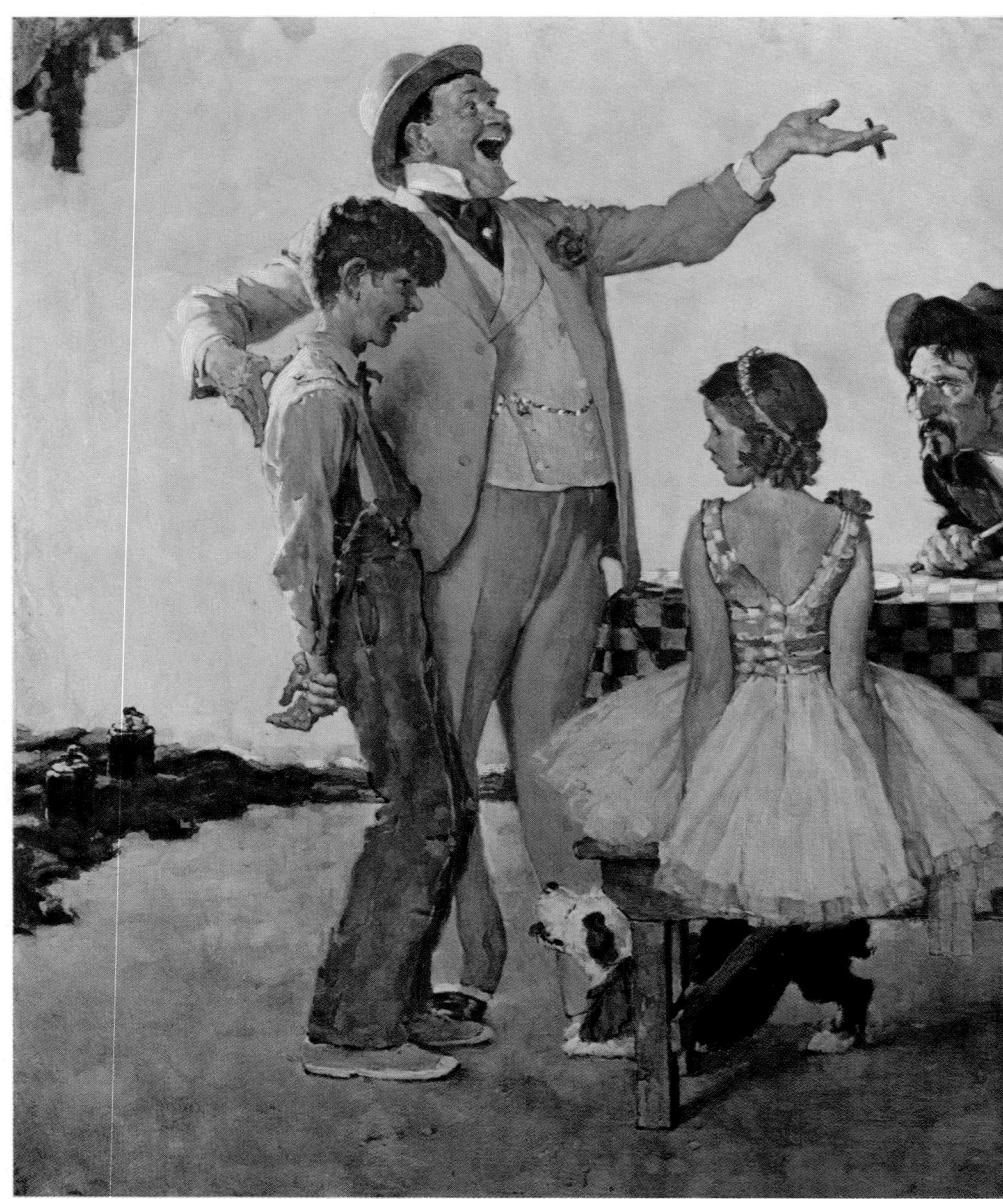

ILLUSTRATION IN OIL FOR "WILLIE TAKES A STEP," BY DON MARQUIS, THE AMERICAN MAGAZINE, JANUARY 1935

Circus pictures are a lot of fun and extremely easy to do. They are so full of character and color that I like to paint them. But it seems that we illustrators have overdone them, and now I simply cannot get an editor to okay the idea of another circus picture. Other illustrators

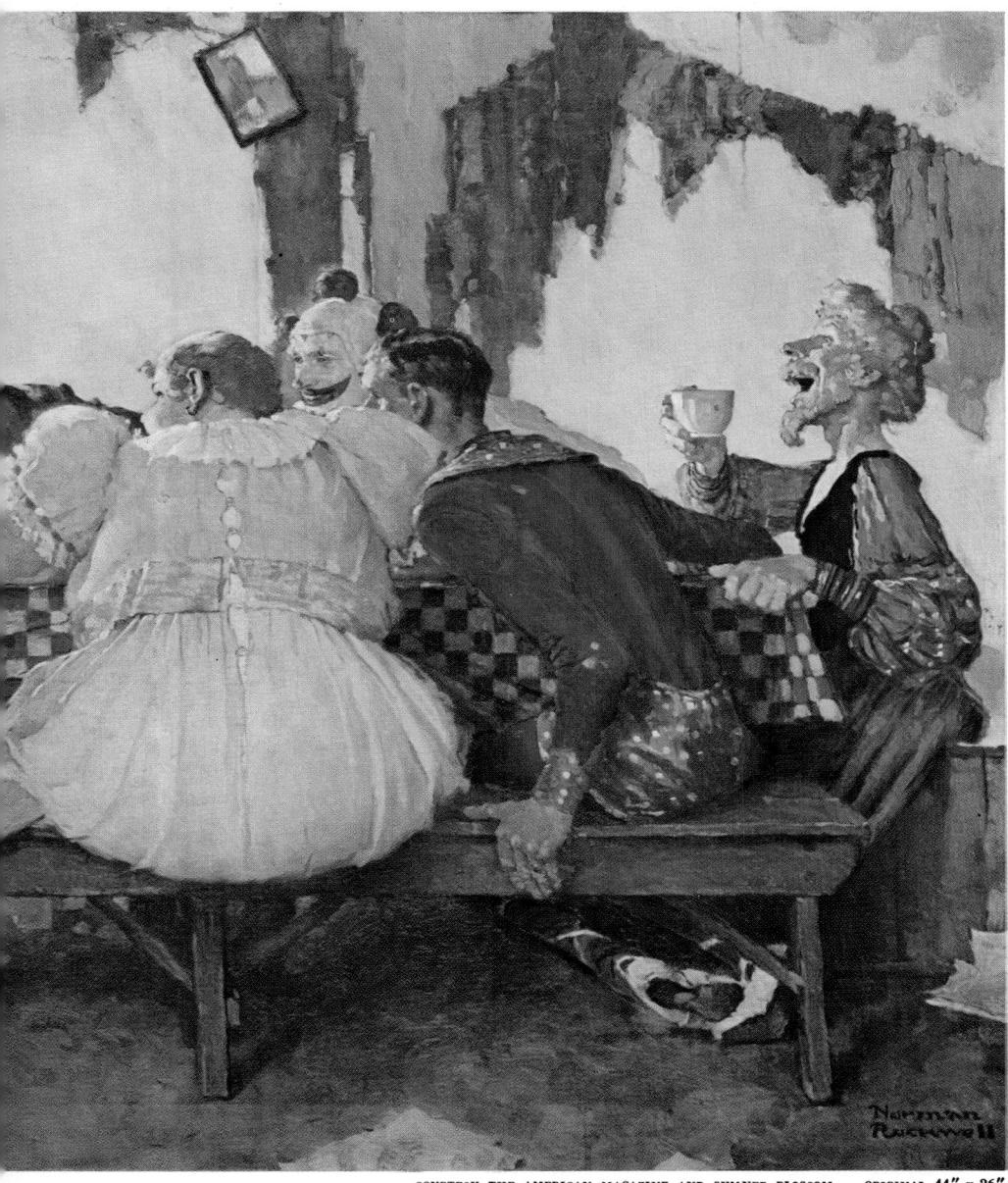

COURTESY THE AMERICAN MAGAZINE AND SUMNER BLOSSOM

tell me they have had the same experience. So for the present I shall let the subject rest, but I hope some day to do one again—if I live. In this case I greatly enjoyed painting the thin man, the fat man, and the acrobat, not to mention all the rest. N.R.

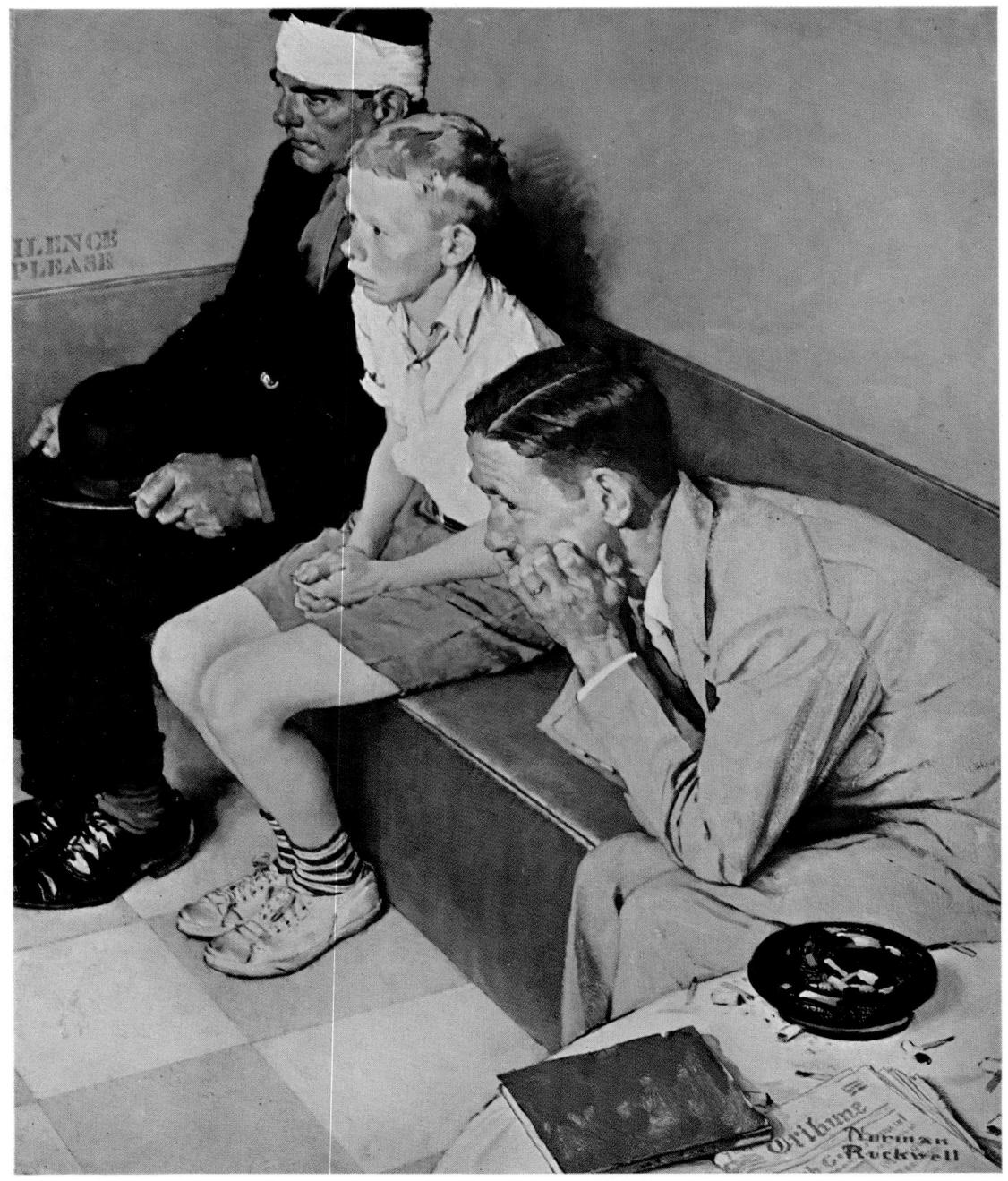

ILLUSTRATION IN OIL FOR STORY ENTITLED, ".22," BY PRICE DAY, THE SATURDAY EVENING POST, OCTOBER 16, 1937

ORIGINAL 23" X 28"

A MOMENT OF TENSENESS IN A HOSPITAL RECEPTION ROOM

This grows on you the longer you study it.

LUSTRATION IN OIL FOR "RURAL VACATION," BY JAKE FALSTAFF, LADIES HOME JOURNAL, AUGUST 1938 ORIGINAL 16" X 20

A DETAIL AT THE EXACT SIZE OF THE ORIGINAL

Above: Most of the subjects in this book are of necessity greatly reduced, so here, to show the degree of finish which I generally use, is a portion of a final painting reproduced at its original size. Note the brush strokes and the canvas grain. At the right is a miniature of the entire picture. N.R.

Opposite: Many illustrators of fiction look through a story to find the most dominant or dramatic incident, and illustrate that. I prefer to discover the atmosphere of a story—the feeling behind it—and then to express this basic quality. The incident which I have here portrayed played but a minor part in the story, but it struck me as being the essence of the situation, the thing which strongly appealed to me. So I tried to express the tenseness of this period of waiting in a hospital reception room. N. R.

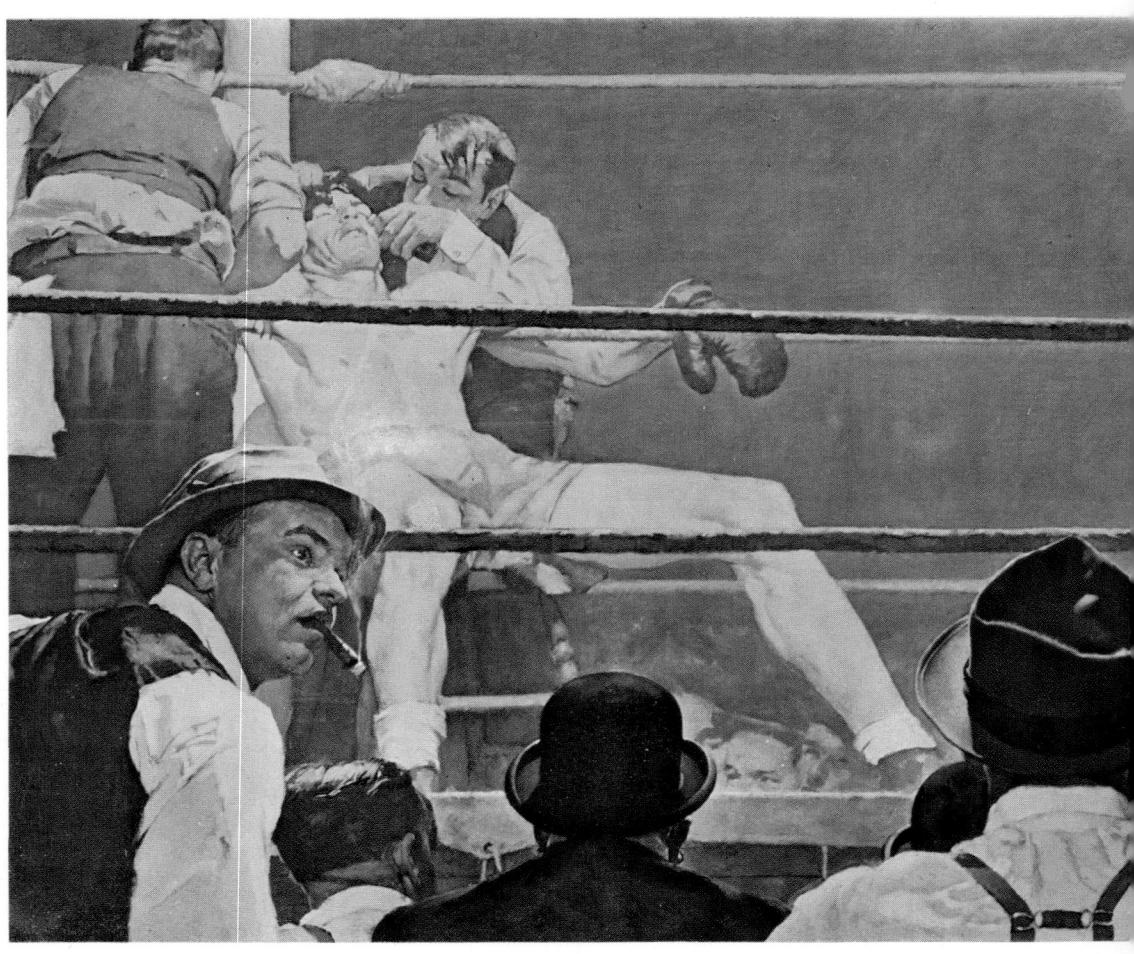

ILLUSTRATION IN OIL FOR "STRICTLY A SHARPSHOOTER," BY D. D. BEAUCHAMP, THE AMERICAN MAGAZINE, JUNE 1941

My problem was to catch the excitement of the prize ring—to create a feeling of tenseness and action. So I journeyed to a club at Columbus Circle, New York, where I studied the effect of the smoke-filled room and the types of people who frequent such places . . . For my models I relied mainly on my usual neighbors and friends. Elizabeth Schaeffer—Mead's wife—posed for the belligerent female. Of course she's really a very fine lady, but you wouldn't know it here. The fighter standing beyond her was modelled by Clarence Decker, Master of the West Arlington Grange. Both of these were posed in attitudes of tense emotional strain. Nip Noyes modelled the derby-hatted man next to Elizabeth; he appears again, derby and all, at the left. The cigar-smok-

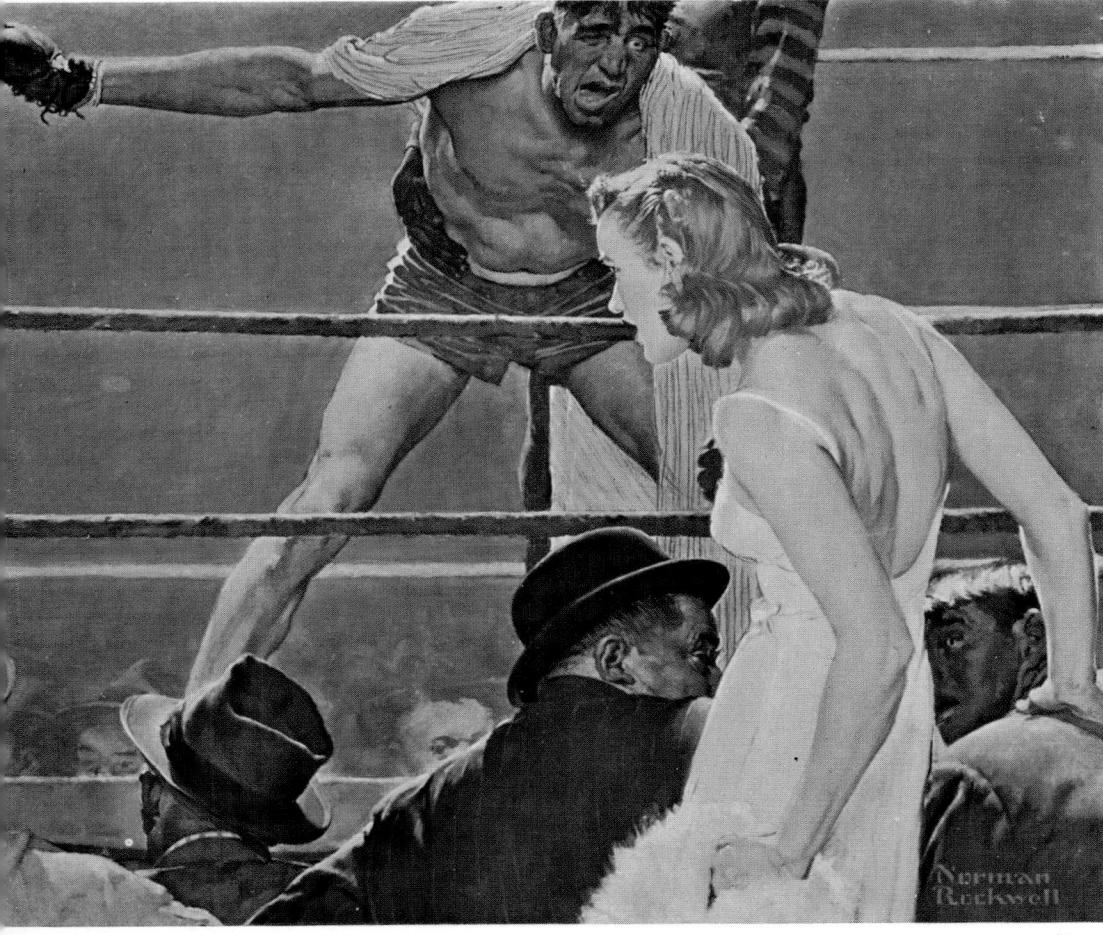

1AGAZINE AND SOCIETY OF ILLUSTRATORS

ORIGINAL 71" x 30"

ing man is my photographer, Gene Pelham; he was also used as the attendant beyond the seated fighter. Only this fighter was a professional model . . . In order to suggest the smoke-laden atmosphere, somewhat indistinct grayish tones were used, quite different from those indicated for most subjects. The relationship between picture proportion and subject matter is always an important one; this composition worked out very naturally to a horizontal proportion—it would not have been easy to treat it successfully as a vertical picture. The cover artist, accustomed to filling vertical spaces, is glad of a chance to paint a horizontal picture now and then. Here the strong parallel lines of the ropes and floor accentuate the horizontal. N.R.

LUSTRATION IN OIL FOR "NORMAN ROCKWELL VISITS A RATION BOARD," THE SATURDAY EVENING POST, JULY 15, 1944 COURTESY (

I visited the Ration Board at Manchester, Vermont, to gather the subject matter for this painting, which appeared as a spread in The Saturday Evening Post. It was an interesting job, for ration boards were then an active factor in the American scene—something which directly or indirectly played a part in the life of every one of us. I couldn't

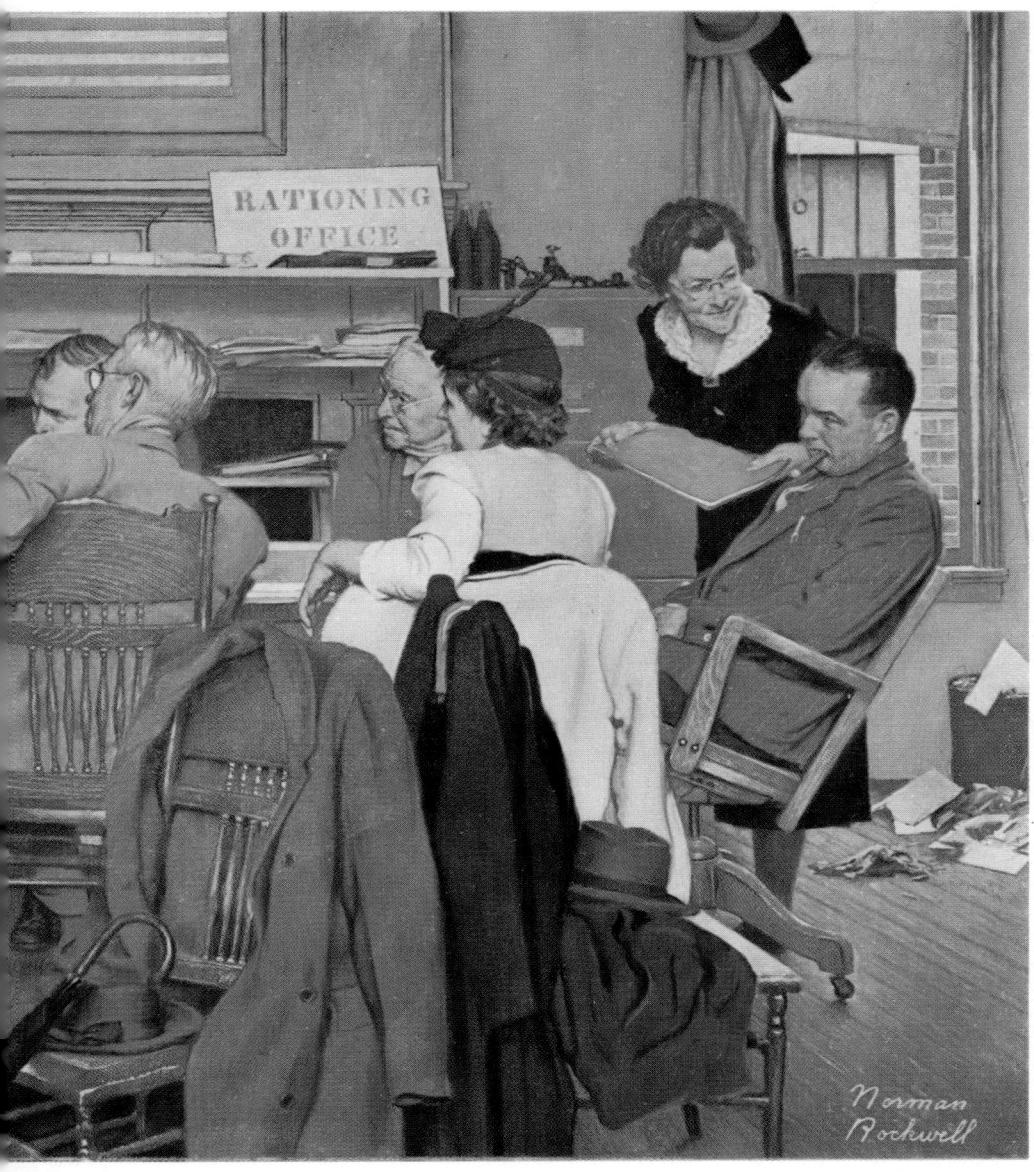

ORIGINAL 24" X 14"

resist working myself into the painting—there I am at the extreme left. In addition to this painting, I did many small figures—a parade of them which accompanied the painting as reproduced in the Post. The longer I observed such boards in action the more I felt like saying, "Hats off!" to such workers the country over. N.R.

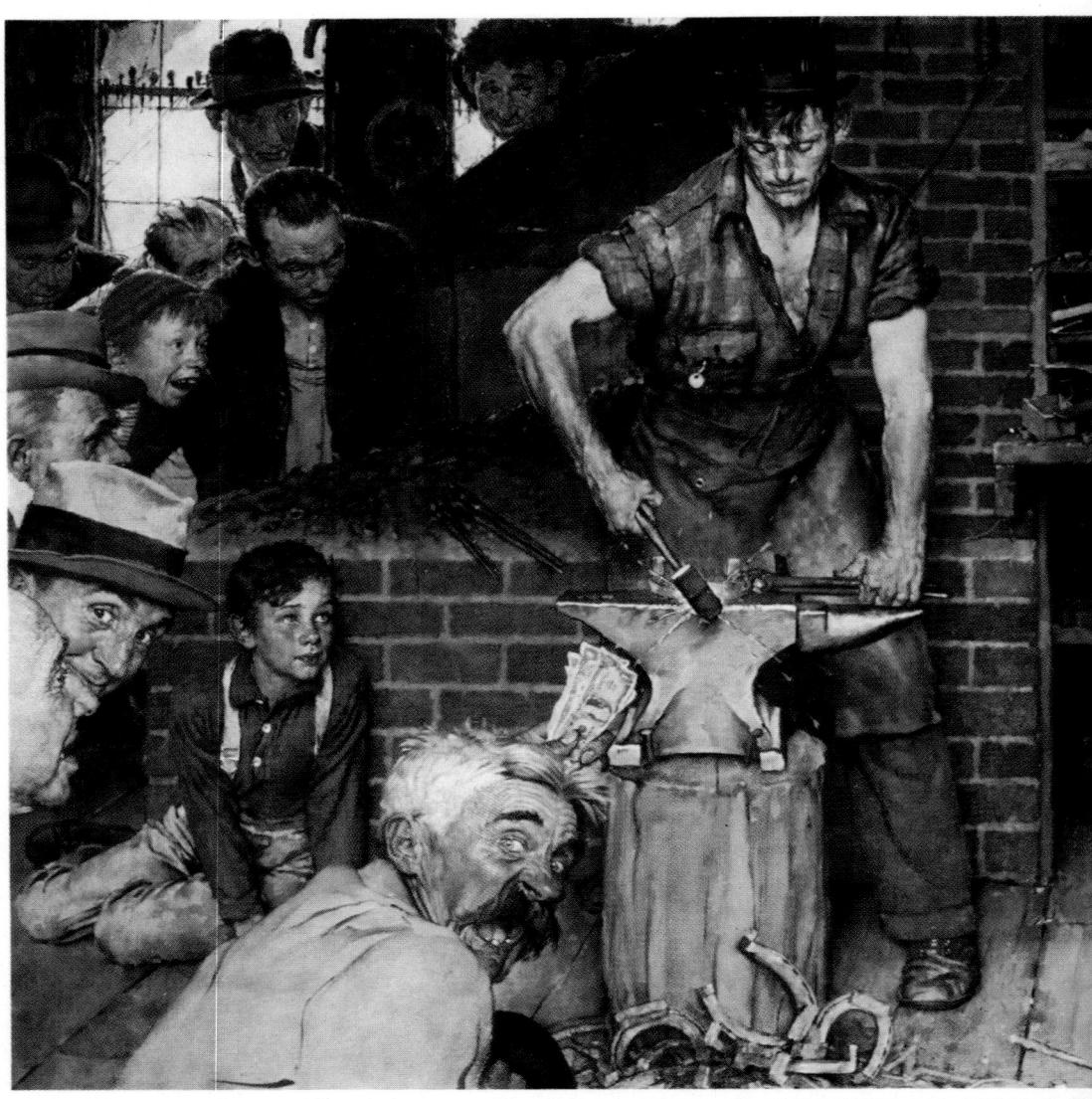

ILLUSTRATION IN OIL FOR "BLACKSMITH'S BOY-HEEL AND TOE," BY EDWARD W. O'BRIEN, THE SATURDAY EVENING POST, NOVEMBER 2, 194

Here is my model, Harvey McKee, waving dollar bills. I used him again at the right (in profile smoking a cigarette), amputating his mustache and giving him blond hair. The sport with the gray derby, cigar and cane was modelled by my Arlington friend, Nip Noyes. I did things to his nose and gave him Harvey McKee's mustache... When I do a picture with a lot of people, I often run out of models, or perhaps there is some space I wish to fill; then the

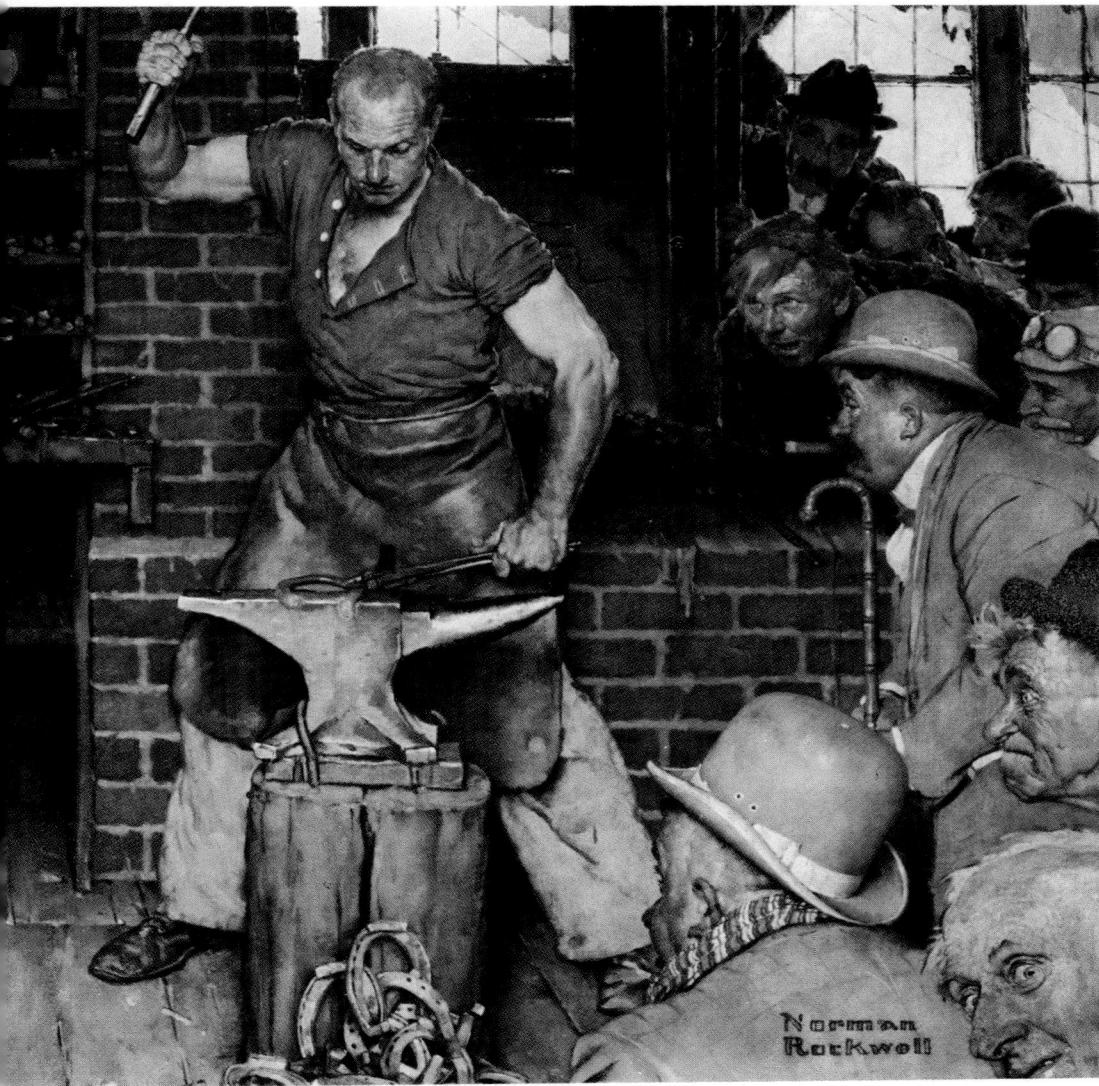

ESY OF THE POST

ORIGINAL 72" x 35"

easiest and cheapest thing to do is to pose myself, so there I am over on the left, wearing a dark-banded hat and looking straight at you . . . The blacksmith shop used for this setting is Moon's in South Shaftsbury, Vermont, not many miles from my studio. It really has this double forge and anvil, an ideal arrangement for my purpose. The sign outside bears the legend, "Practical and Artistic Horse-shoeing." On page 96 is a drawing of this exterior. N. R.

FULL-SIZE DETAIL CROPPED FROM COLOR STUDY IN OIL

This is a section, at the exact size painted, of my color study for the painting reproduced in part on the facing page. I was obviously concerned only with the general effect, so made no effort at refinement. N. R.

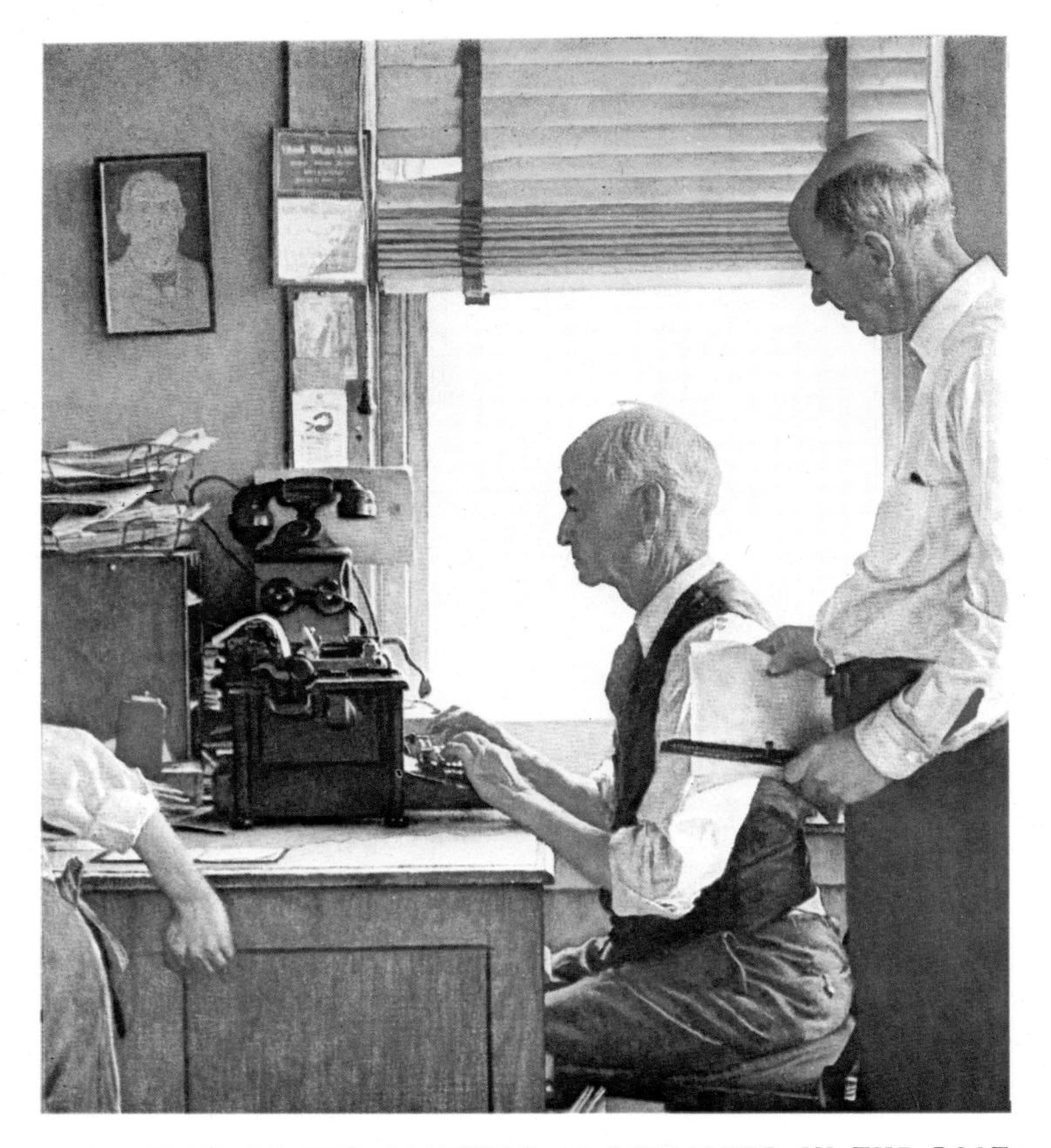

A SECTION OF THE PAINTING AS PUBLISHED IN THE POST

A small portion only of the double-page spread as it ran in the Post, but enough to reveal the degree of finish which I normally like to achieve and which satisfies the reader's desire for stark reality. N.R.

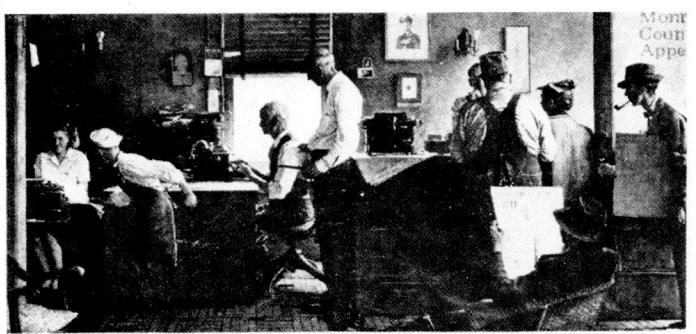

"NORMAN ROCKWELL VISITS A COUNTRY EDITOR," SATURDAY EVENING POST, MAY 25. 1946

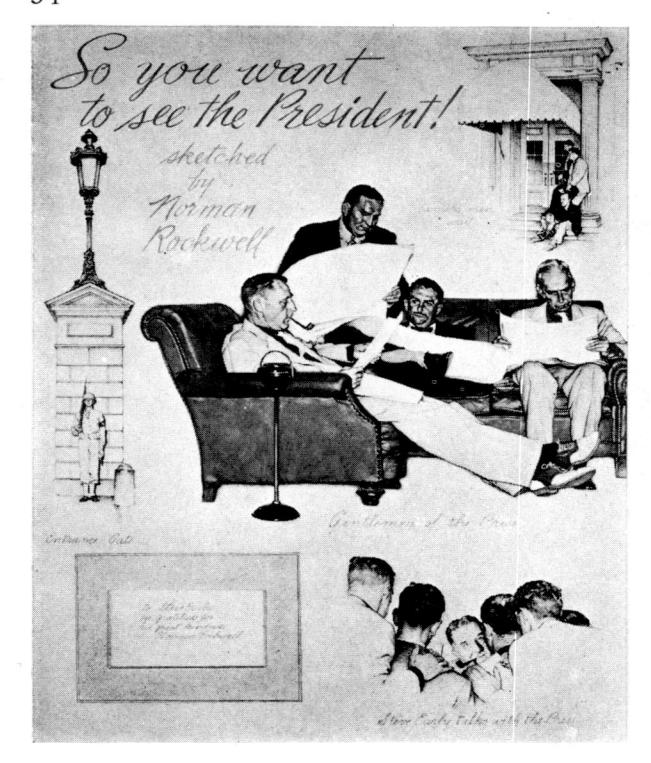

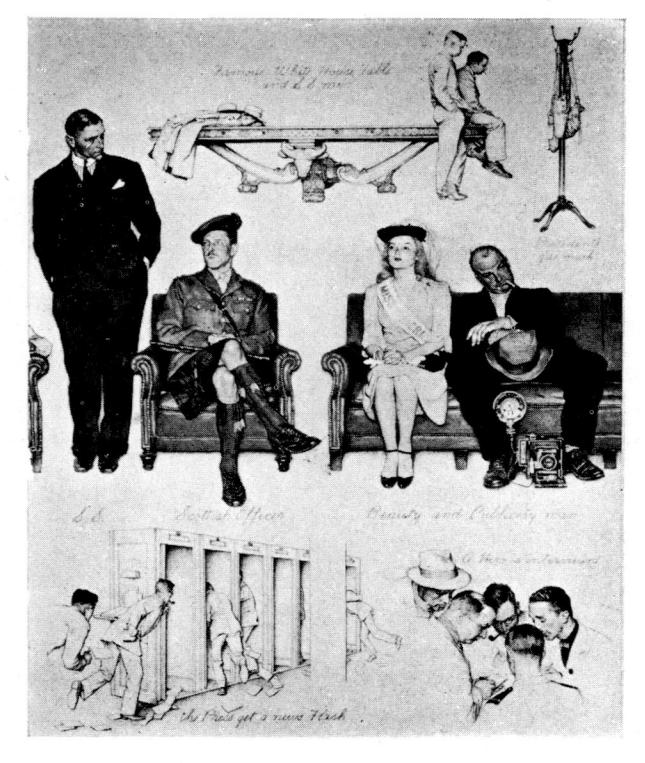

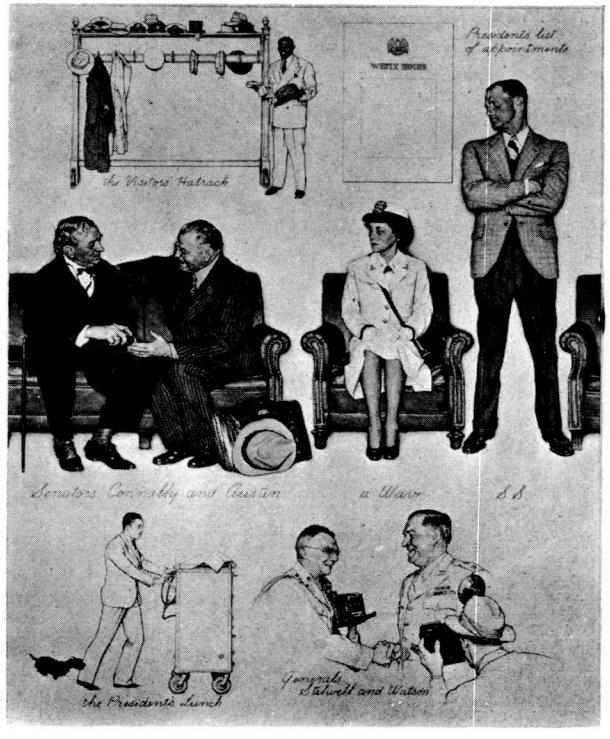

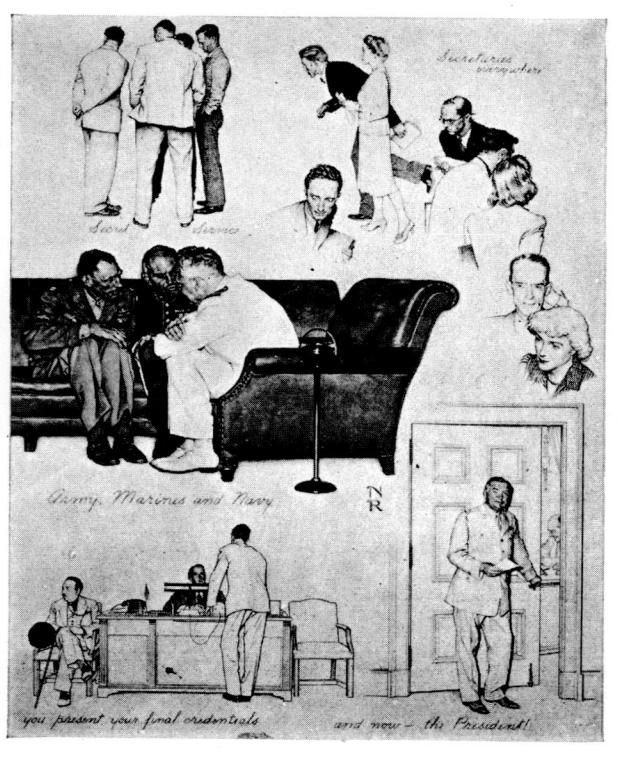

COURTESY OF THE SATURDAY EVENING POST AND STEPHES EARLY

A FOUR-PAGE FEATURE FROM THE SATURDAY EVENING POST, 1943

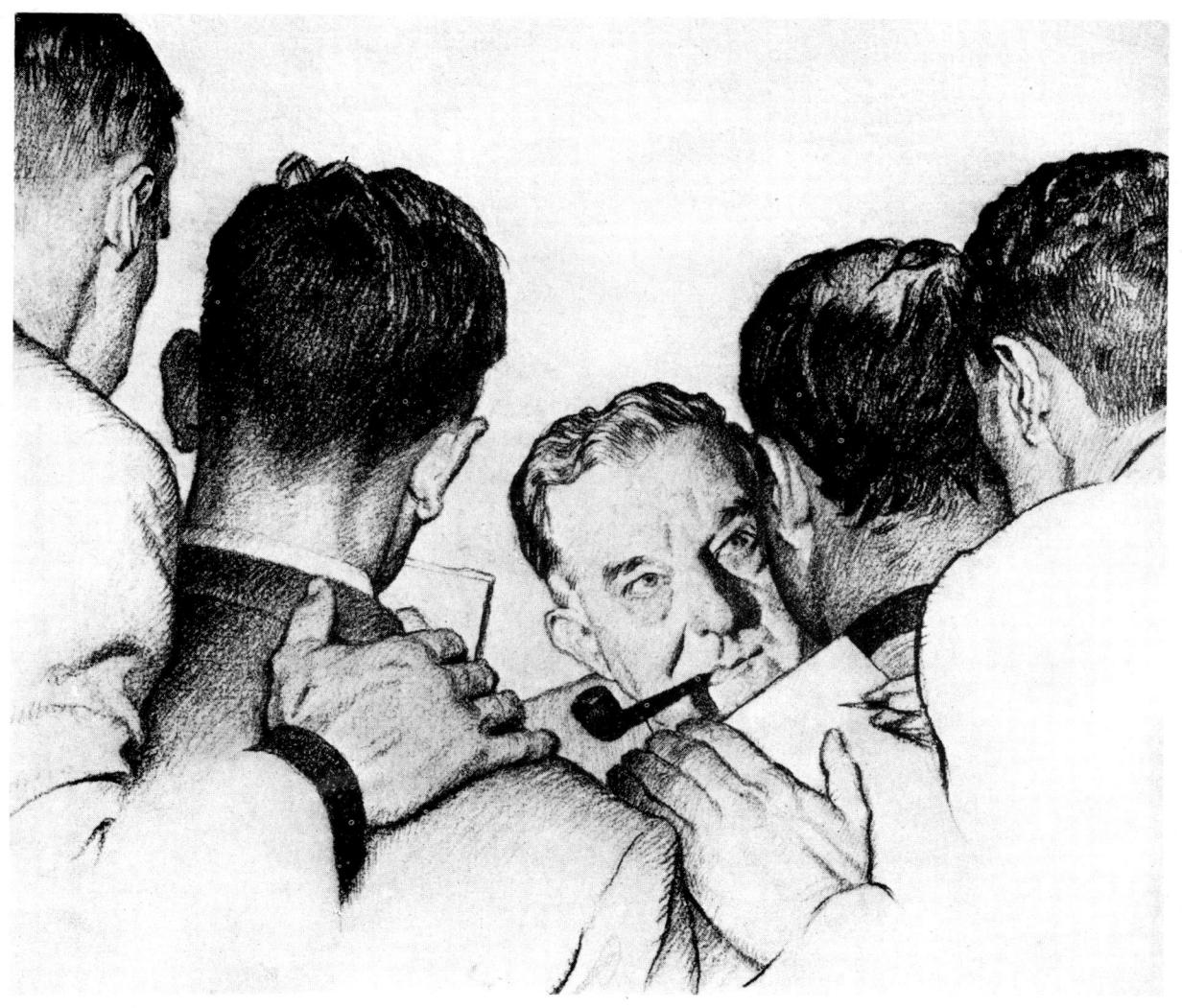

COURTESY OF THE SATURDAY EVENING POST AND STEPHEN EARLY

FULL-SIZE DETAIL IN CRAYON OF PORTION OF SUBJECT OPPOSITE

The Post sent me to the White House, where I wandered about for several days in order to make this visual report on the process of getting in to see the President. Everything is authentic but the Secret Service men; they cannot be portrayed realistically. I made all of these illustrations twice, the first set being destroyed in my fire. These small engravings give only a hint at the much larger originals. Steve Early, Secretary to President Roosevelt at the time of my visit, was kind enough to lend my originals for this book. Above, he is shown releasing some news to assembled reporters. N.R.

soon tug at our hearts whether they be gay or sober in theme.

This compulsion of Rockwell's to tell his own stories in his own way has given us some of his most significant work, such as the Four Freedoms—perhaps his greatest—and that continuing series of graphic Americana which includes his portrayals of the Ration Board, the Country Editor, A Night on a Troop Train and So You Want to See the President! These are all historically important documents and, however they will be regarded by posterity as works of art, there is little doubt that they will become a permanent and valued record of the pageant of present-day America. This, rather than the belief that he is a great painter, is the basis of Rockwell's confidence in the worth-whileness of his work.

The artist's encounters with all kinds of people have netted him many amusing stories. One, with which we must close this chapter, came out of his brush with his Vermont ration board, in preparing for one of the pictures just mentioned. "What I would like," he explained to them, "is the privilege of painting pictures of all you board members in session." The initial reaction, as expressed in their faces, must have been pretty much like that seen in the picture he finally produced. But the first moments of surprise and perhaps mistrust soon gave way to genial acceptance of the proposal but with the reservation from the chairman, "Make us look good now." Rockwell's response was instantaneous. "If I do," he bargained, "will you give me a B card?" Back came the rejoinder, "No, but if you don't, we'll take away your A card."

Below: Exterior view of the blacksmith shop selected as the setting for my painting reproduced in color on pages 90-91. This drawing was done in Wolff crayon on white illustration board. N.R.

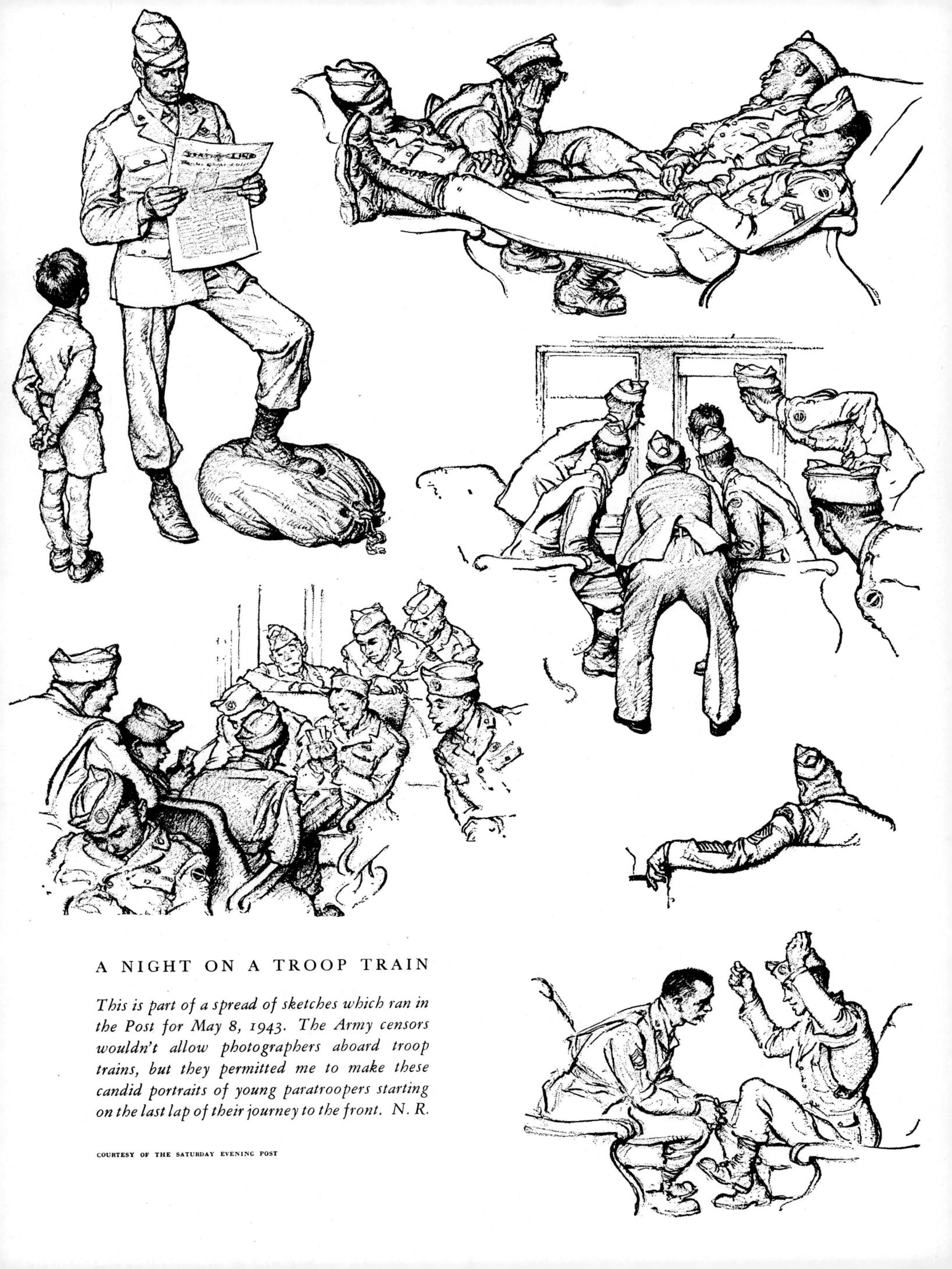

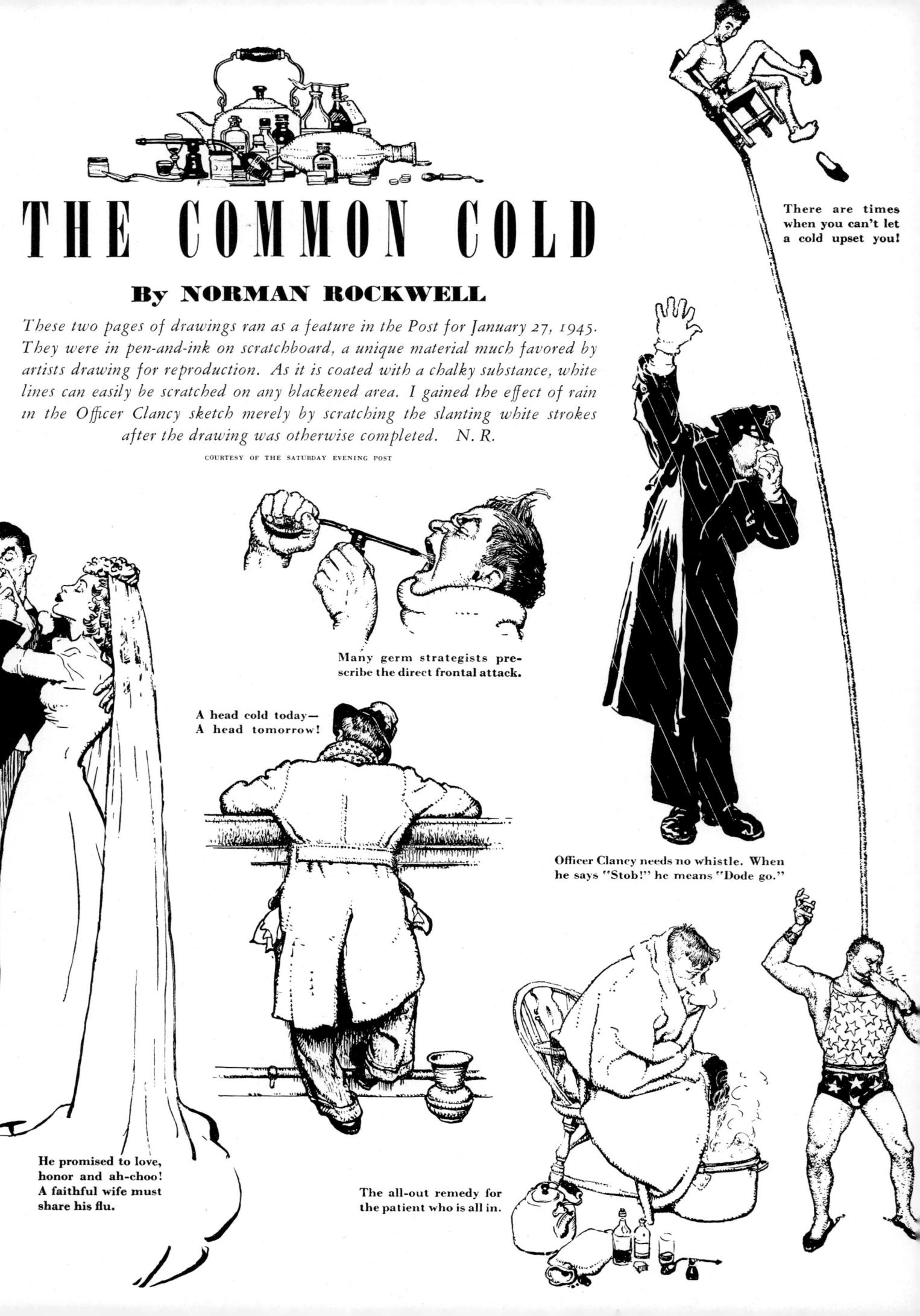

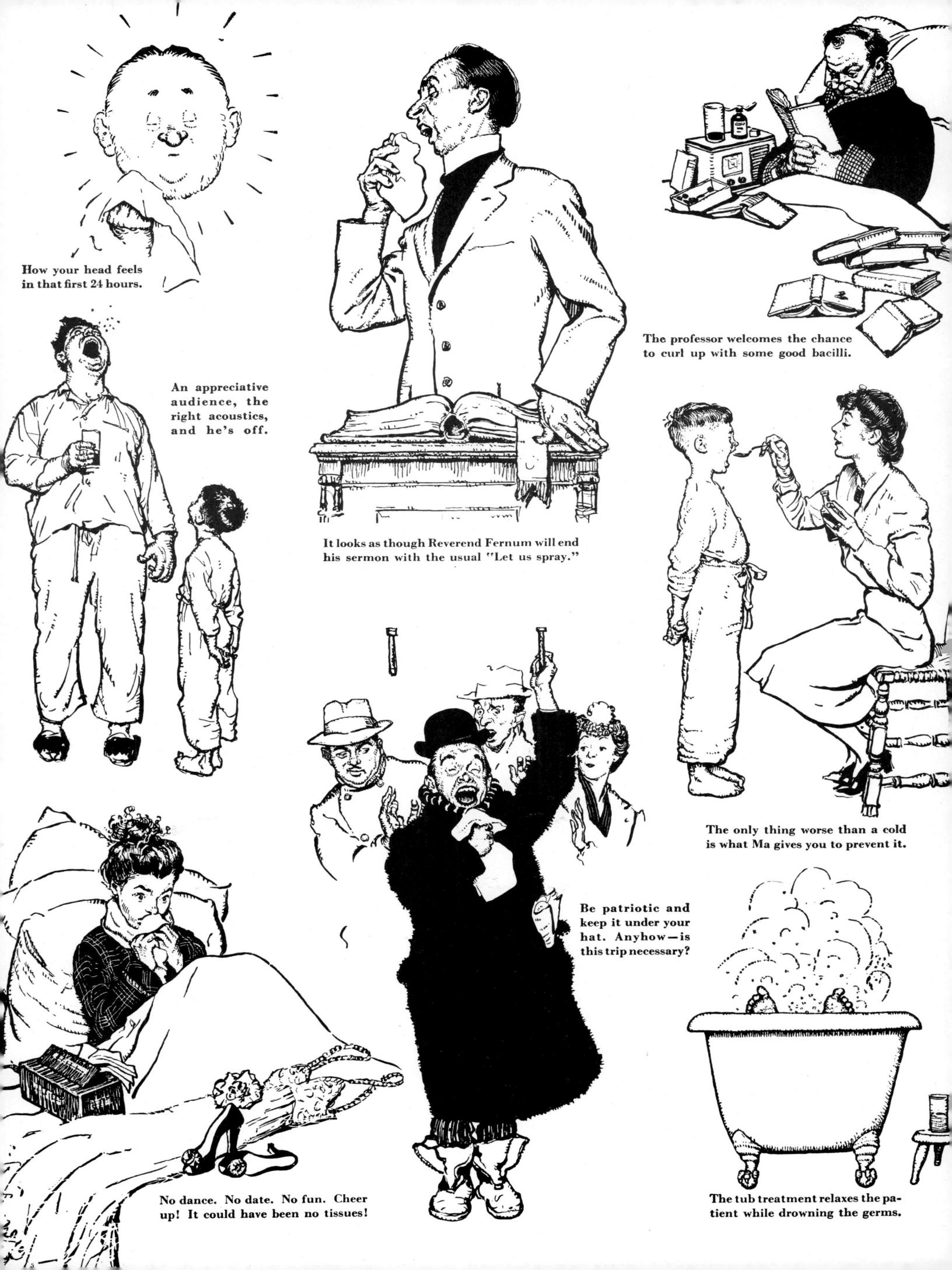

TOM SAWYER-FULL-SIZE DETAIL OF AN OIL STUDY

Every illustrator appreciates the opportunity afforded by a fine book written by a great author. A poorly written book is difficult to illustrate. The reason is obvious. The good author has thought on his subject exhaustively, and knows it so thoroughly that his book teems with picture possibilities. A poorly written story will always bring in elements which, if illustrated, will just ruin the pictorial quality. In "Tom Sawyer" and "Huckleberry Finn" there is a picture on every single page—there is nothing that Mark Twain has his characters do that isn't just perfect. I therefore greatly enjoyed illustrating these books for the Heritage Press. N. R.

V: Illustrating the Book

ROCKWELL's reputation as a book illustrator has been earned more by the quality than by the quantity of his product; he has illustrated relatively few books. These few, however, have proved immensely popular, so much so that publishers are constantly using every type of persuasion—including amazing chunks of monetary bait—to tempt him to do more.

But Norman has become casehardened to all such approaches. His work for the *Post*, interrupted nowadays only by his occasional excursions into the calendar field, occupies every moment. Not that he would mind doing more books if time permitted. "It's fun to do a really good book," he says, "but only the best titles give me any satisfaction. Mark Twain's *Tom Sawyer* and *Huckleberry Finn* are of the type I enjoy. These had long intrigued me, so when George Macy of the Heritage Press invited me several years ago to illustrate them, I was able to throw myself into the task with real enthusiasm."

Having undertaken this commission, Norman, with his customary thoroughness, did what no illustrator of these books had ever done before: he journeyed to Hannibal, Missouri, in order to see with his own eyes the scenes of Mark Twain's boyhood. For days he wandered about, absorbing the feeling of the place. He talked to inhabitants young and old, questioning, listening, thinking. Notebook and sketchbook in hand, he jotted down hundreds of impressions.

One night Norman visited the cave where Tom and Becky got lost.

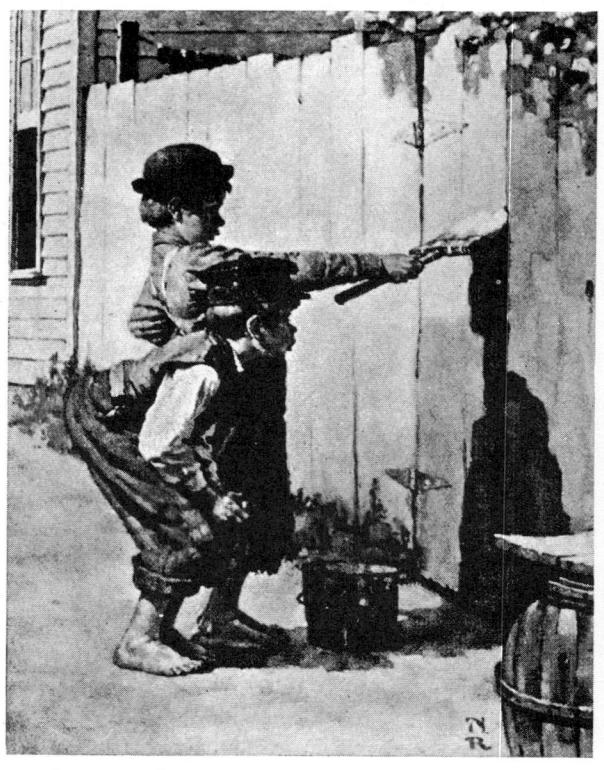

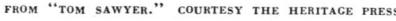

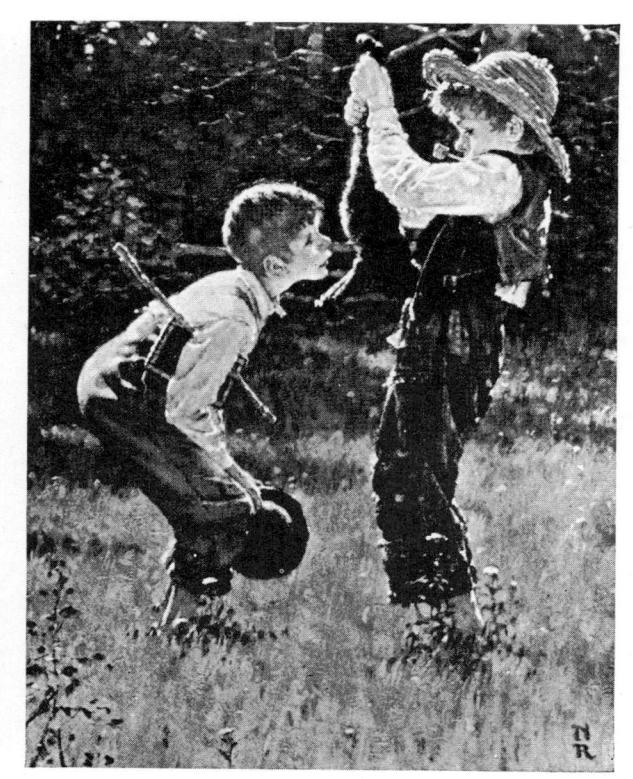

FROM "TOM SAWYER." COURTESY THE HERITAGE PRESS

TOM WHITEWASHING THE FENCE

TOM, HUCK AND THE DEAD CAT

I'm the only illustrator of the Tom Sawyer-Huckleberry Finn stories who ever went to Hannibal, Missouri, to see the place. I wondered before I went there if I could absorb the feeling that Mark Twain had put into his writing. I certainly tried! The whole town of Hannibal lives in the memories of Tom and Huck—or, rather, of Mark Twain. He depicted things just as they actually were. The widow who lived on the hill lived on the hill. If the author says it is twenty paces across the street to Becky Thatcher's, it is twenty paces. He tells about sliding down the water pipe, crawling along to the woodshed, and dropping off to the ground. I actually did it myself. When he talks about rolling the rock down the hill, you may be sure he rolled the rock down the hill. In other words, the Tom Sawyer story is truly autobiographical in the sense that even if Mark Twain didn't personally do some of the things attributed to Tom, he understood exactly how Tom would have done them. That made my task as illustrator an exceptionally interesting one. N. R.

It seems that a couple of murders had just been committed in St. Louis, and the murderers had been known to come toward Hannibal. of Norman's newly acquired friends had volunteered to act that night as guide to the cave, but at the last minute his wife decided that with murderers approaching she was afraid to be left alone. Therefore Norman was led to the cave as agreed, but his guide immediately returned home. Norman entered the spooky place alone and had scarcely started to explore it when his acetylene light flickered out, leaving him in Stygian darkness. Only then did he begin to worry about those two murderers. Had they come to Hannibal? Were they by any chance in the cave? What would they do if they found him? And so he sat there in the dark still as a mouse, apprehensive, startled by every slight sound. One hour passed, two, two and a half. Suddenly a wavering light appeared in the distance, then drew nearer, eerily illuminating the grotesque forms of that strange interior. Could it be the murderers approaching? His heart quickened. But his fears soon proved to be unfounded-it was only his guide come to conduct him back to the village.

After some days, his study material assembled, Norman left Hannibal for home where he took keen enjoyment in completing his task. For each of the books, *Tom Sawyer* and *Huckleberry Finn*, he made a chapter heading, eight paintings in full color and a drawing for the binding. Here we reproduce a number of these paintings, along with a pair of his preliminary studies. The latter are particularly revealing to those who like to know how it's all done. The first of these (page 100) is a full-size detail, in color, portraying the pipe-smoking episode from *Tom Sawyer*. The other, of the switching scene from *Huckleberry Finn*, appears on page 104, opposite the final painting. These studies, by the way, were executed on sheets of illustration board which had previously been coated with shellac. Not all of the surface was covered with paint; the brushwork is free and sketchy.

One of Rockwell's regular models, Fred Hildebrandt, posed for the schoolmaster. And what a difficult pose! It was due to the artist's trouble in finding models capable of holding such action poses that he

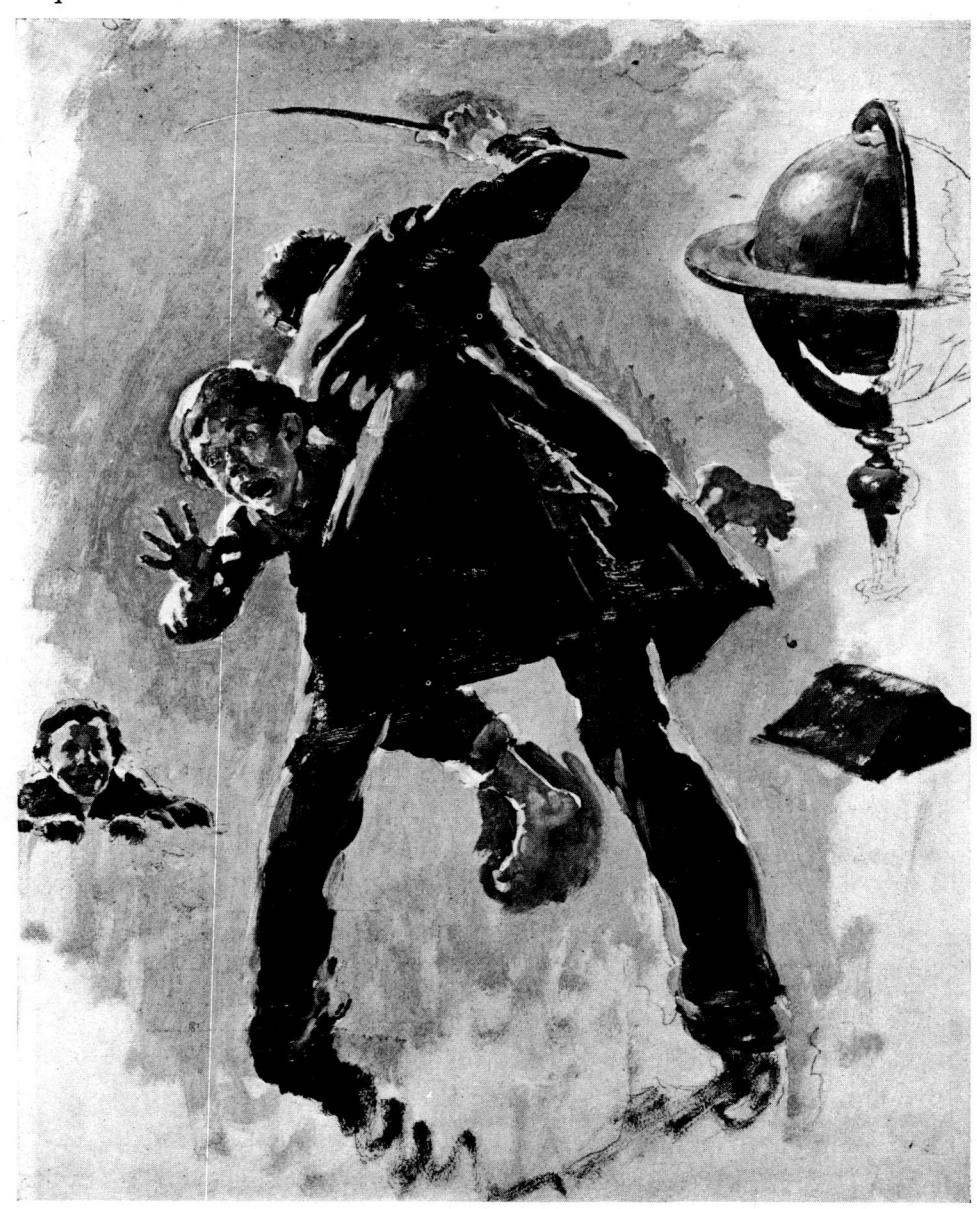

OIL PRELIMINARY STUDY FOR PAINTING OPPOSITE

I always make numerous sketches and studies in preparation for each painting. This one, done in color on illustration board, served as my guide for the painting reproduced on the facing page. If illustration board is first coated with shellac or lacquer, it takes oil paint very well. N.R.

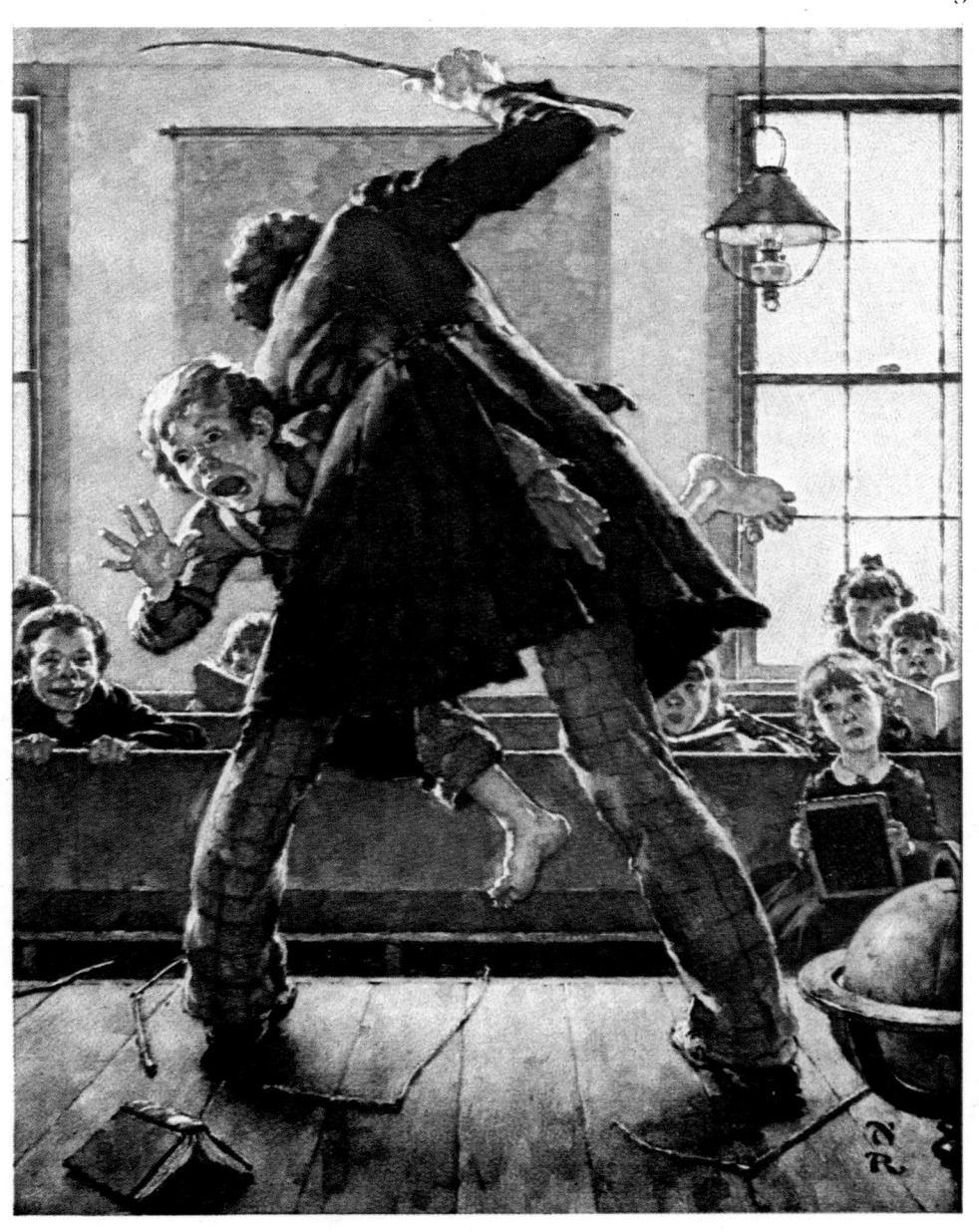

TOM SAWYER SWITCHED FOR TALKING TO HUCK FINN

These aren't easy poses for the artist's models to hold! It was such poses that made me first turn to the camera as a logical aid . . . Fred Hildebrandt was my model for the schoolmaster . . . It was fun picturing the girls so apprehensive and the boys so full of glee. N.R.

first looked with favor on the camera as a possible aid. It is interesting to compare the pose of this switching episode with the somewhat similar one—though the latter pictures a rear view—used for the Interwoven Socks advertisement on page 128.

Back in Norman's New Rochelle days, before he used photographs at all, he relied largely on less than a dozen models. One of these, old Dave Campion, posed for many of his pictures. In a certain instance he was supposed to be fishing. "Just imagine, Dave, that you really are sitting there on the bank fishing," Rockwell said. Ten minutes passed; Norman lost himself in his work. Suddenly Dave jumped up, jerking his arms violently, his face grim. Norman, startled, calmed him down and asked for an explanation. "Didn't you see?" Campion replied. "I hooked a big one and almost landed him—but he got away."

James K. Van Brunt, an elderly man well marked by time, was another favorite model. Norman selected him to pose for the *Post* cover depicting a Colonial sign painter (reproduced in color on page 164), telling him a couple of weeks ahead all about the coming assignment. Van Brunt, standing in front of a mirror in his own room, figured out poses which he thought suitable. When it came to the actual painting, it proved almost impossible to persuade him to relinquish these.

Van Brunt was a great character. He had fought the Indians, and was a veteran of the Civil and Spanish-American Wars. And mighty proud of it. He wore spats, a frock coat, a fawn-colored waistcoat, and sometimes affected a high silk hat. But his pièce de résistance was his remarkable eight-inch mustache, which Norman painted so many times that editors finally threw up their hands in protest. Van Brunt was a small man—he weighed but ninety-eight pounds; his wife weighed over two hundred. She threatened to put him in a little bottle! He was also a short man—of the exact height of Napoleon—but extremely vigorous for his eighty-odd years. Rumor persists that on one hot Decoration Day, as he proudly paraded down the street with head held high, his feet plunked so hard on the asphalt that his tracks can

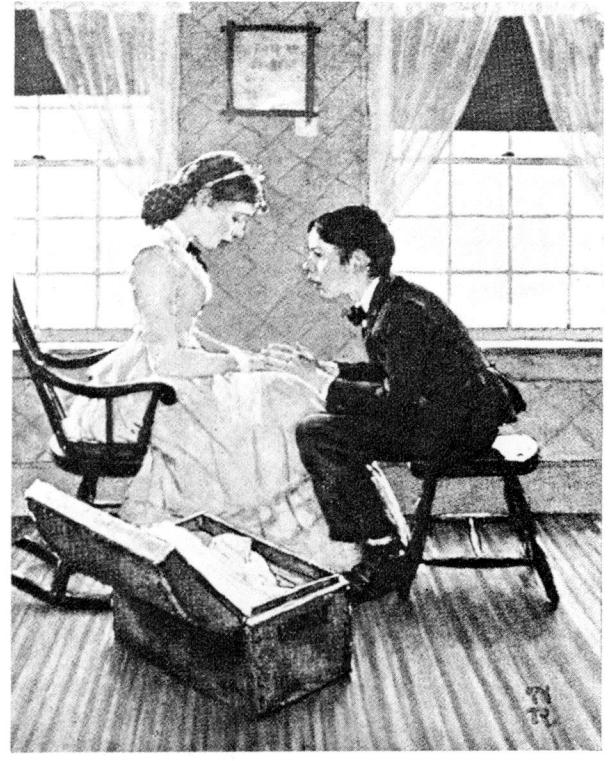

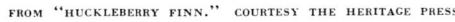

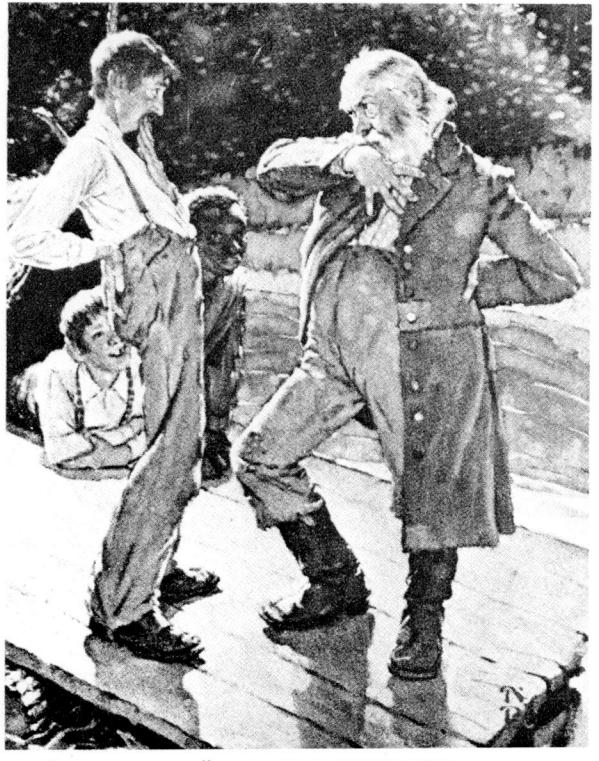

FROM "HUCKLEBERRY FINN." COURTESY THE HERITAGE PRESS

MARY JANE AND HUCKLEBERRY

HUCK, AND LOOY THE DAUPHIN

While at Hannibal, preparing to illustrate "Tom Sawyer" and "Huckleberry Finn," I talked with several people who were boys when Clemens was a boy. It seems he was not a rough-and-tumble kid at all. An old judge whom I met had known him well; he told me that Sam Clemens was really a sickly, sensitive boy, so what he put into his stories were the things that he would have done had he been stronger—things that he no doubt dreamed of doing. If he had actually done these things, possibly he would have been such an extrovert that he could not have written about them . . . I have a feeling also that if Mark Twain had not been brought up in Hannibal, these stories could not have happened; the place has everything! It's on the Mississippi; it's got the cave, the bluffs, the island, just as they were described in the book; it possesses all the romance of an old-time river town. And you can get in a dugout or on a raft and go down the Mississippi as Huck did . . . When you are at Hannibal, wandering about, you soon have the feeling that you are living right in these stories; that shows how well they were written. N. R.

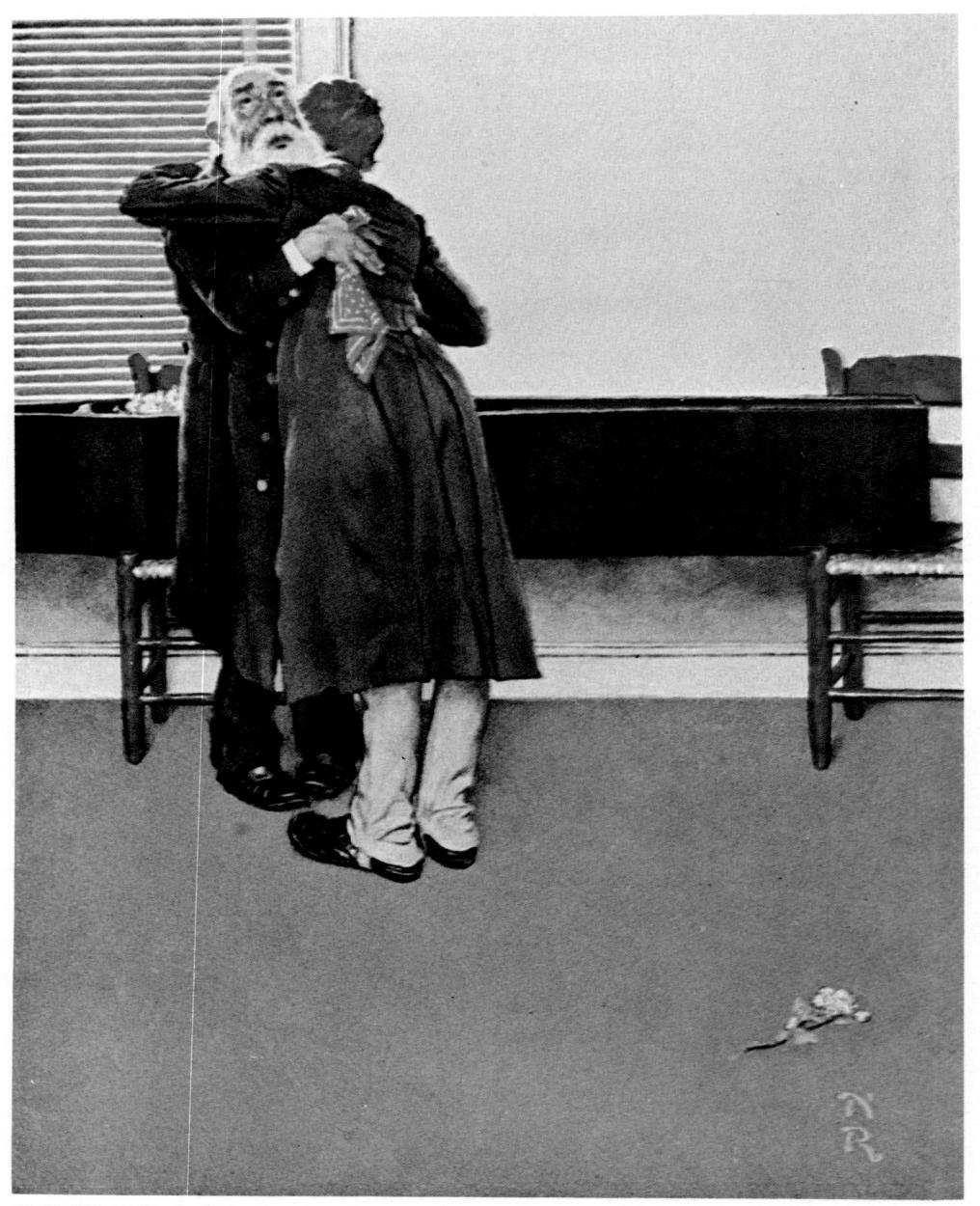

ILLUSTRATION IN OIL FOR "HUCKLEBERRY FINN," BY MARK TWAIN. COURTESY THE H

COURTESY THE HERITAGE PRESS, GEORGE MACY, DIRECTOR

"I NEVER SEE TWO MEN LEAK THE WAY THEY DONE!"

It was great fun analyzing the characters in "Huckleberry Finn" and then trying to portray them as faithfully as possible. The longer I worked at the task, the more in love with the different personalities I became. N. R.

still be seen!

Norman's boy models were many and varied. Eddie Carson and Billy Paine were long on his preferred list. He also used the Bartnett boys, Tom, Dick and Harry. All of these appeared in dozens of paintings. Paine was a lively youngster, much given to joking. One day while posing he amazed Rockwell by suddenly screaming, "Help! help!" at the top of his lungs. As if by magic a policeman flung open the door. Billy had seen him passing and decided to stir things up.

These are but a few of dozens of models who have sat for Rockwell—whose faces have become familiar to us through the pages of books and magazines. Rockwell says, "It would be a great party if my models past and present could be brought together in costume under one roof. There would be little devils from baseball lots and swimming holes, and they would bring along their funny pups. There would be young folks and old folks, thin folks and fat folks, city folks and country folks. The company would include nosey constables, tired druggists, pompous judges, the overworked postman, the friendly corner cop. What a mixed group it would be! But I think we would all understand each other and have a good time."

Rounding up the costumes for these Mark Twain books was part of the fun of this assignment. At that time I lived in New Rochelle where people don't wear old clothes, so in Hannibal I bought my needed costumes right off people's backs. I would lay in wait on Main Street; if a fellow came along in old pants that had character, I would accost him and ask if he wanted to sell them. "I'll give you five dollars for those old pants," I would say. "They ain't worth five dollars," he would reply. I would convince him that I wanted to buy them, and then we'd go over to the car, pull down the curtains, and he'd take them off. The same with hats, shirts, and so forth. In the meantime, I'd have to go into a shop and buy new things to take their places. Gradually by purchase and barter I gathered the toil-worn costumes I needed. N.R.

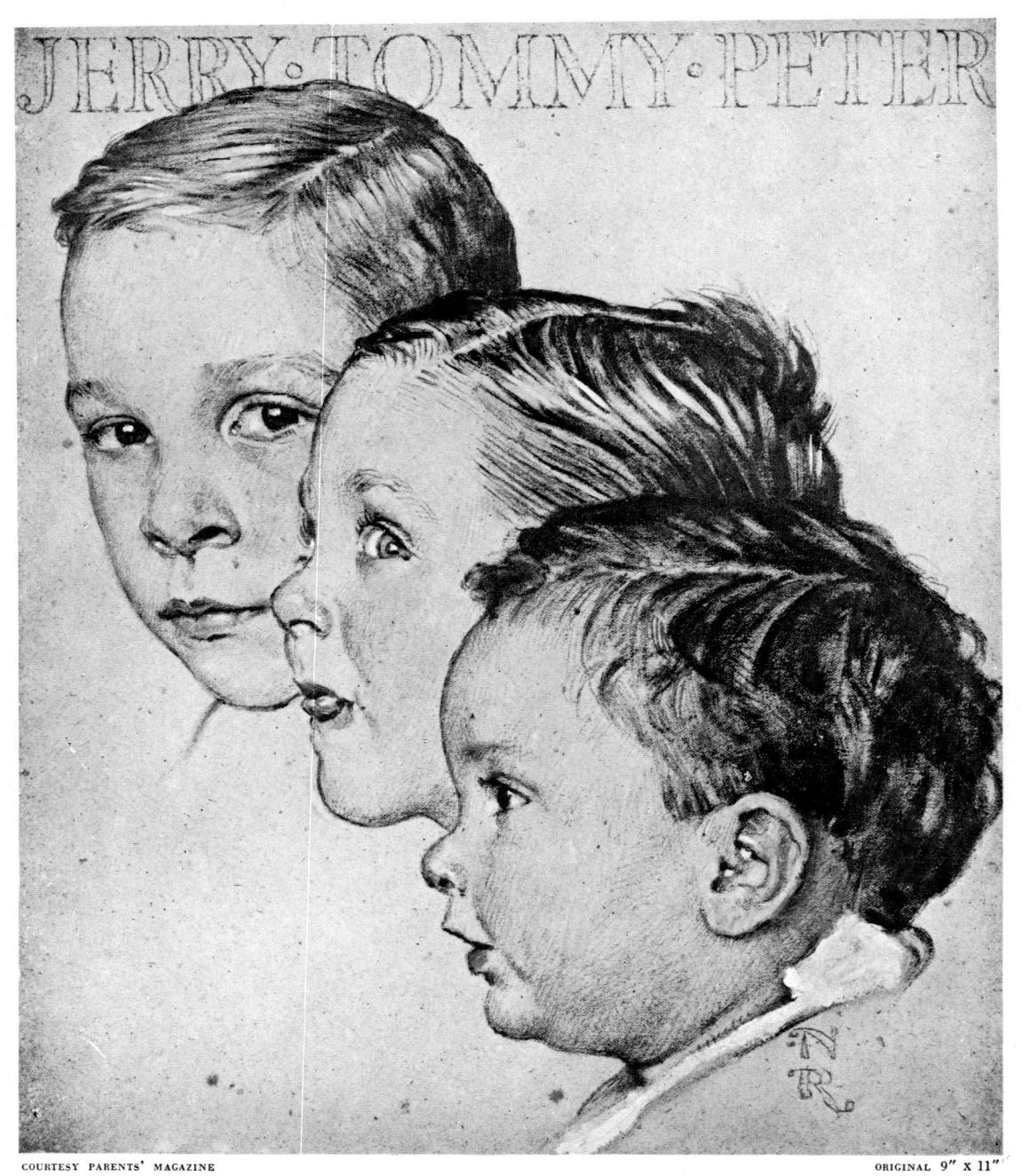

PORTRAITS IN RED CRAYON OF THE ROCKWELL CHILDREN

These were drawn in sanguine chalk on rough craft paper, warm in tone. Then a few touches of white were added; the lettering was black. N.R.

VI: Murals, Portraits and Such

NORMAN ROCKWELL has devoted little time to mural and portrait painting, yet he has produced enough work to make us want to see more. As to murals, he has executed but one, the *Yankee Doodle* picture on pages 114 and 115, now over the bar in The Yankee Doodle Tap Room of The Nassau Tavern at Princeton, New Jersey. Some of his other paintings, not originally designed as murals, have been successfully adapted for that purpose.

The making of an acceptable mural is an achievement for an illustrator, as it is not easy for one accustomed to working at relatively small size, for reproduction on the printed page, to adjust himself to the problem of filling large wall spaces with decorations which will take their places as integral parts of the walls which bear them, and which will at the same time possess qualities worthy of permanent display.

In short, the printed page and the interior walls of buildings call for entirely different approaches. Highly dramatic effects are entirely suitable for the former—are quite essential, indeed, as eye-catching devices in the highly competitive field of periodical publishing. Such dramatic productions, if magnified to a thousand times their area to fill large spaces, would fairly jump off the walls and overwhelm the spectator. Wall paintings must therefore be handled with restraint. Violent action, strong contrasts of tone or color, obtrusive forms and acute perspective are, as a rule, avoided by the muralist.

Rockwell, in painting Yankee Doodle, dodged most of these pitfalls,

III

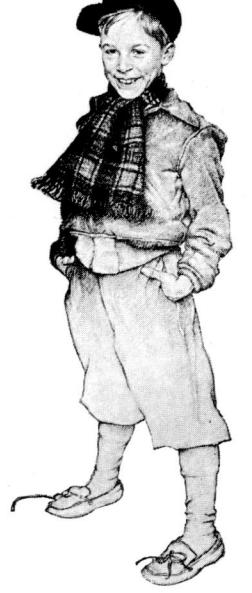

M

"FROM THE POSTHUMOUS PAPERS OF THE PICKWICK CLUB," THE SATURDAY EVENING POST, DECEMBER 28, 1935 COURTESY OF THE POST AND SOCIETY OF ILLUSTRATORS. COLOR PHOTO COLD.

OVER-BAR PAINTING, SOCIETY OF ILLUSTRATORS, N. Y.

This was painted for The Saturday Evening Post in California during a very hot August. The heat in the studio was terrific. Perhaps you can see that the faces are shiny; that is perspiration. I especially remember the stagecoach driver wrapped in those heavy clothes, with sweat running down his face and off his nose... The wonderful part of working near Hollywood is that you can find everything. A place outside the city has every type of historic vehicle, including perfect English coaches... This painting now hangs in the clubhouse of the Society of Illustrators, New York. The bartender, Ped Croslin, is well known to illustrators, who are so fond of him that when he went to war they gave him a dinner. He is not as dour as he looks above. N.R.

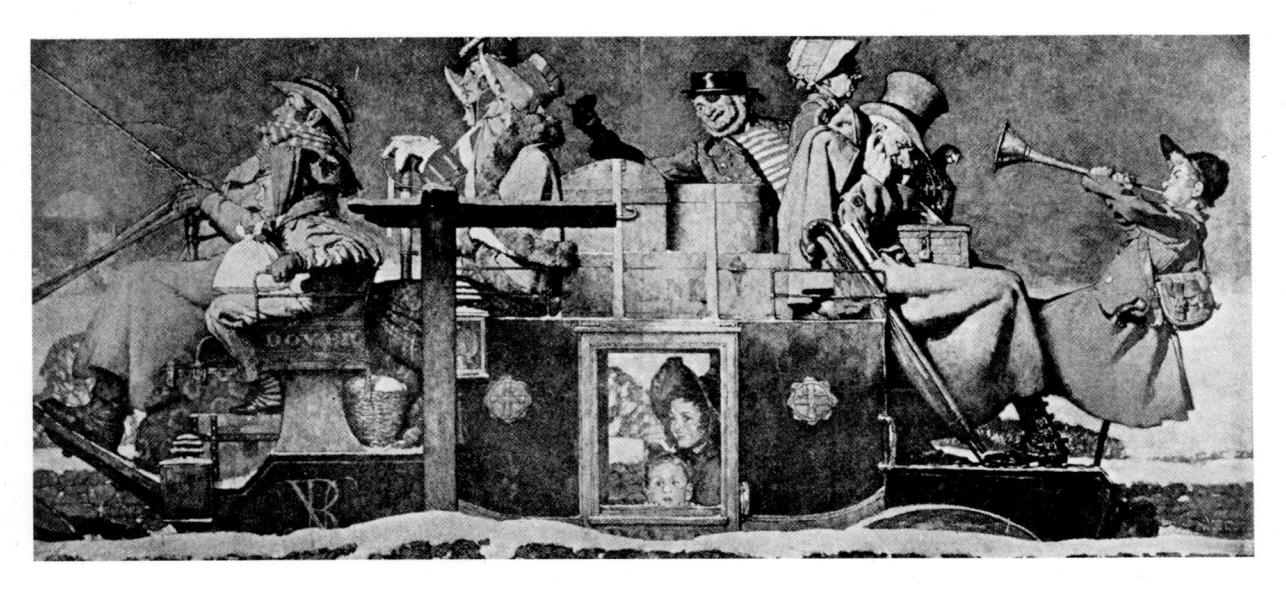

HERE IN BLACK AND WHITE IS THE OVER-BAR PAINTING OPPOSITE

though his result is deliberately illustrative in the same sort of storytelling manner in which he has always liked to paint. However, in telling his story he has displayed rather more of action than most muralists would attempt. He certainly was courageous in parading the ponyriding Yankee Doodle, with his accompanying boys, dogs and goose, directly across the foreground of the canvas, for, as we have just inferred, it is almost a first principle of mural design not to set up strenuous motion of this sort. But the artist skillfully counteracted this strong right-to-left movement. First, he reduced its speed by a number of expedients: by cutting the hitching post and decorative ribbon across the feet and legs of boy, dog and goose; by almost obscuring the legs of the cantering pony; by "braking" the pony by means of the barefoot boy in a braced position, holding its tail; by turning one dog's head back, and by facing a figure or two toward the right. Then he enveloped the lower half of the painting in a mist of shadowy tones that tend to force the spectator's eye to the more distinct and significant areas above. By such means, as well as through his distribution of human interest among the various groups of figures—not to mention a scattered

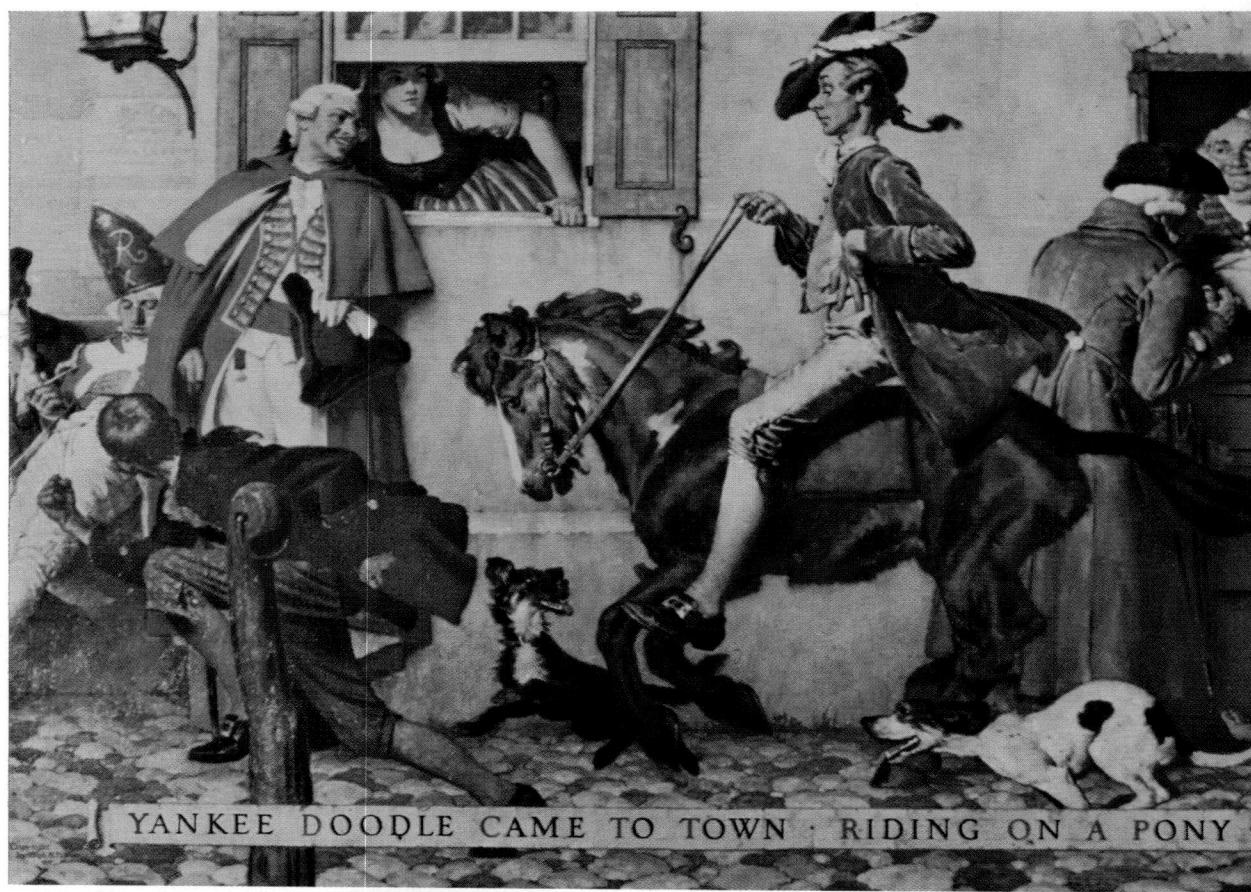

COURTESY NASSAU TAVERN.

PRINCETON MUNICIPAL IMPROVEMENT, INC

MURAL PAINTING AT NASSAU TAVERN, PRINCETON, N. J.

This is the only mural, strictly speaking, that I have ever done. Out of a clear sky, the architect of the Princeton buildings, Thomas Stapleton, asked if I would do a mural for Nassau Tavern—he had seen my Tavern Sign painting in the Post. I said yes, so we went into a huddle and decided that as Princeton was much fought over and around during the Revolution, it would be fitting to do Yankee Doodle. I looked up the costumes of the Hessians and British who fought around Princeton, and had authentic costumes made especially for the picture. I selected Hildebrandt to model Yankee Doodle. The painting, about 13 feet long, was done in my studio. I had it there for nine months. When I was not working on it, because of pressure of other matters, it hung suspended over my head like the sword of Damocles. N.R.

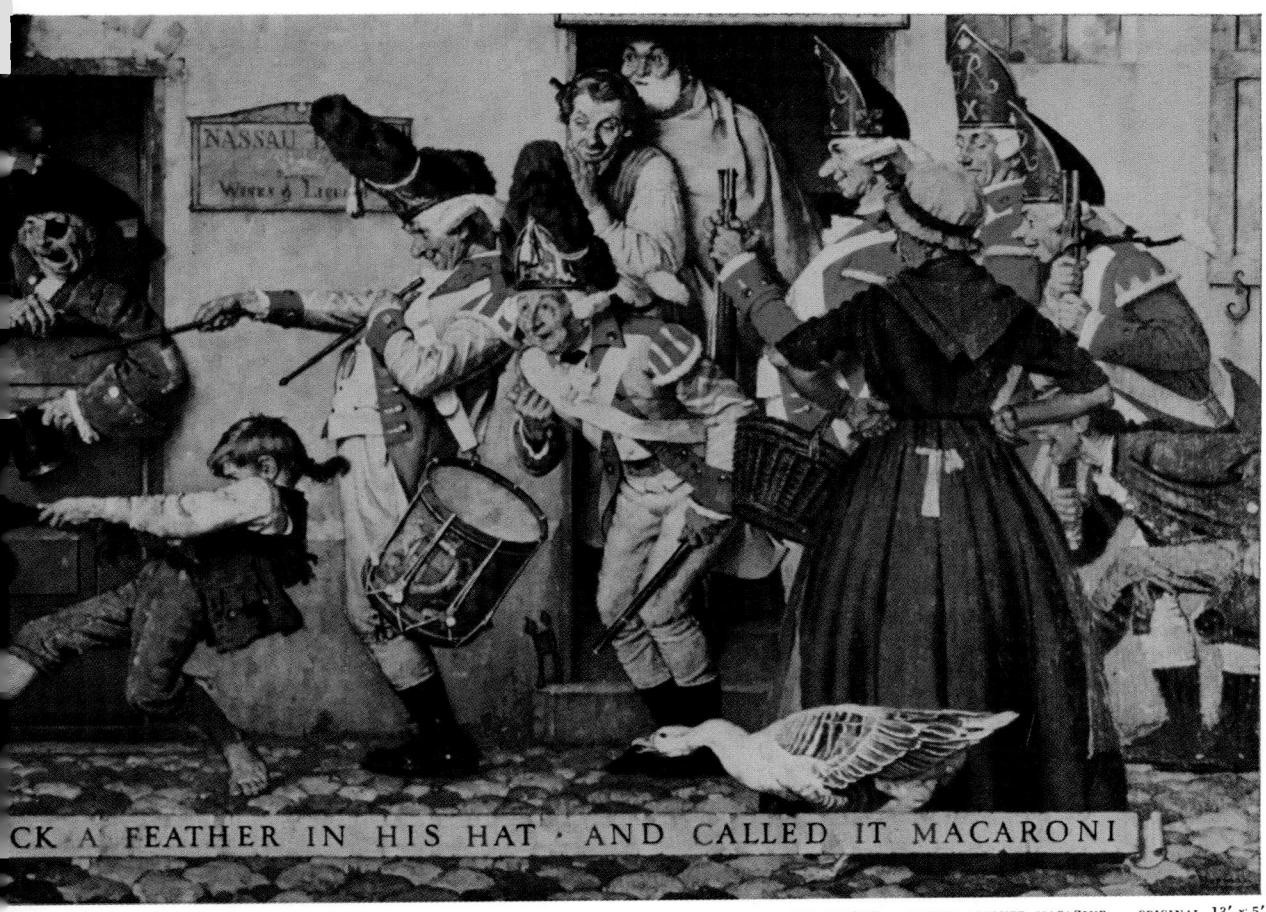

KODACHROME COURTESY CORONET MAGAZINE ORIGINAL 13' x 5

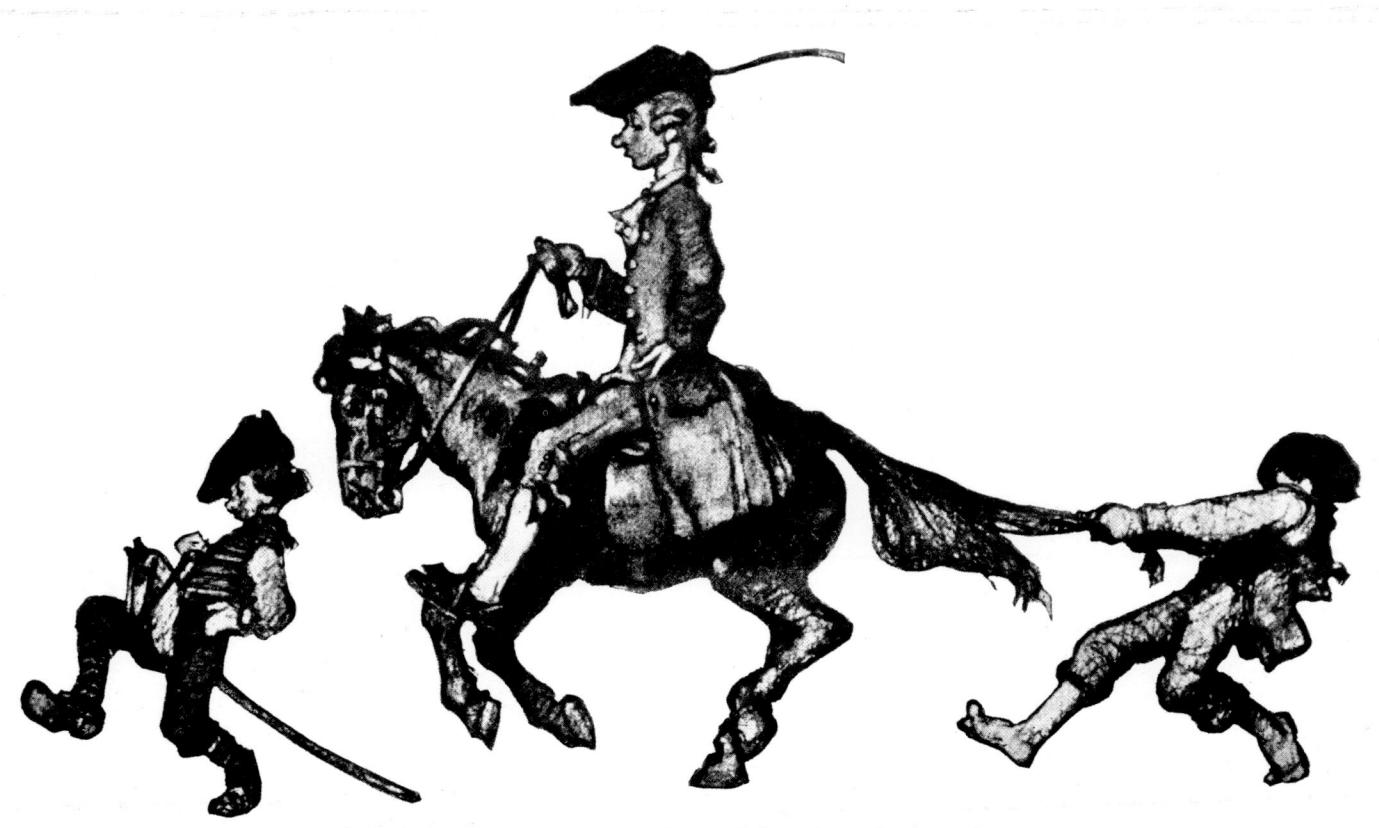

One of many studies in charcoal for the painting above.

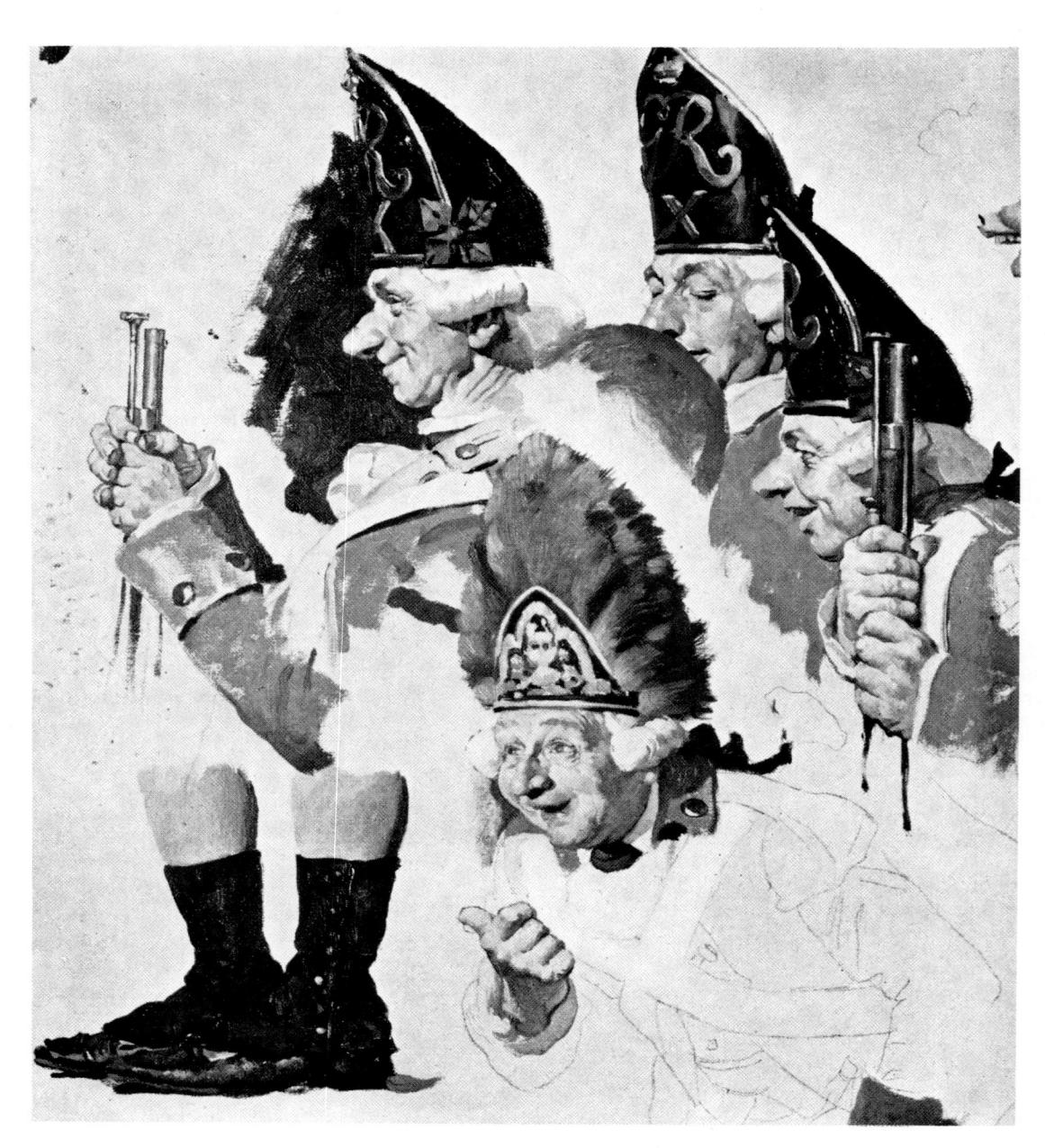

OIL STUDIES FOR YANKEE DOODLE MURAL, NASSAU TAVERN

This shows a portion of one of my experimental canvases—the original was in color. In these, I solve many problems, so there is just that much less to worry about when it comes to the final. But there's always enough! N. R.

spotting of color and tone—the artist has created an allover decoration which satisfactorily weds liveliness and restraint.

He has nicely related this painting to the wall which supports it, by means of several compositional practices. Foremost among these, he portrayed the painting's background of tavern wall, with its doors and windows, in straight front view; this gives us harmonizing verticals and horizontals. All the action takes place at or near this wall, so that we face it directly. We have already mentioned the horizontal ribbon at the bottom; this is another stabilizing influence, tying the whole together and giving it a firm base.

We have so far said nothing about the fine character delineation which the artist has here achieved—we somehow expect this in all his work. Every face and figure will stand critical analysis.

Dover Coach, which we have also chosen to designate as a mural, is, from a compositional standpoint, somewhat similar to Yankee Doodle, though there are two main differences. First, all the action in Dover Coach takes place within the confines of the single vehicle—the figures are moving as a unit. Second, the warm hues of Dover Coach, surrounded by the cooler tones of the sky and background, create a dominant central mass of color interest, wholly unlike the pattern of scattered hues in Yankee Doodle.

While never intended as a mural, Rockwell's Sign Painter has been included because it is quite suitable for wall use. For this purpose, some of the stronger value contrasts could perhaps be suppressed advantageously, though obviously much would depend on the picture's setting. Viewed purely as an historic painting—its true purpose—these contrasts are highly effective. The concentration of interest on the sign painter, as he goes about his task, is a dominant feature of this example.

Different from all of the above, both in subject matter and composition, is Rockwell's *Land of Enchantment*. Here the decorative frame and foreground figures stand in bold silhouette against the dreamlike "land" beyond. The restraint of tone and color in this detached backdrop is notable—it holds together very nicely, yet the spectator can search out without trouble each of the famous characters of fiction.

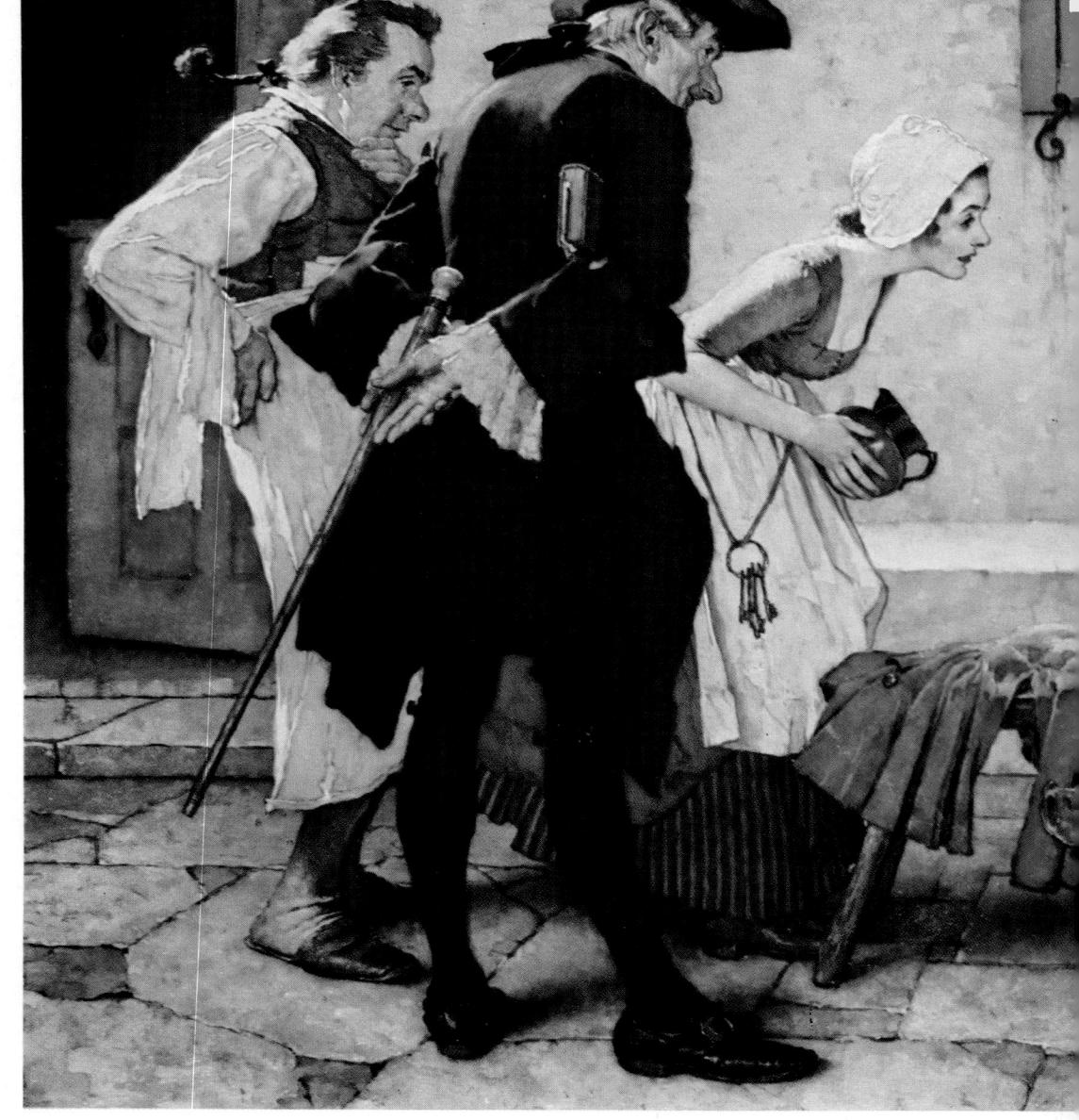

ILLUSTRATION IN OIL FOR FEATURE, "THE NEW TAVERN SIGN," THE SATURDAY EVENING POST, FEBRUARY 22, 1936

At one time I did a great many of these historical illustrations of one kind or another—mostly Colonial. They were fun to do for awhile; I liked the elaborate costumes and romantic settings. In recent years, the everyday happen-

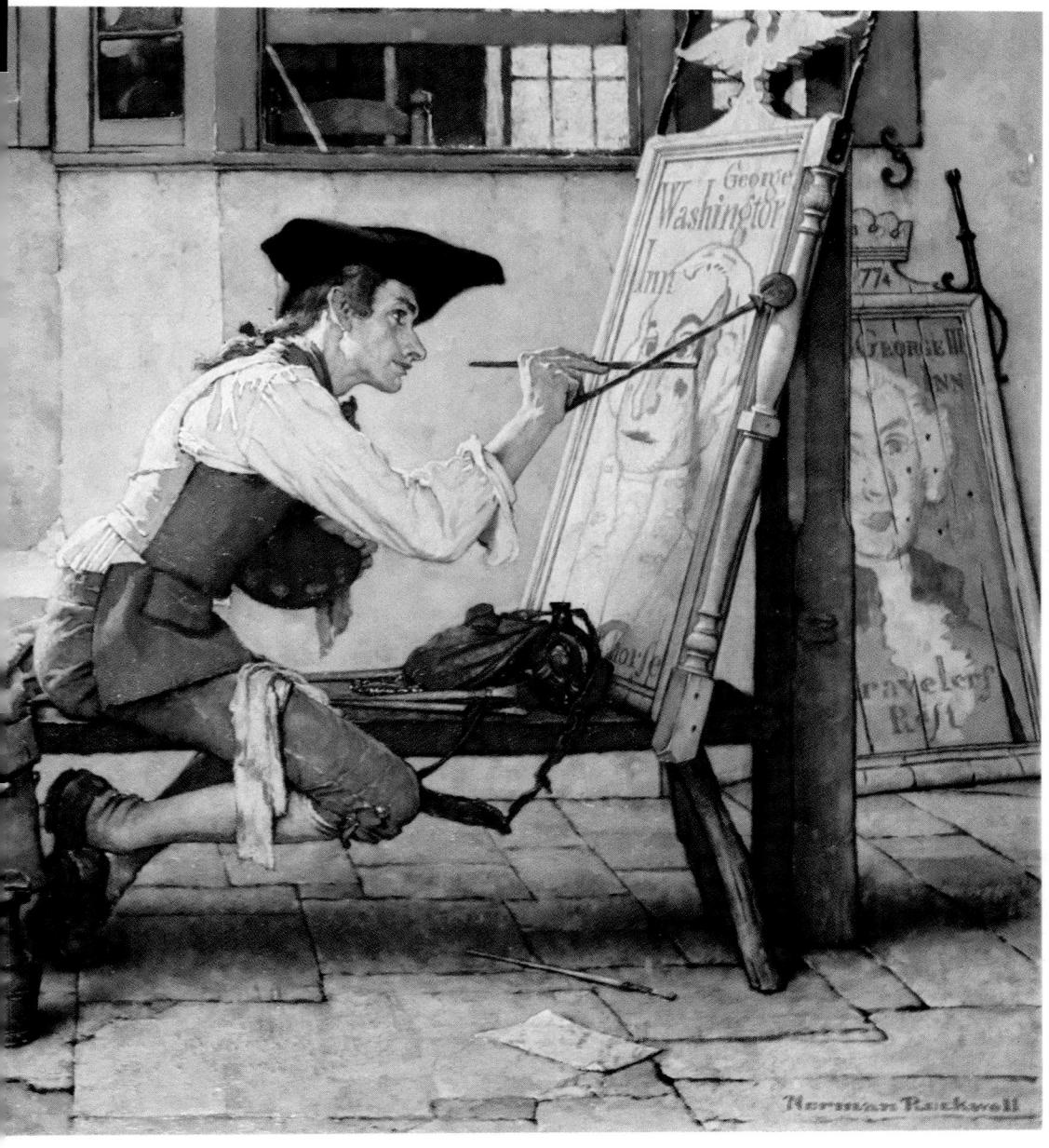

COURTESY OF THE POST AND H. N. HILL

ORIGINAL 54" x 30"

ings have been so exciting that I have preferred to interpret them . . . It was the painting reproduced above which led to my Nassau Tavern mural. In certain details—note the buildings in particular—they are quite similar. N.R.

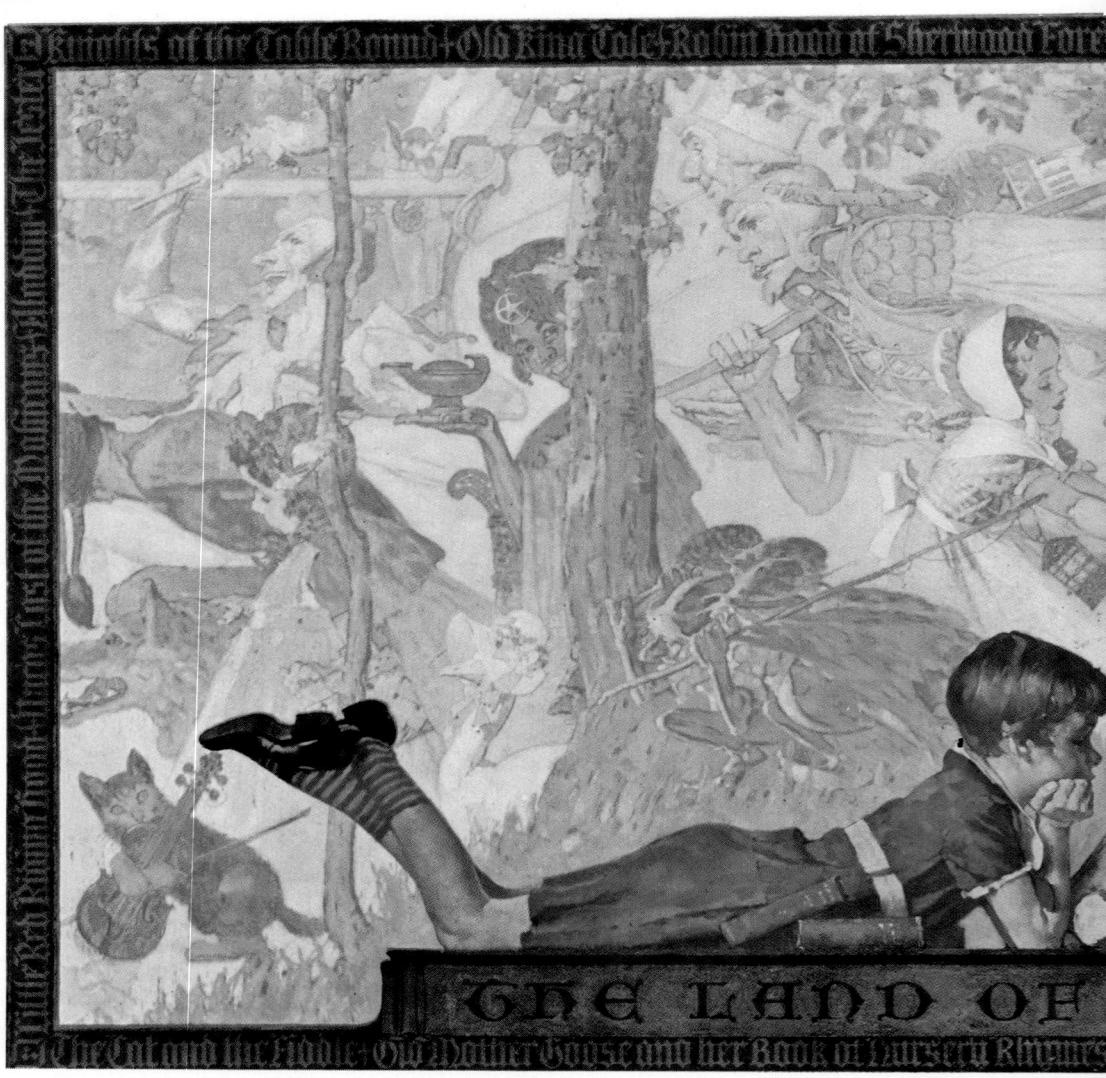

LLUSTRATION IN OIL FOR FEATURE, THE SATURDAY EVENING POST, DECEMBER 22, 1934 COURTESY OF THE POST AND THE PUBLIC LIBRARY OF NET

This painting, which now hangs in the Children's Room of the New Rochelle Public Library, was started as a commission for a wealthy gentleman who wished it as an over-mantel decoration in his children's room. The foreground figures were to be portraits of his son and daughter. Then came the financial crash of 1929 and the patron was no longer wealthy. He was obliged to cancel his order. The Post said, "Why not develop this as a double-page spread?" So, as I was about to sail for France at the time, I took along the sketches I had already made from models, and painted this picture in Paris. It there-

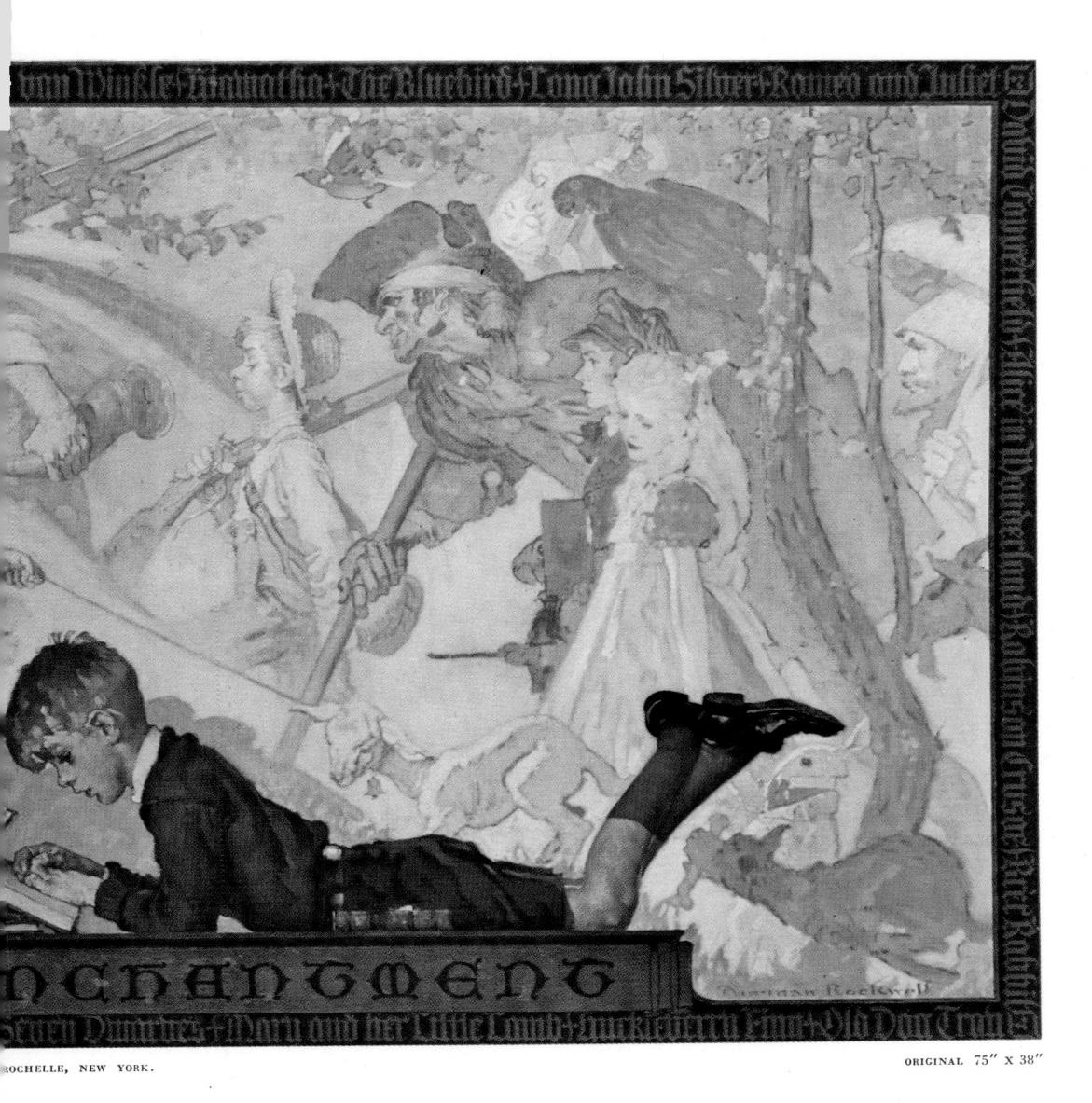

fore became the first double-page spread I ever did for the Post. I have had a great deal of enjoyment doing these spreads, for the main reason that I can paint them as horizontal pictures. This example was one of my largest—about six feet long. I remember very well walking from the station in Philadelphia over to The Saturday Evening Post, carrying it all the way, a station porter at one end and I at the other. A high cross-wind was blowing. We were all right on the avenues, but when we came to a sidestreet we literally had to "tack" or we would have been blown to the next street. N.R.

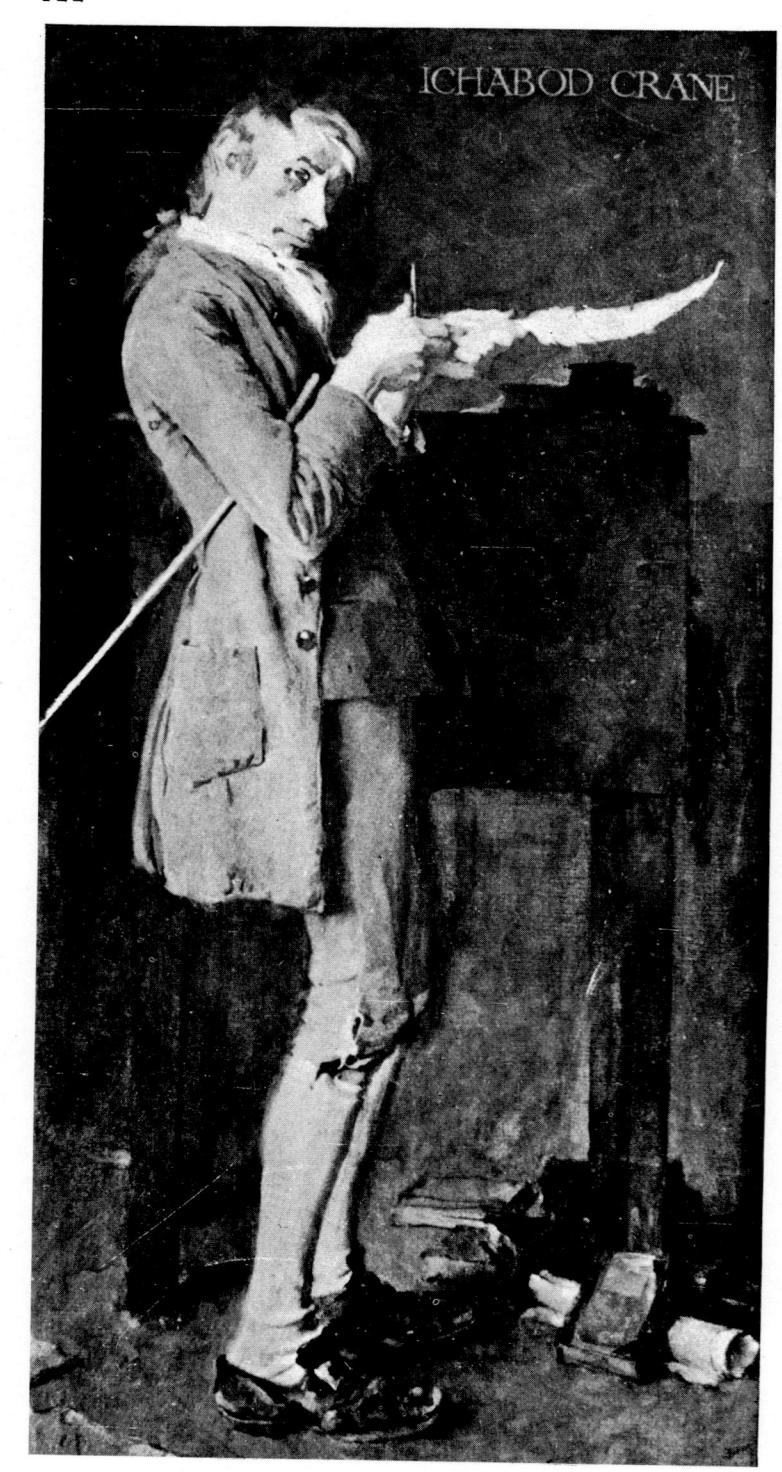

ICHABOD CRANE

These paintings of Ichabod Crane were started in great hope. I had the idea of making a series of pictures of all the celebrated characters in American fiction, such as Ichabod Crane, Anna Christy, Jo in "Little Women," etc. I started in with Captain Ahab, Babbitt, and Ichabod Crane. I painted the last-named twice, as I wasn't satisfied with the first attempt. But it's a sad story. I found no publisher who would take them, so they died a terrible death. But I still think the idea is sound. N.R.

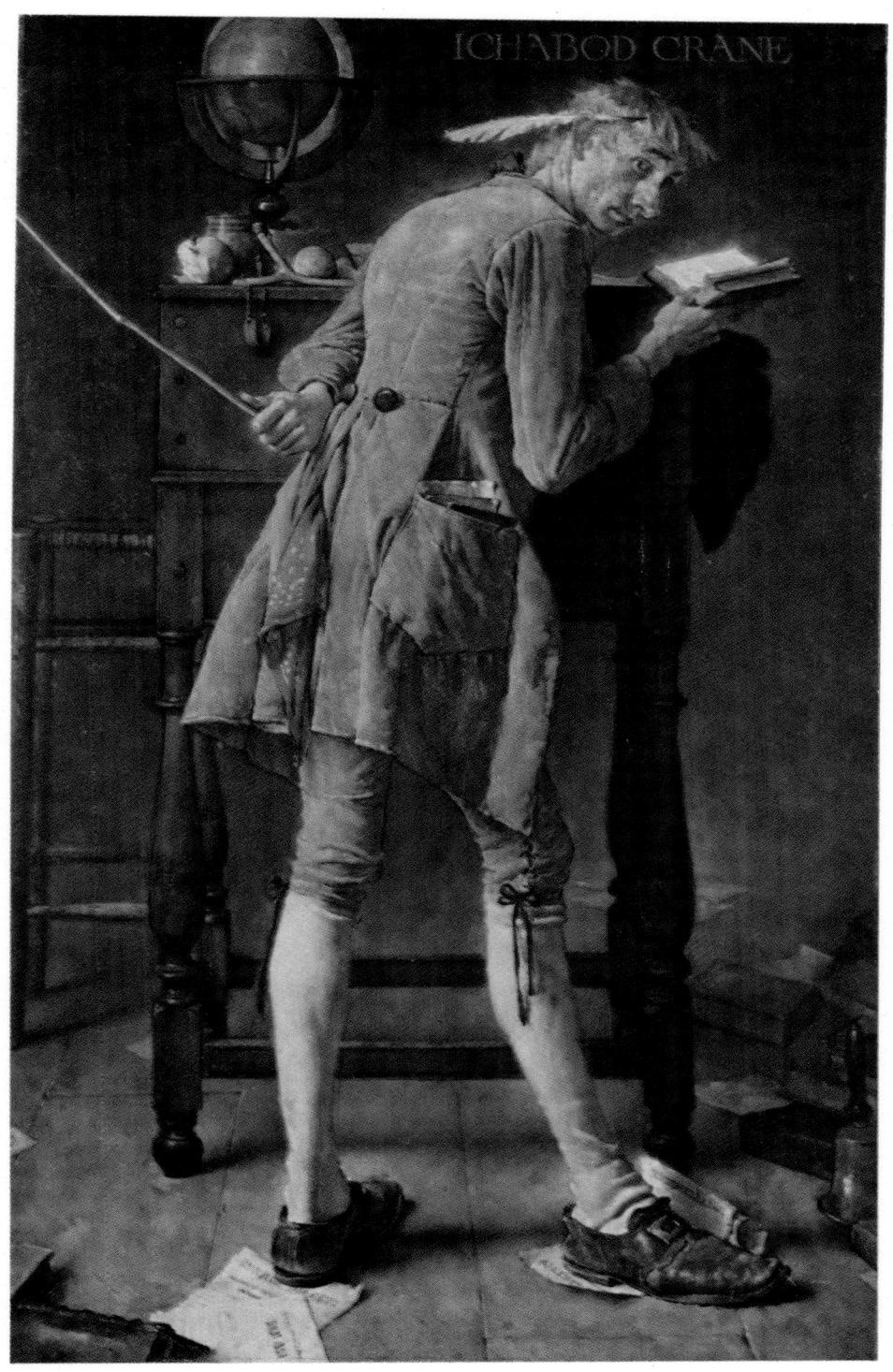

ORIGINAL 24" X 38"

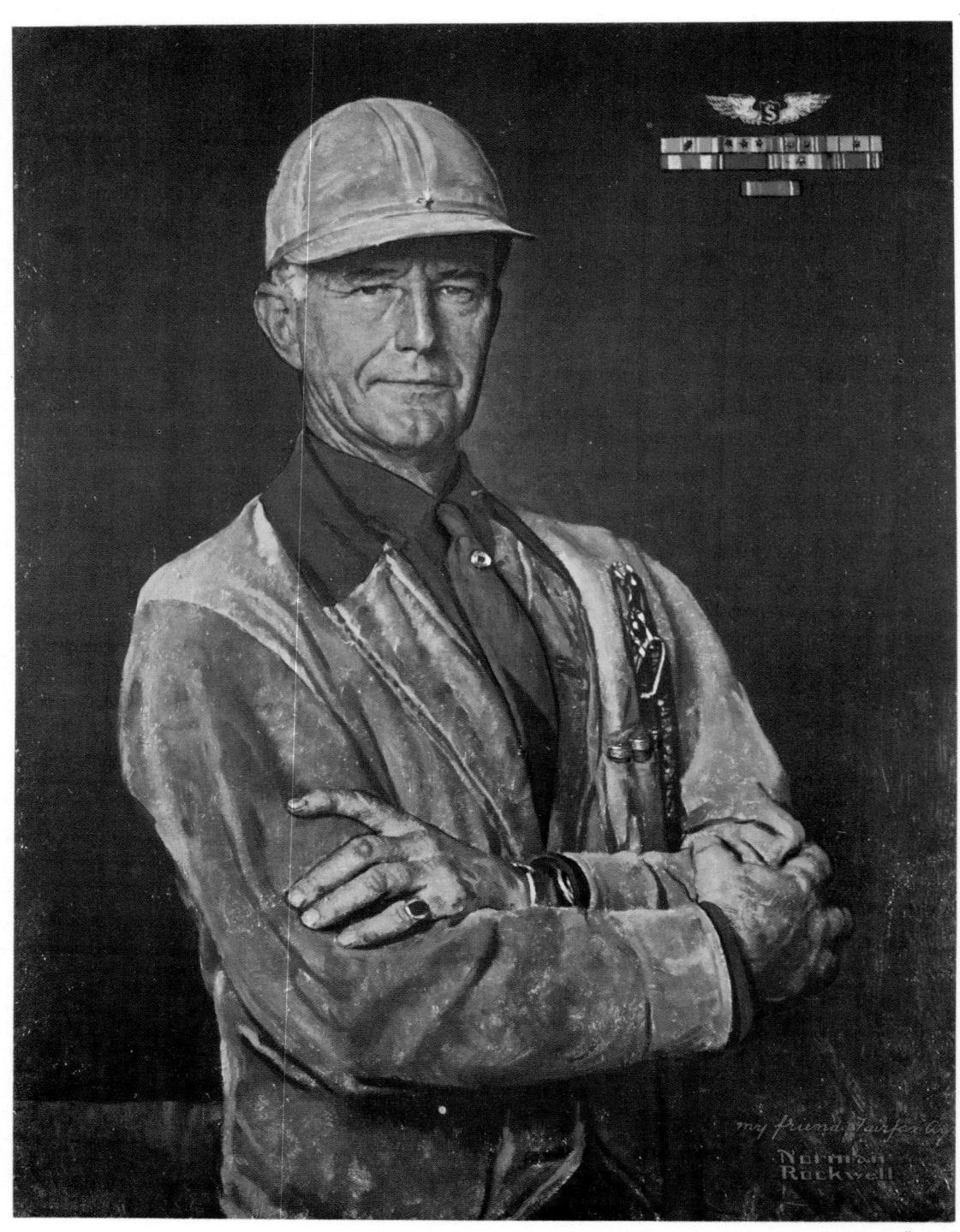

ORIGINAL 33" x 43"

A PORTRAIT IN OIL OF COLONEL HENRY FAIRFAX AYERS

The *Ichabod Crane* subject is still another which, though not planned as a mural, might be so utilized. It is interesting to observe that here, as in the *Sign Painter*, *Dover Coach*, and *Yankee Doodle*, parallel perspective, rather than angular, has been chosen. In fact this is quite characteristic of this artist, who is inclined to avoid sharp perspective unless he is stressing action or emotional intensity, as in the piano playing subject, page 70, and the hospital waiting room, page 84.

Although the heading to our chapter makes reference to portraiture, Rockwell has done very few formal portraits; this of Colonel Ayers is one of his occasional exceptions. But it might well be maintained that he has painted portraits all his life, particularly during the years he has devoted to subject pictures, for these certainly are portraits in a sense not characteristic of run-of-the-mill illustrations.

Printmaking is another art which Rockwell seldom practices, although he has always hoped to find more time for it. On one of his trips abroad he bought an etching press in London, and at considerable expense shipped it home. It is really a beauty, but it stands in the back room of his studio, accusingly idle. "I am forever saying that I am going to drypoint," Norman states, "but because I am always behind in my schedule I never seem to get to it. Just the same, one of these days I am going to do some drypoint—it is a wonderful medium of expression. The fact that you can pull so many prints makes copper plate an excellent medium when duplicates are desired." His drypoint on page 126 indicates what he might do in this field, given the time.

There is a type of work by Rockwell which should be gathered and reproduced some day—his many unpublished sketches, often of a hu-

Opposite: This portrait of Colonel Henry Fairfax Ayers was scarcely dry when it was sent to the engraver to be reproduced for this book. The colonel is a neighbor and a very good friend of mine. He comes from a long line of American fighting men. He is a West Pointer, and was a Colonel of Artillery in the first World War—and went back into the Army during the recent war. Like his forebears, he has won many medals and decorations. N. R.

ONE OF ROCKWELL'S FEW EXCURSIONS INTO PRINTMAKING

At one time I experimented quite a bit with printmaking and found it very fascinating. My etching press, brought from abroad, still stands in the back of my studio where I look at it longingly every now and then and determine to make some more prints. But those awful deadlines never seem to let me...I especially like to do drypoints—the one above is typical. This medium permits a delicacy of line which intrigues me, a delicacy impossible in regular etching... Occasionally I have done block prints, too. The pair of black and white decorations on pages 118-119 I cut in linoleum. No two printmaking methods could be much further apart than drypointing and linoleum printing. Each of course has its faults and virtues, and either is quite a change from the illustrator's more common mediums: soft pencil, charcoal and oil paint ... Many of the black and white illustrations in this book, including the chapter headings and marginal sketches, were drawn with a Wolff crayon (carbon pencil). N. R.

morous nature, made purely for the fun of the thing, or as gifts to his friends. The four post cards which we include are representative. These were done in Europe during a pleasure trip. They were printed on colored cardboard and touched up with opaque watercolor.

One might think that this artist would be intrigued by his picturesque Arlington surroundings to paint landscapes. But this hasn't been the case to date. Other artists who visit him get out their brushes and portray the covered bridge, the Kill, or some of the mountain scenery. All this leaves Norman cold. His interest, as we have repeatedly seen, lies primarily in people. And we wouldn't want it any other way.

When travelling, it is always fun to send mail back home. I drew these cards in ink and had them printed; then I touched them up with opaque paint. N.R.

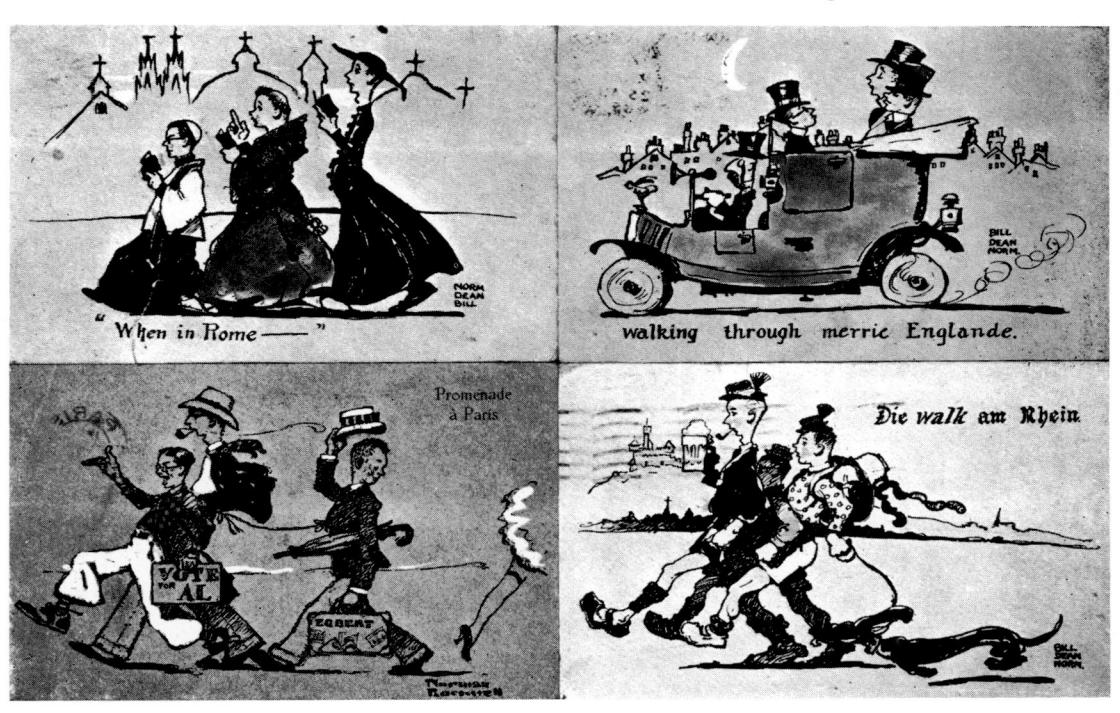

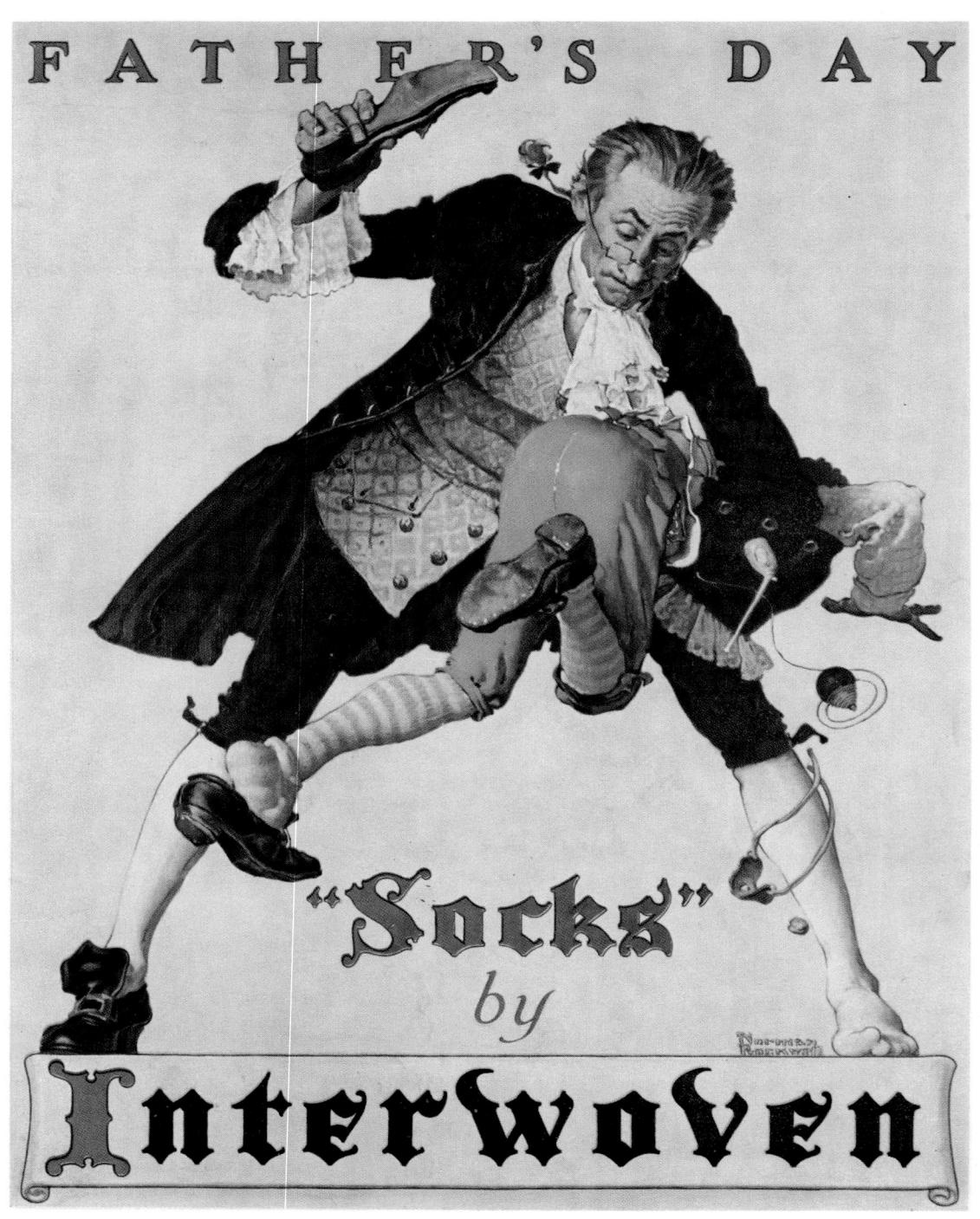

OIL PAINTING FOR ADVERTISEMENT OF INTERWOVEN SOCKS

PUBLISHED BY PERMISSION.

ORIGINAL 24" X 31"

A TYPICAL OIL PAINTING MADE FOR ADVERTISING PURPOSES

VII: Advertising Art

It is common knowledge that there is more money to be made in advertising drawing than in any other type of illustration. A generous share of the huge sums big business spends for promotion finds its way into the pockets of top-flight illustrators. Industry does not haggle over a few thousand dollars when bidding for these artists' work. Rockwell's own practice has been to charge twice as much for an advertising picture as for a magazine cover or illustration. For even the most powerful of publications cannot compete with giant industry. Consequently many artists do more commercial work than editorial assignments, even though, for creative satisfaction, they may prefer the latter.

Rockwell's work is seldom seen today on advertising pages. His income from publication art is sufficient to make him indifferent to the lure of more money from advertisers. Occasionally he succumbs to entreaties and accepts an advertising commission, but only if given free rein.

Opposite: When people ask why I sometimes resort to photographs, I tell them what a job it is to get models to take and hold poses such as were used for this Interwoven Socks advertisement. Any time you wish to become a model, try either of these poses for a few minutes . . . I have never learned to letter well, for lettering is an art in itself, so whenever I have needed lettering, as in this case, I have called on an expert to draw it. Then I have painted it, believing that I could thus get character of my own into it. N. R.

129

From an oil painting, "Still Good," done in 1927 for a page advertisement for Interwoven Socks.

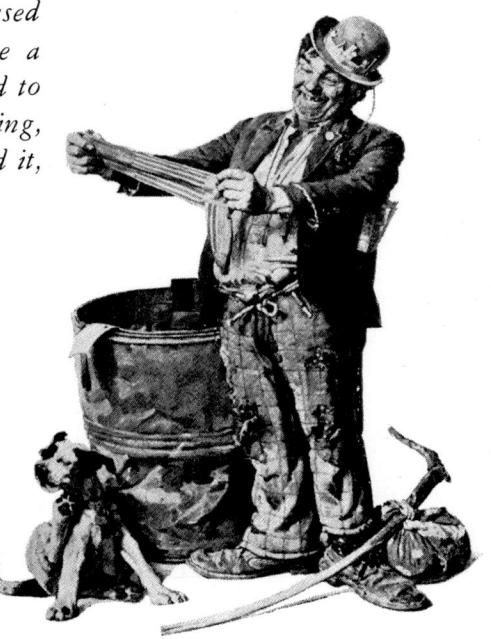

Most advertising ideas originate in the client's brain or in the advertising agency. They are usually hatched in conferences which may or may not include the artist. This is not to say that illustrators have no creative part in the project; their own dramatization of the idea enhances its power, and sometimes, of course, they themselves suggest better ideas than the one originally proposed. But, by and large, an artist's genius has to compromise with the client's money.

In view of Rockwell's consuming interest in people, particularly of the homespun variety, and his eagerness to paint storytelling pictures of those aspects of American life that are so close to his heart, it is easy to understand how rarely an advertising idea, perhaps with a competing message of its own, appeals to him.

Now and then something may be right up his alley. We recall a painting he did for Capitol Boilers years ago. A nearly destitute young musician sits in his cold attic room, hands outstretched before the meager heat of a small stove. His violin rests upon his knees waiting until numbed fingers can be thawed out and the interrupted practice resumed. The display line reads, "The melody stilled by cold." Here the artist could be himself; the story he wished to tell would perfectly serve the needs of the advertiser. This was also the case with the two series for Interwoven Socks and Fisk Tires. The Bernadette poster is likewise a good Rockwellian theme.

Opposite: This Fisk Tire advertisement dates back more than twenty years. The painting is typical of the work I was doing at that time. One thing I liked about this series was the freedom to originate my own ideas; that's half the fun of painting. I always enjoyed doing these tramp pictures. In this case my model was old Pop Fredericks, known to all illustrators. He was a great guy—an old actor. He used to pose twenty-five minutes and then rest. Before the pose we would set the alarm clock, a noisy Big Ben. Waiting for the blasted thing to go off was nerve-racking; after about twenty minutes I would be on edge. Once I had Pop in a sleeping pose and he actually fell asleep. I let him sleep until noon. When he finally awoke he scolded me. "Why didn't you wake me up," he barked, "so I could rest?" N. R.

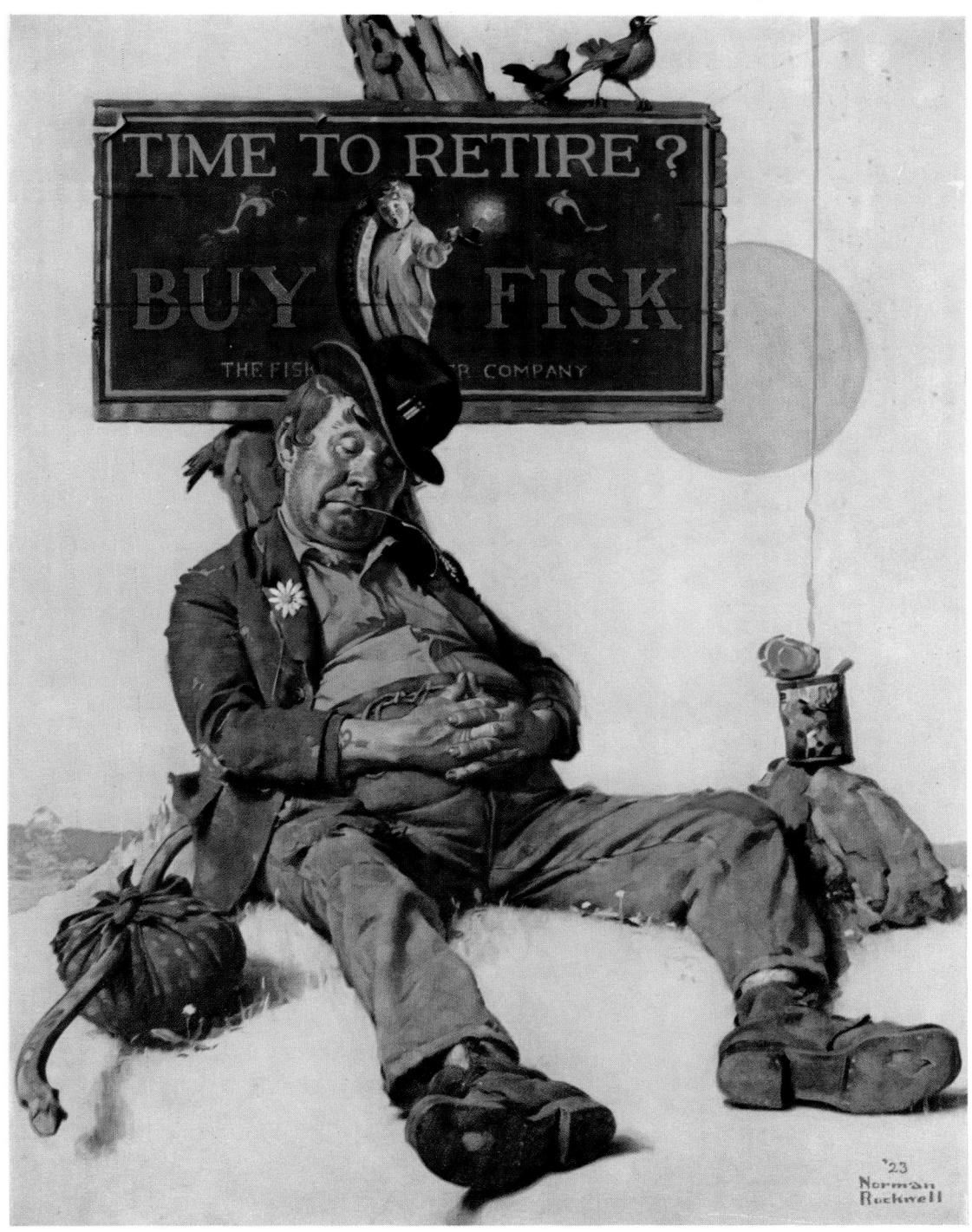

OIL PAINTING FOR ADVERTISEMENT OF FISK TIRES PUBLISHED BY PERMISSION.

ORIGINAL 21" x 27"

TRAMPS, A ROCKWELL SPECIALTY, ARE ALWAYS FAVORITES

BERNADETTE

When the 20th Century-Fox people were promoting "The Song of Bernadette," they commissioned me to make this painting. They sent me photographs of Jennifer Jones, who played the lead, to work from. Nothing else I ever painted was reproduced in so many ways. In addition to its being run in magazines, newspapers and on theatre posters, I was told that it covered the entire wall of one eight-story building. N. R.

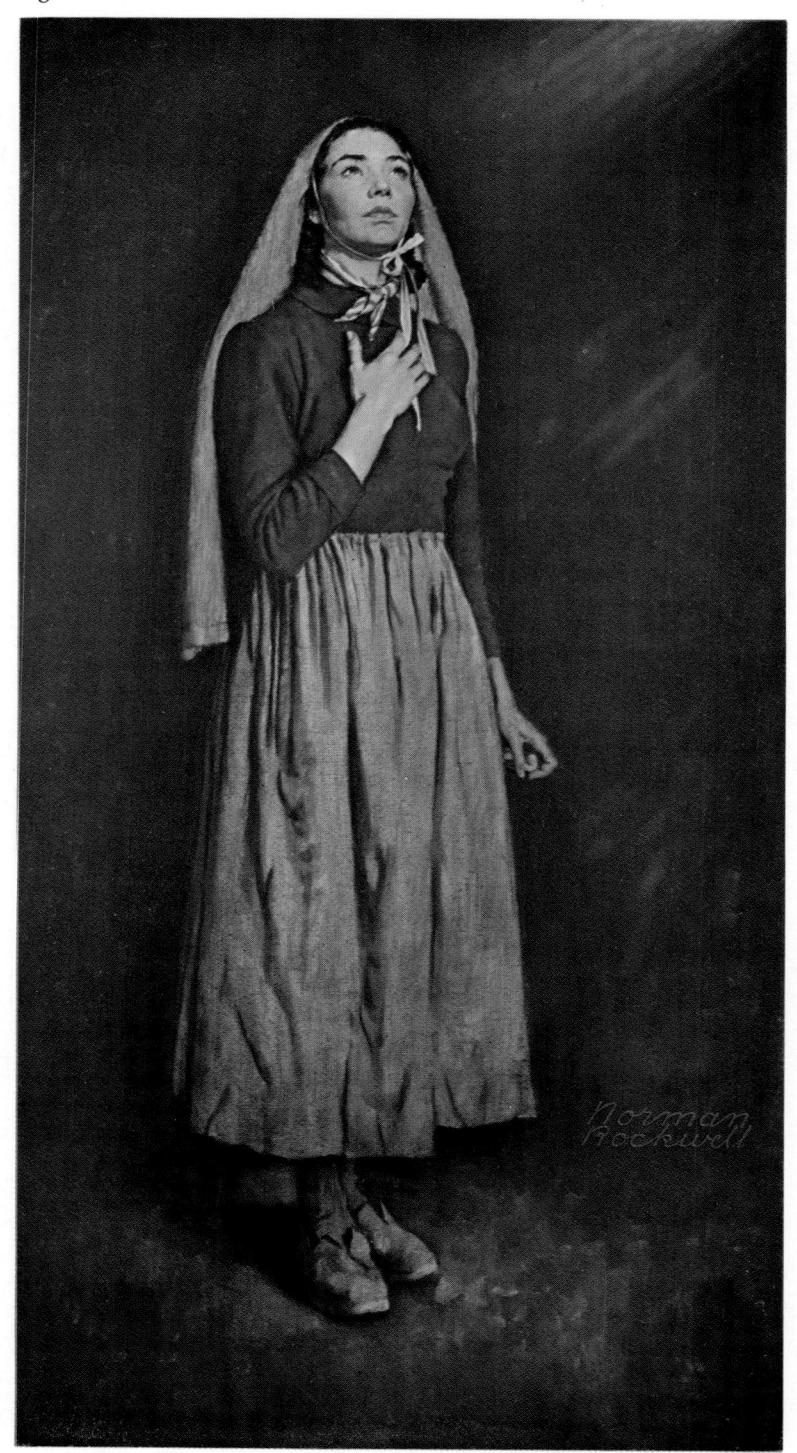

OIL PAINTING FOR 20TH CENTURY-FOX.

PUBLISHED BY PERMISSION.

ORIGINAL 28" x 53"

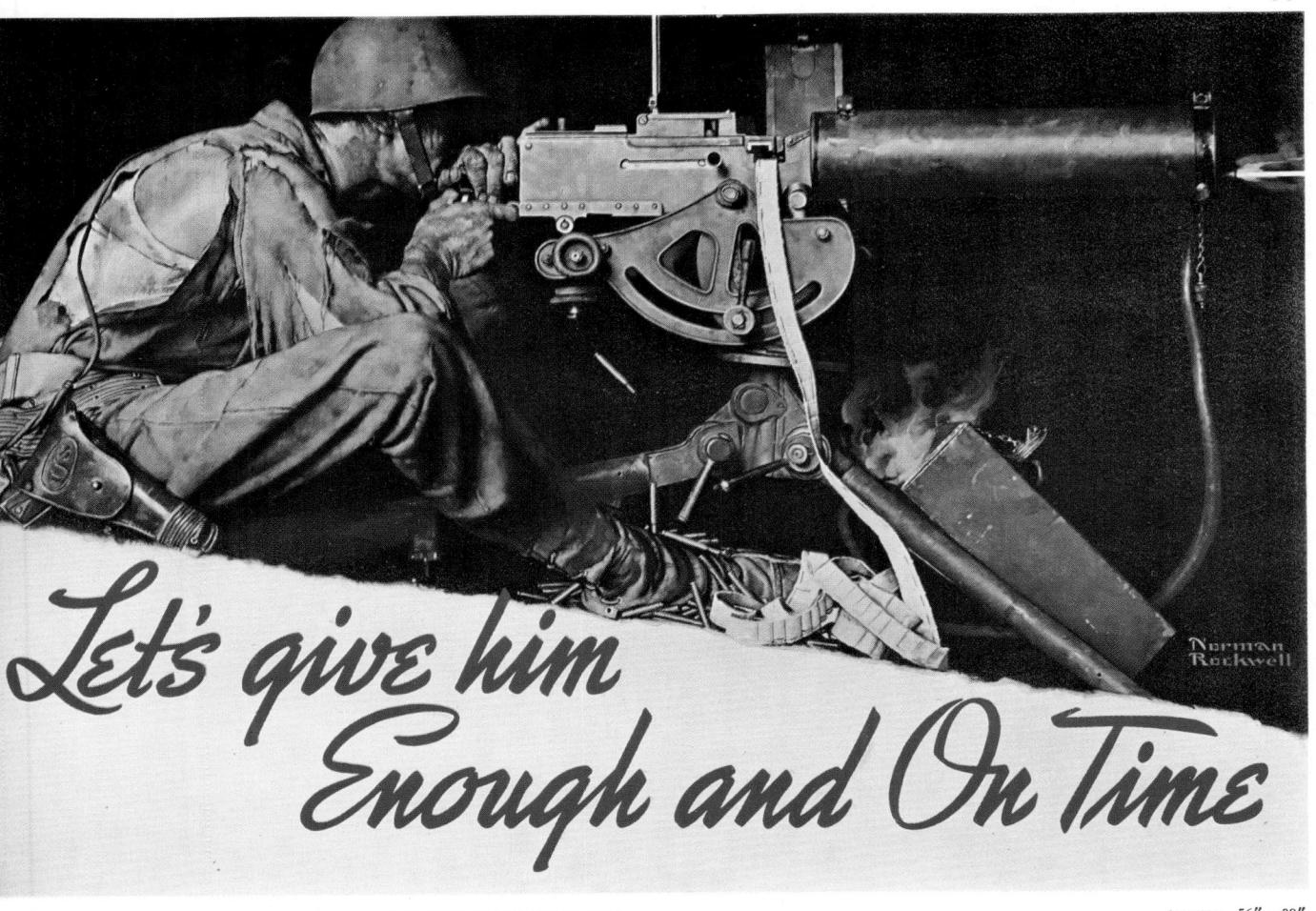

ORIGINAL 56" x 38"

WAR POSTER. COURTESY ORDNANCE DEPARTMENT, UNITED STATES ARMY

A FINE CONTRIBUTION TO THE WAR EFFORT, 1943

When, during the recent war, the Ordnance Department gave me the suggestion for this poster, I made a rough sketch which was approved by the Army. Then a neighbor of mine, Colonel Fairfax Ayers, a retired Army officer-his portrait appears on page 124-arranged to have a gun crew and machine gun sent to my studio. They arrived in a jeep, to the great excitement of our Arlington boys. The gunner insisted that I picture his gun in gleaming good order, but he let me rip his shirt. . . . This final poster represents one of our grand soldiers in a tough spot on the firing line. The coil of cartridge tape and the empty cartridges show that he is about down to his last shot. N.R.

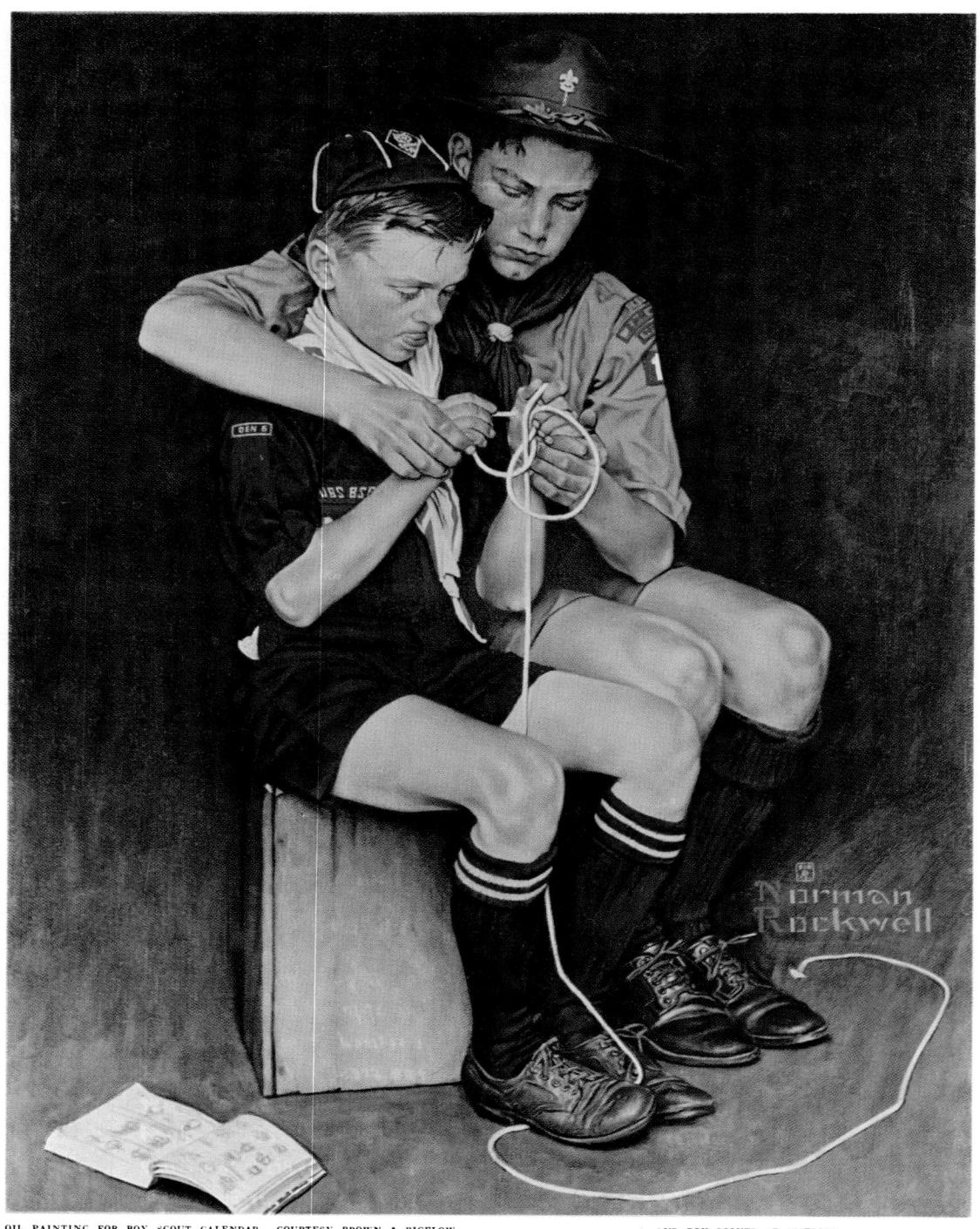

"A GUIDING HAND," BOY SCOUT CALENDAR PAINTING, 1946

VIII: Now It's Calendar Time

"Twenty-two years ago," boasts America's biggest calendar publishing outfit, "Brown & Bigelow scooped the advertising world with the creation of the Boy Scout Calendar, authorized by national headquarters of that organization! Sparked by the genius of Norman Rockwell, this unique idea is now regarded as the most powerful feature in Remembrance Advertising and is the envy of the advertising profession everywhere." The Brown & Bigelow people go on to say that, throughout the years, Norman Rockwell calendars have—to use their trade jargon—"led the calendar parade."

Rockwell got himself into this Boy Scout Calendar business from purely altruistic motives; he painted the first few of the series as a labor of love. He recognized the significance of the Scouts' character building program, believing that helpfulness and consideration for others are things the world can use a lot of. Later, realizing that he was on the producing end of what was getting to be—for the publishers—a pretty lucrative enterprise, he arrived at a conclusion, reasonably enough, that there would be nothing unethical in accepting money for creating the product. Eventually his price per picture exceeded—as Rufus Jarman put it in a *New Yorker* article—"forty-five times what

I truly enjoy doing this type of picture; I have now painted over twenty. In this particular one, my son Tommy posed as a Cub Scout, and his good friend and neighbor, young Jim Edgerton, posed as the Boy Scout. N. R.

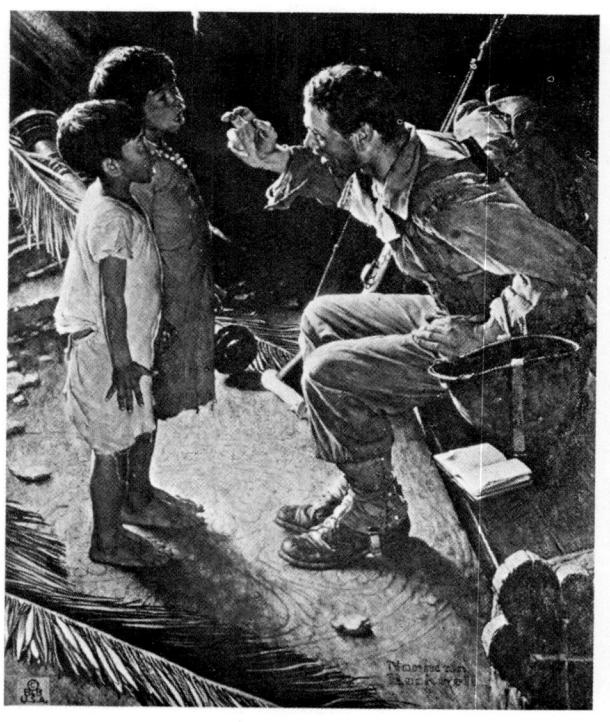

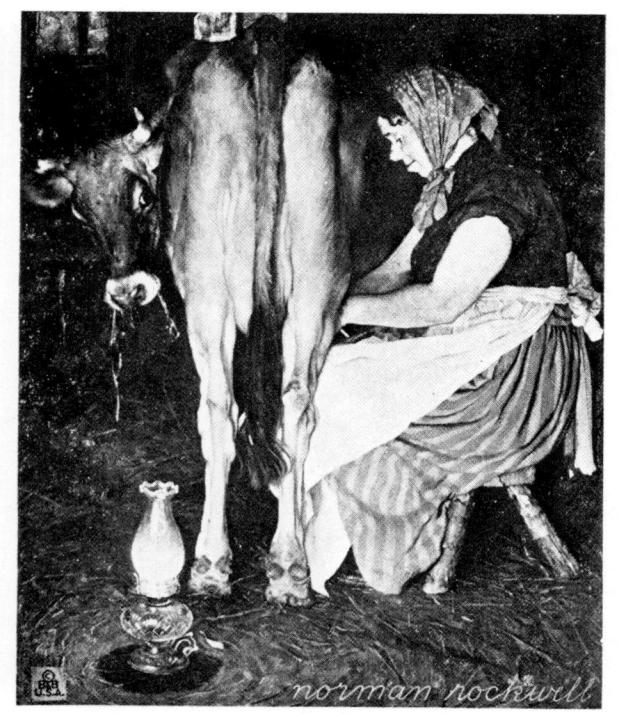

SOLDIER IN THE PHILIPPINES

MRS. O'LEARY AND HER COW

They tell me that for many years the Boy Scout Calendar has been the largest selling calendar in America. At least this was true until the Dionne quintuplets came along; then my friend, Andy Loomis, used them as a calendar subject, and for several years they were in the lead. But gradually the Boy Scouts have forged into first place again . . . I've done other calendars for Brown & Bigelow —the two above, for example. The Philippine cover ("The Land of the Free") was painted in California, near Hollywood. It would have been a real problem to find any Filipinos in Vermont, my usual source for models, but in Hollywood the central casting bureau can get you just about anything you want; apparently they found these youngsters without trouble. My mosaic was based on the floor of the San Gabriel Mission Church in San Gabriel, California . . . As to the cow calendar, picturing that critical moment just before Mrs. O'Leary's cow kicked over the lamp that started the great Chicago fire, this at least is "different." The cow which served as my model belonged to my neighbor. Elizabeth La Bombard (see photo, page xxx) posed as the milkmaid; I had to change her quite a bit to create a suitable Mrs. O'Leary. N.R.

Rembrandt got for *Bathsheba After the Bath*." It exceeds even his handsome per cover take from the *Post*.

That the price is not excessive is evidenced by the continuing demands of the St. Paul publishers, and other firms which would gladly pay even more for an occasional Rockwell picture. But one or two calendars per annum are usually enough for Rockwell, who for the past few years has bound himself to the *Post* in an agreement to paint only for their magazine, and to do a limited number of calendar paintings, including his annual "good deed" for the Boy Scouts.

Lauding one of his calendar pictures, Brown & Bigelow tell us that, "As usual Rockwell has done a remarkable job in perfection of detail, color and storytelling." We italicize "perfection of detail," because stark realism—that means photo-finish—is the sine qua non of all calendar art. And in the Scout calendars, storytelling is a first consideration. Of course perfection of detail characterizes all of Rockwell's paintings for publication, but what the Scout organization demands in this respect—every calendar picture has to bear its stamp of approval—might be termed "super-perfection"; all incidents of Scout ritual, practice, accoutrement and insignia must be meticulously and authoritatively portrayed. The Scout's uniform must always be immaculate, regardless of the blood, sweat and tears that may have accompanied the performance of his good deed. The Scouts themselves have to be carefully typed. They must be sturdy lads; freshly complexioned, wholesome and well-scrubbed—the pride and joy of every mother.

All this of course does violence to reality and leads to an artificial result that Rockwell puts up with because he continues to believe that the salutary effect of his yearly sermon in paint justifies a compromise with esthetics. There is little doubt that his calendar pictures do "appeal to every boy, every dad and mother, and to Scout leaders everywhere," the rank and file of whom prefer them to anything that might be produced by a modern Rembrandt.

Picture ideas—as we have found in our discussion of *Post* covers—sometimes come easy, sometimes hard. Ideas for Boy Scout calendars are no exception. Frequently a chance incident, wholly unrelated to

the particular problem, translates itself in Rockwell's perceptive mind into a good picture story. For example, a panting, thirsty dog seen in a baggage car suggested a very good deed for a calendar Boy Scout. It hasn't been too easy, though, to think of a new Scout cover idea every year for over twenty years. As Rockwell said, in the *New Yorker* article just mentioned, "The Boy Scouts are simply going to have to devise some new good deeds or Brown & Bigelow will be in a stew."

Yet if anyone can think of calendar ideas, Rockwell can. Just as four-leaf clovers seem naturally to jump out at some people from millions of the ordinary variety, picture ideas leap from the mass of everyday incident to Norman's mind. For he has conditioned himself throughout the years to discover his graphic themes in casual happenings that pass unnoticed by others. It is these undramatic things, after all, that fill most of our lives. The awareness of what, in the kaleidoscope of life's confusion, holds magic that will warm the hearts of millions is, without doubt, one of the secrets of Norman Rockwell's reputation as America's best-known and best-loved artist.

Rockwell's calendars are not all on the Boy-Scout theme, as the accompanying illustrations demonstrate. Attention is particularly called to his lively drawings for the Four Seasons calendar.

Opposite: These four drawings, done in Wolff crayon, are from a 1947 calendar which is something of an innovation in that each of them will be surrounded by an ornamental border. For example, "Winter" will have a design of snowflakes around it. This treatment should create an esthetic completeness which many calendars lack. Billy Brown, a friend of one of my sons, modelled for the boy; and Charles Crofut, a village selectman, for the man. N.R.

Winter

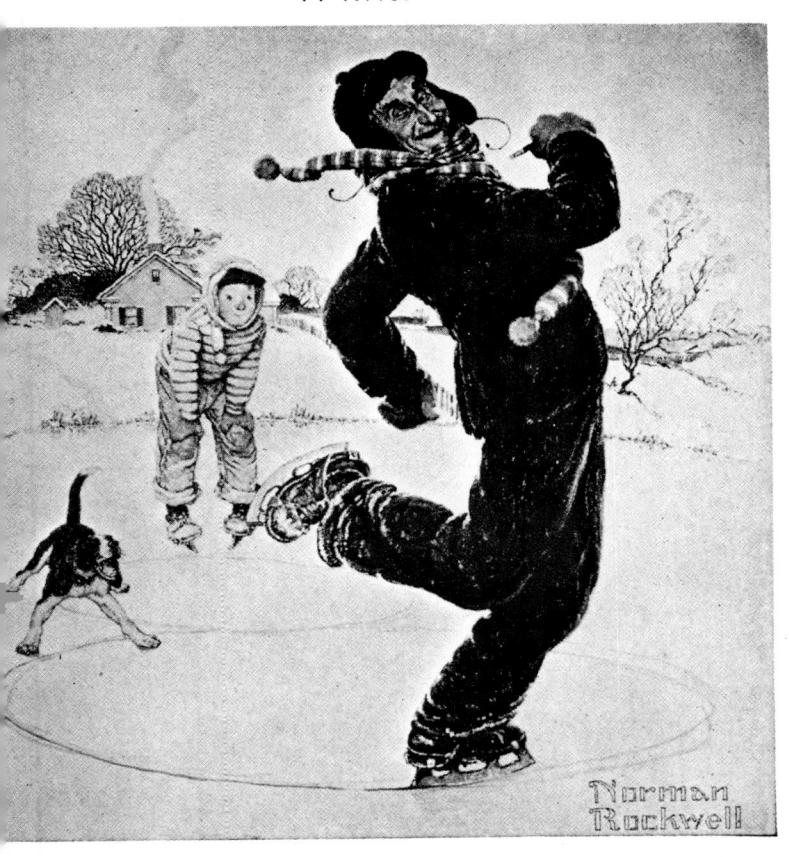

Spring

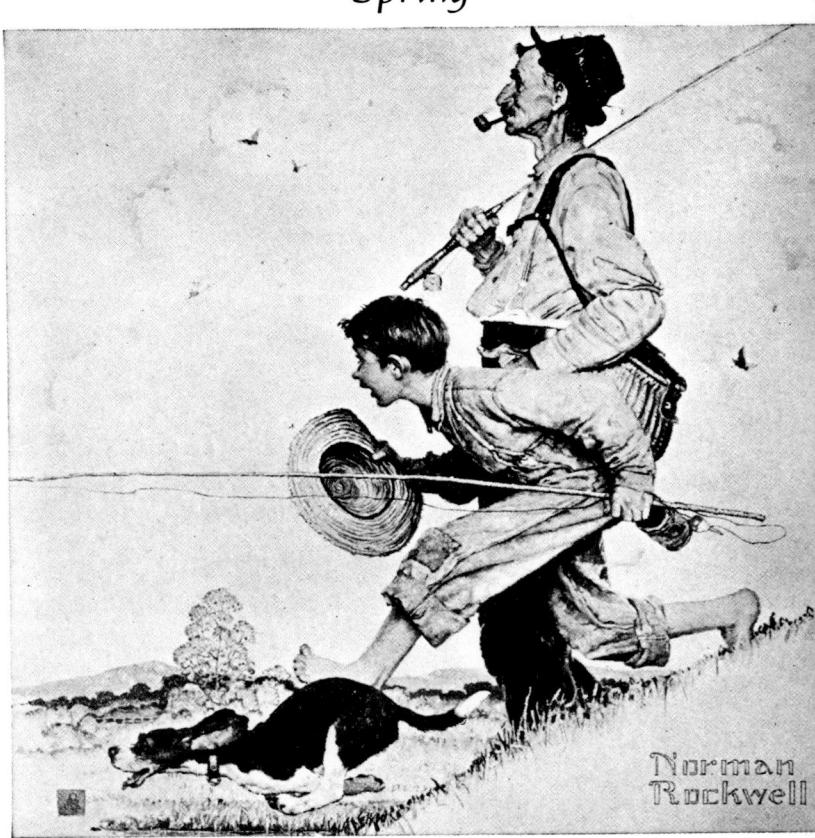

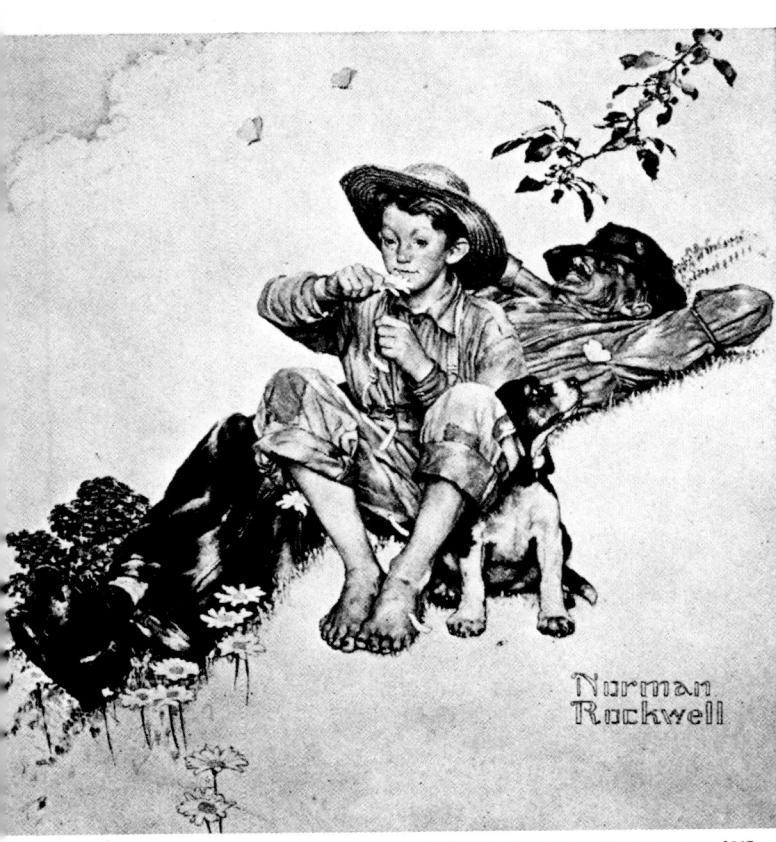

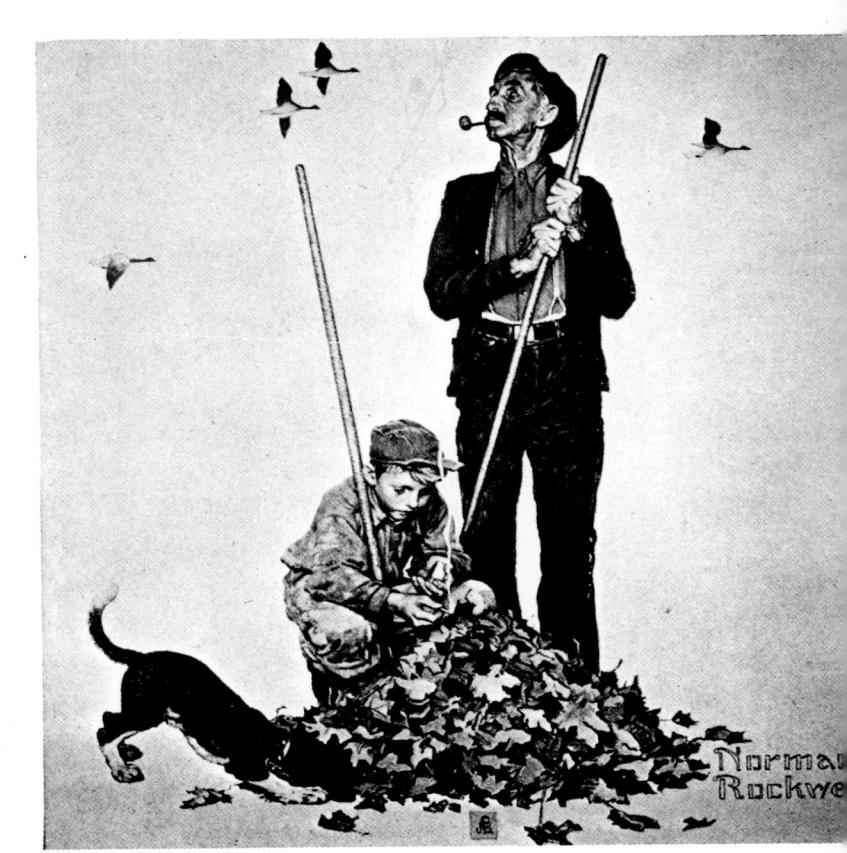

DRAWINGS FOR FOUR SEASONS CALENDAR, 1947. COURTESY OF BROWN & BIGELOW

PUBLISHER'S NOTE

It is said that no other paintings in the world have ever been reproduced and distributed in such numbers as these four which follow, created by Norman Rockwell in 1943. When he first undertook them he thought he could finish them in two months; actually it took seven. "The job was too big for me," he relates. "It should have been tackled by Michelangelo." But Michelangelo wasn't on hand and Rockwell was, with his finger on the pulse of America's need.

When these paintings first appeared in the *Post* their reception was little short of miraculous; requests came for millions of reprints. Then the Government joined in, and additional millions were distributed in connection with the Treasury Department's War Bond Drives. Some were in the form of large posters. The originals were sent all over the nation to be exhibited during Four Freedoms War Bond Shows in which numerous public officials, celebrities and entertainers took part. Eventually the O.W.I. circulated floods of Four Freedoms posters abroad and to the nation's post offices, schools, clubs, railroad stations, and other public or semi-public buildings. And everywhere they were warmly acclaimed.

Many consider these paintings Rockwell's masterpieces; certainly they represent a tremendous contribution to the winning of the war.

THE FOUR FREEDOMS

Freedom of Speech
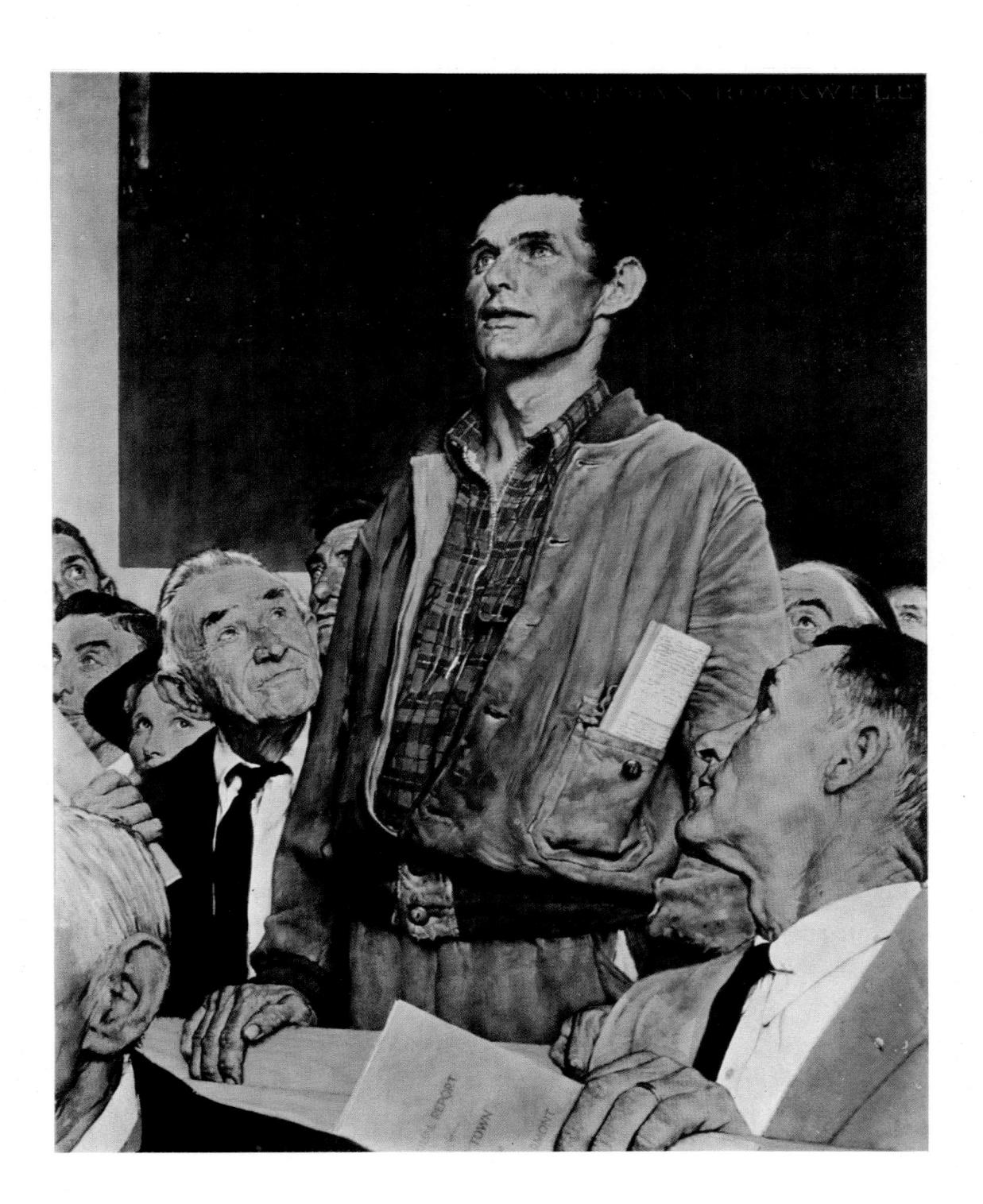

Freedom of Worship

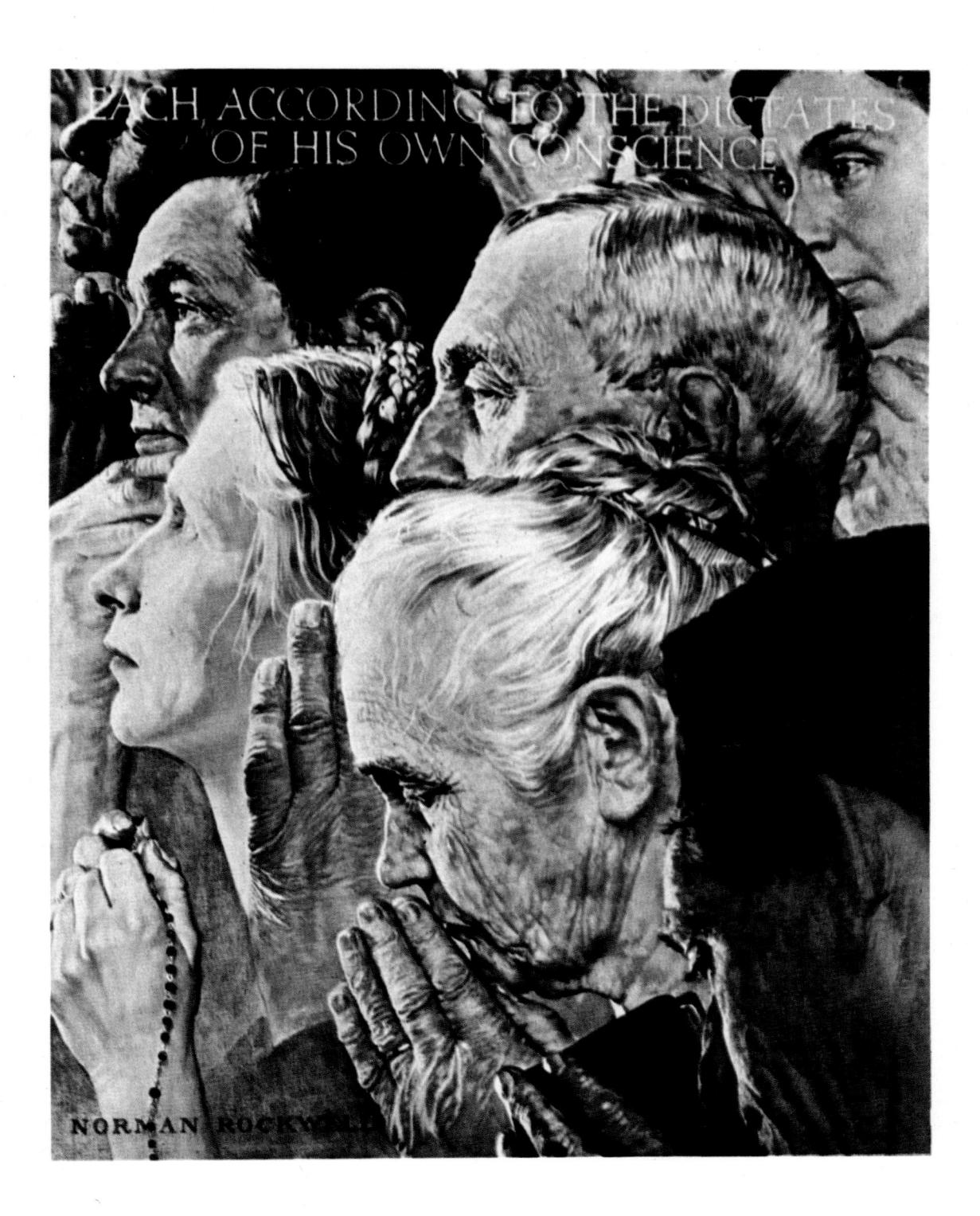

Freedom from Want

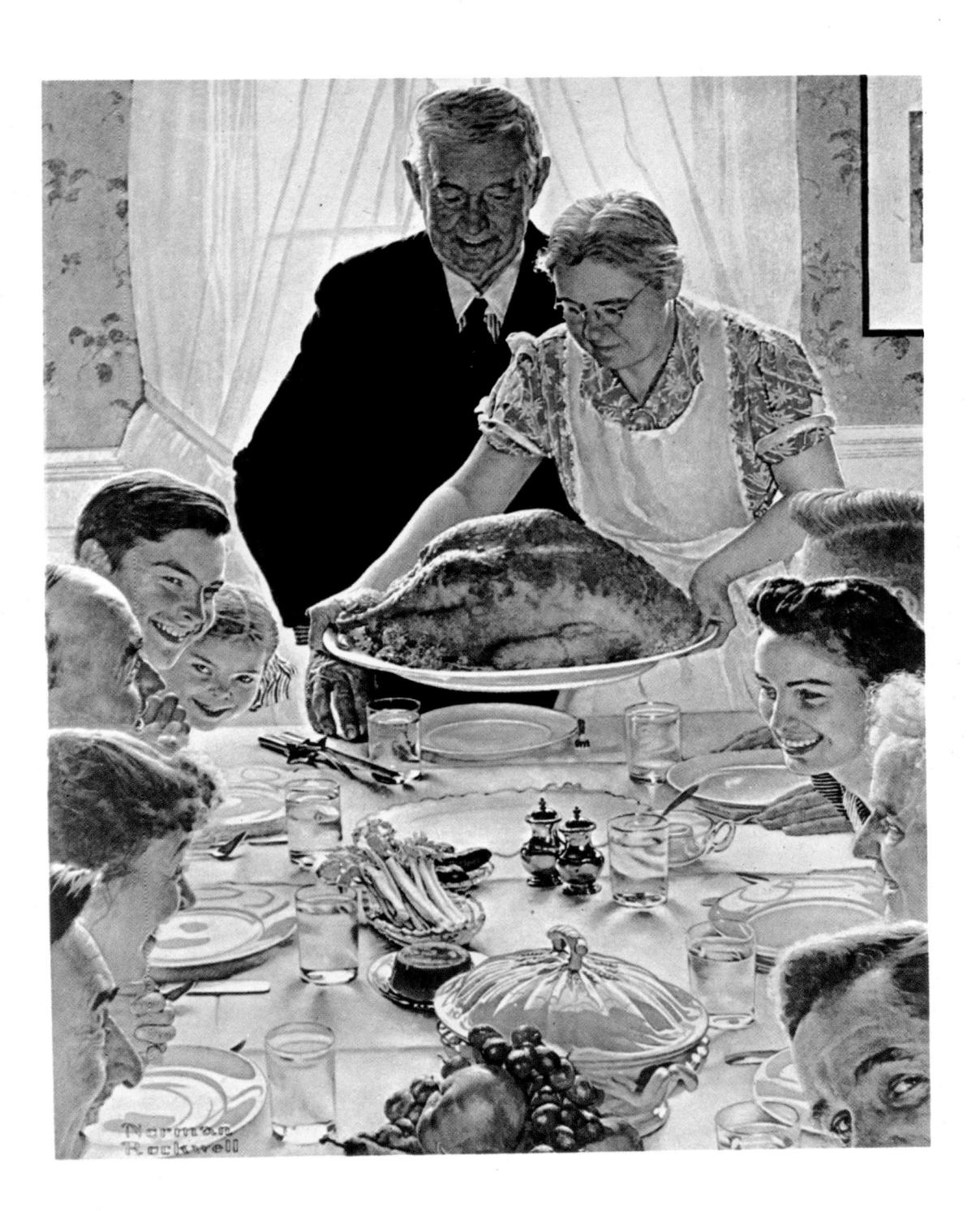

Freedom from Fear

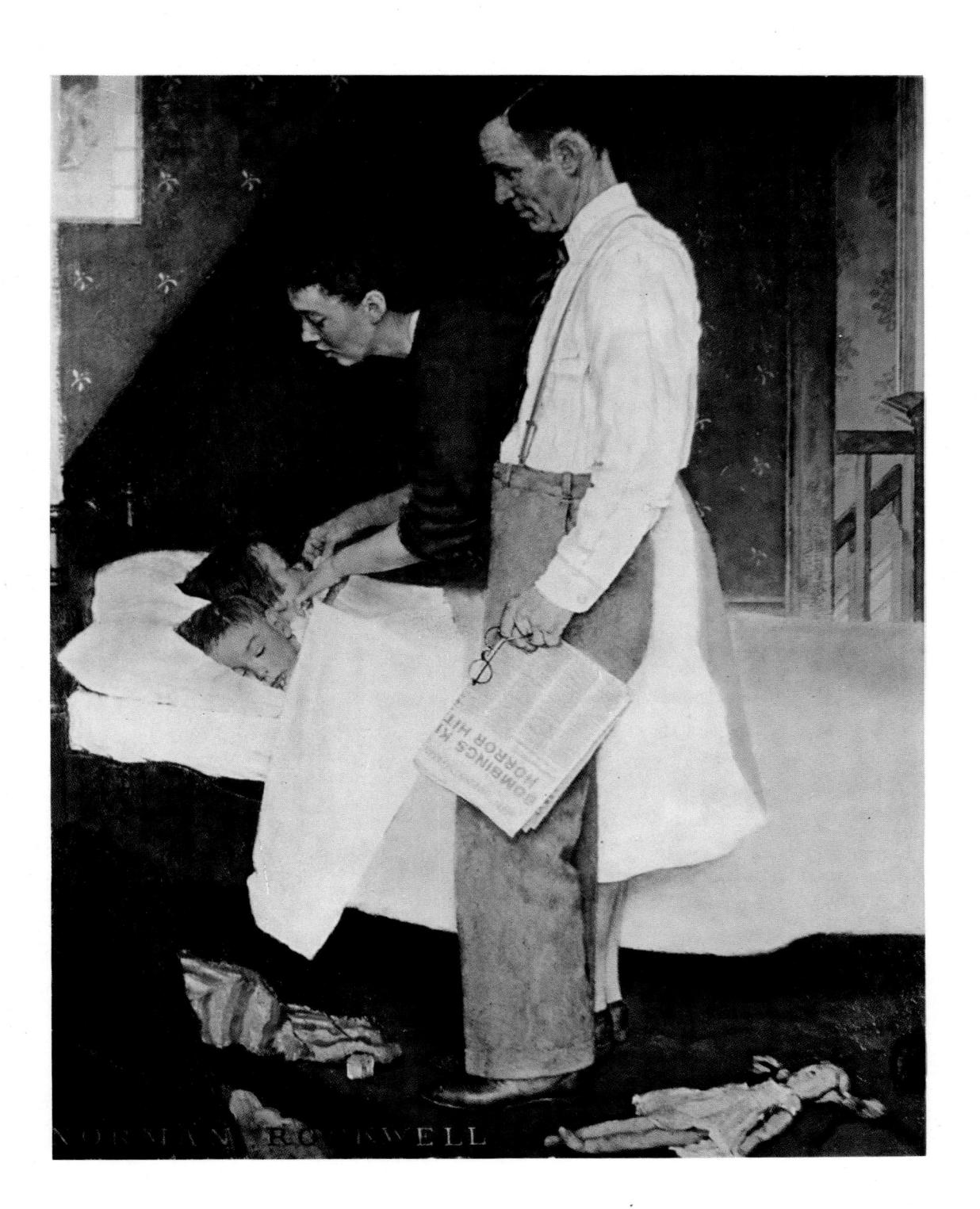

NORMAN ROCKWELL FROM THE

THIRTY YEARS OF ROCKWELL POST COVERS

1916 - 1946

... or, in the artist's own words, "Thirty years before the masthead."

CRADLE TO THE GRAVE

All Saturday Evening Post covers in this section—pages 151 through 192—are courtesy of The Curtis Publishing Company. It should be clearly understood that none of them may be reproduced without the written permission of that company.

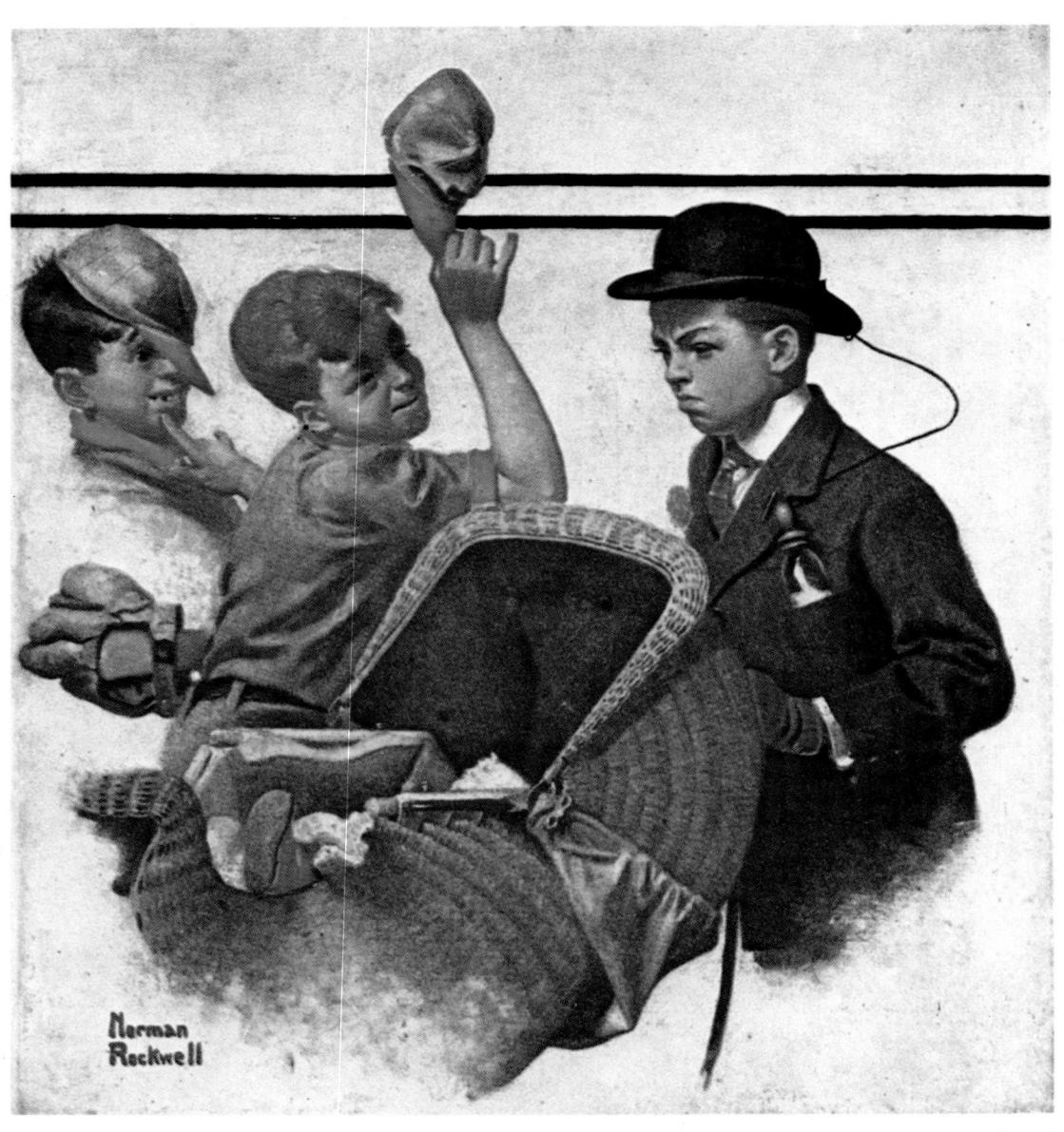

ORIGINAL 19" x 22"

ROCKWELL'S FIRST POST COVER APPEARED IN MAY, 1916

I still have a warm spot in my heart for this, as it initiated my long and enjoyable association with the Post... The best part of the gag was the baby's bottle in the boy's pocket; I received lots of letters about his humiliation. My model was Billy Paine, who posed for many of my early pictures. N. R.

Thirty Years Of Post Covers

"Artists may come and artists may go, but Norman Rockwell goes on forever!" So paraphrased one of Norman's admirers at the close of the recent (1946) exhibition of the Society of Illustrators, held at the Rockefeller Center galleries, New York.

And the remark was both pat and timely, for announcement had just been made that the painting before which his friend was standing—that of the red-headed marine displaying a captured Jap flag (see page 192)—had been chosen by public vote as the best in the show. Quite an honor, for over twelve hundred persons had attended, drawn by the display of the finest illustration of the previous two years, as selected by an eminent jury. And, as if this highest honor weren't enough, Rockwell's painting of a home-coming soldier (see page 188), was voted third best.

So Rockwell's thirty years of outstanding accomplishment as a painter of *Post* covers—of which the following pages serve as a reminder—haven't left him weak and gasping for breath. On the contrary, they have proved to be merely a warming-up period for more and better things both now and in the future. As Rockwell himself so amusingly suggests in his cradle-to-grave continuity on the preceding pages, he's been doing covers ever since he was a youngster, and he'll continue to do them as long as he can hold a brush. Thus he is creating a significant and unbroken record of many years of typical life in the good old U. S. A. during this amazing age of split atoms and such.

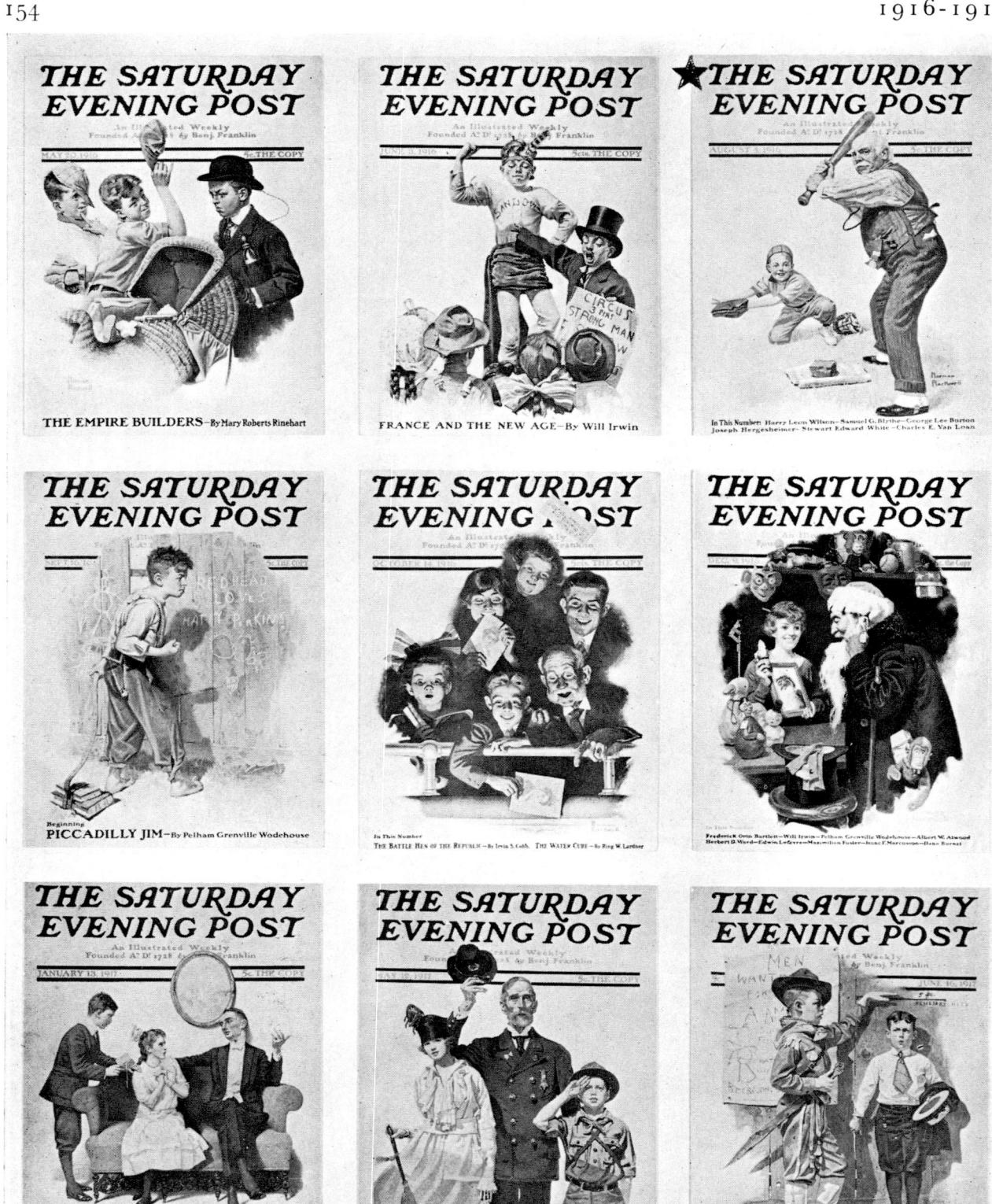

★ The August 5th cover—my third—didn't go so well. First, the editor decided that the man was too rough; then I made him too gentlemanly and I had to make him rough again. Altogether, I did it over completely four times. And my fourth cover I did over six times; it kept bouncing back! N. R.

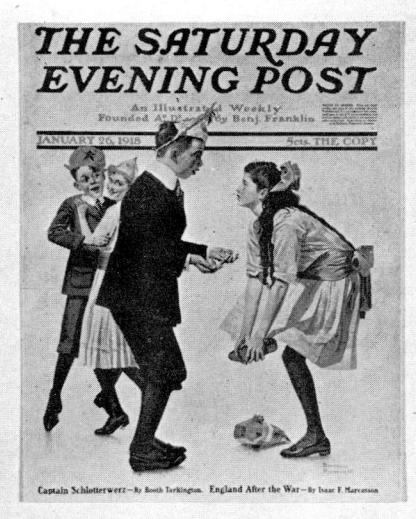

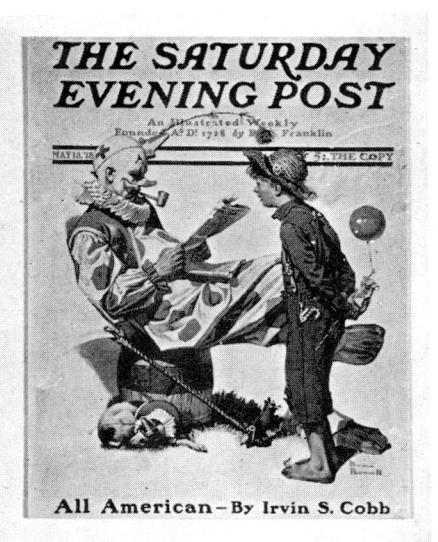

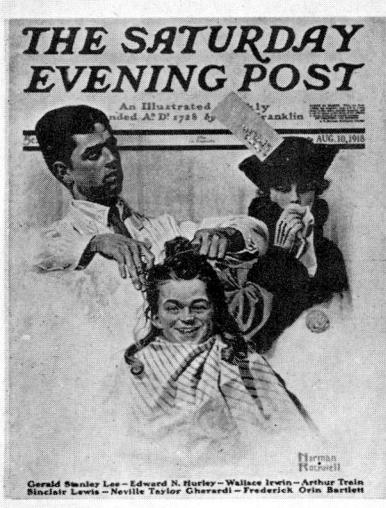

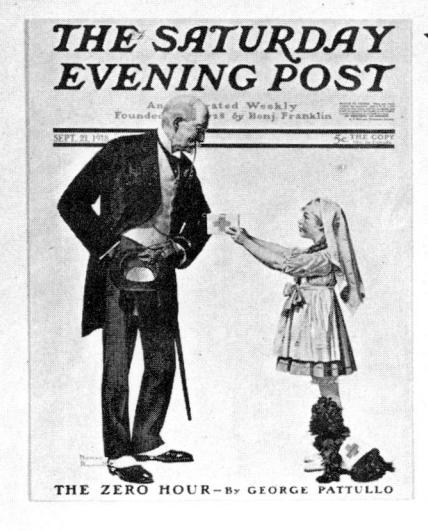

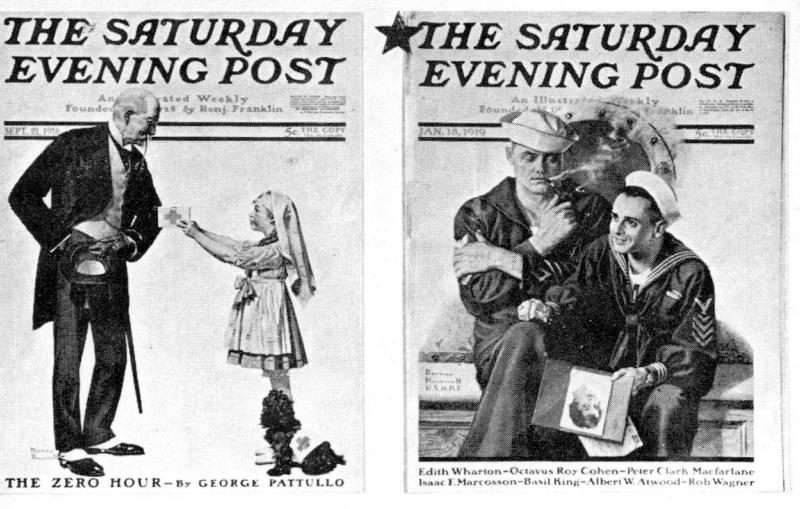

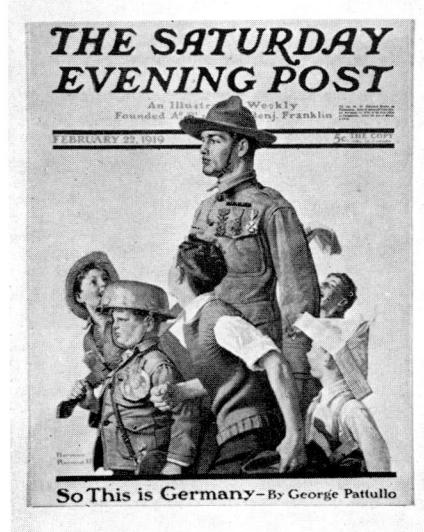

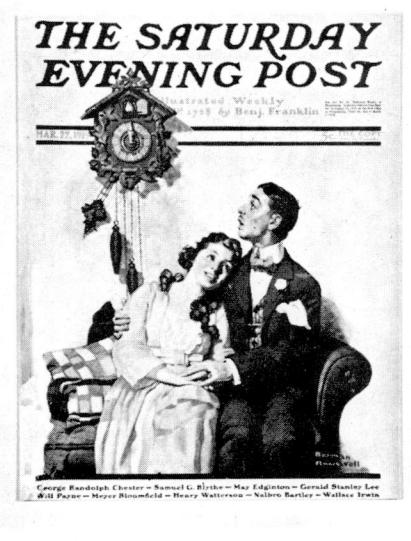

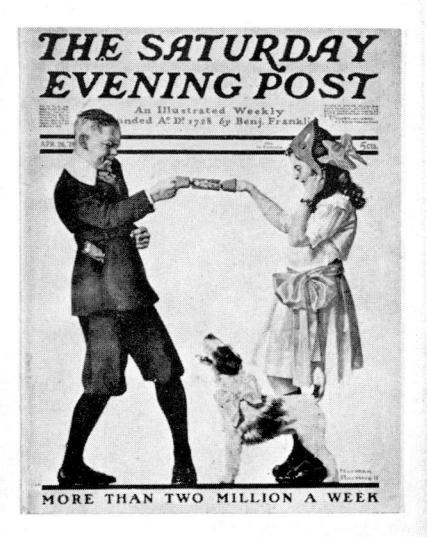

★ I feel like the "old man of the mountain" when I realize that I have done covers during two world wars. I painted this January 18th cover while in the Navy. I was allowed free materials and models and, of course, board and lodging, so I was in the same salary class as the admirals! N.R.

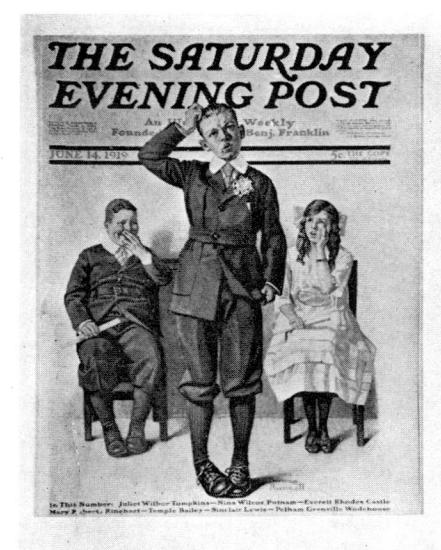

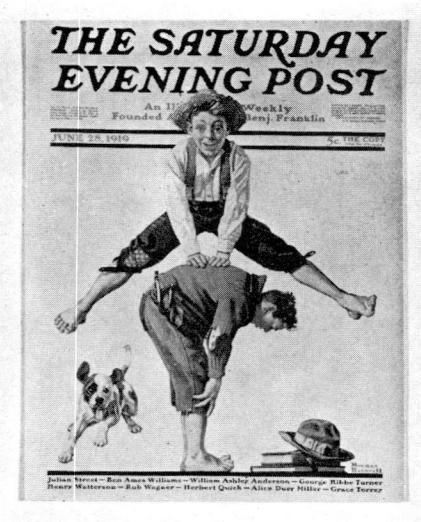

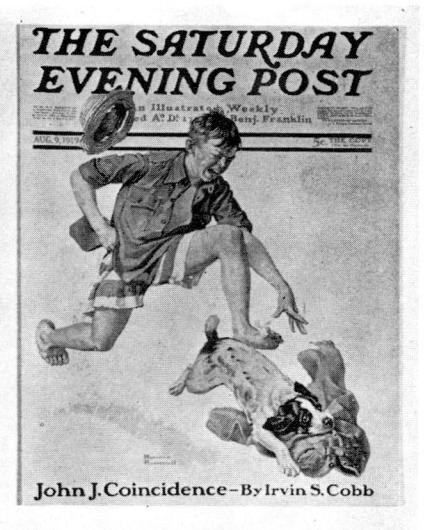

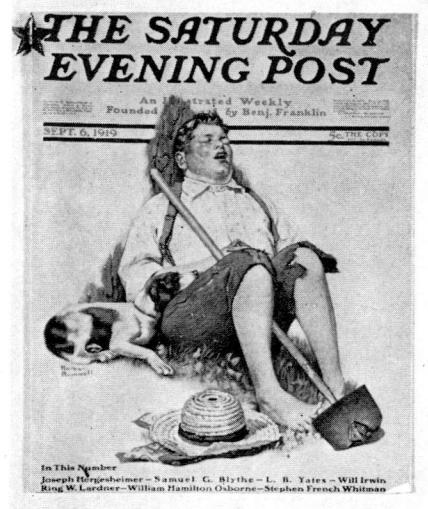

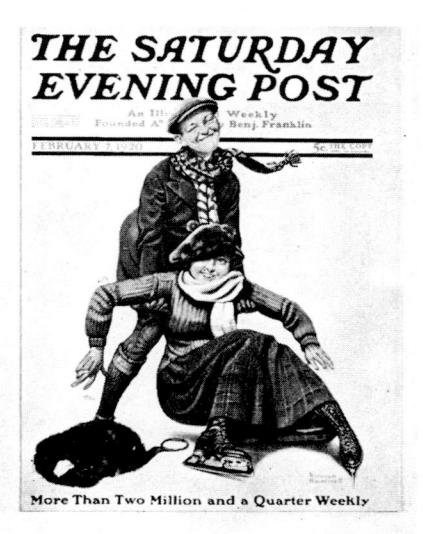

★ It's extremely hard to believe that all these kid models, who wouldn't sit still for me, have now grown up, married, and have grown children of their own. The fat boy who posed asleep at the hoe for the September 6th cover was Buddy Ogden; I believe he became an All-American football full-back.—N. R.

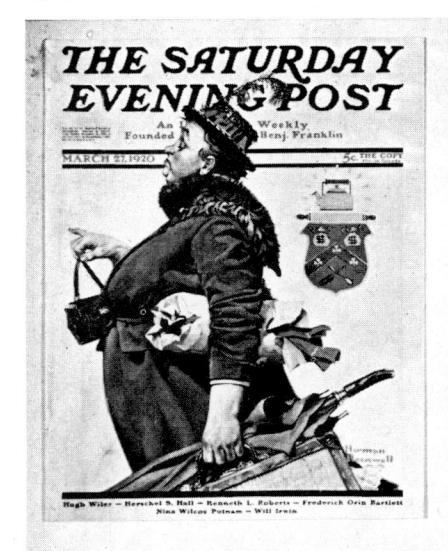

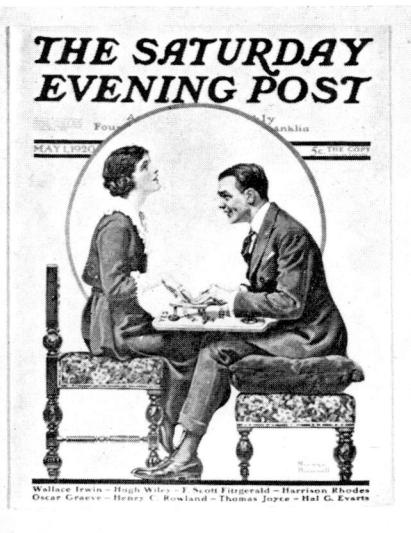

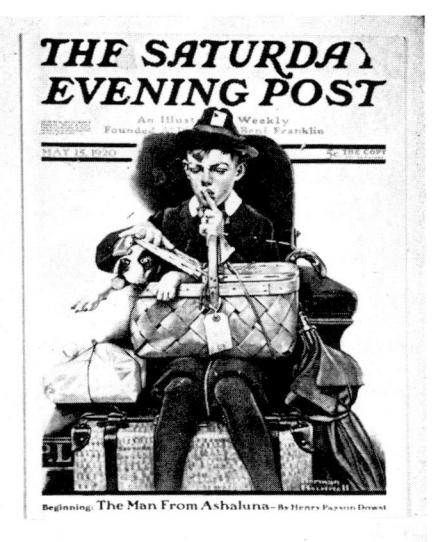

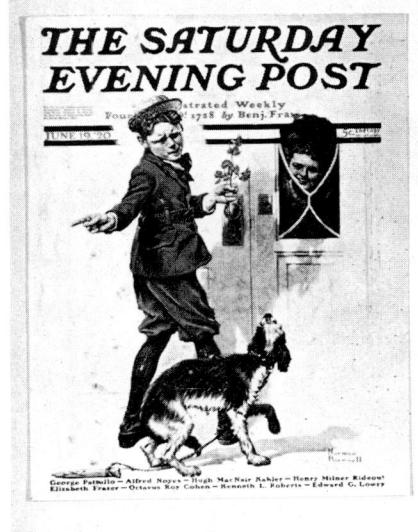

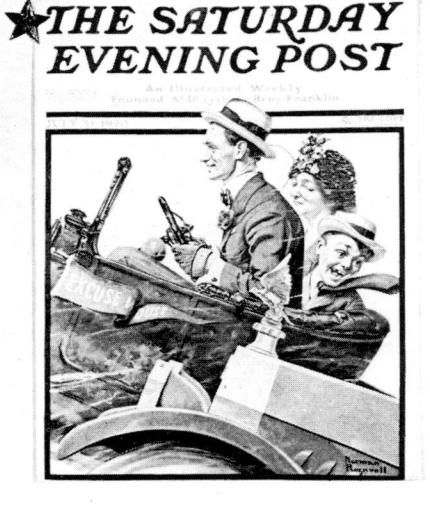

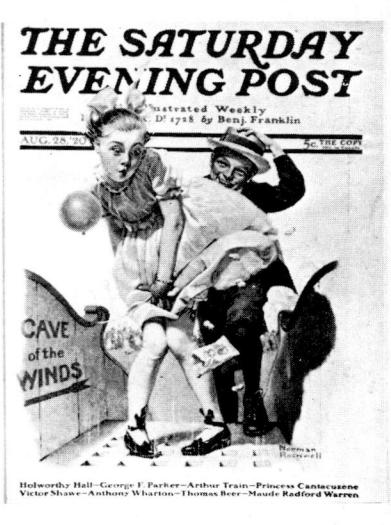

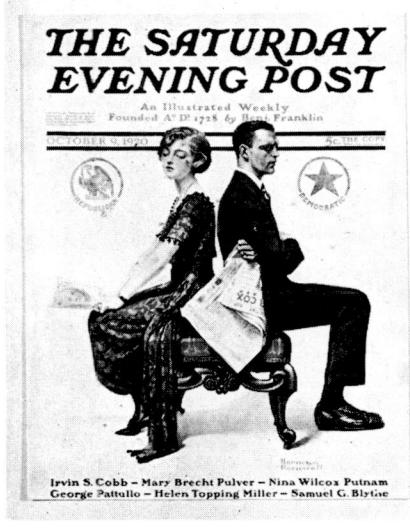

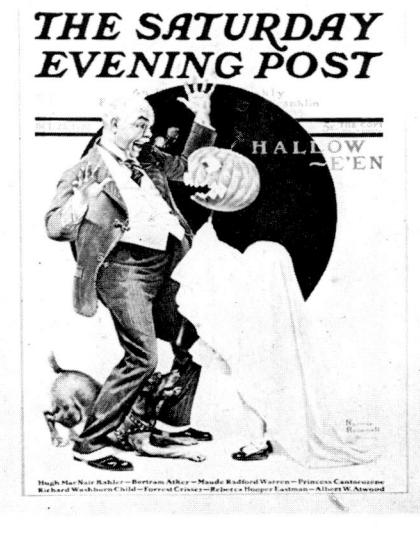

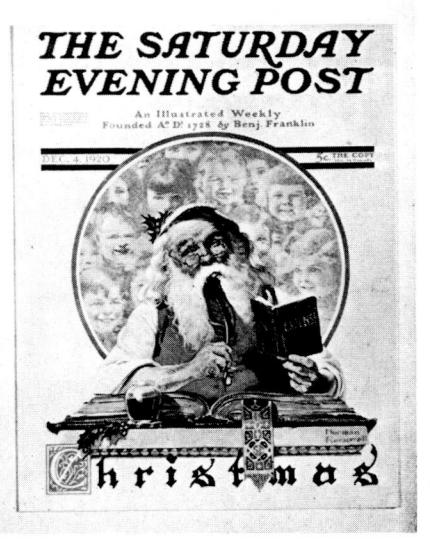

★ This July 31st cover was one of the most popular I ever did. In 1920, Ford jokes abounded; the Ford car was always good for a laugh. My models were Mr. and Mrs. Dave Campion and family. I used Dave frequently. He had a news store in New Rochelle and was a wonderful model. N.R.

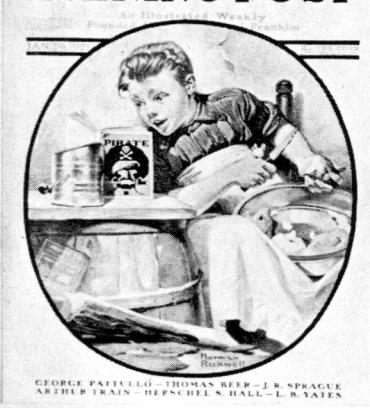

THE SATURDAY **EVENING POST**

THE SATURDAY

THE SATURDAY EVENING POST

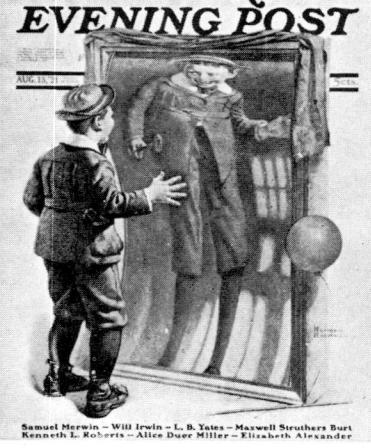

THE SATURDAY

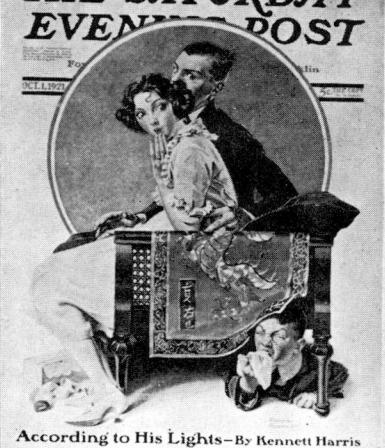

THE SATURDAY **EVENING POST**

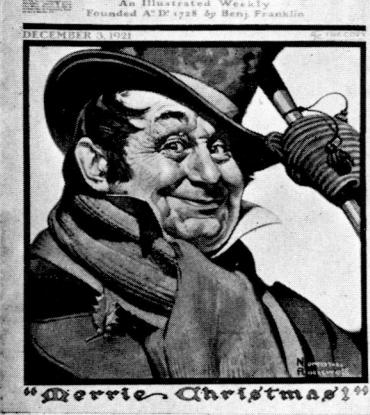

THE SATURDAY EVENING POST

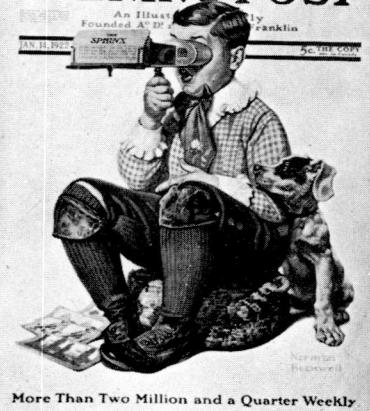

THE SATURDAY EVENING POST

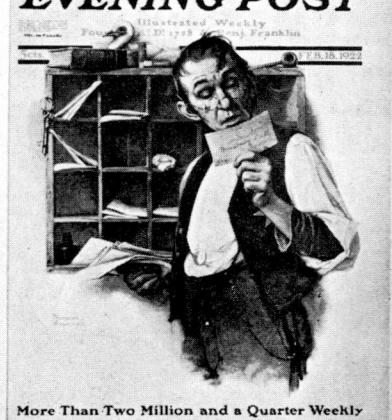

★ For this July 9th cover I engaged a mother to meet me at a photographer's with her child. He was a cheerful child who just wouldn't cry. Finally the woman asked, "You want the kid to cry?" I said "Yes." She pulled a pin from her bosom and jabbed him. He yelped! Well, it was her child! N.R.

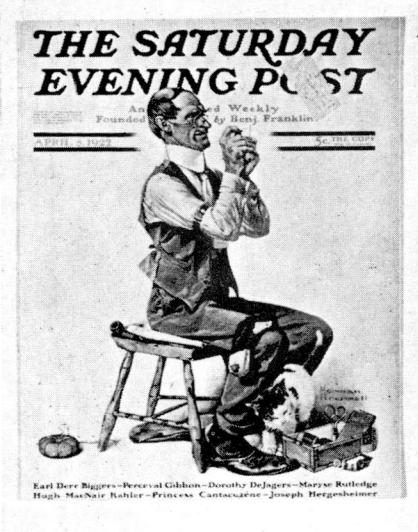

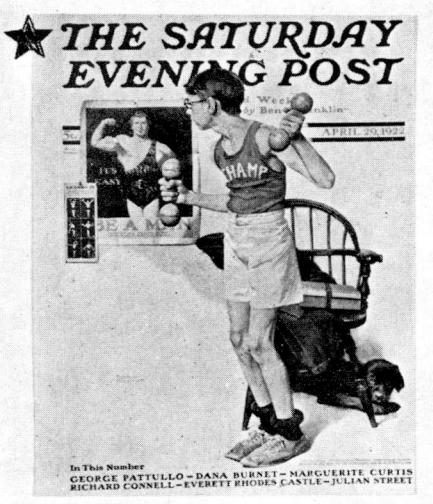

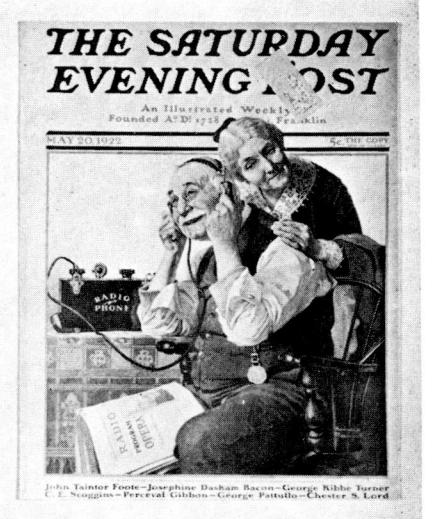

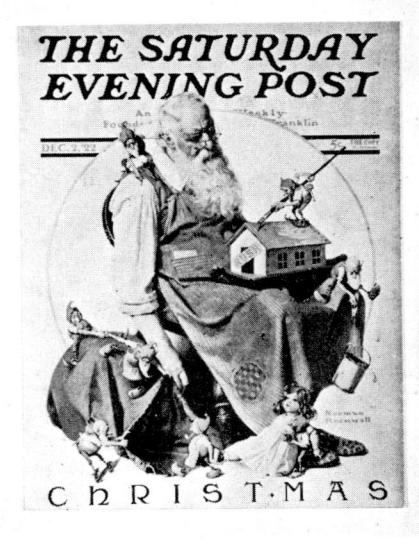

★ My April 29th cover was a sort of self-portrait because in those days I, like lots of other youngsters, went in for physical culture very seriously. However, as I grew older and wiser I decided it was better to keep the figure I had, for, "... be it ever so homely, there's no shape like your own." N. R.

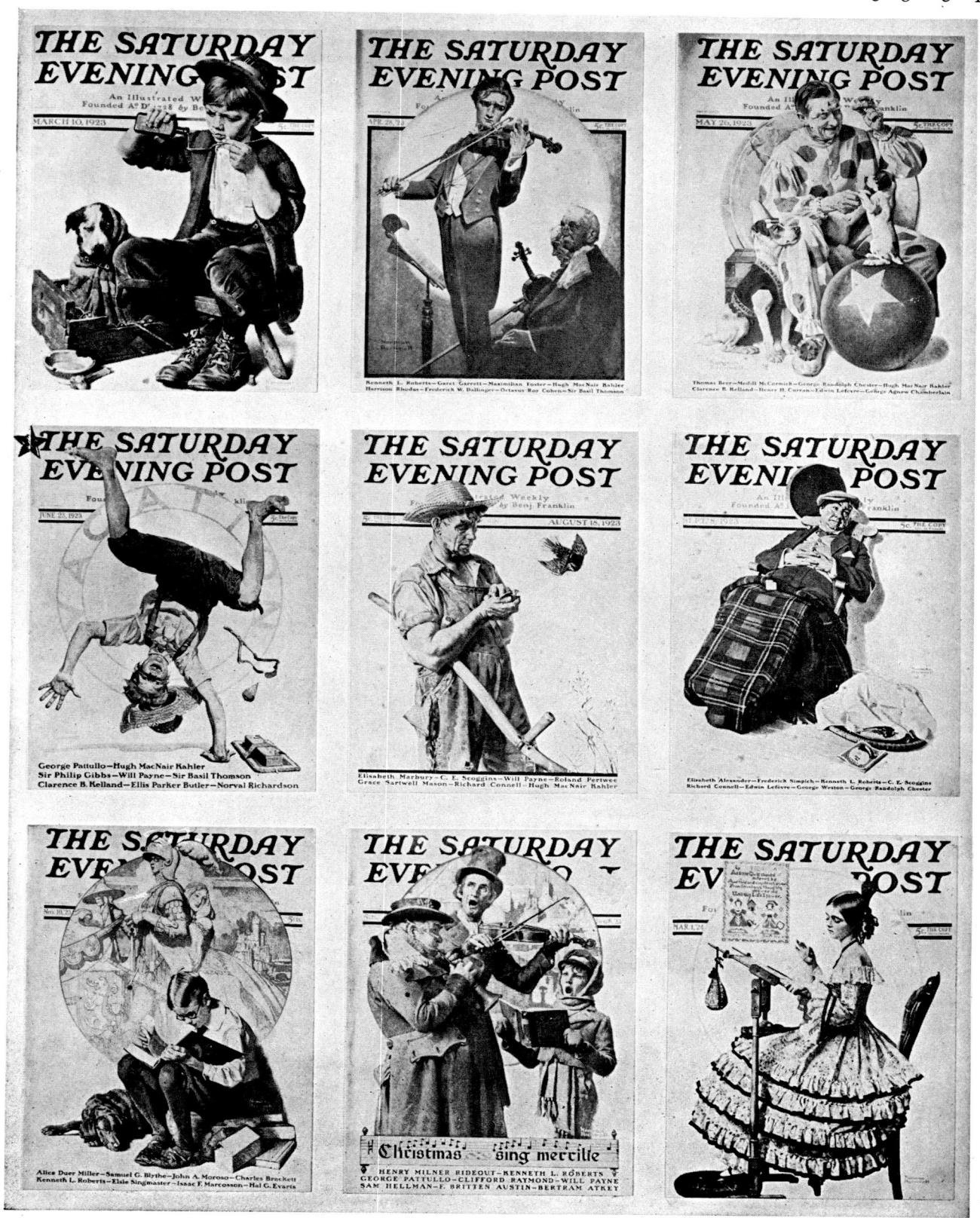

★ There was a trick used for this July 23rd cover of a boy turning a somersault. I had the boy sit in a chair, extend his legs and hold his hands over his head. Then I put a light on the floor and painted the boy. When the finished picture was turned the other side up, there he was, somersaulting! N. R.

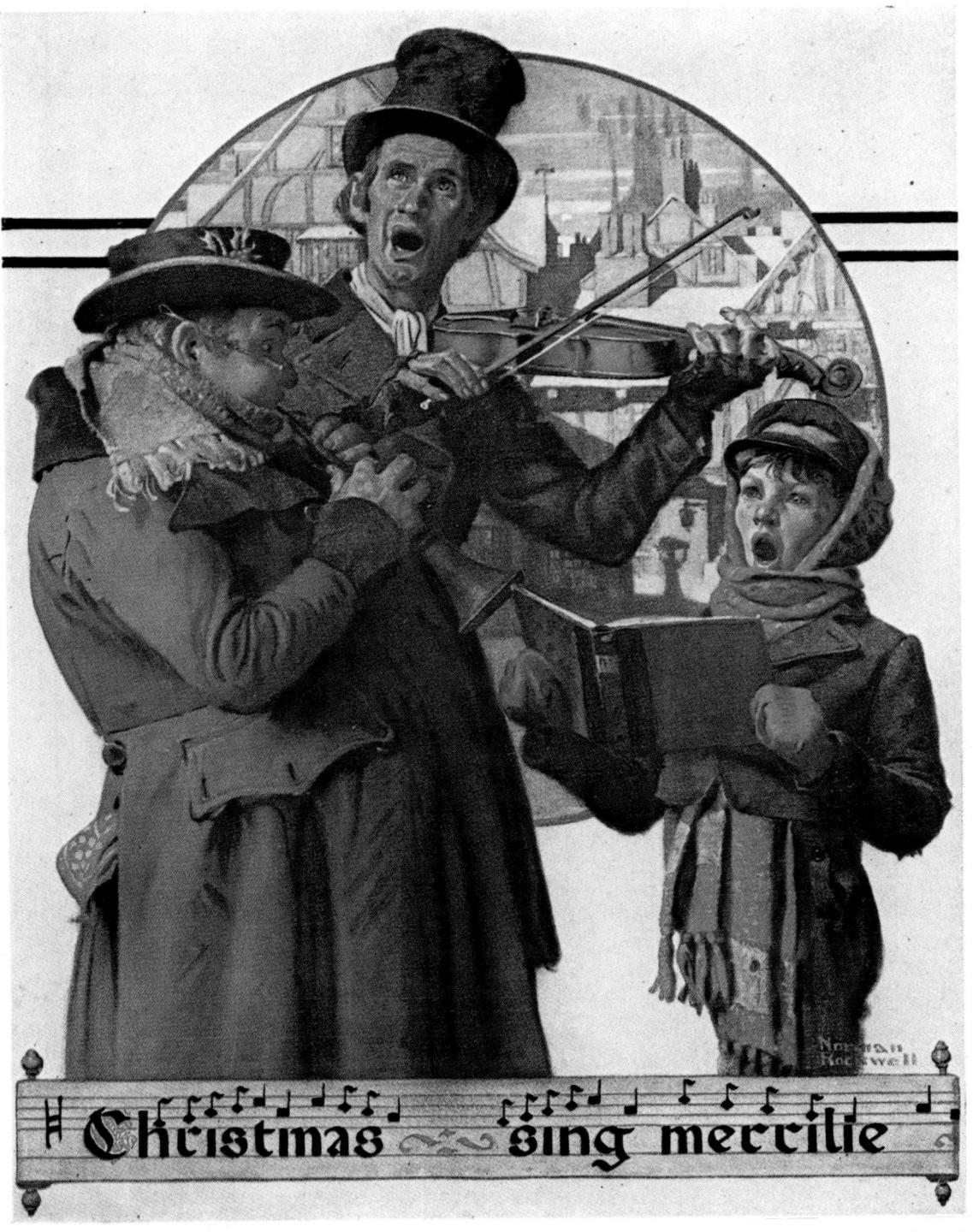

ORIGINAL 23" x 29"

DURING THIS PERIOD, POST COVERS WERE BLACK AND RED

Posing for this December 8th cover was the nearest these carollers ever came to musical performance! Dave Campion couldn't play the violin nor could Pop Fredericks play anything. Bill Sundermeyer had no ear for music. N.R.

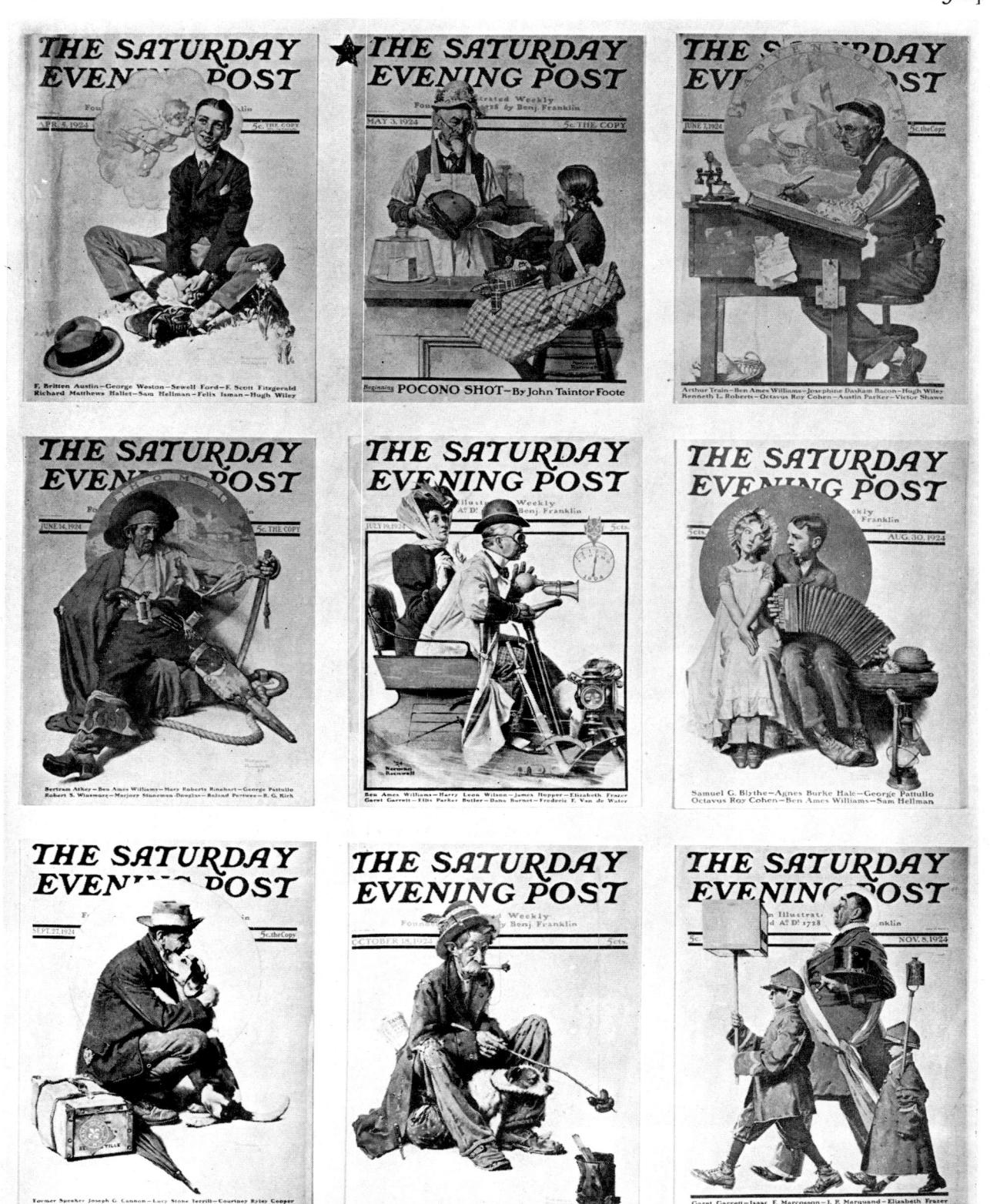

★ J. L. Malone, my model for the May 3rd cover, posed for me a great deal and often read aloud. He had a calm voice; as they say in the movies, "it was entertaining and educational." At times he would read as long as eight hours at a stretch. Other models have read to me, too, and so has my wife. N. R.

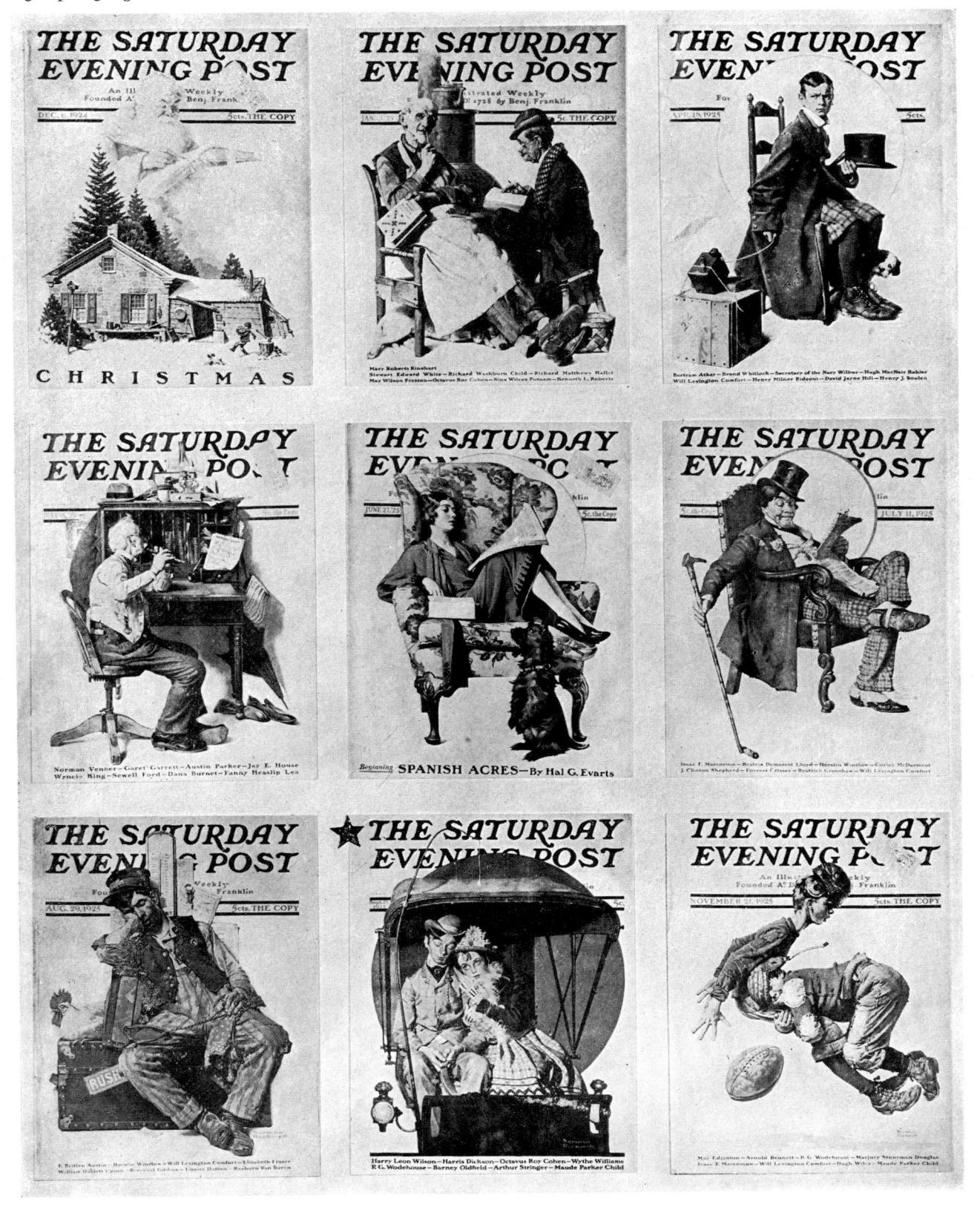

★ The photo at the top of page 44 shows me at work on this September 19th cover. Imagine me dragging that buggy into my studio! I suppose that is the way I looked twenty years ago. I was worried about growing old, and wondering how long I would be in the game. I still worry and wonder! N.R.

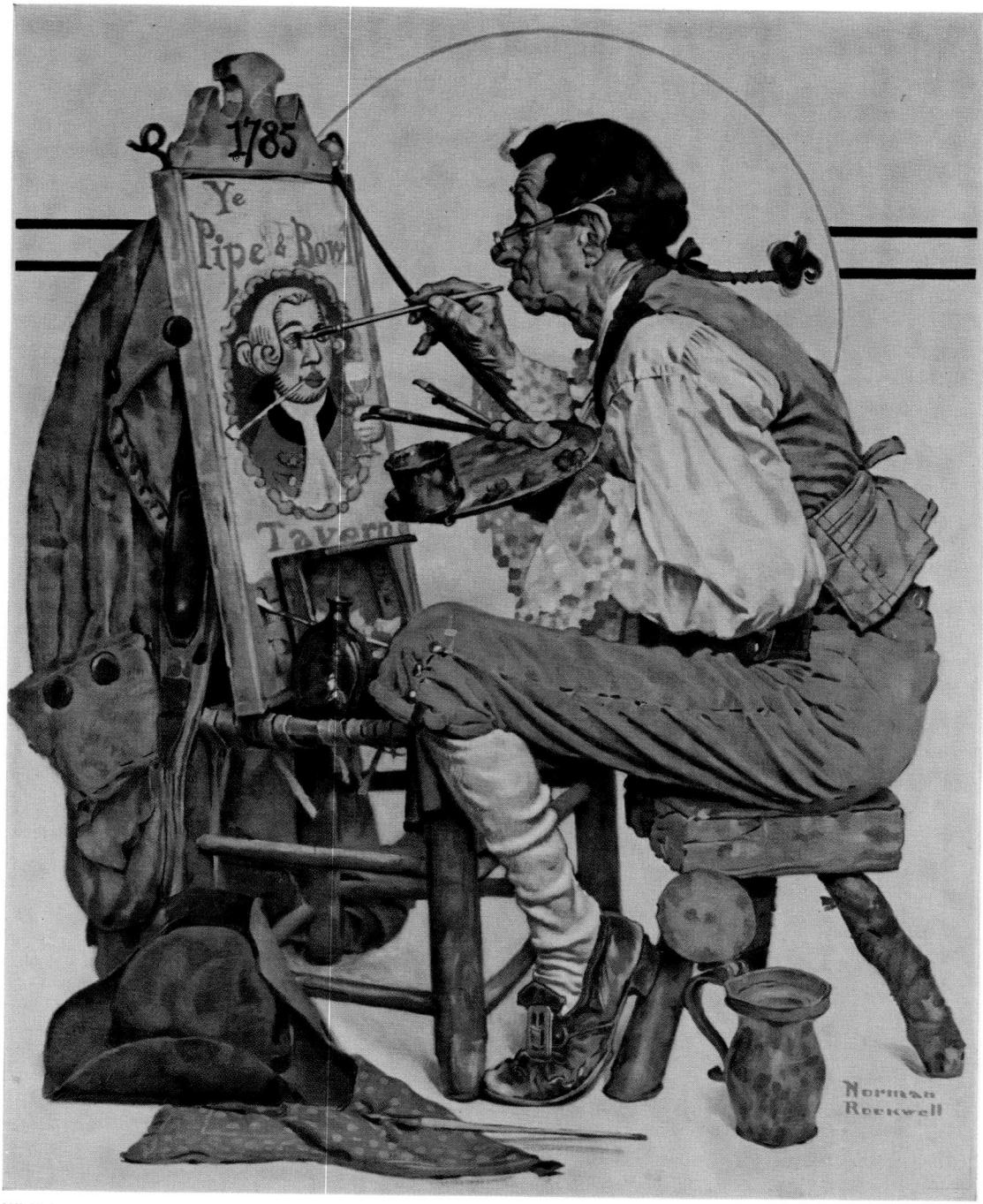

COURTESY OF THE POST AND F. M. HAISTON

ORIGINAL 22" x 27"

THIS WAS THE FIRST POST COVER PRINTED IN FULL COLOR

I paid James K. Van Brunt ten dollars to shave off his eight-inch mustache—his pride and joy—before posing for this painting. It was like cutting down a great oak—he could never quite make the eight inches again. N. R.

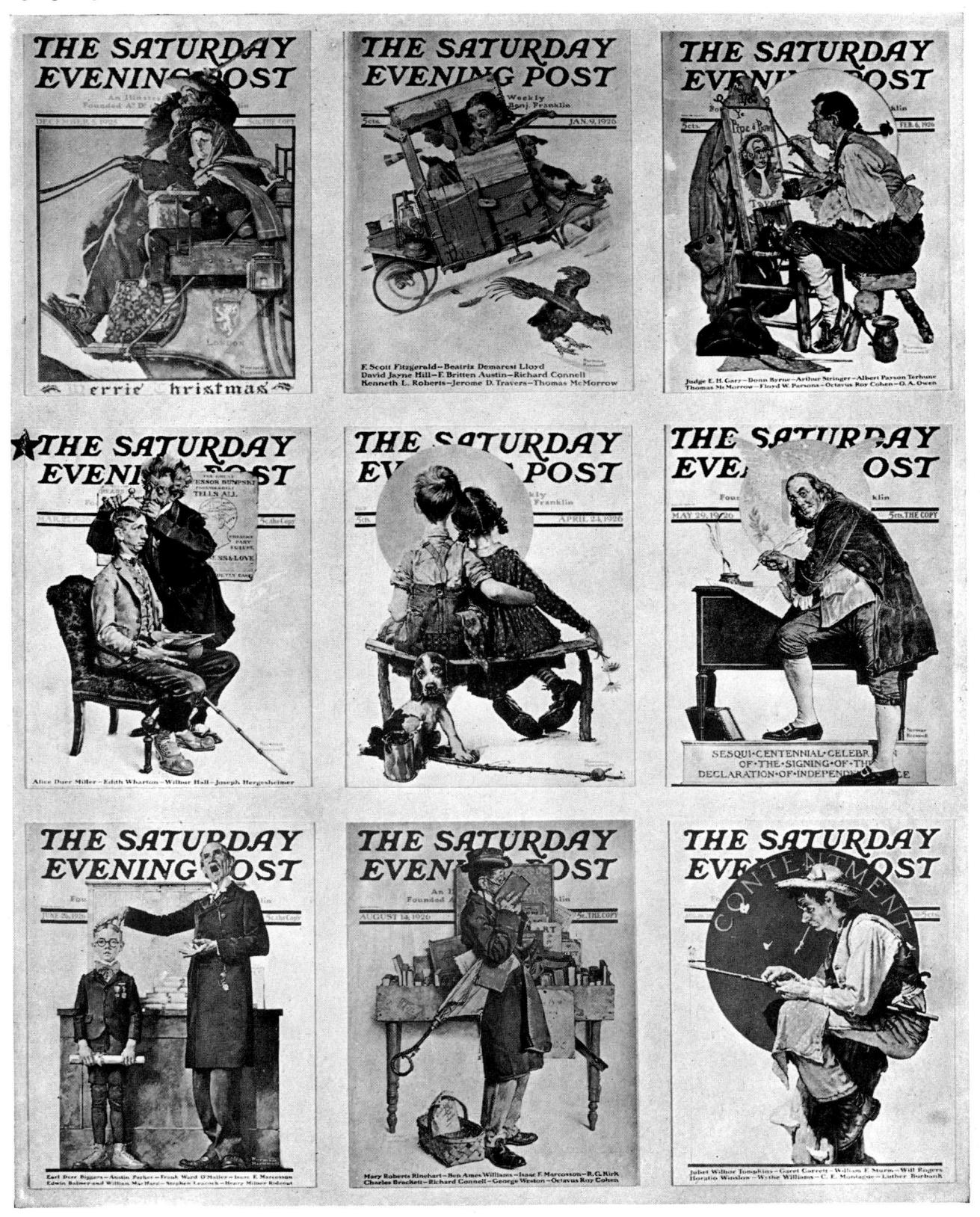

★ This March 27th cover shows Van Brunt with his mustache. It is interesting to compare this with the cover in color, opposite, done after the mustache was removed. By turning these pages one can easily discover other Van Brunt covers—for example, that of October 18, 1924, page 162. N.R.

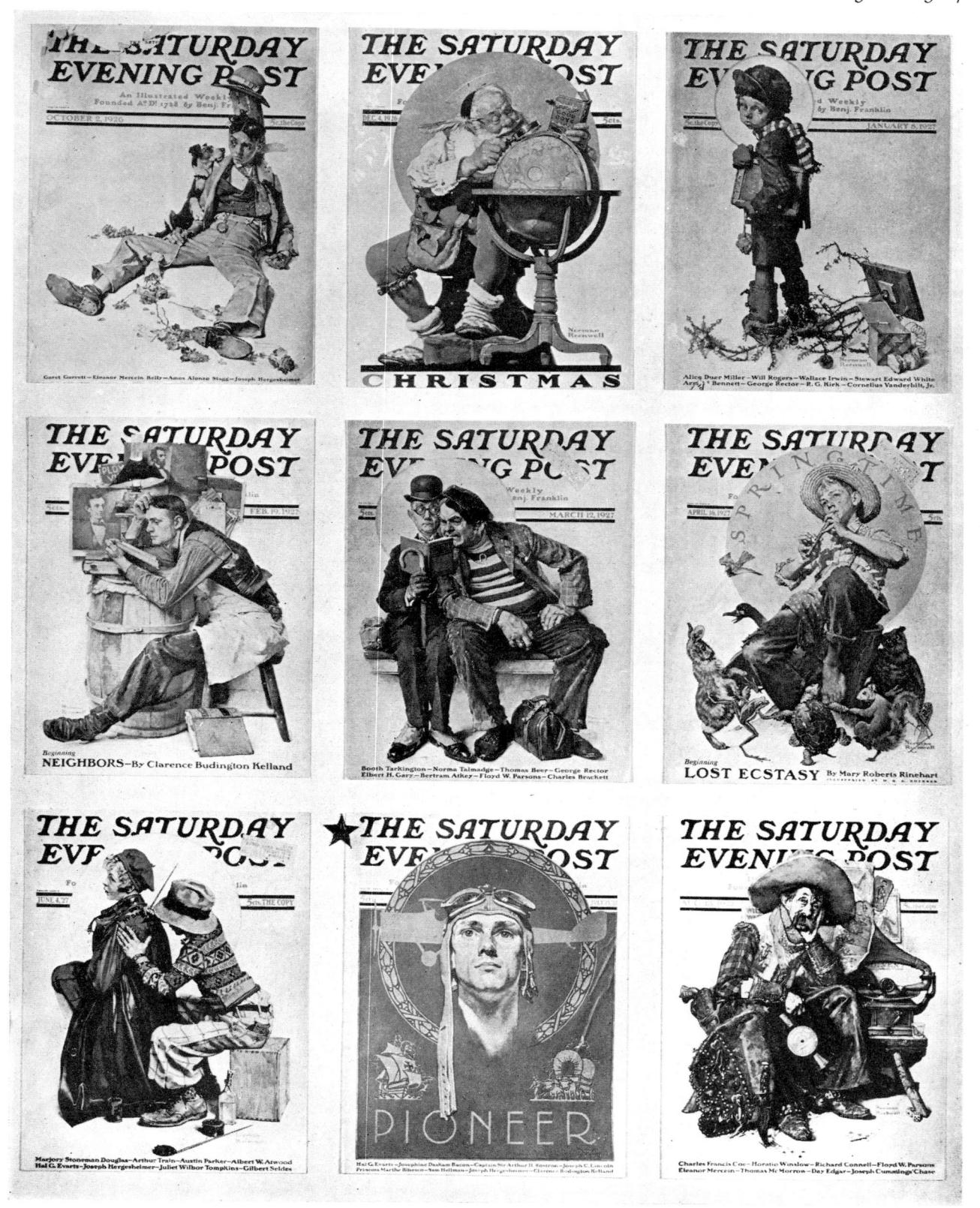

★ Lindbergh had just made history because of his dramatic plane flight across the Atlantic when this July 23rd cover was started. Then it was all work and no sleep until it was finished, so it could be run as soon as possible. With the aid of much coffee, I stuck to it for 26 hours straight. N.R.

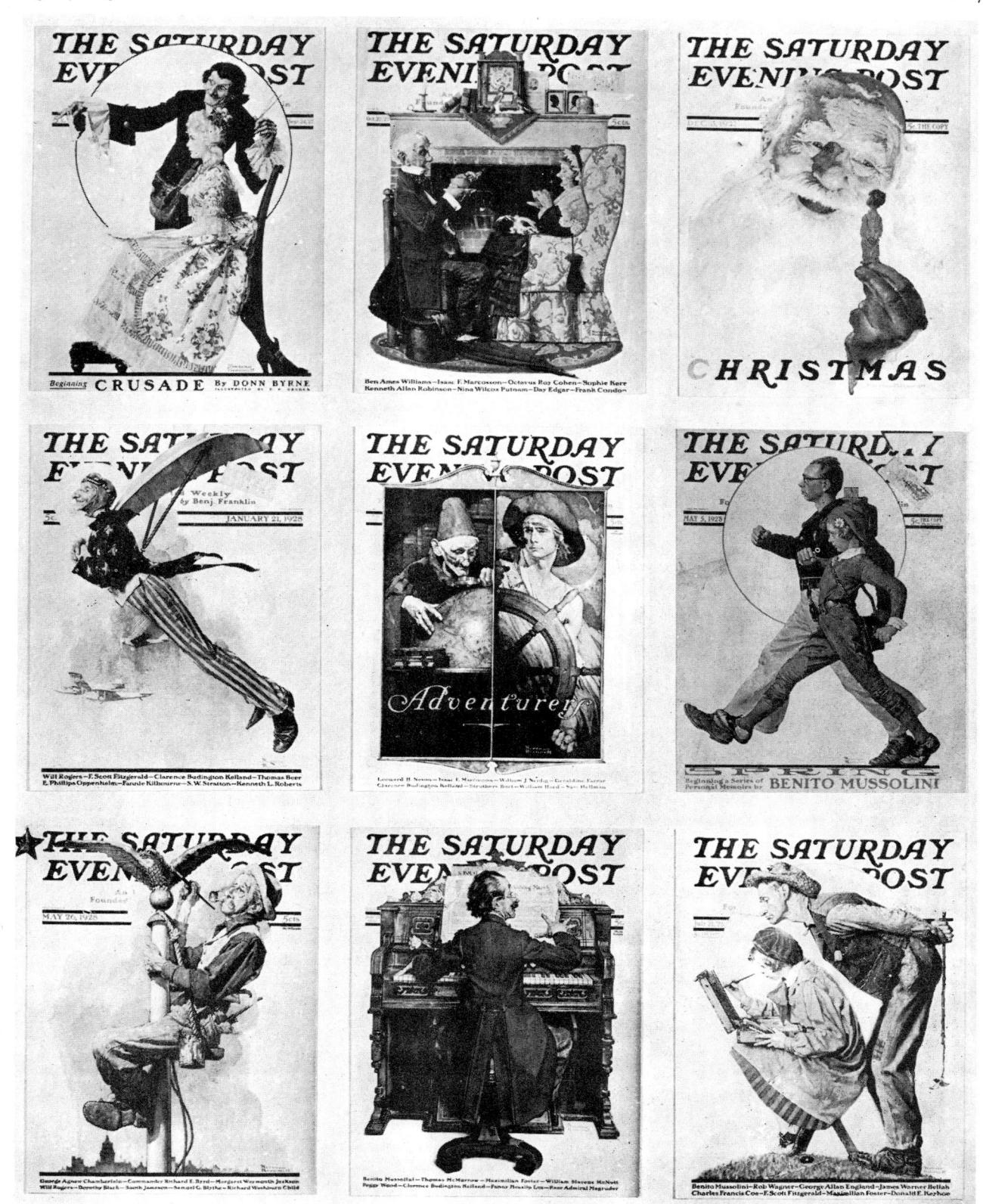

★ This Gilding the Eagle cover, May 26th, while no world-beater, was considered one of my best of this period. My cover of the defeated suitor (October 2, 1926) was certainly one of my worst, if not my all-time low. What makes one good and one had is beyond me. Some just come easily, some don't. N. R.

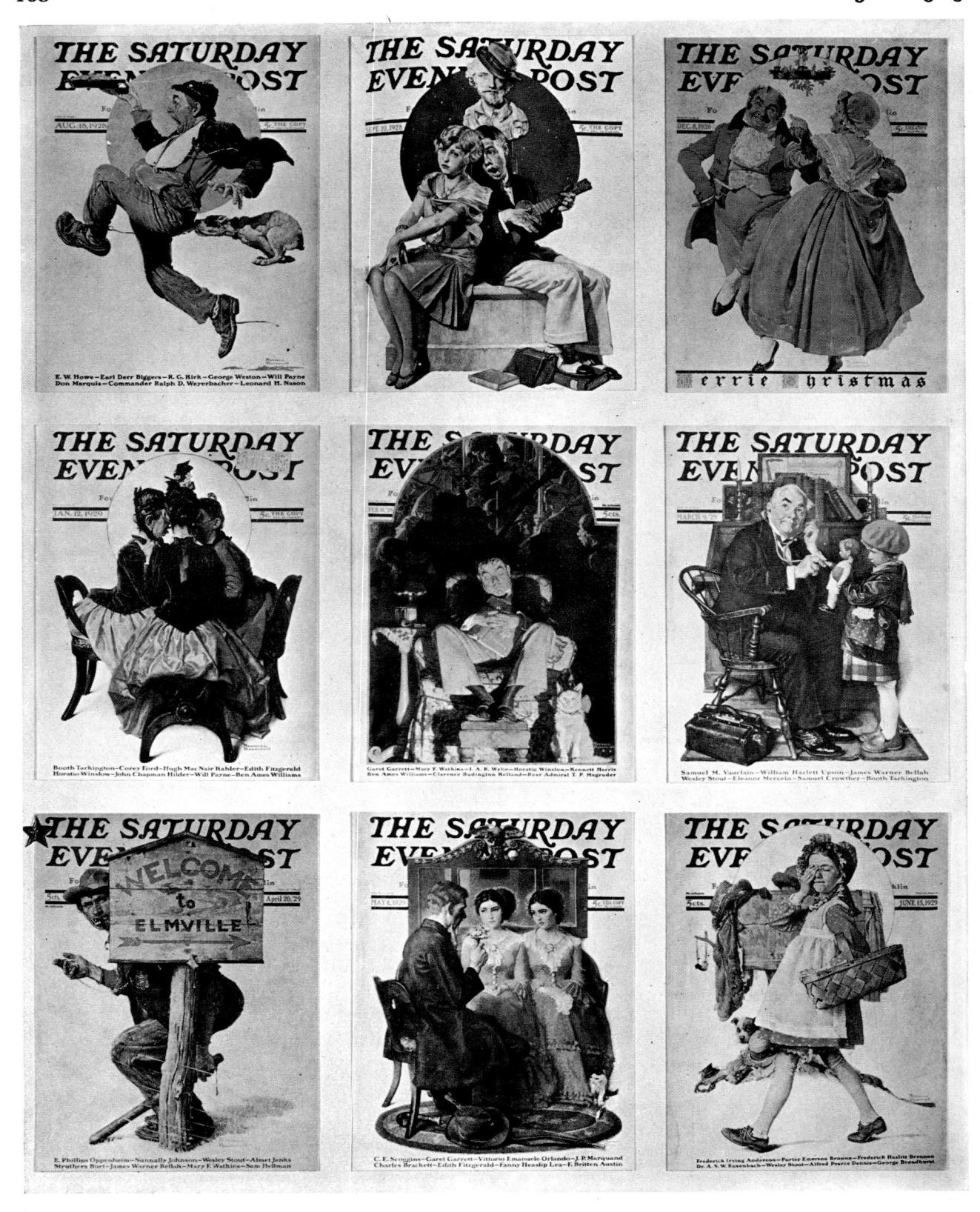

* This incident of the sheriff (cover of April 20, 1929) actually happened to me, not in Elmville, as I have pictured it, but in Amenia, New York. This was back in the days when towns paid their taxes with speeders' fines, and the Amenia cop really nailed me right alongside the "Welcome" sign! N. R.

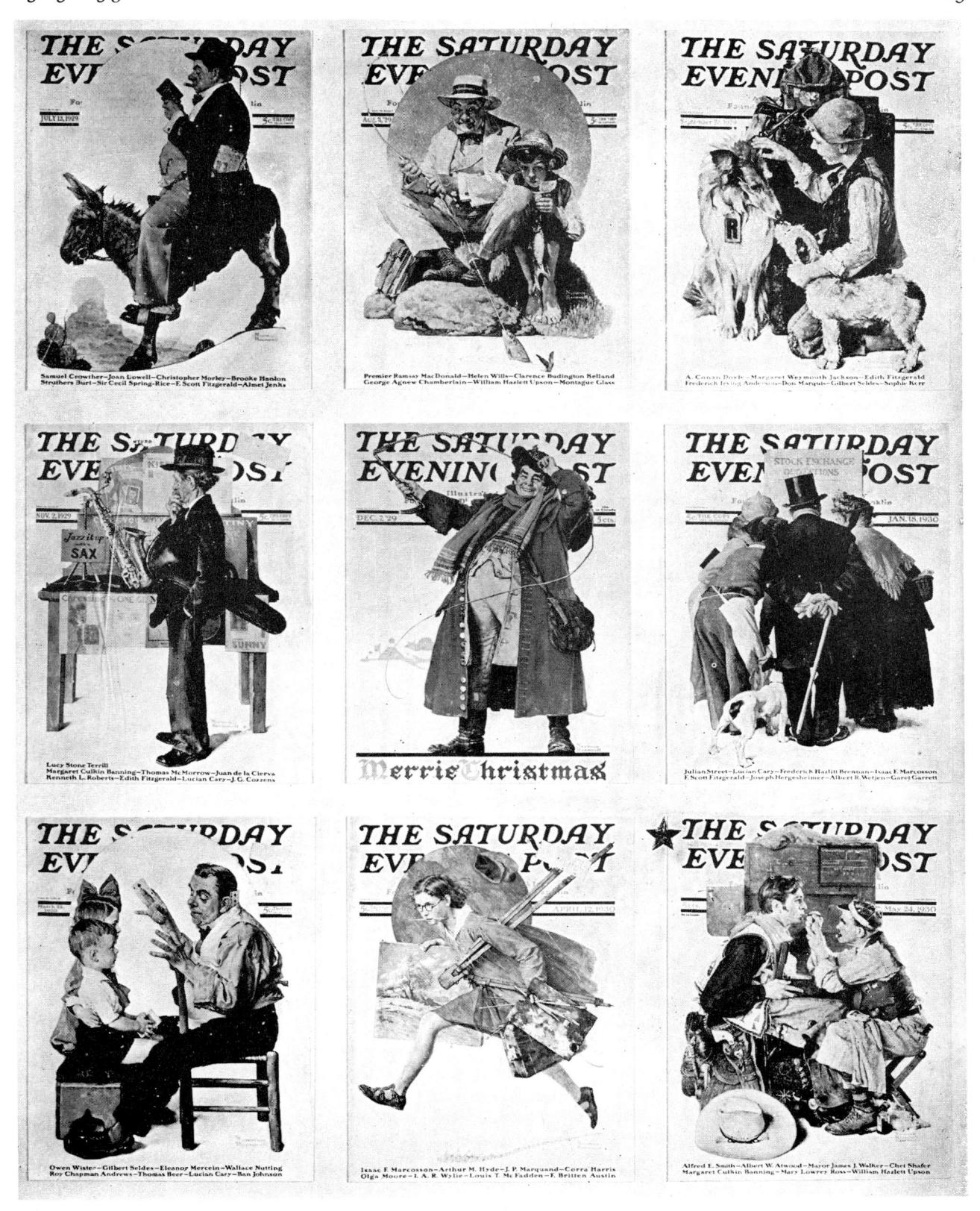

★ My model for this May 24th Movie Cowboy was Gary Cooper. He was already a very well-known actor at the time. He posed for me in Hollywood for three days and worked as conscientiously as any model I ever had. Everyone on the lot was crazy about him, and I could see why. N.R.

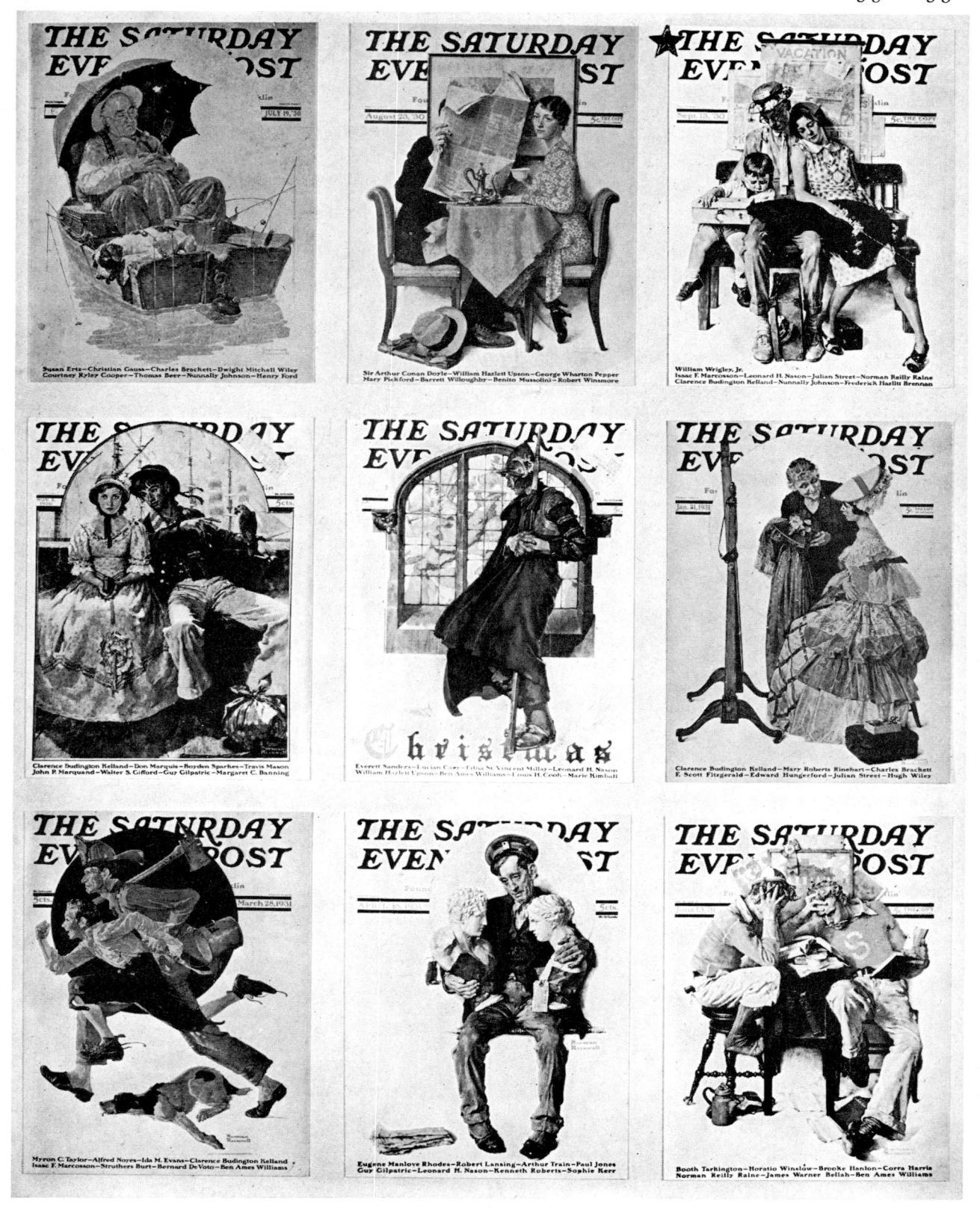

★ My friend Fred Hildebrandt, who posed for this September 13th picture, was quite amazed when he received a proposal of marriage from a woman in Australia who had seen the cover and felt that he would make her a good husband. But he said no, and is still single! N.R.

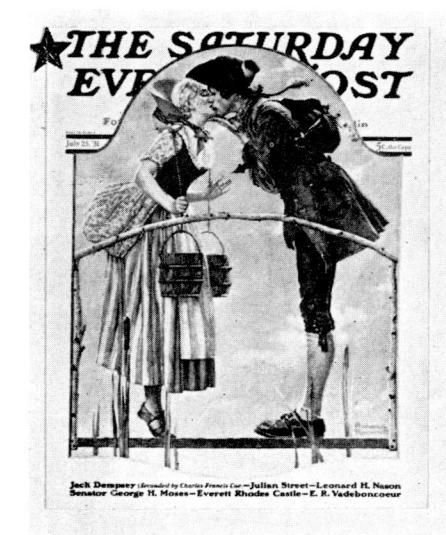

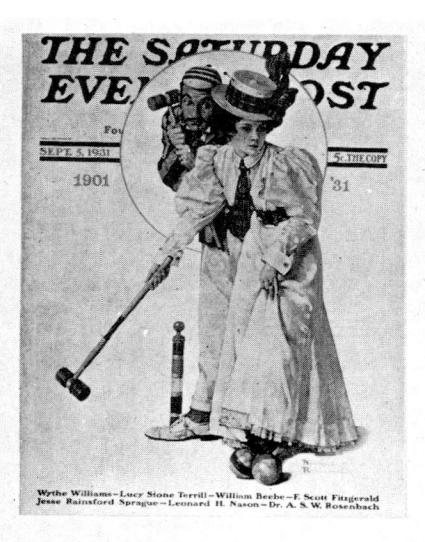

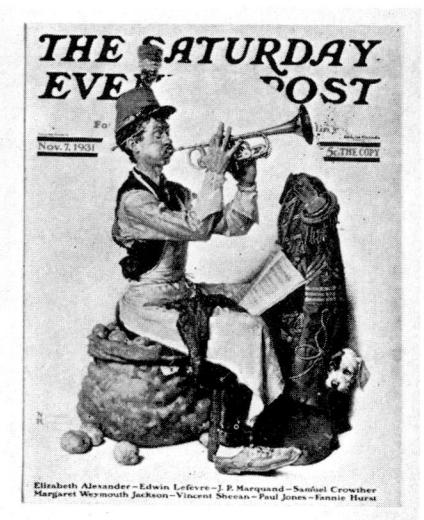

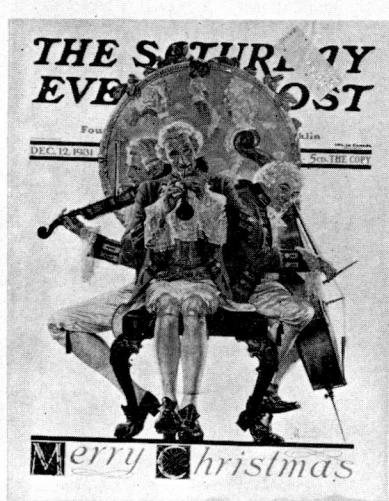

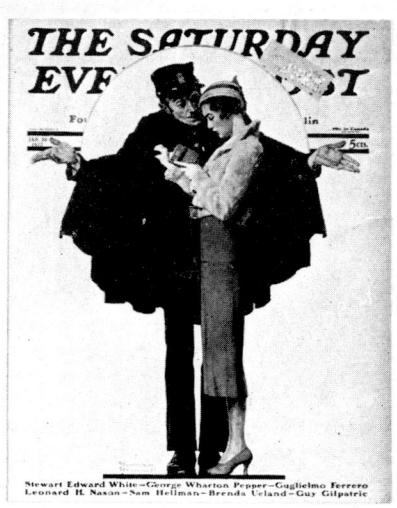

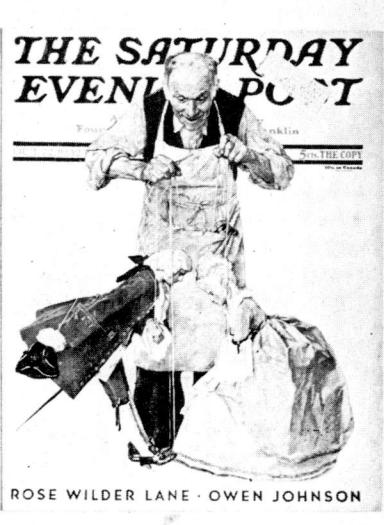

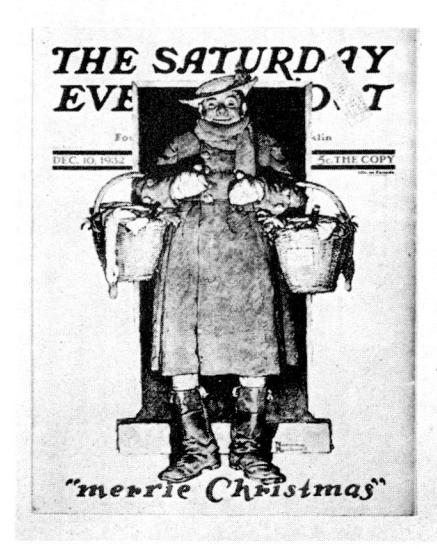

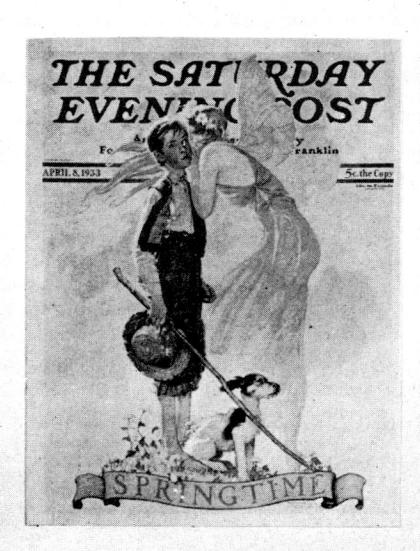

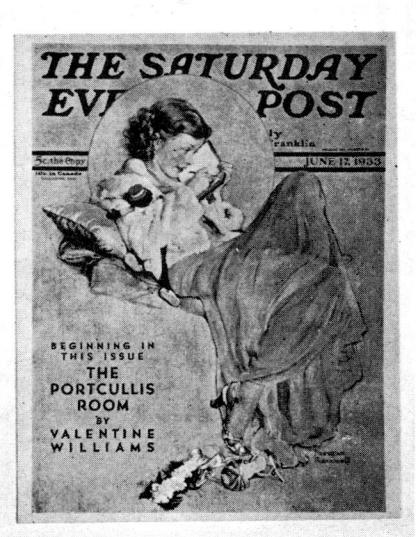

★ Hildebrandt was again tempted when he posed for this July 25th cover. He kissed one local beauty who posed with him in New Rochelle, where the cover was started, another in Chicago—we were now headed west together—and in California he added a heautiful Hollywood extra to his list! N. R.

JAMES NORMAN HALL AND CHARLES NORDHOFF

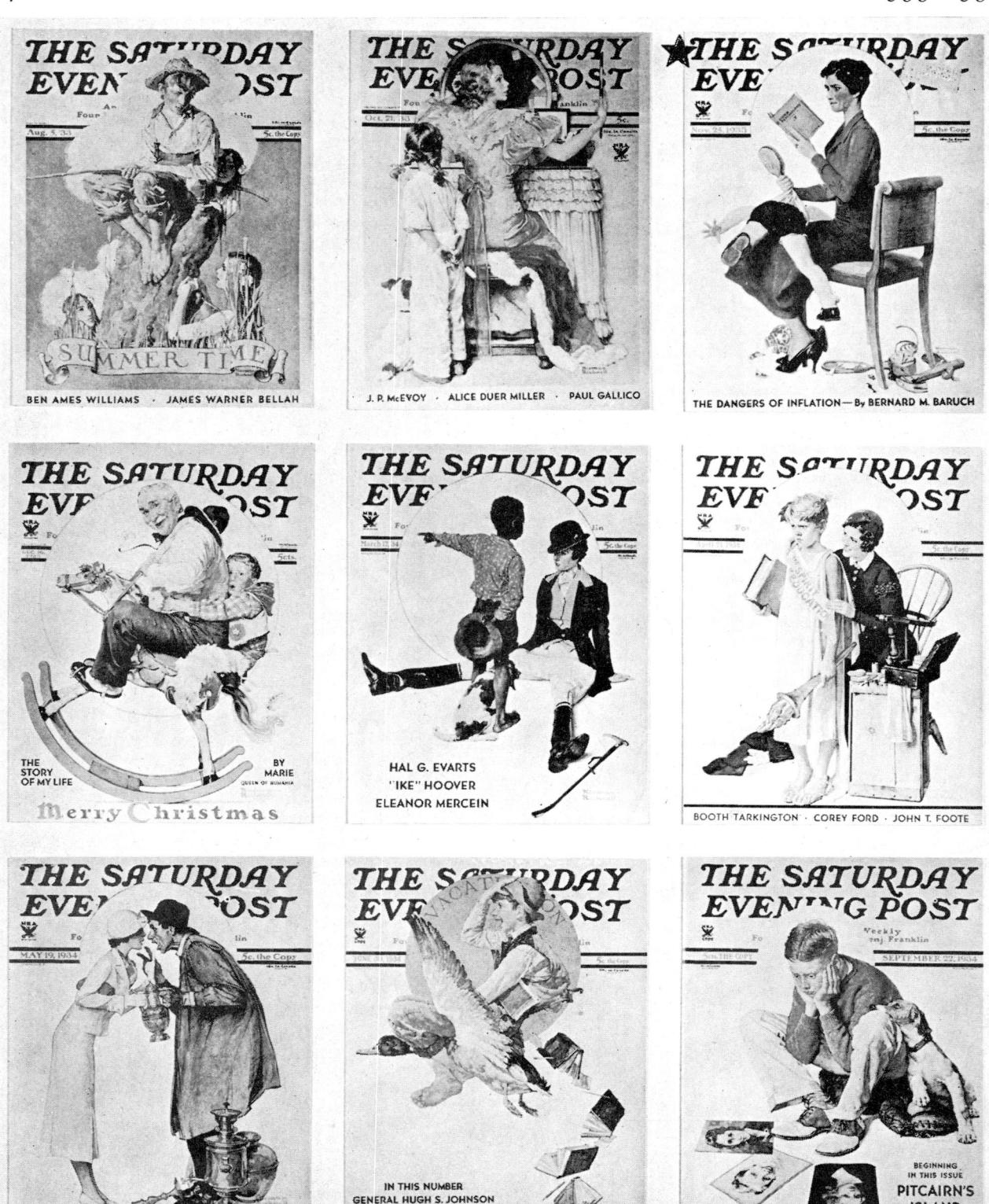

★ This November 25th cover was poorly conceived and painted, but it was timely enough to save it from its just deserts. Child psychology had hit the public like a bombshell. I was personally going through a very low period at this time, doing terrible work—even artists have their ups and downs! N.R.

GARET GARRETT - ALICE DUER MILLER - WALTER EDMOND

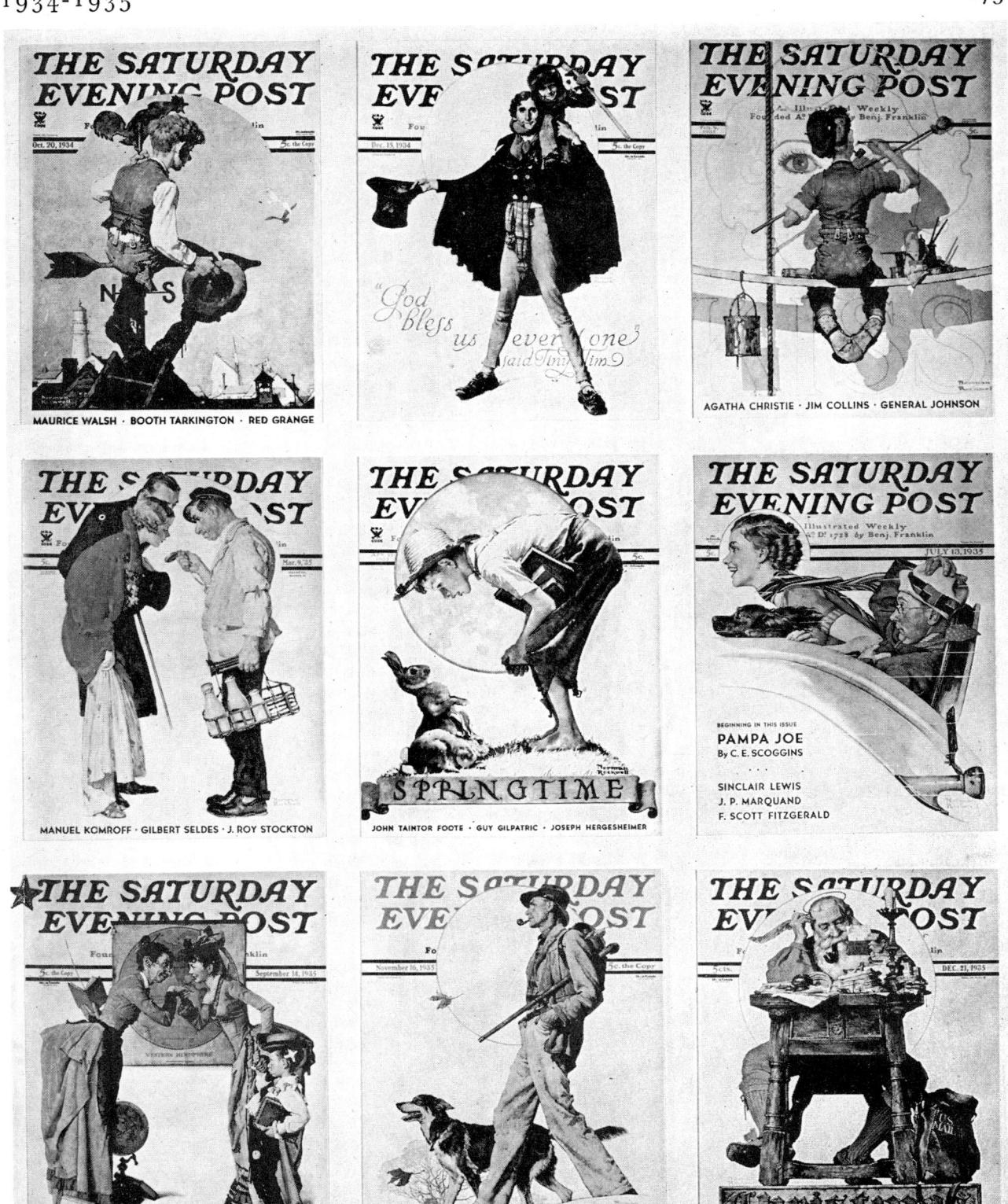

★ Boy! Did I get a slew of hurt fan mail from this September 14th cover! It seemed to me that about every school teacher in the land wrote to complain of my characterization. Similarly, I was taken to task by many post-office employees because of my cover of February 18, 1922; see page 158. N.R.

EVALYN WALSH MCLEAN . JOHN TAINTOR FOOTE

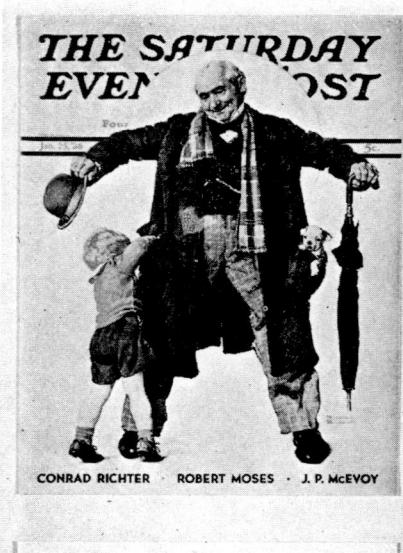

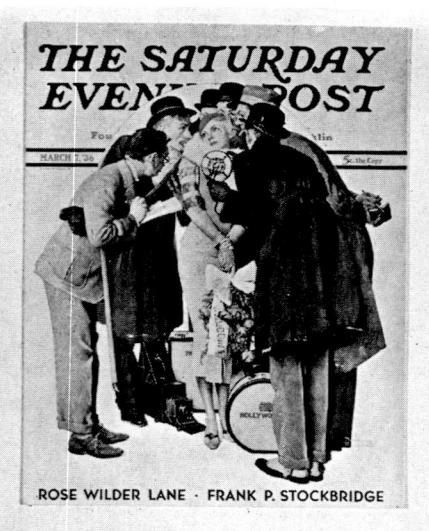

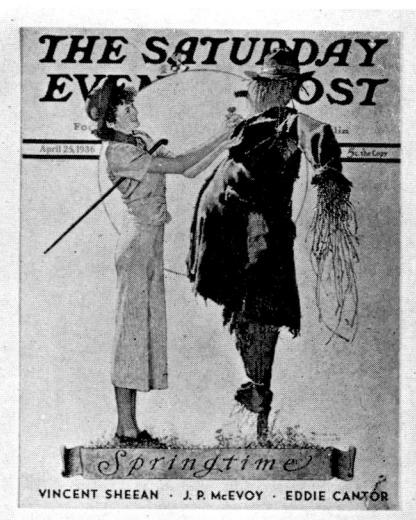

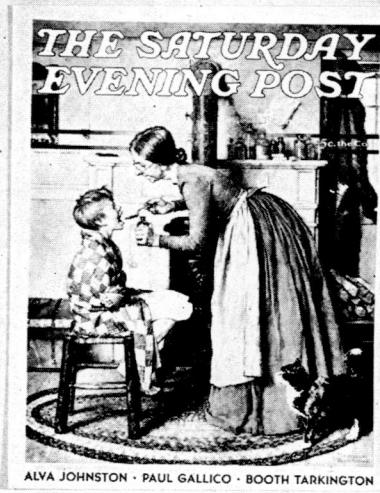

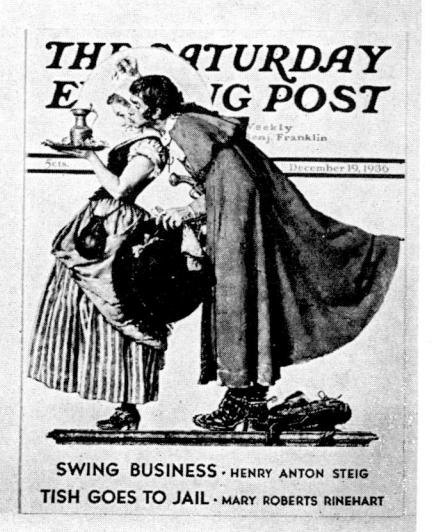

* I sometimes wonder how many people there are running around the country hating me. The woman who posed as the nurse for this October 24th cover was really very good-looking and possessed a very nice figure; she has never forgiven me for what I did to her appearance in this cover painting. N. R.

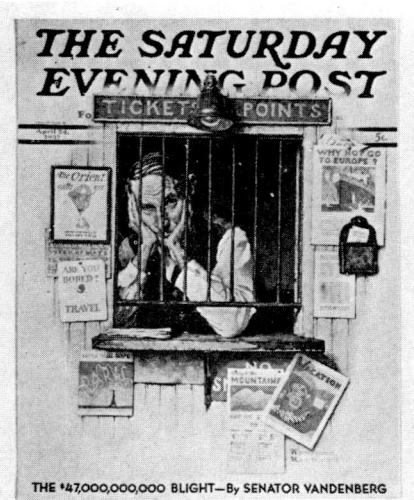

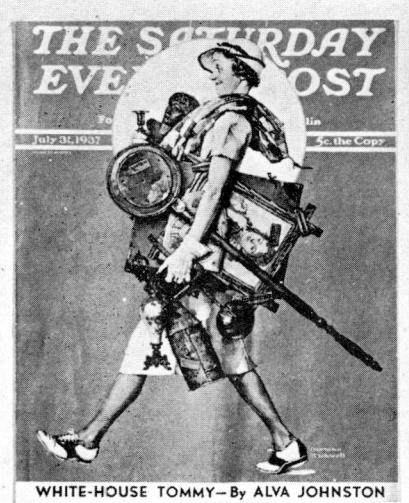

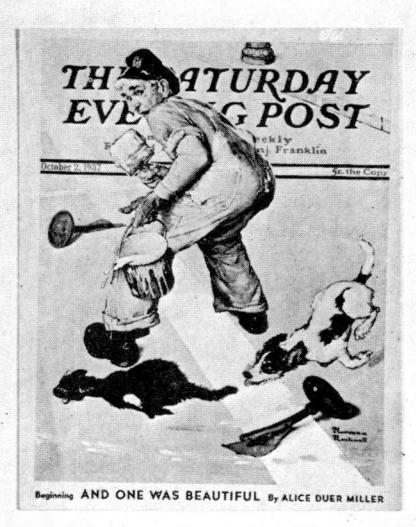

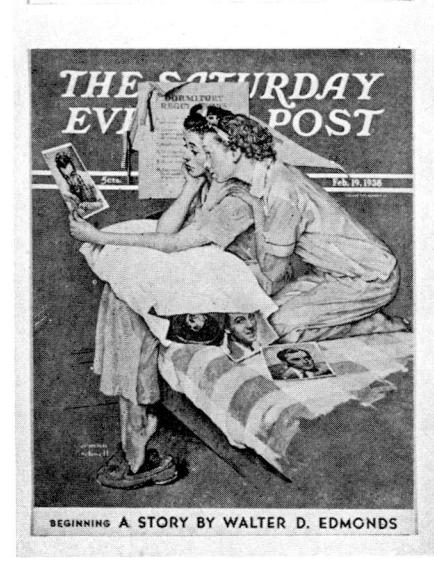

★ It seems that a family in Paris were debating whether or not to fly back to their home in Greece. They saw this June 4th picture of an old lady enjoying her plane trip and felt that they would be cowards not to return home via air—which they did. Later they wrote me a very friendly letter about it. N.R.

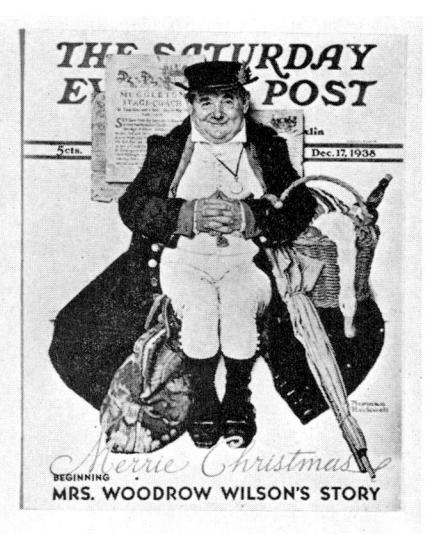

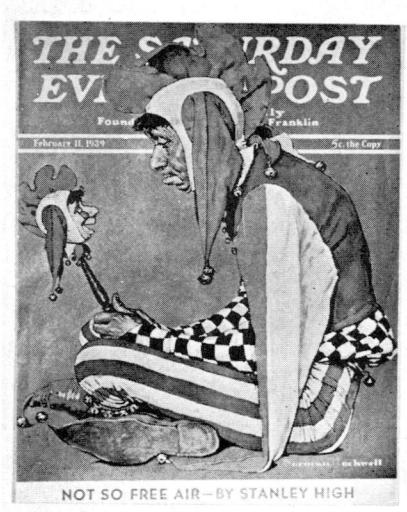

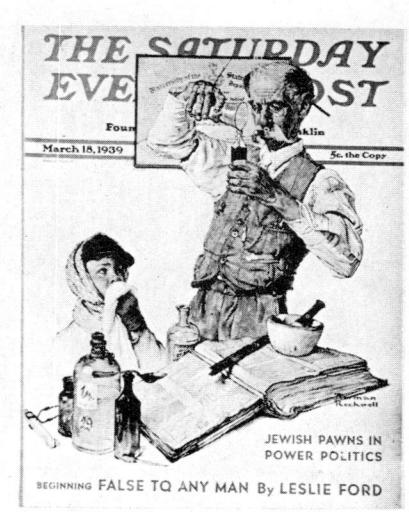

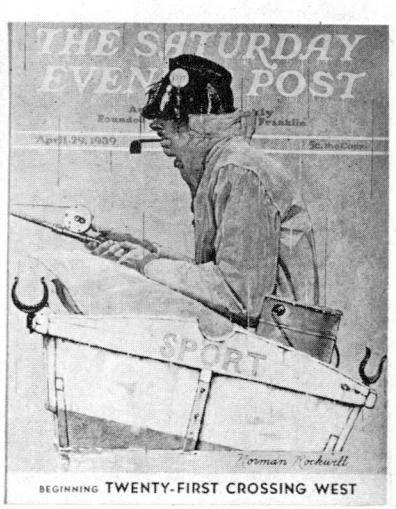

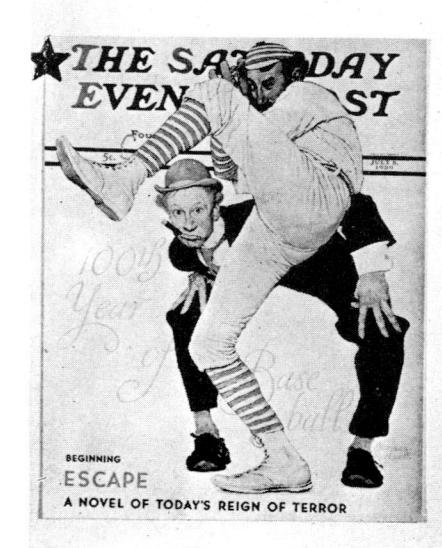

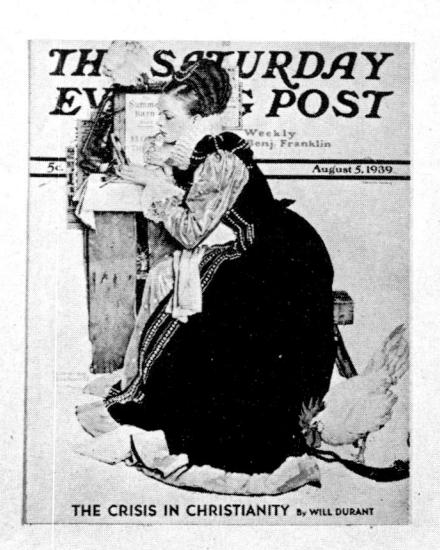

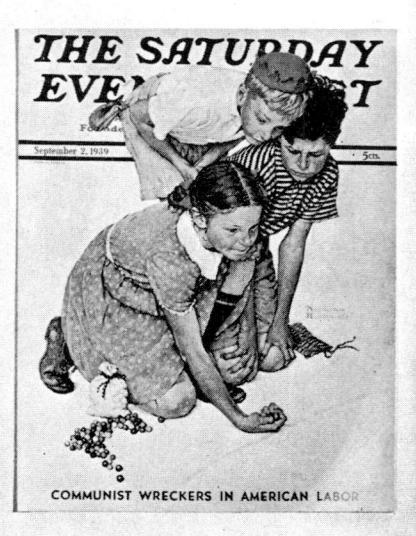

★ This "100th Year of Baseball" cover is typical of the regular cartoon type which I have always enjoyed doing. It is purely burlesque and greatly exaggerated, but a lot of fun. Today, the Post seldom uses these plain backgrounds.... The "marbles" cover was my first after moving to Arlington. N. R.

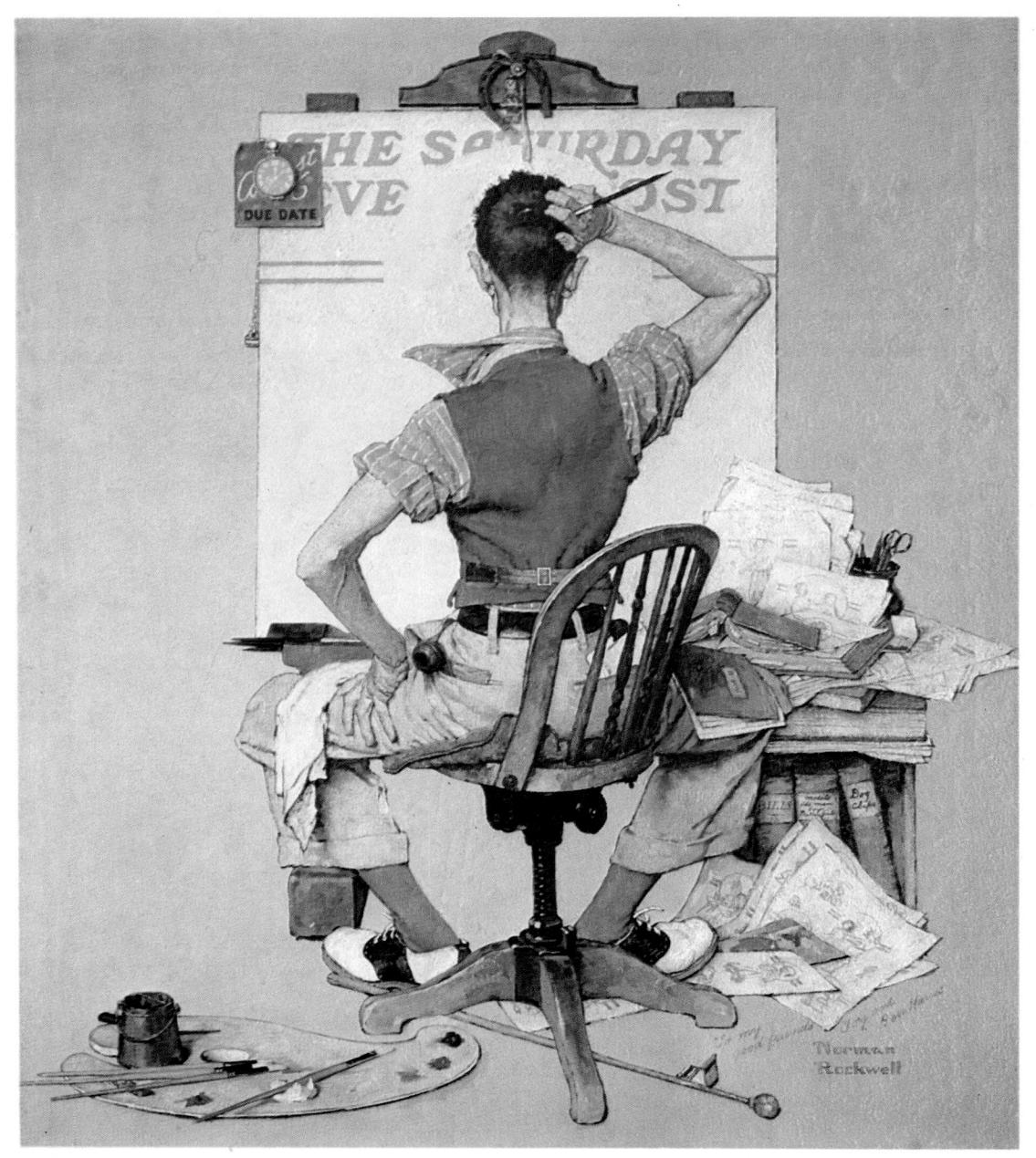

COURTESY OF THE POST AND BEN HARRIS

ORIGINAL 31" x 36"

SELF-PORTRAIT: THE ARTIST WAS FACED WITH A DILEMMA

In agony of soul this cover was done, because the most terrible thing an illustrator has to face is a deadline. Often it is a case of either getting a picture in on time—not done as well as you like—or of doing it well and being too late to have it published. This portrait is reasonably accurate. N.R.

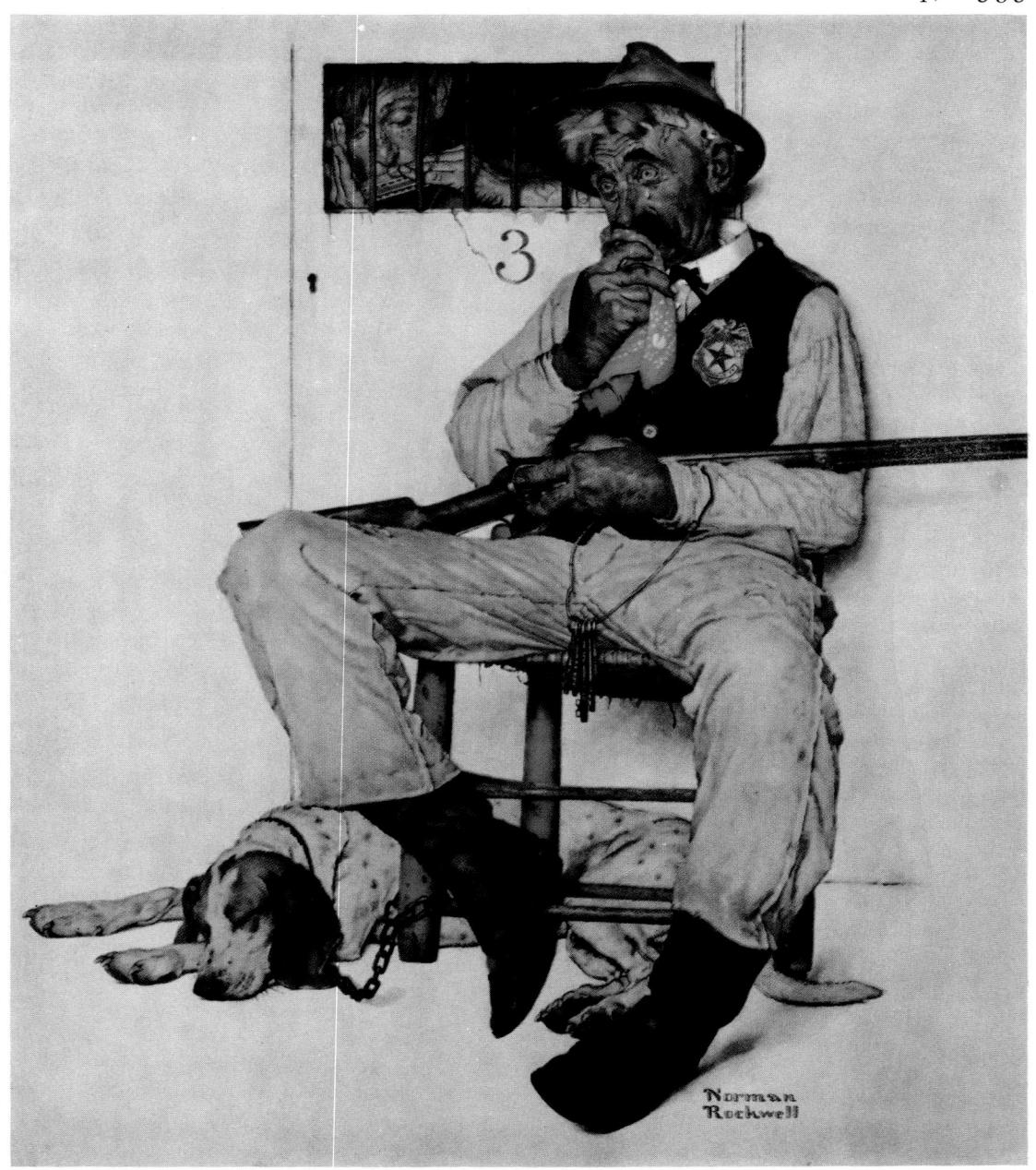

ORIGINAL 39" x 35"

A SILHOUETTED TREATMENT OF A TYPICAL GAG-TYPE COVER

My Arlington neighbor Harvey McKee, my model for this, was really a Deputy Sheriff, a little fellow but very brave. He posed with a broken collarbone and a sore hand, injured when bringing in some disorderly characters. His hand hurt—note swelling—but he was a good scout and didn't quit. N.R.
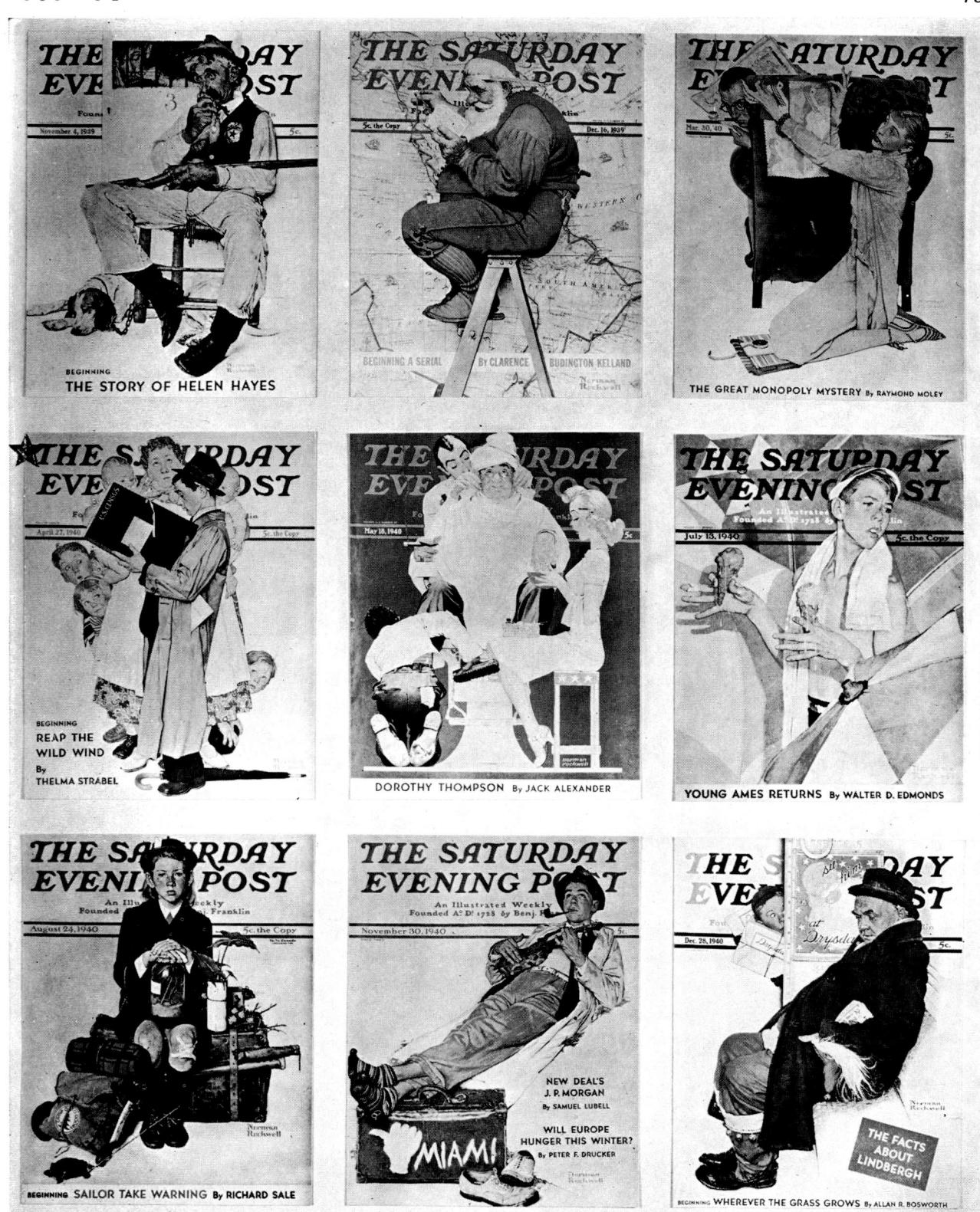

★ The census taker in this April 27th cover has rubbers and an umbrella, yet a careful study of his book shows that he is working in California. Apparently this was a great mistake on my part, for I heard from people all over California that such paraphernalia is completely nonessential. So that's that! N.R.

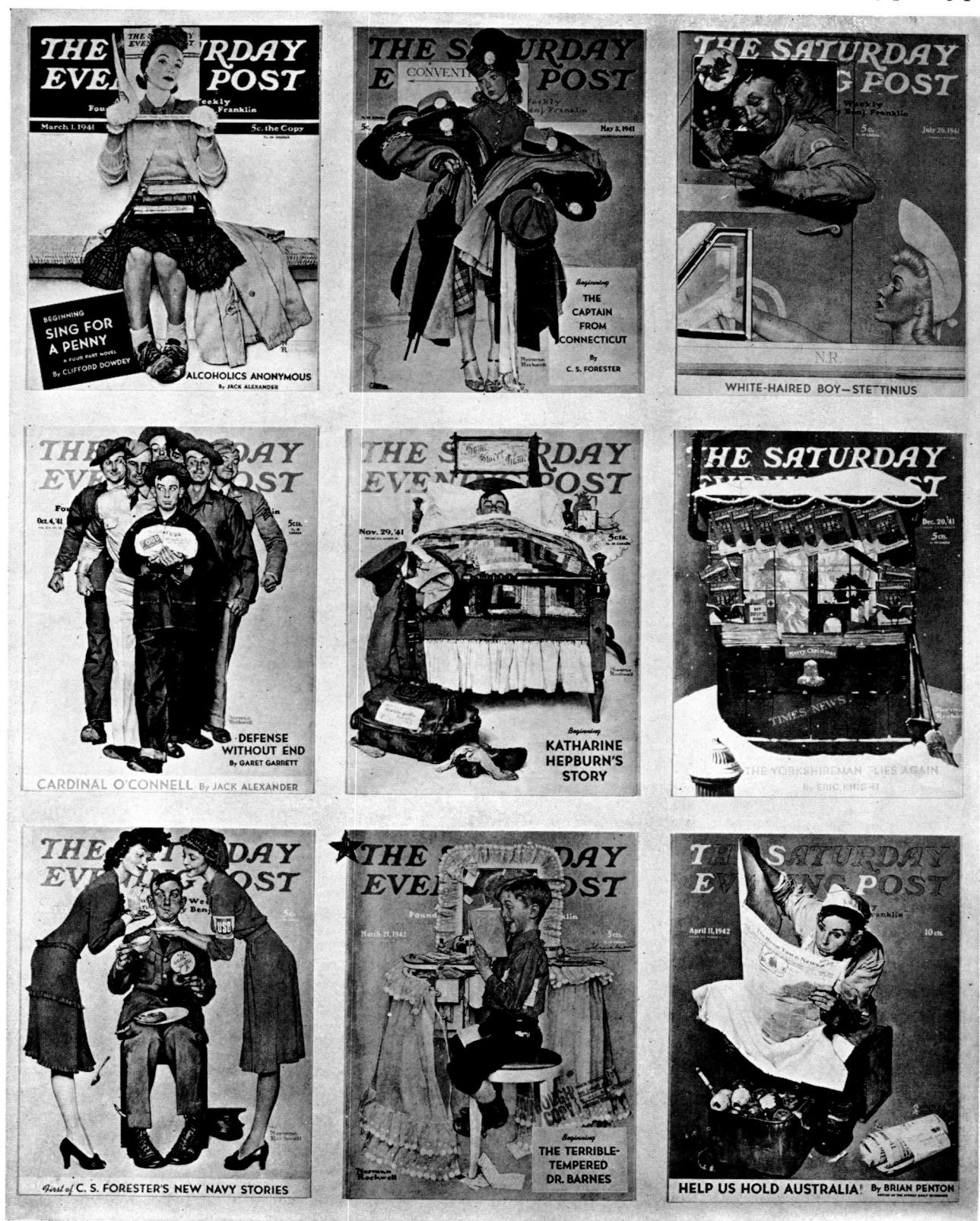

* This mischievous little boy reading his sister's diary (March 21, 1942) is my middle boy, Tommy. He was quite a little devil when this was painted and he still is. Just the kind of a kid who would read his sister's diary with great glee if he had a sister, which he has not. For his portrait, see page 110. N. R.

APRIL 3, 1943

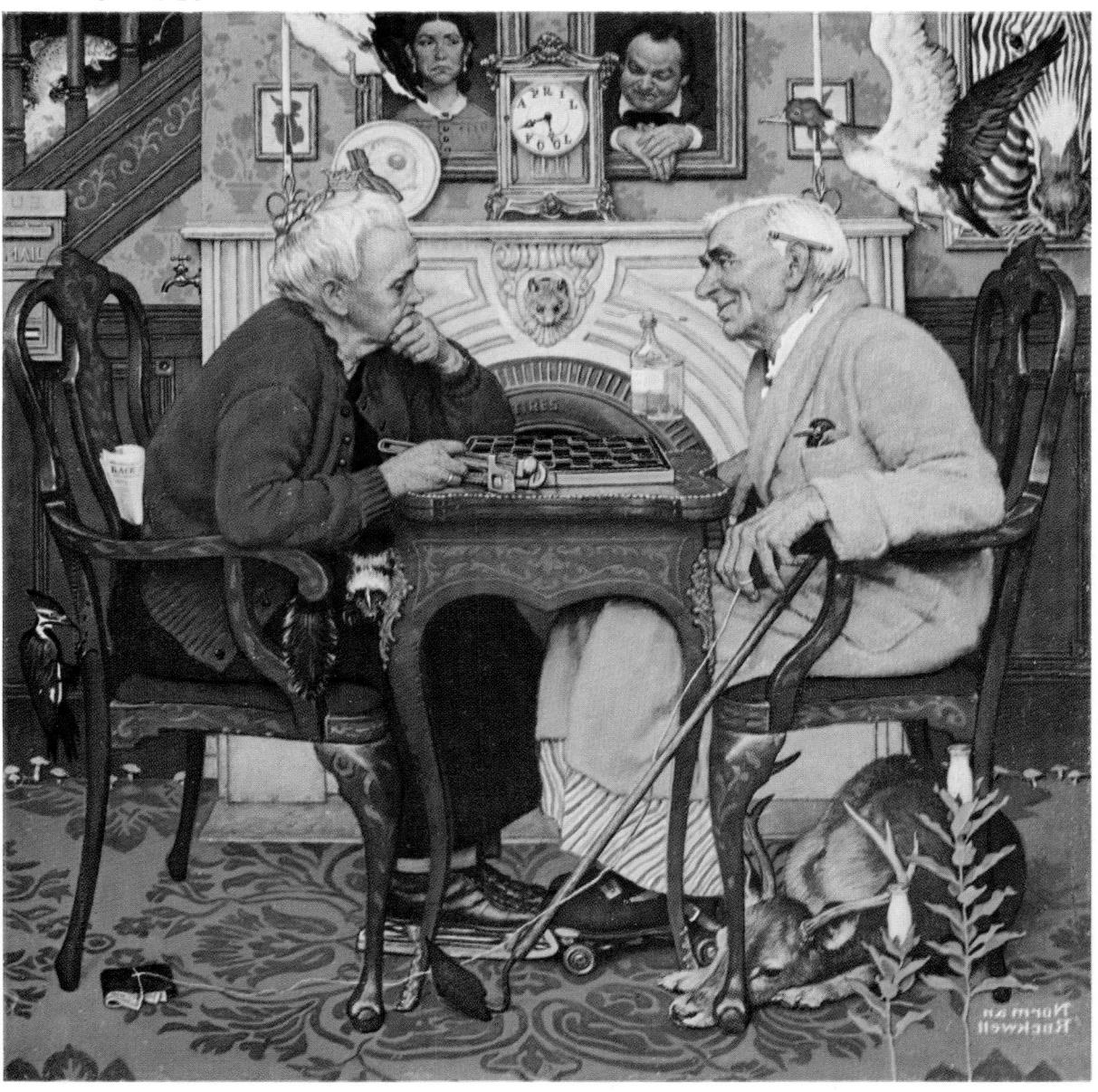

ORIGINAL 11" x 11"

CAN YOU FIND FORTY-FIVE ERRORS IN THIS APRIL FOOL COVER?

I have never done a cover yet but that someone has found things wrong with it. I finally decided to do one cover plumb full of mistakes. I believe there were forty-five in this, but I had a letter from South America listing one hundred eighty-four! The Post was flooded with mail, and so was I. Even Rockwell Kent received a few letters—we often get our mail mixed. N. R.

The Willie Gillis Series

This series grew out of my pondering the plight of an inoffensive, ordinary little guy thrown into the chaos of war. He was not to be an avid, brave, blood-and-guts soldier, though a perfectly willing—if somewhat ineffective—one. My wife hit on the name "Wee Willie Gillis"; it was based on a child's book. So that was what I christened him, not realizing that there were thousands of Gillises, some of them Willies. There even turned out to be a colonel—later promoted to brigadier general—named Willie Gillis.

Next thing was to find a model. One night at a square dance in Arlington, Robert Buck came from over the mountain. I kept moving around him, studying him from different angles, until I decided he would do. He told me afterwards that if I had stared at him just once more he would have knocked me flat.

The series started on the Post of October 4, 1941. After that, Willie Gillis covers appeared with considerable regularity; there were eight or ten in all. Bob was supposedly unfit for military service, which suited me fine; but suddenly he patriotically enlisted as a Navy aviator and dashed off to the South Seas. So, when the Post wanted me to do another Willie Gillis picture, I was in somewhat of a dilemma—all that I had was a group of photographs of Buck. But I finally worked up the idea of showing Willie through six generations. The cover stirred up unusual interest. Hundreds of letters poured in from Gillises and others all over the country. I still hear from people who want to learn what has happened to Willie. I really don't know; I haven't heard from him, though I've been told he's safe and sound. I'm afraid by the time he gets back, he will be completely forgotten. N. R.

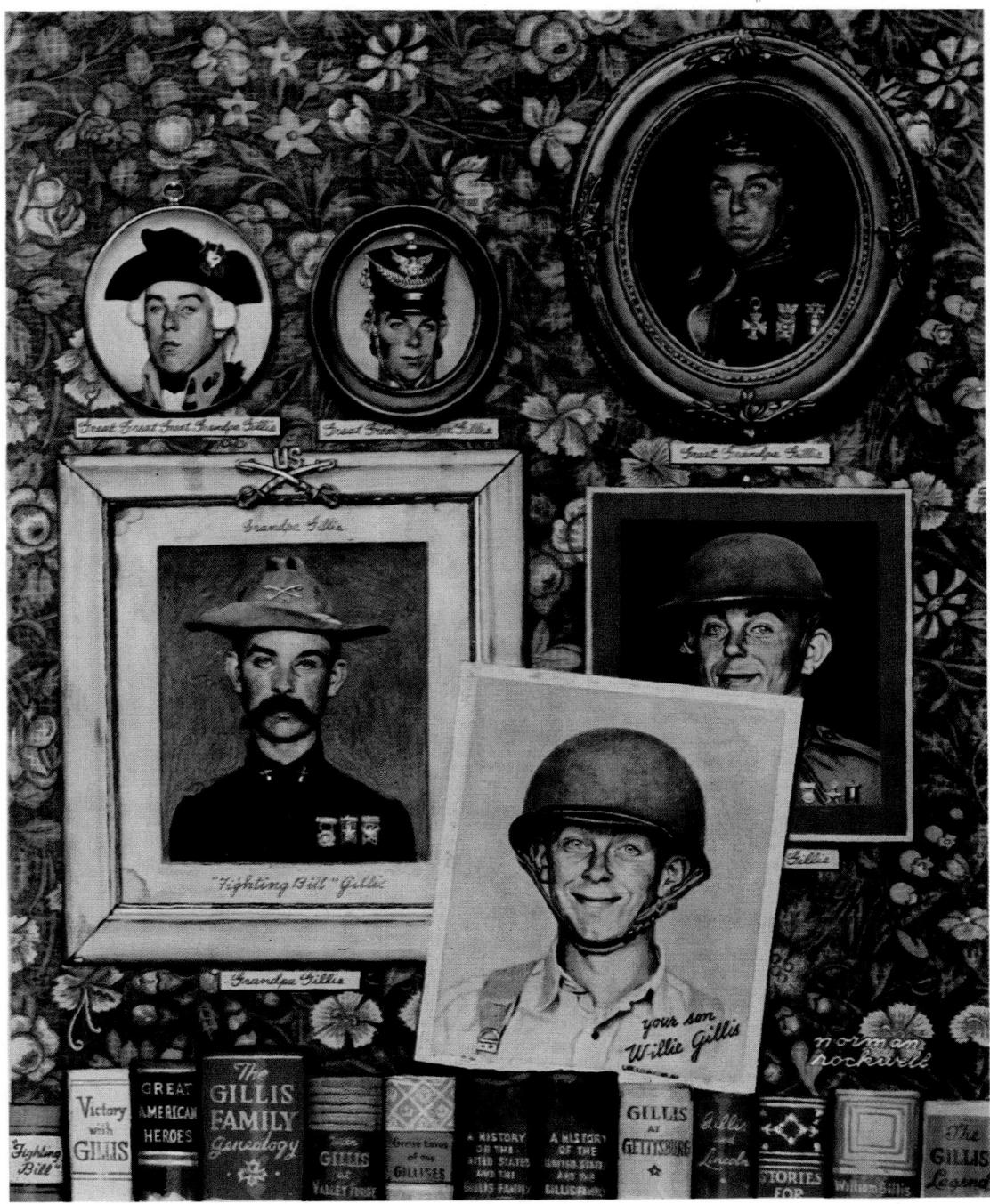

ORIGINAL 11" x 14"

ONE OF A LONG SERIES OF WILLIE GILLIS POST COVERS

After this appeared, I received many letters from Gillises asking where they could purchase the books shown at the bottom. The books are imaginary! N. R.

WE SKIP-BOMB THE JAPS

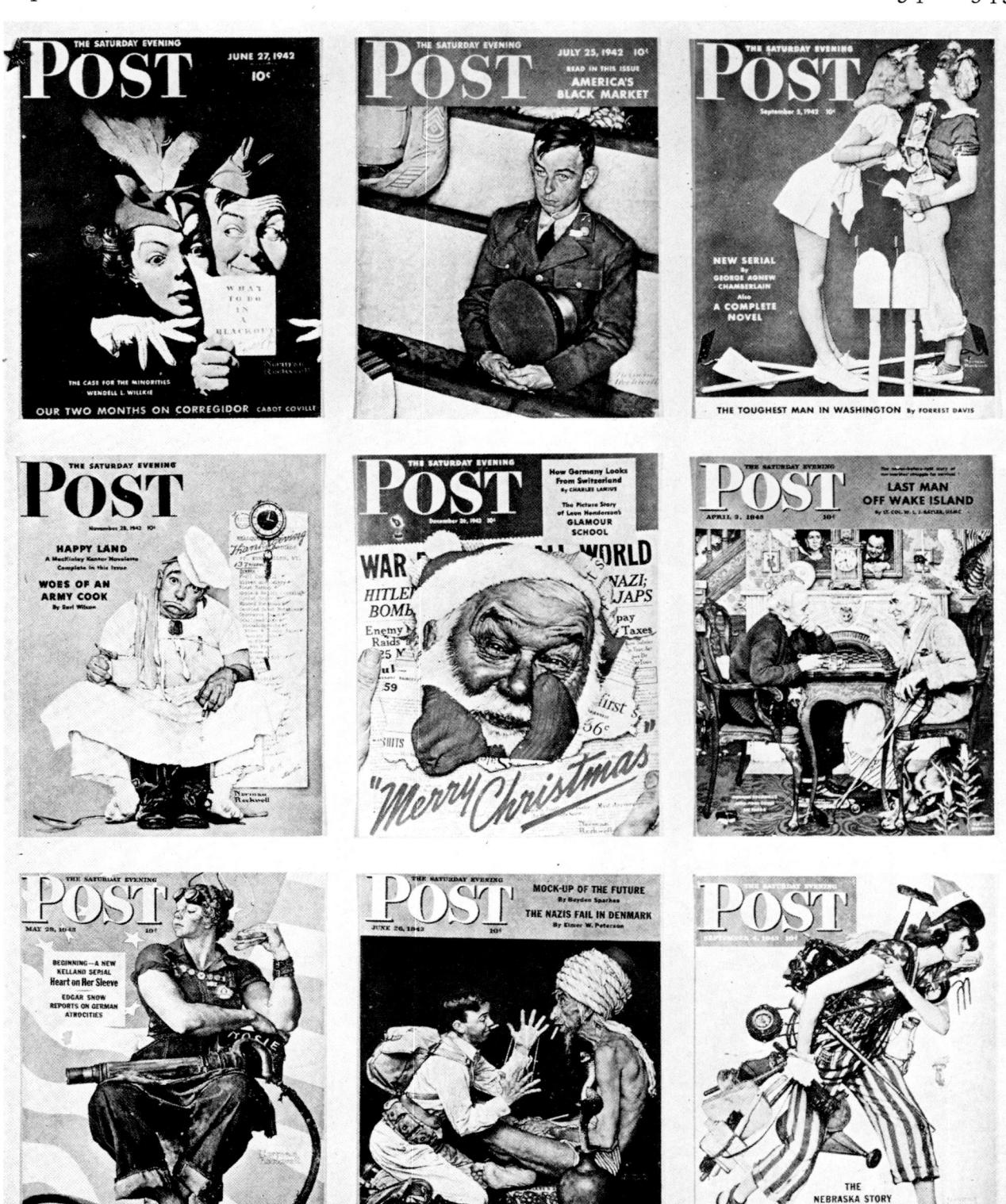

★ This cover of June 27th, 1942, was my first under Ben Hibbs, present editorin-chief of The Saturday Evening Post. I could have painted more than I did of these Willie Gillis Army covers if Bob Buck, my model, hadn't suddenly joined the Navy—the Navy, mind you, after I had made a soldier of him! N. R.

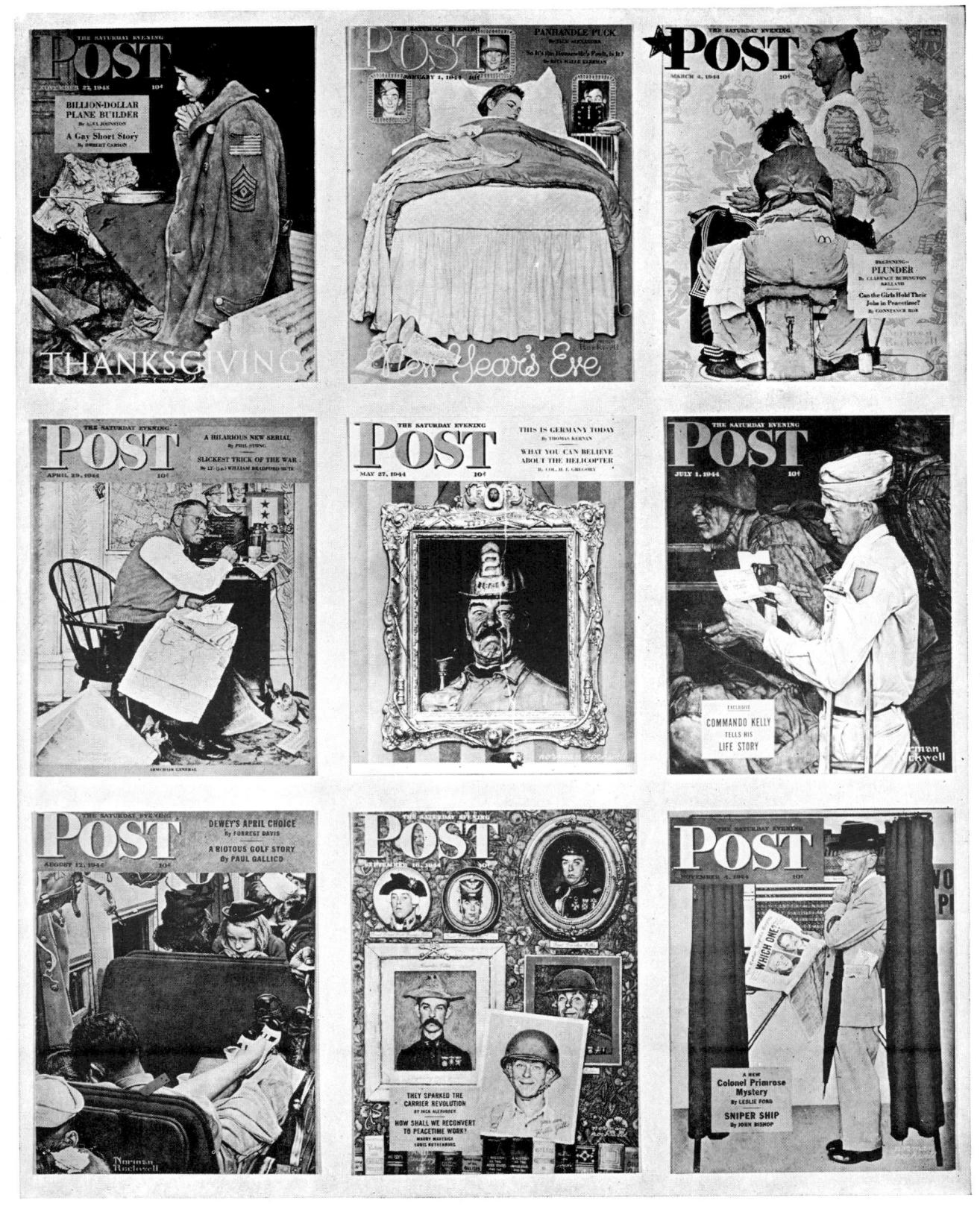

★ This Tattoo Artist cover was very well received, as were most of those which I did bearing on the war. The model was my good friend and fellow illustrator, Mead Schaeffer. He claims that I made his posterior larger than it really is and I claim I didn't. The argument isn't settled yet! N.R.

Portrait of a Railway Station

It hasn't been easy to think of good ideas for thirty or so Christmas covers. I always try to hit on some new angle when I can. In 1944 I got the notion that I would like to do a railroad station interior during a wartime Christmas season—the pathos and humor: the mother meeting the son; the wife meeting her husband; one lover meeting another. The Post liked the idea, and inasmuch as I was going to California, I stopped off at Chicago and taxied around to compare the different stations, finally deciding on the North Western Railroad Station. The Station Master and the Advertising Manager made it wonderful for me. A huge ladder was brought out—the one used to wash the glass ceiling. It had a platform on it. They gave me four men to guard it at the bottom. Then the photographer and I mounted the ladder to get the perspective from every angle. There were many astonished travelers that day, because everyone that came in was made to go through a single gateway so we could take pictures. We photographed over a hundred soldiers, sailors and marines meeting their families and friends. We even staged a few meetings. There was one man—I don't recall his name—who offered to help me, and he and I went out in the crowd and picked the people we liked and induced them to pose. In some cases we had to ask beautiful girls to kiss utter strangers, but they all seemed happy about the whole thing. I arranged for one red-head to kiss a Navy Lieutenant —she said it was too bad I wasn't taking time exposures. (They proved to be a married couple!) Only one person didn't want to pose—a little man in white who was pushing a broom around. He not only refused; he got quite mad about it. Later a number of people wrote that they recognized themselves in the picture.

I took the photographs in June, and the painting based on them came out at Christmas. I therefore had to change light summer clothing to heavy furs, overcoats, etc. I left some of the uniforms light, my alibi being that these people were coming in from the Southwest. N. R.

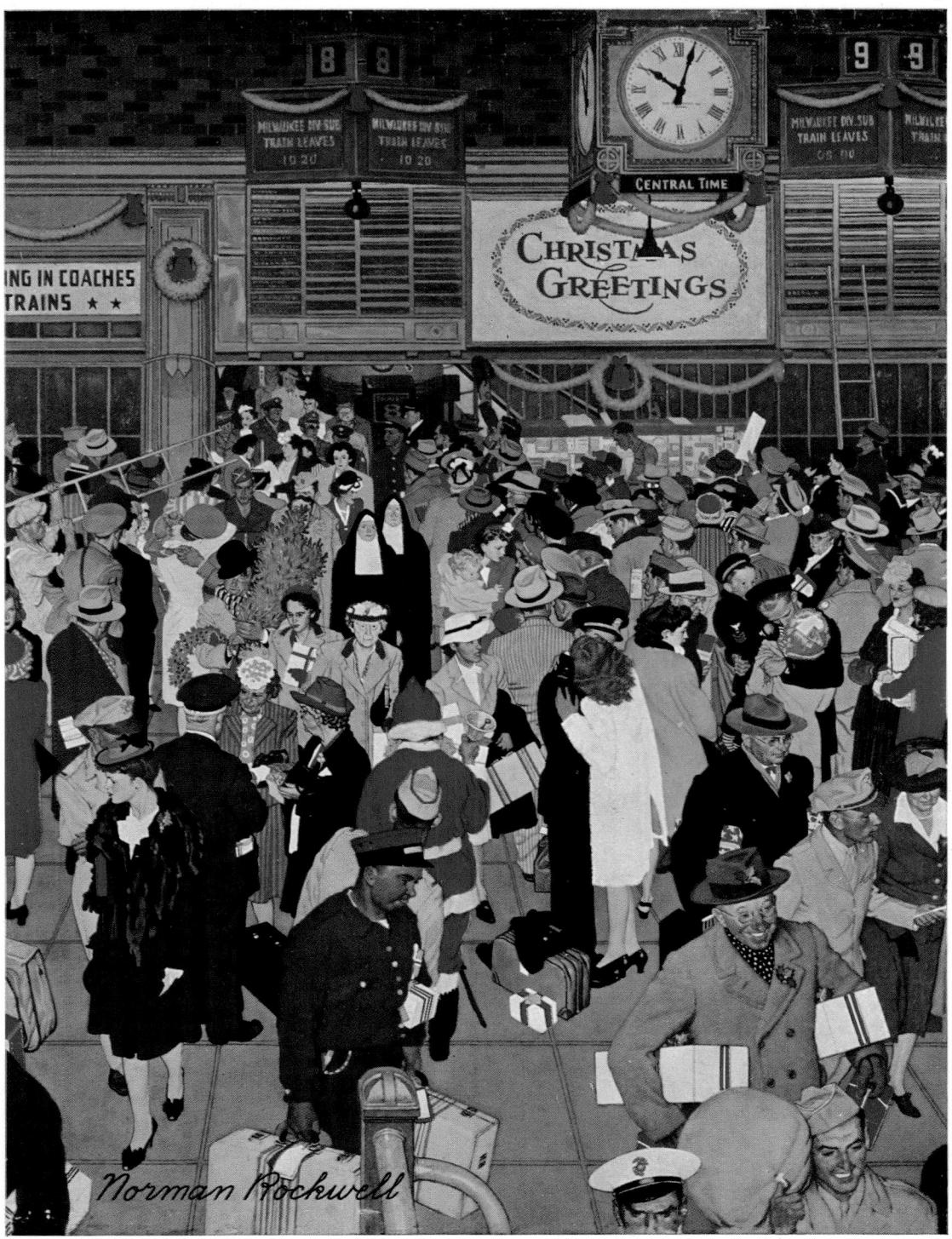

DRIGINAL 25" x 32"

A STATION POSES FOR A PORTRAIT BY NORMAN ROCKWELL

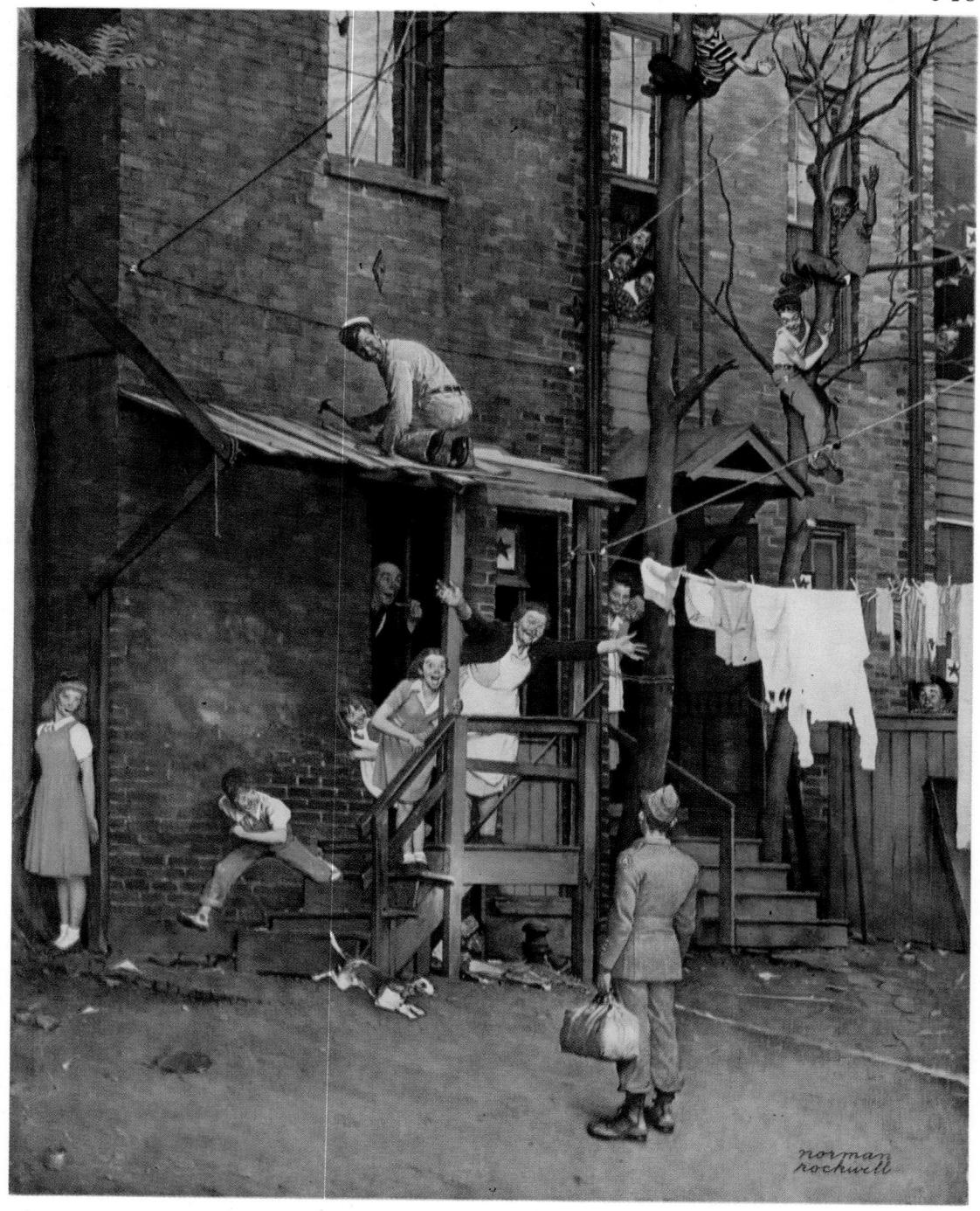

SEE PAGE 197 FOR THE PRELIMINARY DRAWING ON CANVAS

It was of course very gratifying to me when this painting was selected by the U.S. Treasury as the official poster for the eighth war bond drive. More than 300,000 copies were placed on display. I was also pleased when it was honored at the Society of Illustrators' Show—see page 153. N.R.

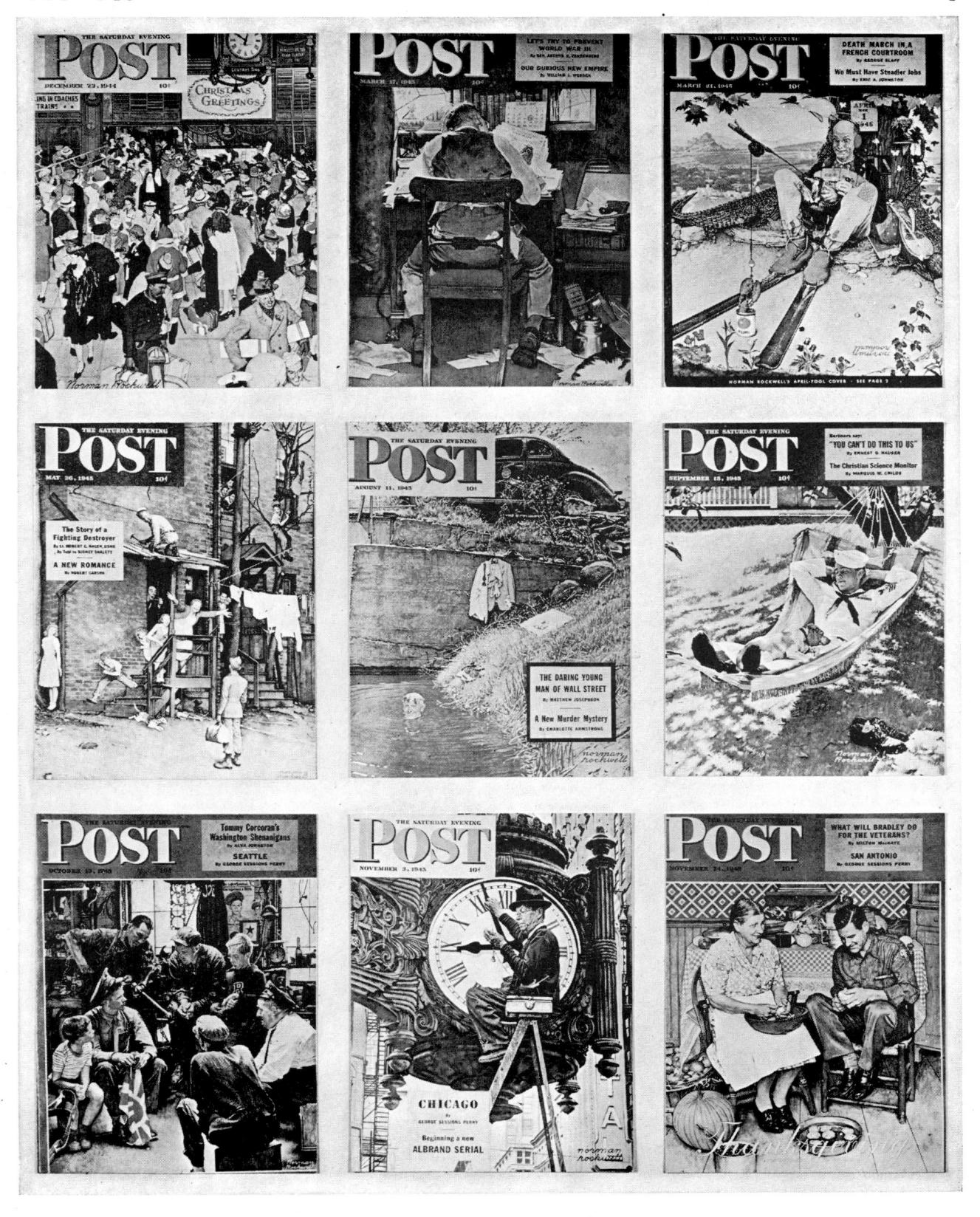

The transition from war to peace gave me the chance to do several covers of the home-coming type. Four of the above might be so described: those of the returned soldier, the hammock-resting sailor, the souvenir-bearing marine, and the veteran doing K.P. and liking it. N.R.

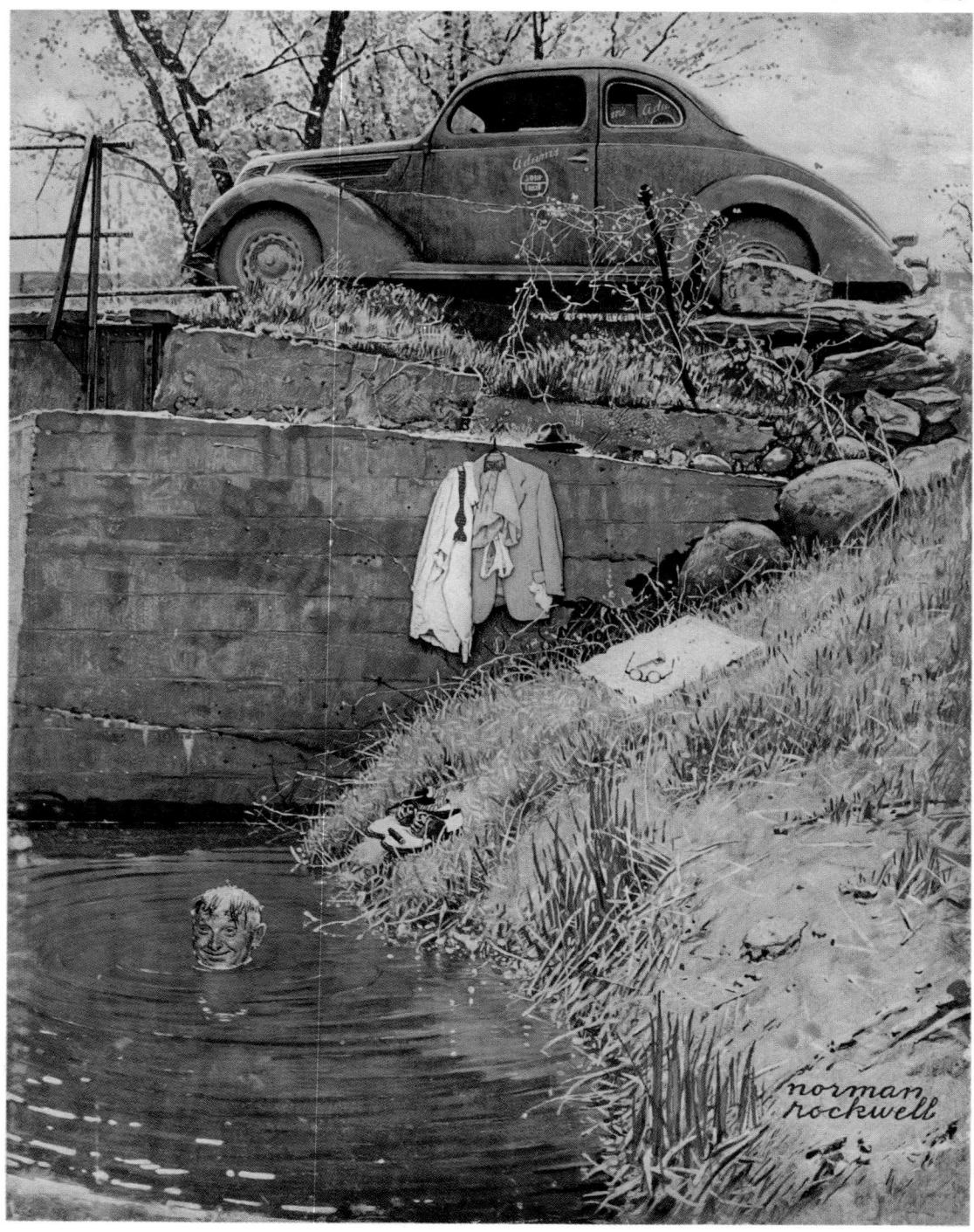

ORIGINAL 17" x 22"

THIS AUGUST COVER PAINTING WAS BEGUN IN COLD MARCH

George Zimmer was my model for this. Had it been painted in July, I'd have posed him in that very water, but March in Vermont—when the picture had to be made—is far too frigid for outdoor bathing. N.R.

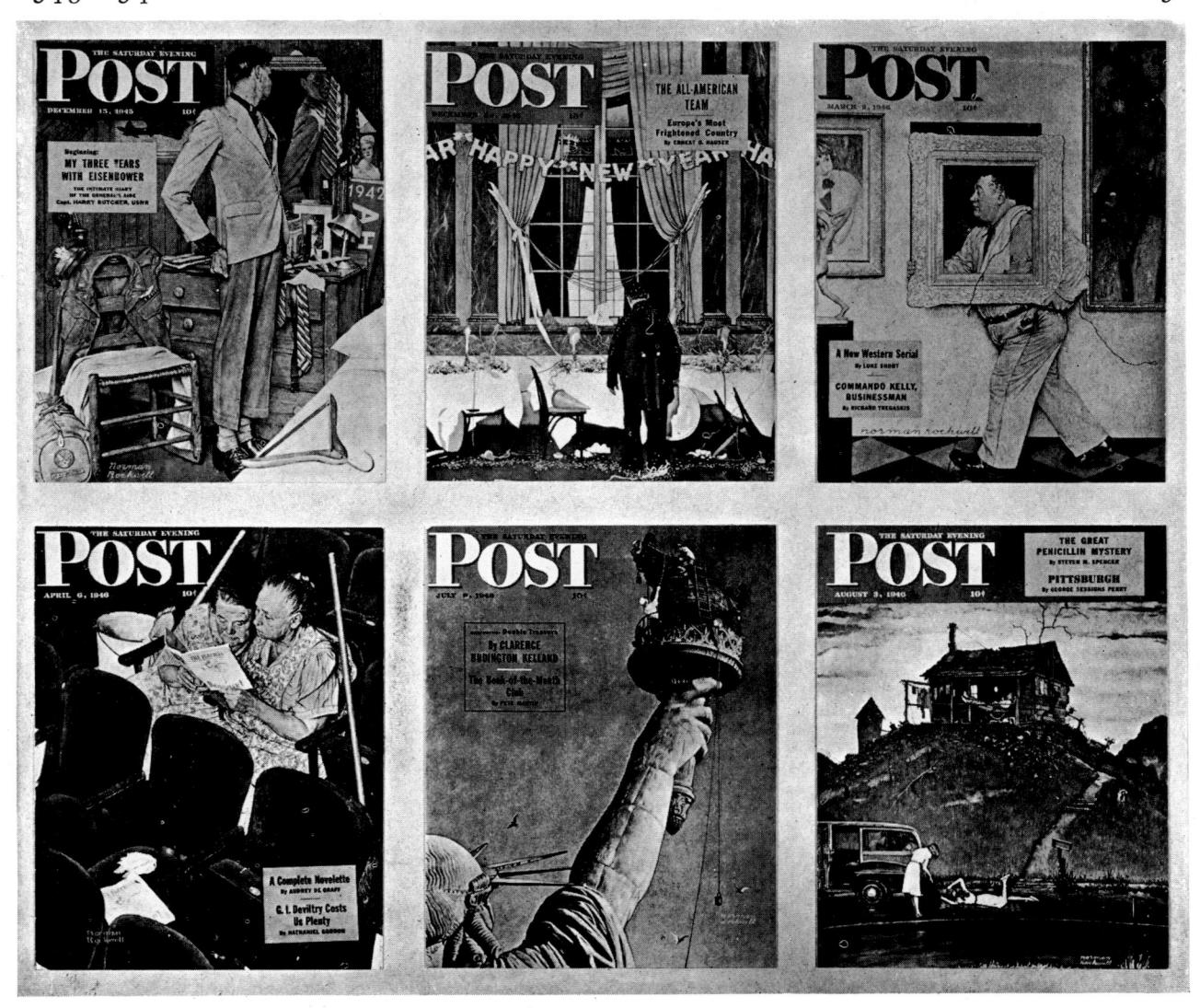

TWO HUNDRED AND FORTY POST COVERS, AND STILL GOING STRONG!

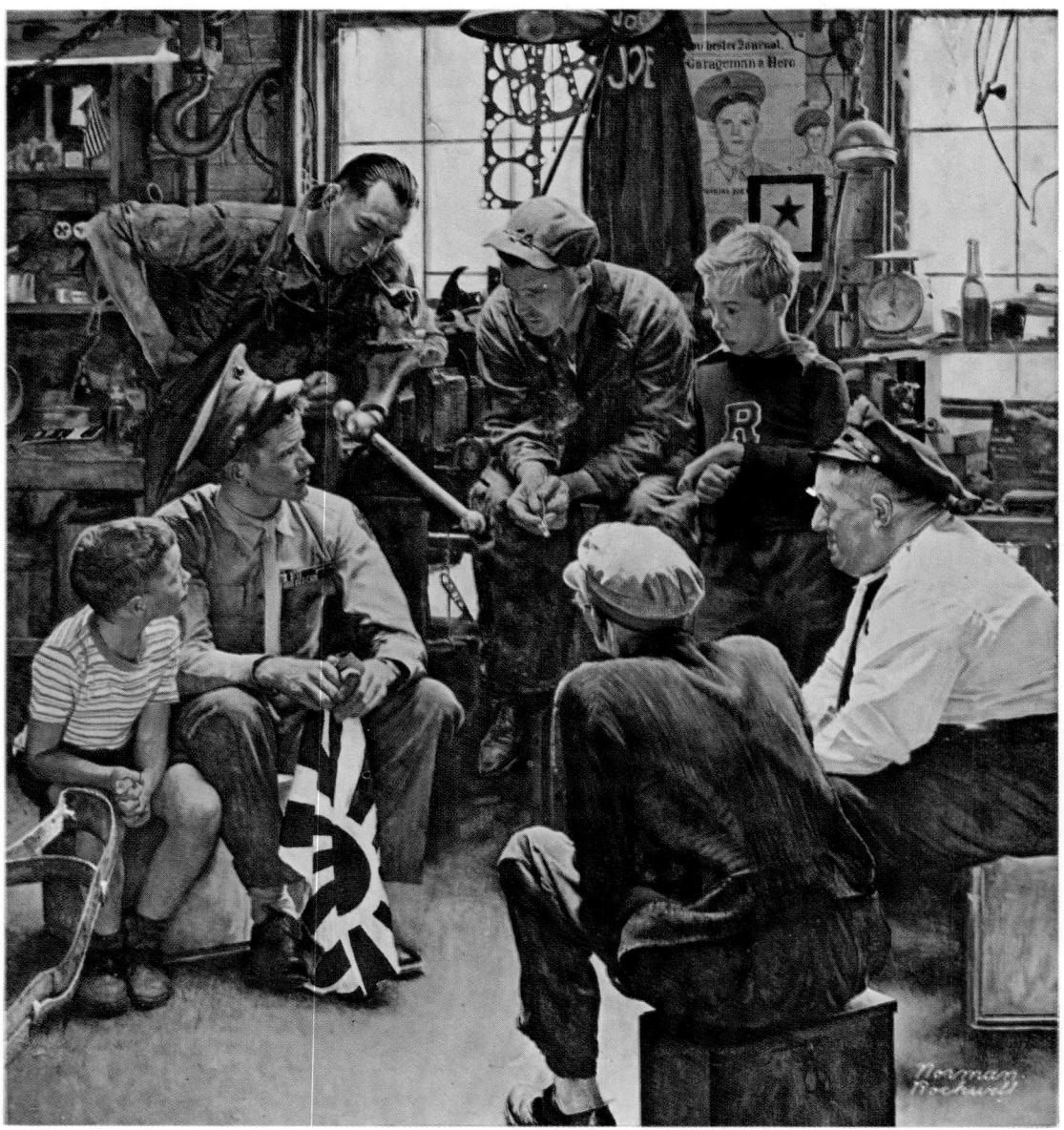

ORIGINAL 42" x 46"

THIS HOME-COMING MARINE COVER PROVED VERY POPULAR

I was of course pleased when this took first place at the Society of Illustrators' exhibit—see page 153. The setting is Bob Benedict's garage in Arlington. The cop is Nip Noyes, our town clerk and editor of the paper. The marine is named Peters; he earned those ribbons the hard way. I discovered him at a square dance, just as I did Bob Buck (Willie Gillis). Two of my sons are included—Jerry, my oldest, and Peter, my youngest. Bob Benedict stands behind the marine. N. R.

IX: Rockwell's Creative and Technical Procedure

WE OPENED Chapter II with the question, "Tell me, Mr. Rockwell, how do you paint a Post cover?" In answering that question in Chapters II and III, we purposely avoided a detailed discussion of the artist's creative and technical processes, realizing that such a discussion would seem tedious to some of our general readers. Yet there are many others—laymen, artists, teachers and students alike—who desire to know, down to the last move, how Norman proceeds with his work.

Hence this final chapter, in which, after a consideration of some of the cover designer's special problems, Rockwell's methods of study and painting are described in a sequence of fifteen steps which constitute a complete record of his procedure in producing a Post cover from the conception of the idea to the delivery of the finished picture.

Rockwell doesn't confine these methods to the painting of Post covers, however. Whatever his work—illustrations, advertisements, calendars, portraits, murals—he seldom wanders far from these fifteen steps.

* * *

Before turning to cover painting, the artist must have learned how to paint. If that pronouncement seems a bit too obvious, remember what happened to an illustration student who disappeared from art school after only a few months' instruction in the fundamentals of drawing. The instructor, asking what had become of the missing one, was told by a fellow student: "Oh, he has bought a camera!"

More about photography later; but any artist will agree that, camera or no camera, the traditional art school training is recommended; an illustrator is first of all an artist.

Granted the best of art training, and skill as a painter, the beginner must also have secured some sort of background in connection with the requirements peculiar to cover art. This he can gain by examining critically many a cover; by doing a great deal of leisurely thinking about covers; by endeavoring to discover why one magazine selects a certain type, and another magazine a wholly contrary type.

Through such analysis, he will soon come to see that different magazines have very different basic editorial plans and, as cover policies are naturally linked closely to these basic plans—are actually a

part of them—it follows that these cover policies are also widely divergent. Some magazines closely relate their cover material, as to general type, at least, to their between-cover content; others do not. Some favor pretty girl covers; others never use them. Some employ striking subjects, bright colors and strong contrasts, on the theory that they will thus gain a maximum of newsstand circulation; others largely disregard all this, apparently holding the premise that lasting favor (which, after all, is what counts) can be won only by superior content on the pages within.

Such cover design policies are by no means fixed; they are subject to constant revision. Some of the changes are marked, others so subtle or gradual that we may scarcely realize they are taking place. But change there is. In fact, the past has seen definite vogues in cover design just as in automobile or cos-

tume design. The tendency toward experimentation and innovation is especially strong today as these are fast-moving times.

While there are many reasons for such fluctuations in both policies and practices, in the last analysis these changes are but the natural reflection of the rapidly altering pattern of our American way of life. Yet there are definite influences at work from time to time. For example, art editors and artists play a leading part in the genesis of each new trend. Both feel that something new is expected of them every so often; both get tired of doing the same old thing in the same old way. So they deliberately alter their course. And younger artists, as they enter the field, know that it's good business to show that they can create something fresh and exciting, either in subject matter or handling; so they try all sorts of stunts, some of which prove extremely effective. If art directors favor one of these stunts and use it, and the public accepts it, a trend may be under way.

We needn't dwell further on such matters as trends and general editorial policies; our main purpose has been to stress the rather obvious fact, already indicated, that before the young or inexperienced artist tries to paint covers he should be able to approach art editors with an awareness not only of the trends

of the day, but of their magazine policies. His best way of judging what policy a periodical favors currently is to study the covers it is using. If such covers appeal to him, that is a good publication to approach. He will hardly be happy for long unless he can do the sort of work he likes, so he should deliberately seek work which he does like, regardless of the immediate financial award. Rockwell emphasizes that the young illustrator about to turn to illustration as a vocation would be foolish to analyze the field cold-bloodedly with the thought of undertaking only such work as looks particularly promising merely from a monetary standpoint.

As the novice pursues his analysis of covers, he soon becomes aware that the kind of people a magazine reaches determines the character of its covers. A highly sophisticated magazine, catering to a so-called "class" audience, will be found to favor quite a different type of cover motif and handling from that chosen by conservative "mass" publications.

The *Post*, which is the popular magazine in millions of families at every level of means and position, logically looks for covers which will interest a fair cross-section of this vast audience. So its covers, like its editorial content, are varied to a marked degree from week to week. Though always in color,

they show a deliberate change of pace. The editors alternate their artists; they work for variety of subject matter; they play one sort of composition against another. In short, they endeavor to keep the *Post* always fresh and stimulating in appearance, and to

give each issue an individuality which identifies it as new the moment it appears on the stands. Since a main part of the *Post's* editorial plan is to reflect and interpret current life—though it is by no means a news magazine—its covers are likely to have a reportorial quality. Yet *Post* covers are by no means all reportorial; a good gag is occasionally acceptable, or a cover by an outstanding "fine" artist, or some other break from the general routine. There is seldom if ever any attempt to relate the picture on a cover directly to any one feature inside.

The *Post* has been one of the leaders in the recent trend towards covers that depict an entire scene—the American scene—rather than an incident. This is exemplified by the railway station interior, page 187, and the home-coming soldier, page 188. Rockwell says that some years ago he, or Leyendecker, or any of the artists of that time, would have done this home-coming with a big figure of a boy, his arms around his mother. But today most people seem interested in whatever records American environment; every homely incident in it—barns, autos,

clotheslines, porches, pumps. So in his home-coming cover the artist followed the current trend by painting the many figures and their entire setting.

The layman or the young artist is often amazed at the prohibitions upon which editors must insist. Certain things are definitely taboo; these vary with different publications. A magazine like the *Post* has a reading public which, in general, is conservative and conventional, tending to be upset by anything that flouts conventions or is in questionable taste. And no matter how careful the artist is, certain

people will read sinister or hidden meanings into his pictures. Therefore, artist and editor must examine each idea from many angles. Does it show a child or an animal suffering? Does it reflect upon the church or raise any controversial religious issue? Might it create political or social dissension? Does it offend good taste in any of a hundred possible ways? If the answer is yes, the idea must be discarded.

Pages might profitably be filled with discussions of these and other conditions that give direction to the would-be cover designer, but let us get on to our account of Norman Rockwell's handling of specific problems and his technical procedures in executing his

paintings.

Step 1: Getting the Idea. The first consideration in doing a cover is, of course, to find an acceptable idea or motif. Since a cover can be no better than the idea behind it, it is essential to think of a truly good idea before a single move is made on paper or canvas. Rockwell's natural preference has always been for the human-interest concept. This is best, he believes, when founded on some deep-seated sentiment or emotion common to mankind.

A cover, particularly if of the gag type, may depict a single, simple incident, in which case its message is immediately obvious, as it generally involves but one emotion. Norman feels that if his painting chances to permit the expression of two opposing emotions simultaneously—perhaps a laugh and a little

sob—it will usually be the better for it. He points out that Dickens and Shakespeare utilized much this same principle by playing comedy against tragedy. "And," he adds, "they were two pretty good men!"

Carrying this thought further, it is his opinion that one reason why cover pictures of young people are so popular—schoolboys, let us say—is that even if a boy is doing something that evokes a smile, the reader, unless very youthful, will experience some nostalgic impression, or sensation of sadness.

În the past, Rockwell did numerous covers based on historic motifs, such as the sign painter, page 164.

Now, his main stress is on today's happenings. He feels that contemporary life is so exciting that people would not be interested in more than occasional motifs from the long ago. During the late war, in particular, life proved so challenging to him that there just wasn't time to do half as many paintings as he wished. At present he calls himself a reporter of current events, an interpreter of human emotions, a recorder of contemporary America. Some day he may again change his approach; he may quite posibly return to the simple, rather static ideas which were in vogue years back—even the historic motifs such as those of Colonial days—dusting them off and putting them to use again.

But in any case, Rockwell favors the storytelling idea. He has never had the least interest in painting covers merely to portray pretty girls, flowers or land-scapes. While he realizes that a pretty face may have newsstand appeal, he considers such appeal transient and shallow—far less important than the type of reader interest inherent in a storytelling idea. But, to emphasize a point made earlier, the idea must be good. "Without a good idea right at the start," Norman says, "only failure can result. No one has to tell the artist when such an idea is good; it just naturally rings the bell. He wants to go ahead and

paint that idea and no other in the world. He can't think up any more. If he has an idea that hasn't much merit he may sometimes try to convince himself that it has, but if he persists in using it, in the

end the cover is certain to prove a flop."

One reason why Rockwell likes Arlington is that here it's very much easier for him to generate ideas. He is so close to people that he gets to know almost their every act and emotion. Under such conditions cover ideas are not hard to find; he is surrounded with them. And he literally thinks in terms of magazine covers. Inspiration sometimes hits him suddenly at unexpected times and places; it's nothing uncommon for him to get out of bed in the night to make a sketch of a thought that has unexpectedly popped. Others are developed more painfully. Rockwell states that it has never been his practice to use cover suggestions created by others-not that they aren't offered by the hundred; almost every mail brings at least one. "Thinking up ideas is part of the fun of my job," he explains. "So my advice to the young artist is to learn to create his own; he will be happier and do more significant work.'

Norman stresses the fact that the basic concept for a cover must usually be decided months before the

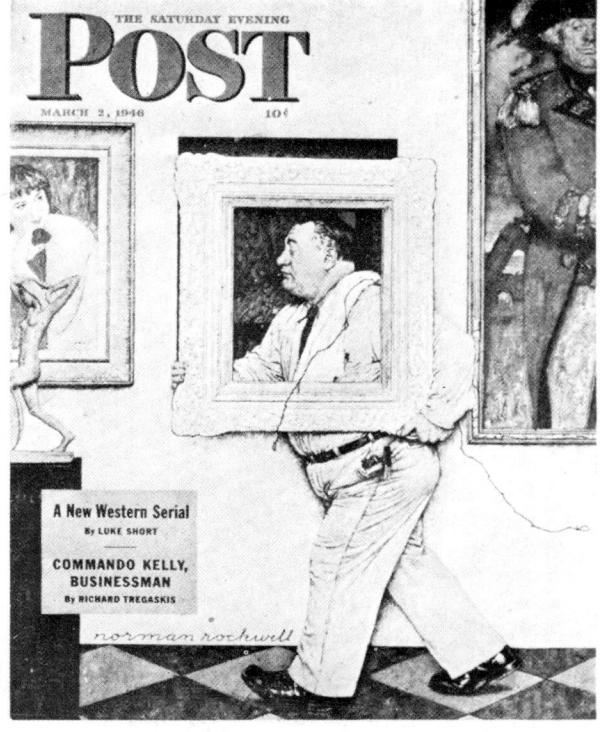

POST COVER FOR MARCH 2, 1946.

COURTESY OF THE SATURDAY EVENING POST

THREE PRELIMINARY SKETCHES, AND THE COVER AS IT APPEARED

cover is to appear. This is important. It is a bit hard for the beginner to realize that cover assignments are made many months in advance. And he should be advised that such special issues as Christmas and Fourth of July are almost certain to be given to professionals rather than the novice. He had better concentrate, at first, upon the in-between issues.

Step 2: Getting the Idea Okayed. When Norman has thought of three or four ideas that really appeal to him, his customary procedure is to rough them out very sketchily in pencil, at small scale, and take them to Kenneth Stuart, art editor of the Post—a top-flight cover artist in his own right—to obtain his suggestions and an okay. Once there, Norman per-

sonally demonstrates each idea by acting out the part of every character in turn. Having worked with Stuart and previous *Post* art editors for so long, he knows rather well in advance what may or may not be approved. He calls Stuart "simply wonderful" in his cooperation. If he shows him several sketches and asks, "Which do you want me to do?" Stuart's customary reply is: "Which do you want to do?" and if there is nothing about any of them which could legitimately be criticized by the reader, Rockwell is usually left free to go ahead with all.

Asked if he had always had this same experience at the *Post*, he replied, "Oh my, no! Not in the old days. When George Horace Lorimer was editor—he was a great editor, a wonderful man—it was my practice to submit five sketches at a time because it seemed to be a policy with him *never* to accept more than three out of five. I generally made up three that I really liked, and put in two fillers."

Occasionally the *Post* okays an idea which Rockwell later has to abandon. Even though he may have been most enthusiastic over his original sketch, when he gets to his studio it doesn't work out as expected. He simply can't go on with it, sometimes to the keen disappointment of the *Post*. Then another conference with Stuart is indicated.

We have already seen that Rockwell's original sketches are usually as meager as they are small, giving but the barest suggestion of the final results. Obviously an editor couldn't be expected to consider seriously such incomplete sketches if submitted by a newcomer; the editor couldn't possibly judge how the finals might turn out. Rockwell's advice to the beginner, therefore, is to submit at least two or three finished cover paintings, and only very carefully fin-

ished sketches of any others, done in color, preferably at actual reproduction size.

Step 3: Selecting the Models. When the idea has been accepted by the Post, Norman's next move is to hunt up the living models to pose for the different characters. This is a most critical task. Artists follow all sorts of procedures in connection with it. Some engage professionals from model agencies; others rather casually choose almost any individuals who chance to be available, providing they approximate what is needed; then, as these artists paint, they take many liberties as to form, expression and all. But not Rockwell. He always insists upon exactly the type required, even though it may entail a lengthy search. Professional models seem synthetic to him; he much prefers everyday people. If, for instance, his scheme calls for a housewife, he finds that no professional can act the part with the skill and spirit of a real housewife.

When, until a few years ago, his studio was in New Rochelle, N. Y., a place of some 60,000 population, he would sometimes wander along the streets for miles in an effort to find the right type willing to pose. He would lurk in doorways, dart out from

alleys, inveigle likely prospects away from home and business. Though he was unusually successful at this, it was time-consuming and sometimes nerve-racking, so more often than not he would fall back on one of his regular models, five or six of whom he employed again and again.

In Arlington, though its population numbers scarcely 1400, he has mentally catalogued practically every inhabitant; usually he can put his finger at once on just the person required for any given purpose. He needs a fat one, a thin one; there they are

right in town where he can get in touch with them the moment he wants them. It's nothing uncommon for him to take a farmer right out of the field, a

storekeeper away from his counter, or a neighbor off of his porch. "And," as he states it, "they are just naturally good actors, not at being somebody else—they wouldn't be that—but at being themselves. Nearly everyone seems to be a perfect model. These people have worked hard and their understanding of the fundamentals of life is reflected in their faces. That is what I like to paint. The more trouble they have had, the more interesting their faces. Even a dog which has been kicked around has more character than a pampered one."

Realizing the desirability of changing his types now and then, Norman keeps on the alert at local Grange meetings, square dances and such gatherings. He can't possibly use all the interesting people he sees. "Every time I go to town meeting or some other public affair," he says, "I fairly drool over the models I have so far missed."

Almost everyone in town—the butcher, the baker, the candlestick maker—seems proud to pose for Rockwell; they look forward eagerly to seeing their faces on the *Post*. A collection of his recent paintings would constitute a fairly complete portrait gallery of Arlington's citizens. The principal gauge Rockwell's neighbors have of his skill is whether or not a painting looks like the person who has sat for him.

Naturally these people are paid for posing. "There is a sweet little old lady," relates Rockwell, "who lives on a farm near me. A tourist came along last summer and wanted to photograph her because he thought she and her house were so lovely. She said: 'You will have to pay me for it; Mr. Rockwell always pays me.'"

Norman's relationship to his Arlington models is quite unique. They are his friends and neighbors, not professionals in the usual sense. They are not only good models, but frank critics whose opinions are respected.

So familiar have Rockwell's characters become to the American public that it is not uncommon to hear a person described as "a typical Norman Rockwell character." And yet, paradoxically, when you make a careful comparison of the dozens of individuals he has painted and drawn, you wonder how he has been able to show such great variety of face and form.

Step 4: Gathering the Props. With suitable models rounded up, Rockwell must hunt for clothes and accessories of correct size and type. Some years ago when he was doing Colonial scenes, tailors were summoned to produce or alter the costumes. newly tailored costumes lack an honest, lived-in look, so Rockwell gradually collected used items of every kind until, by the time his studio burned in 1943, he owned one of the largest and finest collections of historic costumes outside of museums. Today, when he is painting the contemporary American scene, his task is far more simple; his main problem is to get his models to come in the things they regularly wear. If left to themselves, they are likely to don their "Sunday-go-to-meeting" clothes. He has to insist that they dress "in character," usually in work clothes. "They say it takes a lot of loving to make a home," says Norman. "Well, it takes a lot of sun and sweat to give clothes character."

Many and amusing are his experiences in obtaining these things. Once he was able to buy an old overcoat which he saw airing on a line only by purchasing with it a bag of rags and a couple of hundred pounds of old iron. The owner sized him up as a junkman.

In his earlier historic work, in which Rockwell needed not only correct period clothing but authentic antique furniture and accessories, he often spent days scouring the whole countryside, attending auctions and poking into shops, barns and attics for the required chairs, beds, sleighs, carriages—yes, stage-

coaches. Occasionally it was necessary to have suitable things made, such as the two signs in the painting reproduced on pages 118-119. Even today, special furniture and props often have to be built and assembled in his studio. But, more and more, Rockwell seeks and finds the original objects in actual use as he did in developing the covers illustrated in Chapter III, "Some Come Easy: Some Come Hard."

Step 5: Posing and Photographing. With his background or setting ready, next comes the exciting task of posing the costumed figures against it, arranging

every detail exactly as desired in the final painting. First, he explains to his models the purpose of the cover—its idea and how he is trying to express it. Then each is coached in the part he is to play, Norman often enacting it himself by way of demonstration. He gives no arbitrary commands to embarass his models; instead he has the faculty of inspiring each to assume naturally the pose and expression called for by the job. His patter of wisecracks and witticisms usually puts them at ease.

When at length he has posed his models, two possible procedures lie before him. He can draw and paint directly from his set-up, as he did for over twenty years (see the photographs, page 44) and sometimes does even now, or, as is his more common practice today, he can have an abundance of photographs taken to paint from later at his convenience. If the latter course is pursued, his photographer—Norman never uses the camera himself—may take as many as seventy-five shots in preparation for a single cover!

While this is going on the artist directs his models, shifting them from one position to another, rearranging the setting, changing the lighting, until every possibility has been explored. Sometimes Norman poses his models singly, rather than in groups.

This photographic method is common practice among today's illustrators. There are many arguments for and against it. One negative point is that paintings based on photographs are likely to look too photographic—too inanimate. As Rockwell says, "The folks don't step out of the picture and talk to you as they do when you paint from them directly."

Another disadvantage of working from photographs is that they often exhibit distortions of form or tone; the camera and the human eye do not see alike.

Only the experienced artist has the skill to correct such distortions. Then too, the lighting arranged by the photographer is frequently unnatural, especially if he employs flash bulbs or throws lights from several sources at once.

But, by and large, the camera is a very useful tool in the hands of a competent artist. One advantage is that it can record poses which a model couldn't hold long enough to permit the making of a drawing. Another point: photographic shots can be taken from unusual angles—downshots from above, for instance, or shots from near the floor. The artist would be unable to lie on the floor for hours, painting models above him! Photographs are also useful for recording transient effects, or subject matter located at a distance from the studio. Photographs have the added advantage of allowing the artist to try literally dozens of compositions of a subject from which he can finally choose the best, or combine the good features of several. Rockwell sometimes uses the camera to help him decide on the right model by taking photos of a number of people until he finds the one who expresses exactly what he wants to say.

Perhaps the greatest advantage of the camera for Norman is that it saves him an amazing amount of nervous wear and tear. He doubts if he could keep up his present rapid pace without it. "In the old days," he explains, "I would sit and paint for hours before a living model, constantly commanding, 'Hold out your chin,' 'Turn a bit more this way,' or 'Straighten up!' And always I was painting against time, rushing to finish before the model's rest period, or before the light failed. I was under an awful tension, particularly as I would act out every one of those moves for the sitter in order to demonstrate my point.

When quitting time came I was a wreck.

"Then I began to hear how effectively this or that illustrator was using the camera. At first I couldn't believe it. Later I became convinced that it was true, but felt that the method was somehow a bit dishonest, like cheating at solitaire. Still later, I decided that there might be some merit to it after all. It struck me that the Old Masters, with their inventiveness, would surely have found practical ways of utilizing the camera had it been available. So I began

to experiment and discovered that, although the camera is a very tricky thing, it could be of legitimate assistance if employed judiciously. Frankly, I don't know whether my work is better or worse for it. I do know that it has helped to keep me working all these years.

"Painting from photographs can be a wholly creative performance if the artist himself is creative. To

'copy' the form, tone and color of a photographic print certainly is not creative. But one can be creative by modifying drawing, values and other aspects of the photo to realize the creative needs of the subject. The camera is no substitute for those crea-

tive faculties of mind and hand which have always produced art—and always will. The artist who can't draw or paint will never get anywhere trying to work from photographs. An unskilled artist, using photographs, can easily develop absurdities, such as the sun shining from two or three directions at once, or one object incorrect in size in relation to the whole, or perspective convergencies at variance one with another."

Even when Rockwell paints directly from the living model his approach has always been a realistic one. "It has never been natural for me to deviate from the facts of anything before me," he says, "so I have always dressed the models and posed them precisely as I have wanted them in my picture; then I have

PHOTO MCAFEE

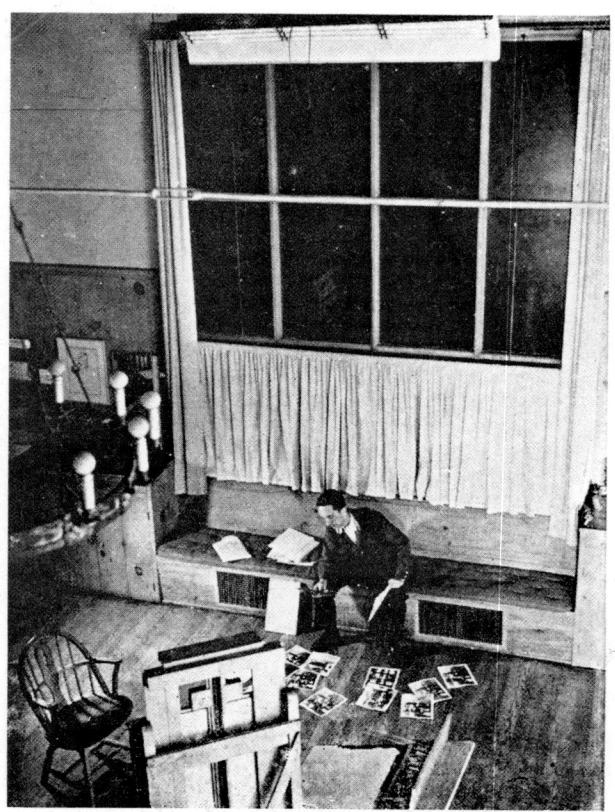

painted the thing before me. If a model has worn a red sweater, I have painted it red-I couldn't possibly have made it green. I have tried again and again to take such liberties, but with little success. But when working with photographs I seem able to recompose in many ways: as to form, tone, and color."

Incidentally, both in posing his models and in his photography—not to mention his later drawing and painting-Rockwell is constantly on the alert for anything which may improve his original scheme. Often some chance happening may react to his advantage. Perhaps it rains when an outdoor subject is being photographed. Should he allow his photographer to stop, discouraged? No. A rainy-day cover might be just the thing!

Whether Rockwell paints from the model, from photographs, or from both, his method from this point

on is much the same.

If he works from photographs, the day after they are taken he has a complete set of 8 x 10 prints in his hands before he starts painting in the morning,

usually around eight o'clock. Spreading them about see photograph—he selects those he thinks he can use and discards the rest. One print may be chosen for its general composition, another for a particular figure, still another for a head or an arm, and so on.

Step 6: Small Studies to Organize Material. With his okayed preliminary pencil sketch and his selected photographs at hand, Norman now makes a study or two—sometimes more—at small size (six inches or so) as an aid in organizing his material. These, like his earlier preliminary, are drawn with a soft pencil. A lot of vital thinking accompanies the drawing.

Step 7: Charcoal Layout, Full Size of Painting. Norman next gets under way with a much larger study which he terms his "charcoal layout." It is made to the exact size he intends his final painting to be; this varies according to the subject matter and how he happens to feel about it. He also finds that it is fun to jump from one size to another on successive jobs. After he had finished the Four Freedoms pictures, each fifty-seven inches tall, he painted an April Fool cover eleven inches square, the exact size of the Post reproduction. He believes that it's good policy to vary sizes for another reason—to surprise the editors now and then. In any case, a cover painting is never made larger than can be gotten into a

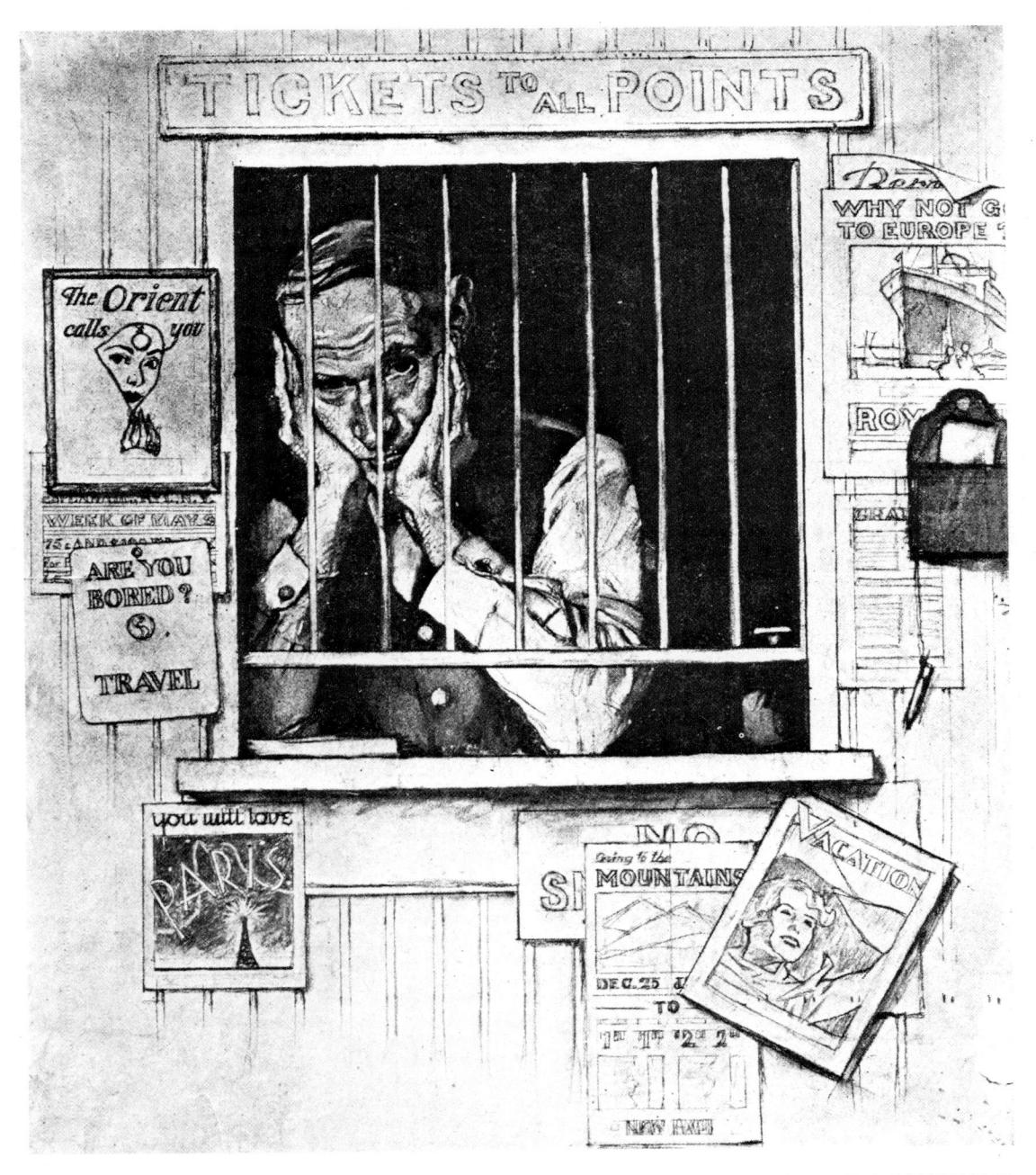

A CHARCOAL LAYOUT AT EXACT SIZE OF FINAL PAINTING

I take the making of these charcoal layouts very seriously. Too many novices, I believe, wait until they are on the canvas before trying to solve many of their problems. It is much better to wrestle with them ahead of time through studies like the above. By comparing this with the reproduction of the final cover (at the top of page 175) it will be noted that they are fundamentally identical. This demonstrates that before I went to the canvas I had decided exactly what I wanted to do and so could proceed without fumbling. Such a practice saves time and insures a better job. N.R.

taxicab, an important point with him, as he usually delivers his work in person or sends his own messenger with it. "When I'm at all doubtful about its acceptance," he confesses, "I may ask my wife or some other pretty girl to deliver it."

Asked if his covers involving a multitude of figures are usually painted larger than those with a single figure, he replied, "Not necessarily. My railway station interior with about a hundred people in it was only two and a half feet high."

In making the charcoal layout, the artist has to take into account the placing of the word "POST," and try to anticipate any probable panels or lines of additional type matter. Unfortunately he can't know in advance where some of these smaller type elements may fall. This is sometimes disconcerting. Perhaps he has tried to tell a quiet, thoughtful little story—it is a decided shock to discover on the printed cover a great panel of display type announcing a murder mystery right next to the most subtle passage in his pictured story. And of course the magazine's mailing department is indifferent when its address-labels obliterate choice esthetic bits. But artists get used to these things; they realize that magazines, after

all, are commercial propositions, and that there are many nonesthetic factors that determine what finally appears upon each cover. "Me and Michelangelo have both had our troubles," Rockwell muses, "but he never had these particular ones."

A major limitation in cover design is that the proportion is always upright. "I wish I could do a

horizontal cover some day," Norman wistfully complains.

As to Materials. In starting the full-size charcoal layout, Rockwell usually selects architects' detail paper. He says, "This has a slight sizing on the surface so, before I draw, I go over it very thoroughly with a kneaded eraser. Then all areas will take the charcoal uniformly."

As to charcoal, his first choice is Fusains Rouget No. 3. He applies this freely, rubbing it down with thumb or finger. (He never uses artists' stumps made of paper or chamois.) It is sometimes necessary in this charcoal layout to draw certain parts again and again, as few important changes are made after it is completed. (See the previous page and page 56 for reproductions of two of these layouts.)

Step 8: Color Sketches at Post Size. The layout completed, it is sprayed with fixatif to keep it from

rubbing. Now the photographer is called in again; he photographs the layout and makes, on mat finish paper, several photographic prints at the exact size of a *Post* cover. Rockwell next works out his color scheme by painting in oil on one of these photographic prints. This is a rapid process—far quicker than coloring an outline drawing would be.

Asked if he paints more than one of these color sketches, Rockwell replied, "Gosh, yes I do, but sometimes I get away with one, sometimes two, sometimes five. It's helpful to compare several. Then I show them to Schaeffer and Atherton, to my nextdoor neighbor, to my wife. If the dog has any criticism I make changes for him, too. Everybody gets a whack at it. If my cover doesn't suit these people it will probably prove a dud.

"While we are discussing this particular use of photographs," Rockwell continued, "I think we ought to explain that it originated in the fertile mind of Mead Schaeffer's wife, Elizabeth. It's a fine idea, for it enables the artist to produce in a minimum of time a fairly accurate sketch, or group of sketches, showing very clearly how the finished cover will look on the newsstand. That is especially important when one is doing small figures. To make the effect even more real, I often cut out the lettering from some appropriate *Post* cover and paste it on my color sketch, a quicker and better device than lettering each sketch. Incidentally, the artist himself doesn't have to execute the lettering on his final painting."

Step 9: Preparing the Canvas. Norman uses only linen canvas, double-primed. It comes by the roll

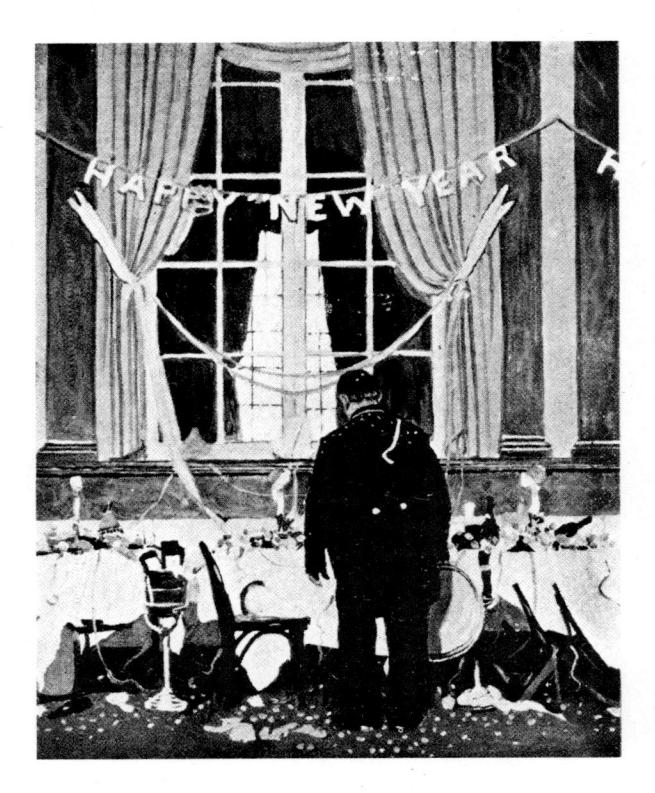

One of several color studies made for the cover at the right. Many minor differences can be discovered between the two reproductions.

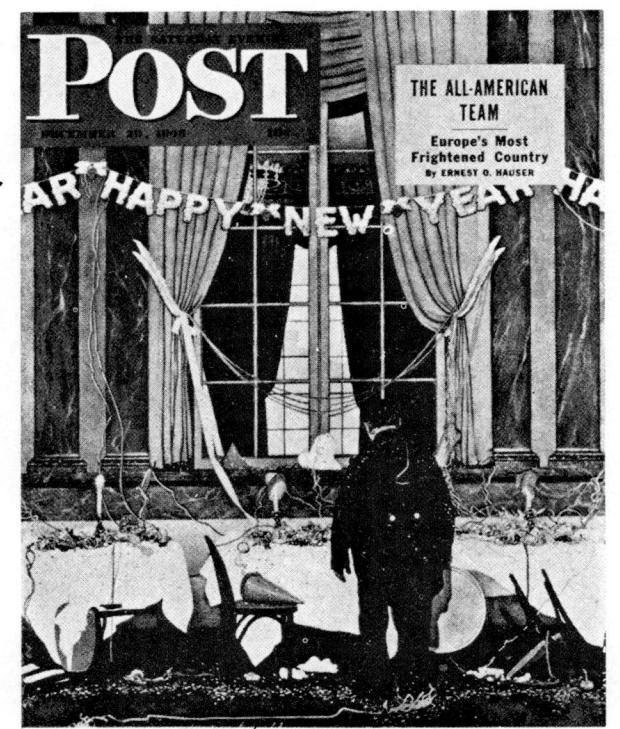

POST COVER FOR DECEMBER 29, 1945.

COURTESY OF THE POST

The setting for this New Year's cover (December 29, 1945) was the Wedgewood Room of the Waldorf-Astoria Hotel in New York.

in three grades—very rough, medium, and very smooth. He keeps plenty on hand and selects the type best suited to his current project, tacking it to a stretcher frame of required size. "I never cut off any excess canvas until the picture is done," he says, "because halfway through the picture I may decide that it would be better if I added an inch on one side or the other. In case the canvas is the least bit buckled after it is stretched, I moisten it on the back; when it dries it becomes as tight as a drumhead."

He has no fixed way of surfacing this canvas. If he wishes to obtain a marked degree of texture, he opens a can of Benjamin Moore's "Sani-flat," pours off most of the liquid and stirs the remaining paste (which is very hard) until it is completely mixed. Next, placing his stretched canvas on the floor, face up, he brushes the thick Sani-flat over its entire surface. When this paint has been well distributed, and before it dries, it is possible to do all sorts of things to it to create interesting textures. One can pat it with a big brush, or put a piece of paper over the whole surface and pull it off again. "Some of

the fellows," says Rockwell, "press mosquito netting and the like into the paint to gain the effects they want, removing the material, of course, once its impression is made. It takes the Sani-flat half a day to dry thoroughly; once dry, it forms a most beautiful white flat ground. But it's probably too much to expect permanency." Occasionally Rockwell substitutes for canvas the support favored by the Old Masters, a wood panel prepared with a gesso ground. Sometimes he paints a small picture on a piece of Whatman hot-pressed board, coating it first with shellac.

Step 10: Transferring to Canvas. Rockwell now makes a transfer from his full-size charcoal layout to the prepared canvas as follows: First, he lays a sheet of architects' tracing paper—it is nearly trans-

parent—over the charcoal layout. On this he carefully traces the entire subject in pencil. Next, he shifts this tracing paper to the canvas, putting a sheet of transfer paper between tracing and canvas. (This must *not* be the carbon type which stenographers use: that would ruin the whole thing because of its penetrating dye.) He now painstakingly relines each line on the tracing paper, thus transferring a corresponding image onto the canvas; this is then sprayed with fixatif to hold it in place.

Asked if an assistant couldn't do this tracing, Rock-well replied, "It is next to impossible to find a capable tracer. There seem to be only three types: the 'creative' tracer who tries to improve the artist's work, the 'pernickety' tracer who traces every thumb-tack hole or fly speck in the paper, and the 'don't-give-adamn' tracer who gets everything wrong. That's why I still trace my own."

Some illustrators transfer by another method. Photographing their charcoal layout, they project the photographic image onto canvas by means of the Balopticon or some similar projector, just as a lantern slide is thrown upon the screen. The projected forms are then outlined on the canvas in pencil or charcoal, after which they may be perfected at leisure.

While considering the Balopticon, we might add that it is now quite common practice among illustrators, once their models have been photographed, to project their chosen photograph directly onto the canvas, immediately outlining this image with charcoal or pencil as a guide for the painting. In other words, they don't draw at all in the usual sense, though they may later greatly refine these projected proportions by the orthodox freehand methods.

At one time it would have been considered cheating to rely on such an aid as the projector-highly unethical if not downright dishonest. Now nobody seems to question the practice. As Norman points out, however, if one simply puts a photograph into a Balopticon, blows it up directly onto his canvas as just described, and then paints from his photograph without using any of his own feeling or imagination, he is bound to produce a very inferior machine-made product—a sort of colored photograph. Norman can see no special harm, however, in blowing up one's general proportions, providing he merely indicates these projected proportions sketchily with his charcoal or pencil and then begins, on this skeleton, to develop the character of each model by adding, subtracting, or refining in any way which suggests itself. But most of this work should be done on one's layout and not on the canvas.

Step 11: Imprimatura. Rockwell is now ready to paint. He usually starts by staining his canvas all over with a thin, even coating, called an "imprimatura," of a single color of oil paint, the hue of which is determined by the general color scheme intended for the picture. His pigment for this imprimatura is usually thinned considerably with rectified turpentine and then rubbed over the entire canvas with a rag.

Step 12: Underpainting in Monochrome. When this imprimatura is dry (a matter of only a few minutes), the next move is to make upon it an "underpainting" of the subject, using a single color—raw umber, perhaps. To obtain the light tones of this underpainting Norman uses no white, but dilutes his paint with turpentine. He also tries for a sort of drybrush quality. Thus he gradually completes a monochromatic roughing-in of his entire subject. With this underpainting sufficiently dry (overnight), he varnishes his entire canvas with French retouching varnish—the alcohol base type—applied full strength. This is so that his later work will not pick up the underpainting.

Step 13: Color Lay-in. When this varnish is dry (this takes a half hour or so) its surface may be too glassy to permit overpainting, in which case it is given a wash of turpentine. This leaves a slight film that will dry overnight. Then he is ready to make a rapid "color lay-in" of the whole picture. This he accomplishes (with his color sketch before him) in approximately his final colors, trying to cover the entire canvas in half a day. In this process much of the underpainting disappears, though indications of it are allowed to remain wherever they prove effective. "Don't do this lay-in too carefully," Rockwell cautions. "You want some accidents to play with."

Choice of Colors. Rockwell's preference over the years has been for Winsor & Newton's colors of the following hues: French ultramarine (blue), viridian, lemon yellow, cadmium yellow (pale), yellow ochre, raw sienna, raw umber, burnt sienna, vermilion,

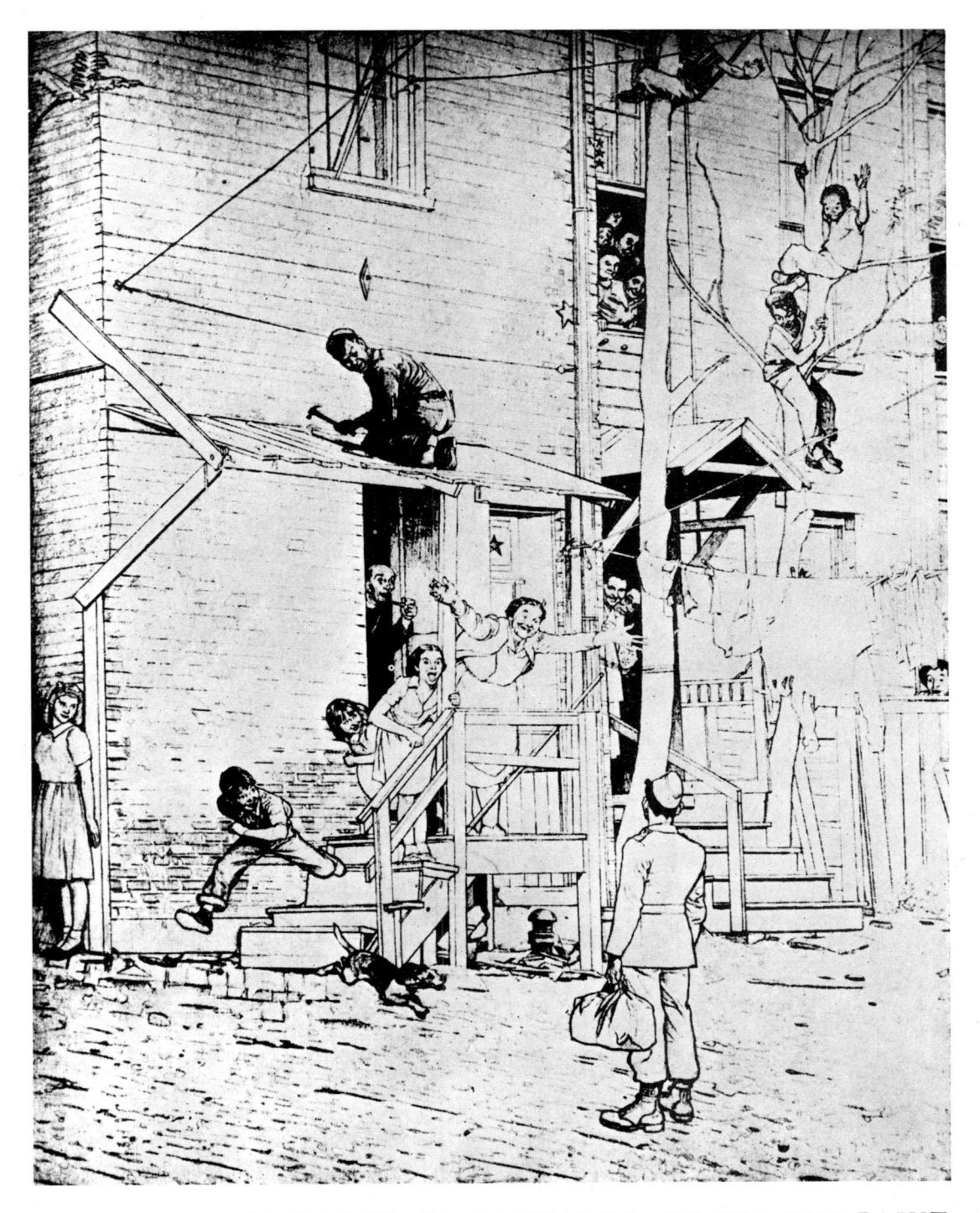

DRAWING TRANSFERRED TO CANVAS READY FOR THE PAINT

After this subject had been transferred to the canvas it was refined, relined and "fixed" ready for the paint. By comparing this outline drawing with the finished painting, page 188, it will be seen that the two are practically alike in form. My charcoal layout and color studies (not reproduced) were my guides. N. R.

cadmium red (deep), venetian red, zinc white, and ivory black. Some pictures also require one or more of the following: Payne's gray, cerulean blue, cobalt blue, terre verte, burnt umber, cadmium orange (medium), mars violet, rose madder, and alizarin crimson.

Palette. The arrangement of these colors on Norman's palette may vary somewhat, but the accompanying sketch shows a typical disposition—the colors in capital letters are those most frequently used. We

have already seen that this palette consists of a heavy adjustable drawing table (the metal stand type) on top of which is a large piece of white glass known as "milk glass"—see photo, page 40. Such a stand permits the raising or lowering of the palette to the desired height; it can also be used horizontally or tipped to any degree. Norman has equipped his stand with a box designed to accommodate tubes of color. He keeps reds at the left, yellows next, then white, and at the right his blues, greens, black and miscellaneous colors. An attached shelf behind this box accommodates his brushes.

Mediums. Convenient to the working surface of this palette, on an adjustable arm-shelf, is a vessel filled with rectified turpentine, and a smaller one containing Grumbacher's Oil Medium No. 2. Norman uses the turpentine for washing his paint brushes and, as he works, he also mixes some of it with the Grumbacher Medium, thus obtaining the medium with which he thins his paints. He doesn't do this mixing in a vessel, but directly on the palette as he prepares his paints. Asked about the relative proportion of the Grumbacher Medium to turpentine,

he explained, "Oh, gosh, it says use it sparingly; I use lots of it."

Brushes, etc. Rockwell's preference is for Rubens' long bristle flats in a variety of sizes. He avoids sable brushes excepting for small, very difficult bits of detail. Sables, he claims, are quite certain to make one's work too slick, smooth and uninteresting. Palette knives of course prove useful for mixing colors, scraping off faulty areas and, occasionally, for applying paint. He uses a maul stick as a rest for his hand. For paint rags he has found nothing better than diaper cloth, which he buys in fifty dollar lots, to the amazement of clerks who recognize but one use for this article.

Step 14: Final Painting. Once Rockwell's allover color lay-in has been completed and has dried overnight, he varnishes it, using alcohol thinner to dilute the varnish. This dries almost immediately and he is ready to start his final painting. In some instances he paints the background first, and saves for last the central head (or heads). In others, he starts with a head and paints from there. Stated differently, if the atmosphere of the picture is the vital thing, he first paints the atmosphere, and then puts the figures or faces in the atmosphere; if a head counts more, he first paints the head and then does the background. In some scenes he paints the distance first, then the middle distance and, finally, the foreground and figures. Whatever his method in detail, he keeps all parts developing simultaneously, believing that at practically every stage a painting should have a finished look.

Technical Methods. Norman follows all the usual orthodox procedures. In much of his work he employs the typical impasto or opaque (solid color) method common to America, in which the paints are applied practically as they come from the tubes, being diluted with medium only enough to make them amenable to brush application. At times he relies, instead, on a glazing technique, such as was much favored by the Old Masters, in which thin color, greatly diluted with medium, is washed over the underpainting after it is dry and varnished. method gives richness and depth of color. Again, he decides on a mixed technique, opaquing part in solid color—perhaps the head and hands—and glazing the remainder. This procedure enriches the picture and makes it more interesting through its variety of surfaces. Sometimes he "paints into the soup" by starting in the morning with medium mixed with a little of the general colors, washing this over the area he intends to work on that day. Then he paints into

this moistened area, gaining a hard-te-define but often desirable character. "Painting over dry paint is very unsatisfactory to me," explains Rockwell. "Painting in soup permits a pleasant blending of the new and former work."

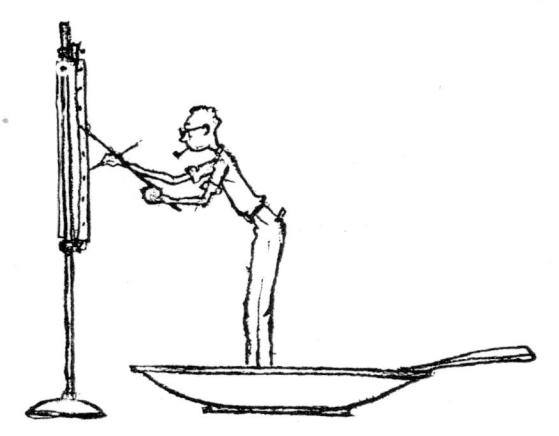

As he proceeds, he often finds that many of the "happy accidents" arrived at in his lay-in can be preserved. He tells of the student who once asked Dean Cornwell what to do if one of these accidents occurred. "Get down on your knees," the noted artist said, "and thank God for it."

"This way I paint is technically terrible," Norman states, "piling paint on varnish and varnish on paint, coat after coat, without adequate time for drying. John Atherton says that it's a wonder my paintings don't explode. Perhaps some day they will! I certainly wouldn't want to guarantee their durability. But I'm inclined to agree with Richard Miller who

didn't consider permanency too important. 'Let the next generation paint its own pictures,' was the substance of his comment. One thing is sure; this is the only method I could possibly use and meet my deadlines. I couldn't meet them, even as it is, if I didn't plan every move in advance and hold to my schedule. Some artists don't seem to worry about time, but in illustration it's advisable to make up your mind to do a certain definite amount in a given period and then do it. It's surprising, but true, that you can accomplish just about what you determine

to do. One should never just paint along vaguely from start to finish, hoping that sooner or later the picture will turn out all right. He should plot every step and work to a fixed schedule. At least *I* think he should. And he should take every possible means to insure success. For example, by varnishing every so often as I do, if something goes wrong I can rub it off with turpentine down to the varnish, without losing the painting beneath."

Rockwell fears that his greatest fault is carrying his paintings too far. "Often my rough studies are better than my finished work," he admits. "Frequently my wife sees a painting, say at ten o'clock in the morning. I am working on a head. She thinks it is swell and says, 'Don't touch it again.' Then she comes out at noon and tells me I have spoiled it by slicking it up too much. And she's right. Even if I try, I can never get back the freshness of the first lay-in, with its accidents. But that's how I do it."

Rockwell sits at his work about half the time and stands the rest. "The older I grow, the more I stand," is his comment. His working day is long. He is usually in the studio at eight or eight-thirty and, excepting for a half hour at noon for lunch—he reads as he eats-and a brief recess at about two when he goes to the house for a "coke" and his mail, he keeps plugging away until he is called for dinner at six. After dinner, it is not uncommon for him to return to the studio for a while, either to paint, to clean his brushes and palette-he does this every night, first with turpentine and next with Ivory soap or to plan his next day's work. During all this period he seldom relaxes his effort excepting, if he finds himself growing tense, to knock off for a few minutes to tidy up his studio.

When a new painting is started, the first day or two require intensively creative work—his very best thought and energy—but after that many hours must be spent on such tedious tasks as transferring to can-

vas, filling in the background and doing details. Rockwell sometimes likes to be read to during these otherwise monotonous periods. Years ago, John Malone, one of his models, started this practice by reading aloud as he posed. "He read beautifully, eight hours a day," Norman relates, "but never fully comprehended anything he read. We covered quite a library, including Guy de Maupassant, Dickens, Tolstoy, Henry James, Voltaire and Jane Austen. I used to fear that there was something odd about me, wanting to be read to, until I learned that Howard

Pyle was addicted to this practice—he painted mighty well, so I felt better about it.

"Mary, my wife, has also read to me a great deal. We have enjoyed dozens of books together, including current titles, and the best of literature, old and new, from many lands. Recently, we have more or less abandoned the practice. I don't seem to need this sort of diversion just now."

Step 15: Framing and Delivery. As Rockwell works, he often slips his painting into a frame to aid him in appraising the effect and, once it is completed, he frames it permanently. "It has been said," he remarks, "that a picture without a frame is like a man without a collar. I agree, and advise the

artist to deliver his picture framed." And in this he follows his own advice. Many people say, "But this cover won't be reproduced in the frame. Why lug that huge thing around?" He replies, "It will give the editors the proper impression of my painting. They won't be distracted by the tacks and the rough edges of the canvas, or by other disturbing elements near by. My motto is, 'the poorer the picture, the better the frame.' Another thing, the frame is a protection in transportation." So off he goes from Arlington to Philadelphia, time after time, struggling along with a huge framed canvas. And that's the last of that job, or so he hopes.

Usually he kills two birds with one stone by also taking with him to Philadelphia his latest idea sketches to discuss with Ken Stuart. On the way back home he often goes right to work planning how best to develop the idea which he and Ken have decided should be tackled first. Back in Arlington he sails into the thing with enthusiasm, confident that this new cover painting will be the best ever. About the only relief he gets from this strenuous and sustained schedule comes from these trips to the Post and his occasional trips about the country rounding up new material. He is most likely to leave the studio, if at all, when a charcoal layout has been completed but before he has transferred it to canvas.

Has the Post ever actually refused a completed cover submitted by Rockwell? The artist can remember only three or four that were not accepted. Sometimes, because of rapidly changing world events,

a cover is outdated before it can appear.

All covers don't go through exactly the same procedure, nor does Rockwell hold to a hard-and-fast method from year to year. Like practically all artists he enjoys experimenting. And he is affected, subconsciously at least, by changing trends. He keeps in his studio a collection of superb reproductions of the work of recognized masters, past and present. Often in plotting a new design he draws part of his inspiration from the work of one of these masters.

He advises students to study the best of all time, rather than to emulate the styles of contemporaries. "The curse of modern illustration is the practice of copying current styles."

Not all illustrators are as painstaking as Rockwell. He considers that students and young illustrators are likely to be too impatient and casual about many things—too much inclined to rush a job through, to call it good enough. He believes that they should be willing to make any effort or sacrifice that may lead to better results. "Neither time nor effort nor materials should be spared if worthy work is to be expected," he says. "Even if it is necessary to give up something—something outside the studio—in order to get the right things in the studio, I think it is almost criminal not to do it that way. I learned this from Leyendecker years ago-he never spared time or money. In World War I, I was in his studio when he was doing a picture of an American aviator. His model was wearing an aviator's coat which Leyendecker had bought. He told me that the artist had paid forty dollars for this jacket and had given it to him to keep. But if Leyendecker hadn't done that, had merely 'gotten by' with a picture of the jacket from a catalog, he would never have done the swell cover he did. Does that get over what I mean? I think it's terribly important."

BEEND